Motion Graphic Design

Motion Graphic Design

Motion Graphic Design
Applied History and Aesthetics

Jon Krasner

AMSTERDAM • BOSTON • HEIDELBERG • LONDON
NEW YORK • OXFORD • PARIS • SAN DIEGO
SAN FRANCISCO • SINGAPORE • SYDNEY • TOKYO
Focal Press is an imprint of Elsevier

Acquisitions Editor: Paul Temme
Associate Acquisitions Editor: Dennis McGonagle
Publishing Services Manager: George Morrison
Project Manager: Kathryn Liston
Assistant Editor: Chris Simpson
Marketing Manager: Rebecca Pease
Cover Design: Jon Krasner
Interior Design and Composition: Jon Krasner

Focal Press is an imprint of Elsevier
30 Corporate Drive, Suite 400, Burlington, MA 01803, USA
Linacre House, Jordan Hill, Oxford OX2 8DP, UK

 Recognizing the importance of preserving what has been written, Elsevier prints its books on acid-free paper whenever possible.

Library of Congress Cataloging-in-Publication Data
(Application submitted)

British Library Cataloguing-in-Publication Data
Acatalogue record for this book is available from the British Library.

ISBN: 978-0-240-80989-2

For information on all Focal Press publications, visit our website at www.books.elsevier.com.

08 09 10 11 12 10 9 8 7 6 5 4 3 2 1

Printed in China

To my father, Robert Krasner, who has always been my source of encouragement, inspiration, and admiration.

To my mother, Lee Krasner, who taught me perseverance and the art of giving.

Finally, to my loving wife, Meagan, and to our children, Harris, Simon, and Julina. You have given me all the love and support that anyone could ask for in a life of adventure.

Brief Contents

Contents

4 Motion Graphics in the Environment

5 Motion Literacy: Choreographing Movement

6 Images, Live-Action, and Type

7 The Pictorial Composition

Contents

12 Motion Graphics Sequencing

preface

enclosed DVD

This book's companion DVD features student work from schools such as Massachusetts College of Art, Ringling School of Art and Design, Kansas City Art Institute, New York University, and California Art Institute. Additionally, it presents examples of today's cutting-edge motion graphics from the following world renown studios and designers:

This disk can be played on most new consumer DVD players and desktop computer DVD-ROM drives. A list of players that have been tested for compatability can be found at apple.com/dvd/compatibility.

twenty2product

Blur

Steelcoast Creative

Digital Kitchen

FUEL TV

METAphrenie

Addikt

Freestyle Collective

Studio Dialog

Viewpoint Creative

Capacity

Beretta Designs

Kemistry

Zona Design

*nailgun**

Belief

abstr^ct:Groove

Velvet Design

Thornberg & Forester

Stardust Studios

Studio Blanc

KRAFT:HAUS

L.inc Design

Shilo

Buck

Imaginary Forces

Velocity Studio

Flying Machine

Giant Octopus

Humunculus

The Ebeling Group

ritxi

Daniel Jenett

David Carson

Tavo Ponce

Susan Detrie

Adam Swaab

acknowledgments

The success of this book would not have been possible without the support and encouragement from the following individuals:

Meagan, thank you for your ongoing support, patience, and encouragement. I could not ask for a more loving and supportive wife.

I want to give special thanks to **Jakob Trollbäck** for writing my foreword. I hope that we have a chance to collaborate in the future.

To my students and colleagues at Fitchburg State College; you continue to be a joy to work with. Each day you keep my mind young and teach me more about the art of teaching and learning.

I want to express my gratitude to my editors at Focal Press, in particular, **Paul Temme** and **Dennis McGonagle**. It has been a pleasure working with you!

Finally, to all of those who generously contributed your work, you will serve as a source of inspiration to my readers. I am grateful to have had the opportunity to get to know each of you and hope that our paths will cross again.

Thank you all for helping me create another book to be proud of!

Introduction

Time—the fourth dimension—has been realized as a vital force in visual communication. Its powerful impact as a vehicle for communication and artistic expression has enhanced the landscape of thinking among graphic designers.

Since the late 1970s, graphic design has evolved from a static publishing discipline to a practice that incorporates a broad range of communications technologies including film, animation, interactive media, and environmental design. The field of motion graphics has captured the imagination of designers and viewers in the twenty-first century. Motion is becoming a principal part of our contemporary visual landscape with integrative technologies merging television, the Internet and immersive environments. The extraordinary evolution of motion graphics in our complex 'information age' mandates the need for effective communication and the demand for motion graphic designers who can design for film, television, the Web, and interactive forms of entertainment.

Designing in time and space presents a set of unique, creative challenges that combine the language of traditional graphic design with the dynamic visual language of cinema into a hybridized system of communication. The objectives of this text are to provide a foundation for understanding the essence of motion graphic design, to examine pictorial and sequential principles that are unique to choreographing image and motion, and to explore how the merging of composition and choreography can communicate visual messages with meaning, expression, and clarity. Additionally, it strives to address how designers have shaped the landscape of visual communication and how stylistic trends can be used in the design process.

Having said that, this book should not be mistaken as a software-specific guide, but should be viewed as a historical and critical overview of how motion graphics has evolved as a commercial practice in the motion picture, broadcast and interactive media industries.

Throughout each chapter, case studies and engaging graphics that feature works of high artistic merit from practitioners and students from across the globe offer insight into how designers formulate ideas, solve problems, and search for artistic expression. Sample assignments are intended to challenge and motivate you to develop an understanding of motion literacy, kinetic images and typography, and the pictorial and sequential aspects of composition.

The human imagination has no limits. The artistic impulse to experiment and innovate burns inside all of us. This text is written with the hope of inspiring you artistically. I encourage to examine this comprehensive text and push ahead to the boundless frontier of motion graphics as an independent and commercial enterprise.

Foreword

Life is linear. Regardless of how much we at times yearn to go back and relive jewel-like events or fast forward past bleak ones or towards milestones, time stubbornly moves on in the same old direction, at the same old pace. Fortunately, our perception of time is far less rigid. How we feel about time does not, of course, always work to our advantage. A great experience usually melts into the past way too fast, while adversity feels endless. To make our existence more gentle, however, our imagination can whisk us forward or backwards. This unique human ability to warp the timeline allows us to reflect over the past, process the present, and picture the future. And when you capture and retell a small moment from along the way, you suddenly are delivering a story.

Stories are at the core of humanity. They are our most fundamental and richest means of exploring, shaping, and sharing our reality. Without our narratives, life would make no sense. But the greatest blessing is a good story's ability to rupture monotony and infuse new emotions and new ideas into our lives. Stories not only result from the power of our imagination but fuel it too, conjuring up a wonderful, free world of relative space and time from which we derive our sense both of purpose and possibility.

Tools for creating time-based design are increasingly easy to access and use. We've therefore seen a giant surge in the number of designers beginning to explore animation and filmmaking. If you're a designer who has spent a lot of time creating static expressions, the addition of motion can be both liberating and confusing.

A self-taught graphic designer from Sweden, Jakob Trollbäck creates seminal and award-winning designs, and is an acknowledged industry leader in branding and motion graphic design.

Trollbäck + Company, currently in its eighth year, produces film titles, television commercials, environmental design, music videos, and short films. Clients include top TV networks (CBS, AMC, HBO, TCM, TNT, and Sundance Channel); film companies (HBO Films, Fox Searchlight, and Miramax); and advertising clients (Nike, Volvo, and Fidelity).

Trollbäck + Company has received numerous creative-industry awards, including those from the Primetime Emmy Awards, AICP Show, Art Directors Club, Arts Design Annual, British D&AD, Broadcast Designers Association, Type Directors Club, and The One Show. Recently, Trollbäck + Company was included in the 2006-2007 Cooper-Hewitt National Design Triennial.

On the one hand, it's rewarding to see how images can unfold over time and working with this new axis can make a designer feel very powerful. On the other, it is easy to get carried away by all the cool possibilities at your fingertips. No matter what, however, the crux of all visual communication, either motion or static, is still actually having something to say. We tend to be instantly hooked by design in motion. Humans are hardwired from our days as hunters and gatherers to be captivated by anything that moves. If a TV is on in a bar, we have to strain to avoid looking at it, no matter how interesting the conversation or how pointless the animation on the screen.

While it's our duty to respect this innate drive to watch, we also must honor the ancient art of storytelling. In these pages, you will find a rich understanding of the history, theory and practice of motion graphics. But after you are done reading, it's all up to you. Make your motion narratives seductive, shocking, useful, beautiful. Whatever you do, be passionate. And if you really want to do something that matters, tell us your best stories.

Jakob Trollbäck
President/Creative Director
Trollbäck + Company, NY
http://www.trollback.com

PART 1

motion graphic design:

DEVELOPING STORY

an overview

Connect

:Motion Montage Prototype 1" © 2007 Jon Krasner

1

a brief history of motion graphics

early practices & pioneers

> *"It seems inevitable to me that some day, in an elegant new hi-tech museum, someone will holler out in recognition and affection: 'Hey look, a whole room of Fischingers!'—or Len Lyes—or any of the great artist-animators of our century. They are the undiscovered treasures of our time."*
> *—Cecile Starr*

The moving image in cinema occupies a unique niche in the history of twentieth-century art. Experimental film pioneers of the 1920s exerted a tremendous influence on succeeding generations of animators and graphic designers. In the motion picture film industry, the development of animated film titles in the 1950s established a new form of graphic design called motion graphics.

00:00:00:01

Precursors of Animation

Since the beginning of our existence, we have endeavored to achieve a sense of motion in art. Our quest for telling stories through the use of moving images dates back to cave paintings found in Lascaux, France and Altamira, Spain, which depicted animals with multiple legs to suggest movement. Attempts to imply motion were also evident in early Egyptian wall decoration and Greek vessel painting.

persistence of vision

Animation cannot be achieved without understanding a fundamental principle of the human eye: *persistence of vision*. This phenomenon involves our eye's ability to retain an image for a fraction of a second after it disappears. Our brain is tricked into perceiving a rapid succession of different still images as a continuous picture. The brief period during which each image persists upon the retina allows it to blend smoothly with the subsequent image.

early optical inventions

Although the concept of persistence of vision had been firmly established by the nineteenth century, the illusion of motion was not achieved until optical devices emerged throughout Europe to provide animated entertainment. Illusionistic theatre boxes, for example, became a popular parlor game in France. They contained a variety of effects that allowed elements to be moved across the stage or lit from behind to create the illusion of depth. Another early form of popular entertainment was the magic lantern, a device that scientists began experimenting with in the 1600s (**1.2**). Magic lantern slide shows involved the projection of hand-painted or photographic glass slides. Using fire (and later gas light), magic lanterns often contained built-in mechanical levers, gears, belts, and pulleys that allowed the slides (which sometimes measured over a foot long) to be moved within the projector. Slides containing images that demonstrated progressive motion could be projected in rapid sequence to create complex moving displays.

One of the first successful devices for creating the illusion of motion was the thaumatrope, made popular in Europe during the 1820s by London physicist Dr. John A. Paris. (Its actual invention has often been credited to the astronomer Sir John Herschel.) This simple apparatus was a small paper disc that was attached to two pieces of string and held on opposite sides (**1.3**). Each side of the disc contained an image,

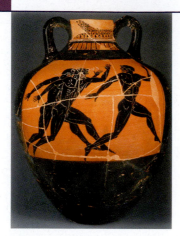

1.1
Panathenaic amphora, c. 500 BC. Photo by H. Lewandowski, Louvre, Paris, France. Réunion des Musées Nationaux © Art Resource, NY.

Several individuals who have been credited with the discovery of persistence of vision include Greek mathematician Euclid, Greek astronomer Claudius Ptolemy, Roman poet Titus Lucretius Carus, British physicist Isaac Newton, Belgian physicist Joseph Plateau, and Swiss physician Peter Roget.

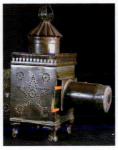
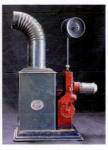

1.2
Magic lantern slide & projectors.
Photos by Dick Waghorne.
Courtesy of the Wileman
Collection of Optical Toys.

1.3
Thaumatrope discs and case.
Photo by Dick Waghorne.
Courtesy of the Wileman
Collection of Optical Toys.

and the two images appeared to become merged together when the disc was spun rapidly. This was accomplished by twirling the disc to wind the string and gently stretching the strings in opposite directions. As a result, the disc would rotate in one direction and then in the other. The faster the rotation, the more believable the illusion.

In 1832, a Belgian physicist named Joseph Plateau introduced the phenakistoscope to Europe. (During the same year, Simon von Stampfer of Vienna, Austria invented a similar device called the stroboscope.) This mechanism consisted of two circular discs mounted on the same axis to a spindle. The outer disc contained vertical slots around the circumference, and the inner disc contained drawings that depicted successive stages of movement. Both discs spun together in the same direction, and when held up to a mirror and peered at through the slots, the progression of images on the second disc appeared to move. Plateau derived his inspiration from Michael Faraday, who invented a device called "Michael Faraday's Wheel," and Peter Mark Roget, the compiler of Roget's Thesaurus. The phenakistoscope was in wide circulation in Europe and America during the nineteenth century until William George Horner invented the zoetrope, which did not require a viewing mirror. Referred to as the "wheel of life," the zoetrope was a short cylinder with an open top that rotated on a central axis. Long slots were cut at equal distances into the outer sides of the drum, and a sequence of drawings on strips of paper were placed around the inside, directly below the slots. When the cylinder was spun, viewers gazed through the slots at the images on the opposite wall of the cylinder, which appeared to spring to life in an endless loop (**1.4**).

The popularity of the zoetrope declined when Parisian engineer Emile Reynaud invented the praxinoscope. A precursor of the film projector, it offered a clearer image by overcoming picture distortion by placing images around the inner walls of an exterior cylinder. Each image was reflected by a set of mirrors attached to the outer walls of an interior

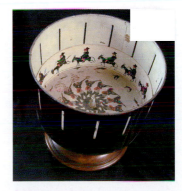

1.4
Zoetrope, top view. Photo: Dick
Waghorne. Wileman Collection
of Optical Toys.

cylinder (**1.5**). When the outer cylinder is rotated, the illusion of movement is seen on any one of the mirrored surfaces. Two years later, Reynaud developed the praxinoscope theatre, a large wooden box containing the praxinoscope. The viewer peered through a small hole in the box's lid at a theatrical background scene that created a narrative context for the moving imagery.

Early Cinematic Inventions

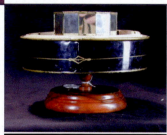

1.5
Praxinoscope. Photos by Dick Waghorne. Wileman Collection of Optical Toys.

During the late 1860s, former California governor Leland Stanford became interested in the research of Etienne Marey, a French physiologist who suggested that the movements of horses were different from what most people thought. Determined to investigate Marey's claim, Stanford hired Eadward Muybridge, who earned a reputation for his photographs of the American West, to record the moving gait of his racehorse with a sequence of still cameras (**1.6**). Muybridge continued to conduct motion experiments, some of which were published in an 1878 article in *Scientific American*. This article suggested that its readers cut the pictures out and place them in a zoetrope to recreate the illusion of motion. This fueled Muybridge to invent the zoopraxiscope, an instrument that allowed him to project up to 200 single images on a screen. This forerunner of the motion picture was received with great enthusiasm in America and England. In 1884, Muybridge was commissioned by the University of Pennsylvania to further his study of animal and human locomotion and produced an enormous compilation of over 100,000 detailed studies of animals and humans engaging in various physical activities. These volumes were a great aid to visual artists in helping them understand movement.

Muybridge's books, Animals in Motion *(1899) and* The Human Figure in Motion *(1901), are available from Dover Publishers. Many of his plates are exhibited at the Kingston-upon-Thames Museum as well as in the collection of the Royal Photographic Society.*

In 1889, Hannibal W. Goodwin, an American clergyman, developed a transparent, celluloid film base, which George Eastman began manufacturing. For the first time in history, long sequences of images could be contained on a single reel. (Zoetrope and praxinoscope strips were limited in that they could only display approximately 15 images per strip.) In Britain, Louis and Auguste Lumiere developed the kinora, a home movie device that consisted of a 14-cm wheel that held a series of pictures. When the wheel was rotated by a handle, the rapid succession of pictures in front of a lens gave the illusion of motion (**1.7**). By 1894, coin-operated kinetoscope parlors could be seen in New York

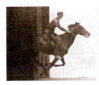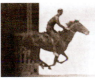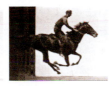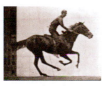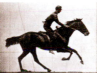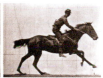

1.6
Motion study, by Eadweard Muybridge. Courtesy of the National Museum of American History.

City, London, and Paris. This eventually led to their invention of the Cinematographe, the first mass-produced camera-printer-projector of modern cinema (**1.8**). For the first time in history, cinematographic films were projected onto a large screen for a paying public.

In addition to filming movies, new developments led to the concept of creating drawings that were specifically designed to move on the big screen. Prior to Warner Brothers, MGM, and Disney, the origins of classical animation can be traced back to newspapers and magazines that displayed political caricatures and comic strips. One of the most famous cartoon personalities before *Mickey Mouse* was *Felix the Cat*. Created by Australian cartoonist Pat Sullivan and animated by Otto Mesmer, Felix was the first animated character to have an identifiable screen personality. In 1914, an American newspaper cartoonist named Winsor McCay introduced a new animated character to the big screen—*Gertie the Dinosaur*. The idea of developing a likeable personality from a living creature had a galvanizing impact upon audiences. As the film was projected on screen, McCay would stand nearby and interact with his character.

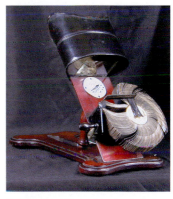

1.7
Kinora. Photo by Dick Waghorne. Wileman Collection of Optical Toys.

Kinora Ltd. was a British factory that sold and rented Kinora reels for personal home viewing. It allowed people to have "motion portraits" taken in a photographic studio to be viewed on their home Kinora. The company supplied an amateur camera that allowed people to create their own movies. In 1914, the factory burned down, and the company decided not to rebuild itself, since public interest in the Kinora had faded.

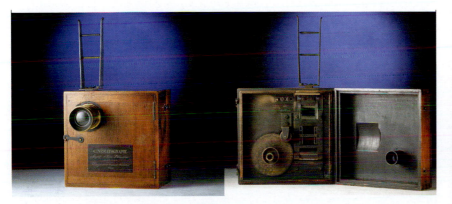

1.8
The Cinematographe, the first mass-produced camera-printer-projector of modern cinema. Courtesy: National Museum of American History.

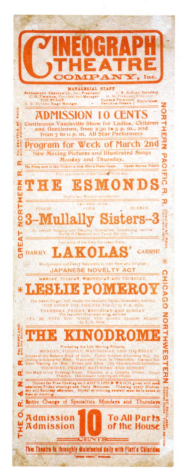

1.9
Ad for "Cineograph Theatre" showing a daily program of motion picture shows (1899–1900). Courtesy of the National Museum of American History.

The cell animation process, developed in 1910 by Earl Hurd at John Bray studios, was a major technical breakthrough in figurative animation that involved the use of translucent sheets of celluloid for overlaying images. Early artists who utilized Bray's process included Max Fleischer (*Betty Boop*), Paul Terry (*Terrytoons*), and Walter Lantz (*Woody Woodpecker*). Stop-motion animation, which can be traced back to the invention of stop-action photography, was used by French filmmaker Georges Méliès, a Paris magician. In Méliès' classic film, *A Trip to the Moon* (1902), stop-action photography allowed Méliès to apply his techniques, which were derived from magic and the theatre, to film. Additional effects, such as the use of superimposed images, double exposures, dissolves, and fades, allowed a series of magical transformations to take place.

Four years later, J. Stuart Blackton, an Englishman who immigrated to the United States, discovered that by exposing one frame of film at a time, a subject could be manipulated between exposures to produce the illusion of motion. In 1906, his company, Vitagraph, released an animated short titled *Humorous Phases of Funny Faces*, one of the earliest surviving American animated films. Blackton's hand is seen creating a line drawing of a male and female character with chalk on a blackboard. The animation of each face's changing facial expression was accomplished through single-frame exposures of each slight variation. When the artist's hand exits the frame, the faces roll their eyes and smoke issues from a cigar in the man's mouth. At the end of the film, Blackton's hand reappears to erase the figures. This new stop-motion technique shocked audiences as the drawings magically came to life (**Chapter 10, figure 10.7**).

1.10
Postage stamp with portrait of Georges Méliès. Courtesy of Anthology Film Archives.

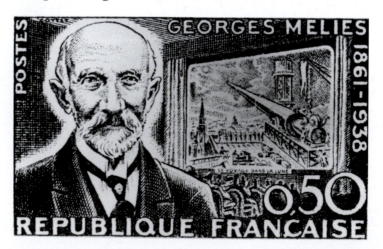

Emile Cohl and Max Fleischer expanded the resources of animation by mixing live footage with hand-drawn elements. Known as the father of French animation, Emile Cohl, a newspaper cartoonist, is known for his first classic film, *Fantasmagorie* (1908). Cohl's 300 subsequent short animations were a product of the Absurdist school of art, which derived artistic inspiration from drug-induced fantasy, hallucinations, and insanity. These works combined hand-drawn animated content and live action. Around 1917, Max Fleischer, an admirer of McCay's realistic style, patented the technique of rotoscoping. This process involved drawing frames by tracing over previously filmed live-action footage, allowing the animator to produce smooth, lifelike movements. Fleischer's next invention, the Rotograph, enabled animated characters to be placed into live, realistic settings. A live action background would be filmed and projected one frame at a time onto a piece of glass. A cel containing an animated character would be placed on the front side of the glass, and the composite scene would be filmed. With this technique, Fleischer went on to develop the personalities of famous characters such as *Koko the Clown*, *Betty Boop*, *Popeye*, and *Superman*.

Experimental Animation

At the turn of the twentieth century, postwar technological and industrial advances, and changing social, economic, and cultural conditions of monopoly capitalism throughout Europe fueled artists' attempts to reject classical representation. This impulse led to the rapid evolution of abstraction in painting and sculpture. Revolutionary Cubist painters began expressing space in geometric terms. Italian Futurists became interested in depicting motion on the canvas as a means of liberating the masses from the cruel treatment that they were receiving from the government. Dada and Surrealist artists sought to overthrow traditional constraints by exploring the spontaneous, the subconscious, and the irrational. These forms of Modernism abandoned the laws of beauty and social organization in an attempt to demolish current aesthetic standards of art. This was manifested in music, poetry, sculpture, painting, graphic design, and experimental filmmaking.

pioneers of "pure cinema"

During the 1920s, huge movie palaces, fan magazines, and studio publicity departments projected wholesome images of stars. (Few

1.11

Filmstrip from the work of Viking Eggeling. From *Experimental Animation*, courtesy of Cecile Starr.

people knew the names of the directors!) Hollywood's mass-produced romances and genre films reaffirmed values such as the family and patriotism. In Germany, France, and Denmark, filmmakers began to embrace a more personal attitude toward film through the medium of animation. Their basic motivation was not inspired by commercial gain; rather, it came from a personal drive to create art. "Pure cinema," as the first abstract animated films were called, won the respect of the art community who viewed film as an expressive medium.

During the early 1900s, Swedish musician and painter Viking Eggeling described his theory of painting by way of music, in terms of "instruments" and "orchestration." His desire was to establish what he referred to as a "universal language" of abstract symbols, and he strived to accomplish this by emphasizing musical structure and avoiding representation. The nihilistic tendencies of the Dada movement gave Eggeling the freedom to break from conventional schools of thought, and he collaborated with German filmmaker Hans Richter on a series of scroll drawings that utilized straight lines and curves of varying orientations and thicknesses. These structures were arranged in a linear progression across a long scroll of paper, forcing viewers to see them in a temporal context. Driven by the need to integrate time into his work, he turned his attention to film and produced *Symphonie Diagonale* in 1923. Taking almost four years to complete, this frame-by-frame animation showed a strong correlation between music and painting in the movements of the figures, which were created from paper cutouts and tin foil (**1.11**). Eggeling died in Berlin approximately two weeks after his film was released.

A major contributor to the Cubist movement, Fernand Léger has been described as "a painter who linked industry to art." Born in northwestern France, he desired to express his love for city life, common people, and everyday objects in painting. By 1911, he became identified with his tubular and curvilinear structures, which contrasted with the more angular shapes produced by other cubists, such as Picasso and Braque. During the 1920s, Leger began to pursue film and produced his classic, *Ballet Mechanique* (1923). Created without a script, this masterpiece demonstrated a desire to combine the energy of the machine with the elegance of classical ballet. Fragments of reflective, metal machinery, disembodied parts of figures, and camera reflections were orchestrated into a seductive, rhythmic mechanical dance. Conceptually, this

film has been interpreted as a personal statement in a world of accelerating technological advancement and sexual liberation. From an artistic perspective, it represented a daring jump into the territory of kinetic abstraction.

German Dadaist Hans Richter collaborated with Viking Eggeling to produce a large body of "scroll drawings" that depicted sequential transformations of geometric forms that he described as "the music of the orchestrated form." Richter saw film animation as the next logical step for expressing the kinetic interplay between positive and negative forms. Richter's silent films of the late 1920s demonstrated a more surreal approach that combined animation with live-action footage. At the time, these shocking films challenged artistic conventions by exploring fantasy through the use of special effects, many of which are used in contemporary filmmaking. In *Ghosts Before Breakfast* (1927), people and objects engage in unusual behavior set in bizarre and often disturbing settings. Flying hats continually reappear in conjunction with surrealistic live images of men's beards magically appearing and disappearing, teacups filling up by themselves, men disappearing behind street signs, and objects moving in reverse. In a scene containing a bull's eye, a man's head becomes detached from his body and floats inside the target. In another scene of a blossoming tree branch, fast-motion photography was used. Richter also played back the film in reverse and used negatives to defy the laws of the natural world.

After World War I, German painter Walter Ruttmann became impatient with the static quality of his artwork and saw the potential of film as a medium for abstraction, motion, and the passage of time. In 1920, he founded his own film company in Munich and pioneered a series of playful animated films entitled *Opus*, all of which explored the interaction of geometric forms (**1.13**). (*Opus 1* [1919–1921] was one of the earliest abstract films produced and one of the few that was filmed in black and white and hand-tinted.) The technical process that Ruttmann employed remains questionable, although it is known that he painted directly onto glass and used clay forms molded on sticks that, when turned, changed their appearance. Ruttmann's later documentary, *Berlin: Symphony of a City*, gives a cross-section impression of life in Berlin in the late 1920s. The dynamism of urbanization in motion is portrayed in bustling trains, horses, masses of people, spinning wheels, and machines, offering an intimate model of Berlin.

1.12
Filmstrip from *Rhythm 23* (1923) by Hans Richter. From *Experimental Animation*, courtesy of Cecile Starr.

1.13
Frames from *Opus III* (c. 1923)
and *Opus IV* (c. 1924), by Walter
Ruttmann. From *Experimental Ani-
mation*, courtesy of Cecile Starr.

Born in Brooklyn, New York, Emanuel Radnitsky (known as Man Ray), became an enigmatic leader of the Dada–Surrealist and American avant-garde movements of the 1920s and 1930s. After establishing Dadaism in New York City with Marcel Duchamp and Francis Picabia, he moved to Paris and became a portrait photographer for the wealthy avant-garde. By the early 1920s, he developed a reputation for his use of natural light and informal poses during a time when Pictorialism was the predominant style of photography in Europe. Commercial success gave him the freedom to experiment, and his discovery of the "Rayograph" (later called the photogram) made a significant contribution to the field of photography. Throughout the 1920s, Man Ray produced Surrealist films that were created without a camera, such as *Anemic Cinema* (1925–26) and *L'Etoile de Mer* (1928). He often described them as "inventions of light forms and movements."

In the 1930s, Russian-born filmmaker Alexander Alexeieff and American Claire Parker invented the pinboard (later named the pinscreen), one of the most eccentric traditional animation techniques. This contraption consisted of thousands of closely-spaced pins that were pushed and pulled into a perforated screen, using rollers to achieve varying heights. When subject to lighting, cast shadows from the pins produced a wide range of tones, creating dramatic textural effects that resembled a mezzotint, wood carving, or etching. The extraordinary results of this process are evident in classic pieces such as *Night on Bald Mountain* (**Chapter 6, figure 6.35**) and *The Nose*, a film based on a story about a Russian major whose nose is discovered

by a barber in a loaf of bread. According to Parker, "Instead of brushes we use different sized rollers; for instance, bed casters, ball-bearings, etc., to push the pins toward either surface, thus obtaining the shades or lines of gray, black, or white, which we need to compose the picture."

Revolutionary New Zealand animator Len Lye, who often referred to himself as "an artist for the twenty-first century," pioneered the direct-on-film technique of cameraless animation by painting and scratching onto 35mm celluloid. His use of abstract, metaphorical images are a product of his association with Surrealism, Futurism, Constructivism, and Abstract Expressionism, as well as his affinity for jazz, Oceanic art, and calligraphy. His use of percussive music, saturated color, and organic forms had a major impact on a genre that later became known as music video. Living in Samoa between 1922 and 1923, Lye became inspired by Aboriginal motifs and produced his first animated silent film, *Tusalava* (1929), which he created to express "the beginnings of organic life" (**1.14**). This film took approximately two years to complete, since each frame was hand-painted and photographed individually. In a 16mm abstract film titled *Free Radicals* (1958), Lye scratched the content onto a few thousand feet of black film leader using tools ranging from sewing needles to Indian arrowheads.

1.14
Frame from *Tuslava* (1929), by Len Lye. From *Experimental Animation*, courtesy of Cecile Starr.

In Canada, Norman McLaren has been described as a "poet of animation." Inspired by the masterpieces of filmmakers Eisenstein and Pudovkin, he began animating directly onto film, scratching into its emulsion to make its stock transparent. (At the time, he was unaware that Len Lye was conducting similar experiments.) In 1941, he was invited to join the newly formed National Film Board of Canada (NFB), and there, he founded an animation department and experimented with a wide range of techniques. Films, such as *Fiddle-de-Dee* (1947) and *Begone Dull Care* (1949), were made by painting on both sides of 35mm celluloid. Incredibly rich textures and patterns were achieved through brushing and spraying, scratching, and pressing cloths into the paint before it dried. For over four decades, McLaren produced films for the NFB that served as an inspiration for animators throughout the world. In 1989, two years after his death, the head office building of the NFB was renamed the Norman McLaren Building.

Len Lye was always fascinated with the idea of composition with motion. As a teenager, he used an old box as a frame and devised a pulley mechanism with a phonograph handle attached to a string. An object would be attached to the other end of the string, and when the handle was turned, the pulley wheels would make the object revolve inside of the frame.

Berlin animator Lotte Reiniger is known for her silhouette cut-out animation style during the sound-on film era of the 1930s. Her full-length feature film, *The Adventures of Prince Achmed* (**Chapter 10,**

1.15
Lotte Reiniger in the 1920s.
From *Experimental Animation*,
courtesy of Cecile Starr.

1.16
Mary Ellen Bute, c. 1954. From
Experimental Animation, courtesy
of Cecile Starr.

1.17
Frame from *Abstronic* (1954),
by Mary Ellen Bute. From
Experimental Animation,
courtesy of Cecile Starr.

figure 10.12), was among the first animated motion pictures to be produced, taking approximately three years to complete. The main characters were marionettes that were composed of black cardboard figures cut out with scissors and photographed frame-by-frame.

Born in Texas, Mary Ellen Bute studied painting and earned a degree in stage lighting at Yale. She became interested in filmmaking as a means of exploring kinetic art, and in collaboration with Joseph Schillinger, a musician and musical composer who had developed a theory about the reduction of musical structure to mathematical formulas, began animating a film that would prove that music could be illustrated with images. Because of the intricacy of the images, however, this ambitious film was not completed. Mary Ellen Bute incorporated many different types of found objects in her work including combs, colanders, Ping-Pong balls, and eggbeaters and photographed them frame-by-frame at various speeds. She intentionally distorted them by filming their reflections against a wall to conceal their origin. Her first film from the 1930s, *Rhythm in Light*, involved shooting paper and cardboard models through mirrors and glass ashtrays to achieve multiple reflections. Mary Ellen also explored oscilloscope patterns as a means of controlling light to produce rhythm (**1.17**). Between 1934 and 1959, her abstract films played in regular movie theaters around the country.

As a leading innovator of experimental film, Oskar Fischinger believed that visual music was the future of art. Born in Germany, he was exiled to Los Angeles when Hitler came to power and the Nazis censured abstraction as "degenerate." During the early 1920s, his pursuit of the Futurist goal to make painting dynamic manifested in a series of film studies created from charcoal drawings of pure, geometric shapes and lines. Constructed from approximately 5,000 drawings, they demonstrated a desire to marry sound and image. Fischinger also experimented with images produced from a wax-slicing machine and explored color film techniques, cardboard cutouts, liquids, and structural wire supports. In 1938, Fischinger was hired by Disney Studios to design and animate portions of *Fantasia*. His presence in Hollywood helped shape generations of West Coast artists, filmmakers, graphic designers, and musicians.

Born in Portland, Oregon, Harry Smith, who began recording Native American songs and rituals as a teenager, emerged as a complex artistic figure in sound recording, filmmaking, painting, and ethno-

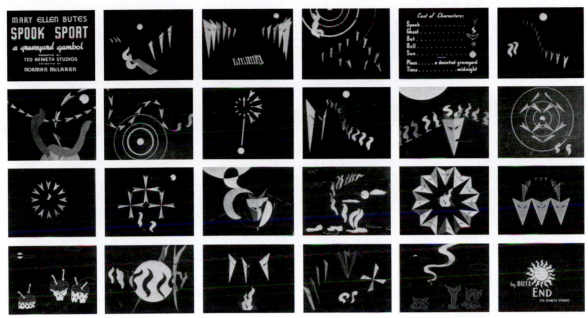

1.18
Frames from *Spook Sport* (1939), by Mary Ellen Bute and Norman McLaren. From *Experimental Animation*, courtesy of Cecile Starr.

graphic collecting. Intrigued by the occult, he often spoke of his art in alchemical and cosmological terms. His process involved hand-painting onto 35mm film stock in combination with stop motion and collage. Similar to his life and personality, his compositions are complex and mysterious and have been interpreted as explorations of unconscious mental processes. Like an alchemist, he worked on his films secretly for almost 30 years. At times, Smith spoke of synesthesia and the search for correspondences among color, sound, and movement. His painstaking direct-on-film process involved a wide range of nonconventional tools and techniques ranging from adhesive gum dots to Vaseline, masking tape, and razor blades. Throughout the 1950s and 1960s, Smith's collage films became increasingly complex. He cut out pictures and meticulously filed them away in envelopes, building up an image archive which he used in later works such as *Film # 12, Heaven and Earth Magic* (**1.20**).

After studying painting at Stanford, Robert Breer moved to Paris and became heavily influenced by the hard-edged geometric qualities of Neo-plasticism and the abstractions of the De Stijl and Blue Rider movements. Eventually, Breer felt restricted by the boundaries of the static canvas and produced a series of animations that attempted to preserve the formal aspects of his paintings. He also experimented with rapid montage by juxtaposing frames of images in quick succession.

"I wanted to manipulate light to produce visual compositions in time continuity such as a musician manipulates sound to produce music . . . By turning knobs and switches on a control board I can 'draw' with a beam of light with as much freedom as with a brush."
— *Mary Ellen Bute*

1.19
Painting (untitled) by Harry Smith. Courtesy of the Harry Smith Archives and Anthology Film Archives.

1.20
Frame from *Film # 12, Heaven and Earth Magic* (1957–1962), by Harry Smith. Courtesy of the Harry Smith Archives and Anthology Film Archives.

"By simply limiting the viewer of a painting to 1/24th of a second I produce one unit of cinema and by adding several of these units together I produce a motion picture."

— *Robert Breer*

Jan Švankmajer was one of the most remarkable European filmmakers of the 1960s. His innovative works have helped expand traditional animation beyond the concept of Disney cartoons. His bizarre, often grotesque, Surrealist style aroused controversy after the 1968 Soviet invasion of Czechoslovakia, and his opportunities to work in Czech studios were restricted. Nevertheless, he employed a wide range of techniques and used almost anything he could find, including man-made objects, animals, plants, insects, and bones in order to fuse object animation with live action. Švankmajer's love of rapid montage and extreme close-ups is evident in films such as *Historia Naturae* (1967), *Leonardo's Diary* (1972), and *Quiet Week In A House* (1969). His surrealist orientation is evident in his use of somber, haunting images of living creatures and inanimate objects that are thrust into worlds of ambiguity. The impact of his images often dominates over the narrative, as people take on the appearance of robots, and inanimate objects engage in savage acts of decapitation, suicide, and cannibalism. In *The Last Trick of Mr. Schwarcewalld and Mr. Edgar* (1964), a beetle crawls out of the head of the main character who wears a wooden mask. In *Jabberwocky* (1971), branches blossom and apples drop and burst open to reveal maggots. A jackknife dances on a table, falls flat, and its blade closes to produce a trickle of blood that oozes out of its body. In another scene, a tea party of dolls dine at a small table, consuming other dolls who have been crushed in a meat grinder and cooked on a miniature range.

Inspired by Eastern European culture and the films of Jan Švankmajer, identical twin brothers Stephen and Timothy Quay (the "Brothers Quay") were among the most accomplished puppet animation artists to emerge during the 1970s. Their exquisite sense of detail and decor, openness to spontaneity, and use of extreme close-ups have enchanted audiences worldwide, and their innovations contributed a unique sense of visual poetry to animated film. The miniature sets of the Quays create a world of repressed childhood dreams. Absurd and incomprehensible images (e.g., antiquated-looking toys, machinery, bones, meat, etc.) exist in a chaotic, multilayered world where human characters live at the mercy of insidious machines. Unexpected, irrational events distort space and time beyond recognition. The harsh, grimy atmosphere of decay, the ominous quality of chiaroscuro, the dazzling use of light and texture and adept camera movement give their films an eerie, sublime quality. Some of their best known shorts include *Street of Crocodiles* (1986), *The Institute Benjamenta* (1995), and *In Absentia* (2000). The Quays have also produced network IDs, commercials for Coca-Cola, MTV, and Nikon, and music videos including Peter Gabriel's "Sledgehammer." The Brothers Quay currently reside in North London and work in South London at their studio, Atelier Koninck.

"We really believe that with animation one can create an alternate universe, and what we want to achieve with our films is an 'objective' alternate universe, not a dream or a nightmare but an autonomous and self-sufficient world, with its particular laws and lucidity . . .The same type of logic is found in the ballet, where there is no dialogue and everything is based on the language of gestures, the music, the lighting, and sound."
—Stephen & Timothy Quay

During the 1970s, American animators Frank and Caroline Mouris developed the technique of collage animation in their Academy Award-winning film *Frank Film* (1973). In the 1990s, they went on to create the short, *Frankly Caroline* (1999). Both films are characterized by an overabundance of images representing Western culture and iconography. The objective of these films was to provide a visual biography of their lives and their collaborative personal and working partnership. Frank Mouris describes *Frank Film* as a "personal film that you do to get the artistic inclinations out of your system before going commercial." The Mouris' animation style has appeared in many music videos and television spots on PBS, MTV, and the Nickelodeon channels. Their animated shorts have also been featured on programs such as *Sesame Street* and *3-2-1 Contact*.

"I treat objects in a very subjective way, and I treat subjects by themselves in a very objective way."
—Frank Mouris

computer animation pioneers

Since the 1960s, advancements in digital technology have exerted a tremendous influence over subsequent generations of animators and commercial motion graphic designers all over the world.

1.21
Frames from *Arabesque*, by John Whitney. Courtesy of The Estate of John and James Whitney and the iota Center.

1.22
John Whitney's book, *Digital Harmony: On the Complementarity of Music and Visual Art,* explains the influence of historical figures such as Pythagoras and Arnold Schoenberg on his artistic process. It also provides insight into his groundbreaking work in computer animation and the integration of music and filmmaking. Courtesy of The Estate of John and James Whitney.

John Whitney hypothesized a future in which computers would be reduced to the size of a television for home use. His interest in film, electronic music, and photography was influenced by French and German avant-garde filmmakers of the 1920s. Whitney felt that music was part of the essence of life and attempted to balance science with aesthetics by elevating the status of the computer as a viable artistic medium to achieve a correlation between musical composition and abstract animation. In collaboration with his brother James, he devised a pendulum sound recorder that produced synthetic music for his animated compositions. During World War II, Whitney discovered that the targeting elements in bomb sights and antiaircraft guns could calculate trajectories that could be used to plot graphics. From surplus antiaircraft hardware, he built a mechanical analog computer (which he called a "cam machine") that was capable of metamorphosing images and type. This later proved to be successful in commercial advertising and in film titling. During the 1950s, Whitney began producing 16mm films for television and produced the title sequence for Alfred Hitchcock's *Vertigo* (created in partnership with Saul Bass). He also directed short musical films for CBS and in 1957, worked with Charles Eames to create a large seven-screen presentation for the Fuller Dome in Moscow. In 1960, Whitney founded Motion Graphics Inc. and produced openings for shows such as *Dinah Shore* and *Bob Hope*. He also produced *Catalogue*, a compilation of the effects that he had perfected with his analog computer (**1.23**). In 1974, John Whitney, Jr. and Gary Demos formed a Motion Picture Products group which led to the first use of computer graphics for motion pictures while working on the film *Westworld* (1973). This film employed pixelization—a technique that produces a computerized mosaic by dividing a picture into square blocks and averaging each block's color into a single color.

1.23
Frame from *Catalogue*, by John Whitney. Courtesy of The Estate of John and James Whitney and the iotaCenter.

During the 1960s, Stan Vanderbeek became one of the most highly acclaimed underground filmmakers to experiment with computer graphics and multiple screen projection. He produced films using a variety of processes including collage, hand-drawn animation, live action, film loops, video, and computer-generated graphics. He also invented the Movie-Drome theatre, a 360° overhead projection area that surrounded audiences with images as they lay on their backs around the perimeter of the dome. This development later influenced the construction of worldwide "life theaters" and image libraries to advance international communication and global understanding.

During the time that Vanderbeek was producing collage films, Ken Knowlton, an employee of Bell Labs, was developing a Beflix programming language for the production of raster-based animation, a system used by Vanderbeek. Knowlton also investigated pattern perception and developed an algorithm that could fragment and reconstruct a picture using dot patterns. During the 1990s, he won several awards for his digital mosaics that, close up, depicted a complex array of objects, and from a distance, became discernible as a recognizable image.

1.24
John Whitney. Photo courtesy of Anthology Film Archives.

In 1961, MIT student Ivan Sutherland created a vector-based drawing program called Sketchpad. Using a light pen with a small photoelectric cell in its tip, shapes could be constructed without having to be drawn freehand. He also invented the first head-mounted display for viewing images in stereoscopic 3D. (Twenty years later, NASA used his technique to conduct virtual reality research.) Dave Evans, who was hired to form a computer science program at the University of Utah, recruited Sutherland, and by the late 1960s, the University of Utah became a primary computer graphics research facility that attracted John Warnock (founder of Adobe Systems and inventor of the PostScript page description language) and Jim Clark (founder of Silicon Graphics).

"My computer program is like a piano. I could continue to use it creatively all my life."
—John Whitney

A few years earlier, Robert Abel, who had originally produced films with Saul Bass, established the computer graphics studio Robert Abel & Associates with his friend Con Pederson in 1971. He was contracted by Disney to develop promotional materials and the opening sequence to *The Black Hole* (1979), and later to produce graphics for Disney's movie *Tron* (1982). Abel won multiple awards, including two Emmys and a Golden Globe, and his company became recognized for its ability to incorporate conventional cinematography and special effects techniques into the domain of CGI.

"Technology just frees us to realize what we can imagine. It's like being given the power to do magic."
—Robert Abel

Motion Graphics in Film Titles

1.25
Saul Bass in his later years. Photo courtesy of Anthology Film Archives.

"The title sequence of a film is like the frame around a painting; it should enhance and comment on what is 'inside,' alerting and sensitizing the viewer to the emotional tones, the story ideas, and the visual style which will be found in the work itself."

—Walter Murch

Film title design evolved as a form of experimental filmmaking within the realm of commercial motion pictures. The origin of film titles can be traced back to the silent film era, where credit sequences were presented on title cards containing text. They were inserted throughout the film to maintain the flow of the story. (Ironically, they often interfered with the pacing of the narrative.) Hand-drawn white lettering superimposed over a black background provided information such as the title, the names of the individuals involved (director, technicians, cast, etc.), the dialogue, and action for the scenes. Sometimes the letters were embellished with decorative outlines, and usually the genre of the film dictated the style. For example, large, distressed block letters marked horror, while a fine, elegant script characterized romance. After the implementation of sound, titles began to evolve into complete narratives and became elevated to an art form.

During the 1950s, American graphic design pioneer Saul Bass became the movie industry's leading film title innovator. His evocative opening credit sequences for directors such as Alfred Hitchcock, Martin Scorsese, Stanley Kubrick, and Otto Preminger garnered public attention and were considered to be miniature films in themselves.

Born in New York City in 1920, Bass developed a passion for art at a young age and became grounded in the aesthetics of Modernist design through the influence of Gyorgy Kepes, a strong force in the establishment of the Bauhaus in Chicago. After working for several advertising agencies, he moved to Los Angeles and founded Saul Bass & Associates in 1946. His initial work in Hollywood consisted of print for movie advertisements and poster designs. In 1954, he created his first title sequence for the film *Carmen Jones* (1954). Bass viewed the credits as a logical extension of the film and as an opportunity to enhance the story. His subsequent animated openings for Otto Preminger's *The Man With the Golden Arm* (1955) and *Anatomy of a Murder* (1959) elevated the role of the movie title as a prelude to the film. They also represented a rebirth of abstract animation since the experimental avant-garde films from the 1920s. According to Director Martin Scorsese, "Bass fashioned title sequences into an art, creating in some cases, like *Vertigo*, a mini-film within a film. His motion graphics compositions function as a prologue to the movie—setting the tone, providing the mood and foreshadowing the action."

During the 1960s, Friz Freleng, known for his work on the Looney Tunes and Merrie Melodies series of cartoons from Warner Bros, developed the opening cartoon animation for *The Pink Panther* (1963). This immediately became an icon of pop culture, appearing in a number of sequels and eventually its own television series. Freleng's cool, contemporary design style, the use of spinning letters and unscrambling words, along with the distinctive theme music from Henry Mancini was a complete departure from the cheaply made theatrical cartoons of the time.

In contrast, American designer Maurice Binder's openings for the classic James Bond movies gained popularity in their abstract, erotic imagery. Beginning with *Dr. No* and ending with *License to Kill,* Binder's stylish credit sequences for fourteen 007 films became a trademark of the series and have been described as a visual "striptease" of nude figures against swirling, enveloping backgrounds of color. In a time where pop music and fashion permeated mainstream entertainment, these sensual openings were a perfect match for Bond's character. The classic gun barrel opening that precedes the traditional pre-credit opening sequences in every 007 film was initially created by Binder for the opening to *Dr. No* (1962). Gunshots, which are fired across the screen, transform into the barrel of a gun that follows the motion of the silhouetted figure of Bond. The figure turns toward the camera and fires, and a red wash flows down from the top of the screen as the gun barrel becomes reduced to a white dot. Binder achieved this effect by actually photographing through the barrel of a .38 revolver. This sequence became a trademark of the 007 series and was used extensively throughout its promotion. (Each actor playing Bond had his own interpretation of the famous gun barrel walk-on, the first being stuntman Bob Simmons, then Sean Connery, George Lazenby, Roger Moore, Timothy Dalton, and finally Pierce Brosnan.)

Terry Gilliam's contribution to animation is manifested in a series of bizarre title sequences and animated shorts that he produced for Monty Python. Born in Minnesota, Gilliam became strongly influenced by *Help!* and *MAD Magazine* while studying at Occidental College in California. Gilliam joined *Fang*, the college's literary magazine, and sent copies of the magazine to Harvey Kurtzman, editor of *Help!* and co-founder of *MAD*. After receiving a positive response from Kurtzman, he went to New York and was hired as Kurtzman's assistant editor. Here, Gilliam met a British comedian named John Cleese and, in 1969,

> "We love doing titles. We do them in a nice, obsessive way—we futz with them until we're happy and do things that nobody else will notice but us. . .There's a Yiddish word for it, 'meshugas,' which is 'craziness.' I admire obsessiveness in others."
> —Saul Bass

Maurice Binder is known for his striking title designs in The Mouse That Roared *(1959),* Repulsion *(1964), and* The Last Emperor *(1989). A source of information on Binder is a short documentary included on the DVD* On Her Majesty's Secret Service.

was asked to join the Monty Python group as animator for the show's opening credits. Gilliam's outrageous cutout animations worked well with the group's comedy routine. His ability to transform images of mundane objects into outrageous "actors" not only entertained his audiences but has demonstrated what stop-motion collage animation was capable of achieving. Terry Gilliam also became involved in directing live action during the 1970s and 1980s. Quirky stage sets, bizarre costumes, and puzzling camera angles are seen in *Jabberwocky* (1977), *Time Bandits* (1981), *Brazil* (1985), *The Age of Reason* (1988), and *The Adventures of Baron Munchausen* (1989).

"What I do in film is the opposite of what is done with the print image. Dracula is a very good example of the process. There is very little information on the screen at any time, and you let the effect unfold slowly so the audience doesn't know what they're looking at until the very end...The audience is captive at a film—I can play with their minds."

—Richard Greenberg

In 1977, Richard Alan Greenberg and his brother Robert founded R/Greenberg Associates. Richard, a traditionally-schooled designer, established a name for his company by "flying" the opening titles for the feature film *Superman* (1978). This sequence demonstrated an early example of computer-assisted effects that enabled the animation of three-dimensional typography. Throughout the 1980s and 1990s, Richard Greenberg designed title credits for features including *Family Business* (1989), *Flash Gordon* (1980), *Altered States* (1980), *Another You* (1991), *Death Becomes Her* (1992), *Executive Decision* (1996), and *Foxfire* (1996). Many of these titles are treated as visual metaphors that set the tone of the movie.

For the past four decades, groundbreaking title sequences for classics such as *Dr. Strangelove* (1964), *The Thomas Crown Affair* (1968), and *A Clockwork Orange* (1971) earned Cuban-born filmmaker Pablo Ferro a reputation as a master of title design, along with legendary designer Saul Bass. During his advertising career in the 1950s, Ferro introduced several techniques to the commercial film industry including rapid-cut editing, hand-drawn animation, extreme close-ups, split-screen montage, overlays, and hand-drawn type. Many designers claim that his quick-cut technique, in particular, influenced what later became known in television as the "MTV style." In the opening sequence to the film *To Die For* (1995), Ferro developed the leading character through a montage of newspaper and magazine covers. (Nicole Kidman is so desperate to be a television newscaster that she convinces her lover to kill her husband so that she can pursue her career.) Pablo Ferro's revitalization of hand-lettered movie titles and classic broadcast animations such as NBC's Peacock and Burlington Mills' "stitching" logo also became his trademarks.

Influenced by Pablo Ferro and Saul Bass, Kyle Cooper was one of the first graphic designers to reshape the conservative motion picture industry during the 1990s by applying trends in print design and incorporating the computer to combine conventional and digital processes. After studying under legendary designer Paul Rand at the Yale University School of Art, he worked at R/Greenberg Associates in New York and contributed to the title sequence for *True Lies* (1994). In 1995, his opening credit sequence for David Fincher's psychological thriller *Se7en*, which expressed the concept of a deranged, compulsive killer, immediately seized public attention. Today, it is regarded as a landmark in motion graphic design history.

After designing the opening for John Frankenheimer's interpretation of H.G. Wells's novel *The Island of Dr. Moreau* (1996), Kyle Cooper, Chip Houghton, and Peter Frankfurt founded Imaginary Forces, a motion graphics studio in Los Angeles.

"Cooper's titles for Se7en transformed the written word into a performer. Cooper brought a new sensibility into the language of cinema—a taste for subtly deranged typographic details over large-scale special effects."
—Jean-Luc Godard

Motion Graphics in Television

Early cinematic techniques that were used in experimental avant-garde film and movie title sequences became adopted in broadcast motion graphics, as television became a new medium for animation.

Harry Marks and network identities

By the late 1960s, most prime time television content was produced on color film. Tape recording technology also became available, and color videotape machines and tape cartridge systems were offered by RCA, providing stations with a reliable method of playback. Broadcasters stretched the limits of portability with large cameras and recorders. Program relay by satellite also emerged, giving viewers live images from all over the world. When there were just three television networks, brand identity was easily captured in three signature logos: NBC's Peacock, CBS's Eye, and ABC's round logo designed by Paul Rand.

During that time, Harry Marks, who was working for ABC, conceived the idea of the moving logo and hired Douglas Trumbull, who pioneered the special effects in the film *2001: A Space Odyssey* (1968), to assist him in his endeavors. Trumbull's slit scan camera, which he had developed as an extension of John Whitney's work, was mounted on a track and moved toward artwork that was illuminated on a table. In

As vice president and creative director at ABC and CBS, Harry Marks has been recognized throughout the United States and the rest of the world as the legendary father of broadcast motion graphics. Throughout his career, he pushed the envelope of digital technology and produced cutting-edge work that earned many awards, including an Emmy and the first Life Achievement Award from the Broadcast Design Association.

1.26
Frames from NBC's *Monday Night at the Movies* and ABC's *Sunday Night Movie* by Dale Herigstad (1989). Courtesy of Harry Marks/Pacific Data Images and NBC.

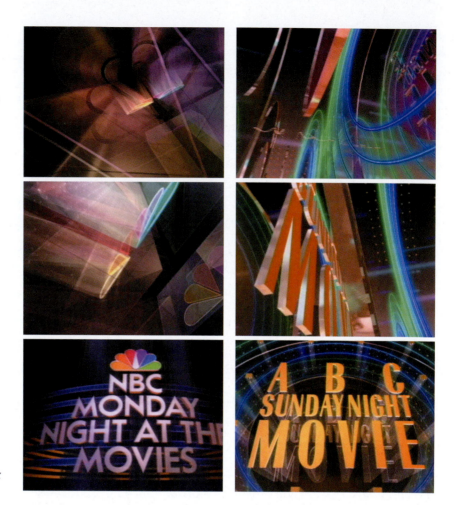

"There were maybe two or three of us paying attention to what the screen looked like . . . It happened around the time that I saw 2001. I thought if we could translate that kind of animation into something readable we would have something that no else had . . . I think we opened the screen so it wasn't this three-by-four box any longer, but it had inferences of much bigger worlds outside the box. We were looking for a viewport."
—Harry Marks

front of the art, an opaque screen with a thin vertical slit restricted the field of view of the camera to a narrow horizontal angle. Although this process was laborious and expensive, it introduced many graphic possibilities into the broadcast world. The animated opening sequence to ABC's *Movie of the Week* was a major accomplishment and captivated audiences nationwide. As a precursor to modern digital animation techniques, it brought about a major graphic design revolution.

Summary

Optical devices that emerged throughout Europe during the late nineteenth century demonstrated the phenomenon of persistence of vision, which involves our eye's ability to retain an image for a fraction of a second after it disappears. Eadward Muybridge's motion studies of animals and humans served as an aid to visual artists in helping them

understand movement. In Britain, the Lumiere brothers took these experiments further and invented the first camera-printer-projector of modern cinema.

At the beginning of the twentieth century, artists began rejecting classical representation and desired to express space in geometric terms. Many desired to produce abstract, experimental animations that explored new techniques such as direct-on-film and collage During the 1970s, figures such as Stan Vanderbeek, John Whitney, and Robert Abel began exploring methods of computer animation for film titles. During the 1950s, graphic design pioneer Saul Bass became the movie industry's leading film title innovator. His evocative opening credit sequences for directors such as Hitchcock and Preminger garnered public attention and were considered to be miniature films in themselves. During the 1960s, Friz Freleng's opening cartoon for *The Pink Panther* (1963) and Maurice Binder's openings for the classic James Bond movies became icons of pop culture. Terry Gilliam's film titles, animated shorts, bizarre stage sets, costumes, and puzzling camera angles have set many design trends. In 1977, Richard Alan Greenberg and his brother Robert founded R/Greenberg Associates and established their reputation for their "flying" opening titles in the feature film *Superman* (1978). Many designers claim that Cuban filmmaker Pablo Ferro's groundbreaking title sequences for classics such as *Dr. Strangelove* (1964)—in their use of rapid-cut editing and handdrawn type—influenced what became known in television as the "MTV style." Influenced by Pablo Ferro and Saul Bass, Kyle Cooper was one of the first graphic designers to reshape the conservative motion picture industry during the 1990s by applying trends in print design and incorporating the computer to combine conventional and digital processes. In 1995, his credit openings for David Fincher's psychological thriller *Se7en* immediately seized public attention and to this day is regarded as a landmark in motion graphic design history.

Early cinematic techniques that were used in experimental avant-garde film and title sequences became adopted in television. Harry Marks, who was working for ABC, conceived the idea of the moving logo and hired Douglas Trumbull, who pioneered the special effects in the film *2001: A Space Odyssey* (1968), to help him animate the sequence to ABC's *Movie of the Week*, which captivated audiences nationwide and brought about a major graphic design revolution.

2

motion graphics in film and television

an overview

Since the 1950s, when legendary Saul Bass revolutionized film title design, the movie and broadcast design industries have integrated the language of traditional graphic design with the dynamic visual language of cinema. Today, motion graphic designers have become leading players in the creation of film titles and many forms of television graphics.

00:00:00:02

Film Titles

A film's opening titles are the first images that viewers experience once the lights are dimmed. Since the 1950s, movie title sequences have evolved as a form of experimental filmmaking in commercial motion pictures. A film's opening credits are designed to create the context of a film and establish expectations about its atmosphere and tone.

During the 1950s, Saul Bass used suggestive, metaphorical images as storytelling devices for priming the audience. For example, in *Anatomy of a Murder* (1959), he introduces a silhouette that disappears from view and reappears in disjointed parts that jump on and off the frame in concert with Duke Ellington's musical theme. A mood of betrayal and impending doom is established early on, keeping viewers on the edge of their seats. In *The Man with the Golden Arm*, a jagged arm foreshadows the schizophrenic mindset of the main character. *The Seven Year Itch* (1955) uses abstract graphic shapes to form a sealed-off door that separates the main characters' apartments. In *North by Northwest*, bars of text ascend and descend to emulate the motion of elevators. Anticipation grows as racing horizontal and vertical lines invade the frame and intersect to form the grid pattern of a skyscraper for the film's opening shot. Bass's humorous closing sequence to *Around the World in 80 Days* (1956) shows a frantic clock on legs journeying around the world, encountering symbols that represent various places (i.e., elephants in India, pyramids in Egypt, saloon doors in the American West, etc.). In Hitchcock's comedy–thriller *Psycho* (1960), parallel lines and type convey the dark side of the human psyche.

Bass's use of typography was also revolutionary during a time when motion pictures used plain, static text for their credits. In *West Side Story* (1961), the credits are treated as graffiti, and in *The Age of Innocence* (1993), as epistolary script. *Around the World in 80 Days* introduces the credits as fireworks that illuminate the scene when the clock encounters Paris. In the opening to *Cape Fear* (1991), Saul and Elaine Bass enlarged a sign reading "Cape Fear" on a Xerox machine. Using a kitty-litter box, Elaine put ink in the water to make it more reflective, submerged the sign in the water, and created ripples with a hair dryer. As the shimmering water settled, the words slowly appeared.

Maurice Binder's 007 opening sequences during the 1960s combined realistic and abstract images of undulating liquids and silhouettes of

sensuous, female dancers to create erotic, mysterious environments. The titles to *For Your Eyes Only* (1981) show a nude female figure in a background consisting of a close-up of a fiber-optic lamp. In the opening sequence to *The Spy Who Loved Me* (1977), female figures move like belly dancers, as if they were conjuring up the vivid masses of background colors. After Bond jumps off a mountain slope and his parachute opens, a silhouette of a woman's hands rises from the bottom of the frame to cradle the parachute as the tune of "Nobody Does It Better" begins. In *You Only Live Twice* (1967), the credits begin with a close-up of a deceased 007 lying in a pool of blood that transforms into a Japanese fan. A solarized background of an erupting volcano fills the screen with red lava, and silhouetted parasols burst from the lava, giving way to the silhouette of a mountainside fading into a sunrise.

Kyle Cooper's groundbreaking opening credits to the movie *Se7en* (1995) incorporate scratched, hand-drawn letter forms that nervously jump around on the screen to the soundtrack by Trent Reznor (Nine Inch Nails), as close-up shots of instruments of torture (scissors, trays, and tape) flash before the audience's eyes. Profane words appear in conjunction with biblical, nihilistic images to contribute to the mood of dementia and cold, calculated precision. When the negative was sent out for processing, the lab was told that pieces of film leader and twisted film were part of the finished product.

Today, motion graphics studios continue to produce award-winning titles for feature films. The titles to Guillermo Del Toro's *Mimic* (1997), by Imaginary Forces, introduced the crisis of a genetic experiment gone awry by displaying close-up images of moths and butterflies pinned to a wall. X-rays sporadically flash upon the screen to reveal the insects in menacing positions. These images are interchanged with pinned up newspaper clippings featuring an insect-based epidemic and photographs of children affected by the disease. Torn headlines that read "disaster" and "tragic" appear beneath the insects, and maps of New York City subways convey the atmosphere of a subterranean underworld. Quick cuts display accompanying credits that jump around to different in the frame to the sound of flapping wings and distant voices of screaming children. According to Kyle Cooper, "we did a temp sequence where we took a bunch of photographs, integrated them with graphics on a Mac-based Photoshop program, then dissolved back and forth and filmed it out." The engaging title sequence to Nickelodeon Movies' feature film *Clockstoppers* (2002) is based on

the premise of a wristwatch that has the power to slow down or accelerate time. Creative Director Karin Fong from Imaginary Forces conceived the idea of exploring the mechanics of a watch on a microscopic level to convey the theme of time travel. Footage of clock mechanisms, lights, and rich textures were composited and time-warped to symbolize the distortion of time in a virtual world. This futuristic sequence places us inside the watch so that we can observe its compelling mechanics while discovering the credits along the way, as lines of typography spin in 3D space to form the hands of a clock (**2.1**).

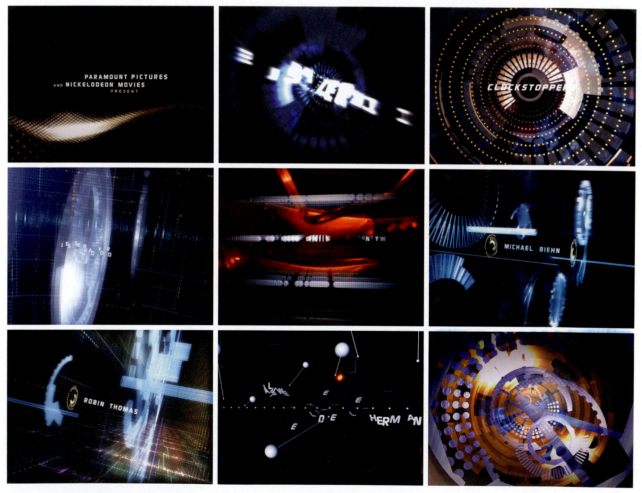

2.1
Frames from the opening titles to *Clockstoppers* (2002). Designed and produced by Imaginary Forces. © Nickelodeon Movies and Paramount Pictures.

Joel Schumacher's psychological thriller, *The Number 23* (2007), portrays an average man whose obsession with recurring instances of the number 23 in human history thrusts him into a nightmarish underworld of sex and death. Imaginary Forces' haunting title

sequence indoctrinates us to the cryptic enigma of the number 23 by showing us coincidental connections and catastrophes in history. For example, humans have 23 pairs of chromosomes; the Hiroshima bomb that was dropped August 6, 1945 (8+6+1+9+4+5 = 23); 230 people died on TWA flight 800; blood pumps through the body every 23 seconds; the attack on the Twin Towers occurred on 9/11/2001 (9+11+2+0+0+1 = 23). Accompanied by unsettling music, the sequence is imbued with the color red, an obvious motif that references the deep red color of the book that is prominent in the story. The interaction of vernacular typography with the movement of a typewriter and the blood seeping into the fabric brings the composition to life and effectively expresses the downward spiral of the film's narrative (**2.2**).

2.2
Frames from the opening title sequence to *The Number 23* (2007). Designed and produced by Imaginary Forces. © New Line Cinema.

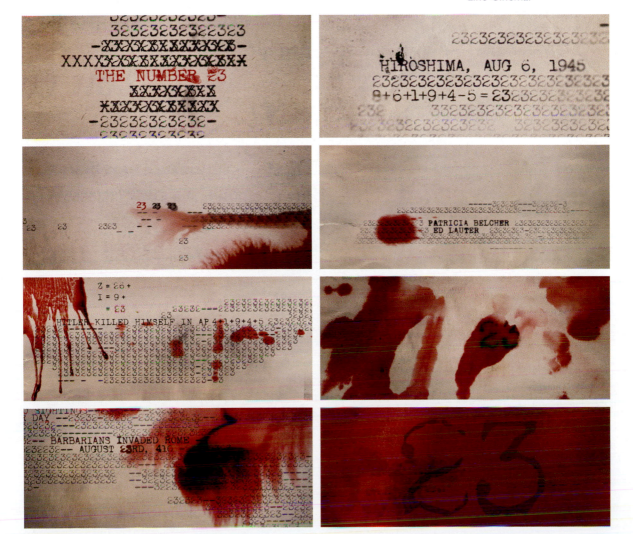

Imaginary Forces' stylish titles to director Andrew Niccol's futuristic thriller *Gattaca* (1997) are based on the movie's concept of genetic modification and its possible future use in human genetic engineering in the near future (**2.3**). Extreme close-ups of nail clippings fall to the ground with oppressive thuds and clatters, followed by hair and dead skin, all carriers of our genetic codes. These images are accompanied by the credits that display the letters A, T, C, and G—the four nucleotide bases of DNA (Adenine, Thymine, Cytosine, and Guanine)—in a bolder, semi-serif face typeface. This subtle introduction of the main characters communicates the movie's premise of "perfect" humans being bred and trained for elite jobs, while imperfect "Godchildren" born the old-fashioned way are doomed to marginal lives.

2.3
Frame from the opening title sequence to *Gattaca* (1997). Designed and produced by Imaginary Forces. © Jersey Films and Columbia TriStar.

2.4
Kyle Cooper's stunning opening credits for *Spider-Man* (2002) recap the sheer power of the film and build anticipation for the film in a very memorable way. The vintage comic-style imagery by Alex Ross supports the credits that get caught in the web as they are introduced. Designed and produced by Imaginary Forces. © Columbia Pictures.

The opening title sequence for the film *Thank You For Smoking* (2006) borrows from an eclectic mix of cigarette package designs to give viewers a nostalgic spin on the movie's playful atmosphere. Shadowplay Studios turned the director's initial idea, which was to present a slide show of various package designs, into a rich, animated presentation that brings to life various brands of cigarettes (**2.5**).

2.5
The clever title sequence to *Thank You For Smoking (2006) borrows from an eclectic mix* of cigarette package designs to give viewers a nostalgic spin on the movie's playful atmosphere. Courtesy of Shadowplay Studios.

2.6
Frames from the opening titles to *Genesis 3:19* (2007). Courtesy of Onesize.

In an experimental short film, Onesize, a motion graphics studio in the Netherlands created the opening and ending credits for *Genesis 3:19* (2007), a compelling independent movie directed by Dany Saadia. The film depicts a story of how people are bound together by coincidence. The title sequence shows a journey through space in which we enter a "3D blue-print" of our galaxy the way God created it," according to Rogier Hendriks, the company's founder. "We see how everything in the galaxy is connected to a big clock mechanism. . .The film is all about how everything is connected" (**2.6**).

In the prologue to *A Thousand Suns* (2007), a documentary about the dangers of nuclear power, Dutch designer Joost Korngold was given several photographs and a written narrative from director Matthew Modin. He decided to place the photographs inside of glass frames and film them falling to the ground and breaking. The event was played back slowly in reverse to create the effect of the images and frames becoming whole again. This concept served as a metaphor for turning

back time in order to pursue a second chance to make things different for future generations. Typography was treated in very subtle manner to give the appearance of melting—a second metaphor conveying the idea of nuclear meltdown—the strength of a thousand suns (**2.7**).

2.7
Frames from the opening titles to *A Thousand Suns* (2007). Courtesy of Joost Korngold. © Renascent.

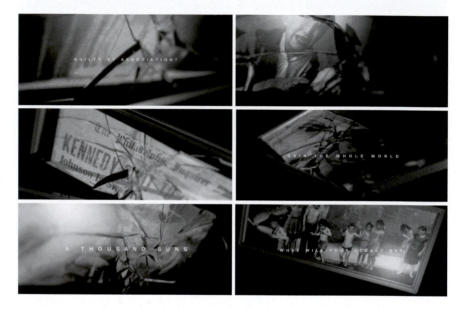

In addition to large design studios, individual designers, such as Deborah Ross, have established worldwide reputations for their highly acclaimed work. Deborah's opening titles for Anthony Minghella's *The Talented Mr. Ripley* (1999) is one of the longest credit sequences (over eight minutes) to be produced on a Mac G4 desktop computer. (Trish Meyer of Cybermotion, Sherman Oaks, California, was the predominant animator). Los Angeles-based designer Deborah Ross played upon the theme of jazz by referencing 1950s and 1960s album cover art from the Blue Note jazz label; this look is characterized by the liberal use of graphic shapes and typography. A distressed typewriter font fades in and out in concert with emerging hard-edged shapes that contain actor Matt Damon's face looking to the side in a contemplative pose. The letters of the title are compressed together with a rapid succession of adjectives that express Ripley's personality. Portions of the film were tinted with animated bars of color that served as masks to create transitions between the scenes. According to Deborah: "This underscored the dueling musical themes of jazz versus classical in the story, as well as the bohemian 'coolness' of the period. Sometimes, these bars echo playful piano keys; other times, they are jagged shapes that foretell the disturbing psychological aspects of the story." (**2.8**)

Network Branding

The average supermarket carries thousands of individual product lines. In order to get us to "tune in" to a particular product, its owner must gain our attention before we get to the supermarket. Similarly, within today's multichannel universe, branding is often necessary for a network to keep up with its competition. Television companies have become increasingly image conscious, investing large amounts of time assessing their audiences and spending huge sums of money on developing their on-screen look. Increased competition for viewers continues to drive the need for more compelling on-air graphics.

station IDs

Station identifications (also called *stings* or *network IDs*) identify the station or network being aired. Because of the number of signals that are available, the Federal Communications Commission (FCC) requires that all television and radio stations in the U.S. identify themselves on an hourly basis and at the beginning and end of each broadcast period. The station's call letters must be included, as well as its city of license and channel number signifying its dial position (even though television sets do not come with dials anymore). Additionally, the communities that the station serves must either appear on screen or be announced verbally. The FCC offers some flexibility so that stations can schedule around their programming and commercials. Many television stations have their identifications programmed to play automatically during the period of five minutes before the hour. Many have also developed clever ways to utilize their station identification as a promotional tool. A promotion for an upcoming show or newscast can fulfill its identification requirements while building its audience by telling viewers to tune in to an event.

When animating a station ID, you must be able to apply the aesthetics of effective logo treatment to a time-based environment. Attention must be given to negative and positive shape relationships, as well as to contextual design elements that contribute toward the message that the ID is sending. Additionally, consideration must be given to how elements move, change, and interact with each other over time and across space. Although station identities are typically between 5–10 seconds, story structure should be explored in order to establish the tone and affect how the audience perceives and sustains the believability of the message.

2.8
Frames from the titles to *The Talented Mr. Ripley*. Designed and produced by Deborah Ross Film Design. © Miramax.

2.9
The call letters of this station ID are "WPRI," and the city is Providence. The channel "12" identifies the dial position. Courtesy of Giant Octopus.

2.10
Station ID storyboard. Courtesy of Susan Detrie and The Studio at New Wave Entertainment. © HBO.

As part of a network campaign for HBO, this storyboard was created with the idea of using geometric outlines of the logo.

Shilo, an award-winning design studio located on the East and West Coasts and throughout Europe, designed a set of station IDs for AMC's twentieth anniversary celebration. Each is a short vignette depicting different genres that AMC has featured. For example, "big-screen battles" are portrayed with iconic images of airplanes and parachutes, "great action movies" with police cars and headlights, and "romantic movies" with rose petals and jewelry (**Chapter 7, figure 7.33**).

During the late 1980s, world-renowned graphic designer April Greiman developed twelve IDs for Lifetime Television, using available low-end technology, including computers, Kodak disposable cameras, and 8mm video shot without a tripod. Her goal was to produce the most innovative use of the Lifetime Television identity from "hybridized" footage elements (**2.12**). In Imaginary Forces' more recent identity package for Lifetime Television, an elegant composition was created that comprised of handwritten images, Polaroid photographs, and free-floating natural images such as leaves and butterflies (**2.13**).

2.11
Station ID for KGMB-TV, the first TV station in Hawaii and a licensed broadcast affiliate of CBS. Courtesy of Giant Octopus.

show openers

Like a magazine cover or the introductory credits to a movie, a *show opener* sets the stage for the upcoming program. Imaginative show openers help to promote the network's identity and tone and can make the difference between captivating viewers or making them reach for the remote. Show openings typically last between 15–30 seconds.

In an opener to *Court TV Movies*, Court TV wanted a direct, yet engaging means of promoting their movie block. Hatmaker, a broadcast design studio located in Massachusetts, combined fresh takes of

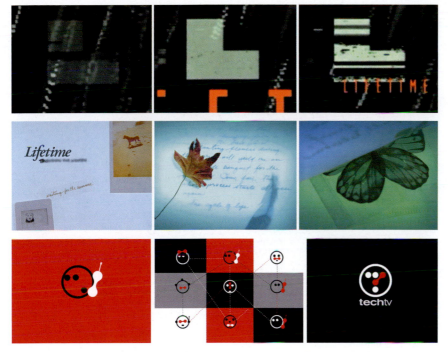

2.12
ID for Lifetime Television.
Courtesy of April Greiman, Made
In Space. © Lifetime Television.

2.13
Lifetime Television network ID.
Courtesy of Imaginary Forces.
© Lifetime Television.

2.14
Frames from an ID for Tech TV,
a 24-hour cable channel in San
Francisco (2001). Courtesy of
Viewpoint Creative. © Tech TV.

iconic cinematic imagery that suggested story snippets of original video footage and a rich theatrical palette. The graphics embrace the genre while conveying a sense of sheer entertainment (**2.17**).

The opening to *The Hungry Detective*, a program on Food Network that was hosted by Chris Cognac, was outsourced to four independent artists living in Chile. The underlying concept was based on a police investigator in search of the best off-the-beaten path restaurants in the U.S. to write about. With a tight budget and a time-frame of three weeks to deliver an entire package consisting of an open, lower thirds, and transitions, Matias Rivera, one of the artists, managed to deliver an intriguing kinetic collage of objects that exist on an investigator's desktop. For example, a magnifying glass communicated a "micro and macro" concept that would allow viewers to "fly" inside the elements almost microscopically (**2.18**).

2.15
Frames from the opening titles to
Lawbreakers. Courtesy of ZONA
Design and The History Channel.

Combinations of live footage
punctuated with shattered glass
reflects the program's pacing and
episodic quality.

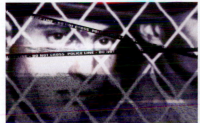

2.16
In a show open to *Destination Style*, typography was treated in a haiku-like way to complement the beauty and poetry of fashion and to express the global aspect of the show. Courtesy of Susan Detrie and The Travel Channel.

2.17
Frames from the show opening to *Court TV Movies*. Courtesy of Hatmaker and Court TV.

ZDF (Zweites Deutsches Fernsehen or Second German Television) is a public service German television channel based in Mainz. Velvet, a motion design studio based in Munich, designed an opening and show package for ZDF's culture program *Aspekte*, which is based on the concept of the mirror of culture and society. Combinations of photographic and live-action images showing various artistic and cultural events contain "people with mirrorheads" that "awake illusions or open new perspectives." The dynamic typographic animations consist of letterforms that move into an empty block, or spread out of a violin player like musical sounds or notes. This content is found in every element of the package including the logo, which contains a mirror as a means of self-reflection (**2.19**).

On September 10 and September 11, 2006, a two-part miniseries entitled *The Path to 911*, was broadcast on ABC television. Written by Cyrus Nowrasteh and directed by David L. Cunningham, the film dramatized the 1993 and September 11, 2001 attacks upon the World Trade Center in New York City. The opening sequence sets the tone of the film in a very poignant and beautiful way through the mind of a New Yorker. Digital Kitchen, a Seattle-based motion graphics studio, aimed to portray this sensitive subject in a way that engaged the viewer, while setting the mood for the film (**2.20**). The concept began as a short piece that showed vignettes of New Yorkers involved in their mundane

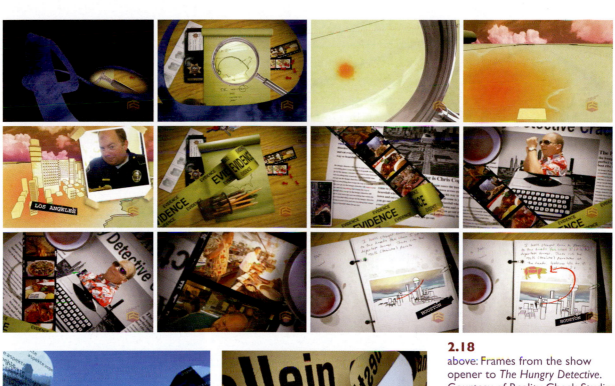

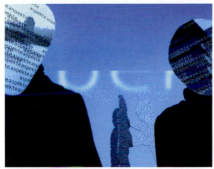

2.18
above: Frames from the show
opener to *The Hungry Detective*.
Courtesy of Reality Check Studios.

2.19
Frames from the show opener
for ZDF's culture program
Aspekte. Courtesy of Velvet.

morning routines before leaving for work. Over time, it evolved into a
longer sequence, beginning from the first person point-of-view shot
looking out of a Brooklyn window, to activities centered around getting
to work, and then to shots showing the city waking up, slowly

migrating toward the Trade Center buildings. According to designer Lindsay Daniels, two days of shooting the live-action imagery in New York City was challenging, in that the goal was to capture interesting and unusual, yet structured angles, and voyeuristic viewpoints allude to the concept that someone was watching the city. Another conceptual element of the composition is the use of moiré patterns that become more prominent as the pace of the editing increases, to depict the city waking up. Throughout the composition, they serve a double purpose: 1) to enforce the concept of the city being watched, and 2) to transition into the architecture of the Trade Center buildings.

2.20
Frames from the opening titles to *The Path to 911.* Courtesy of Digital Kitchen.

ZONA Design, Inc., a New York-based design and branding studio, created the sexy and exciting opening title sequence for Orchard Films' *Indie Sex,* a four-part mini-series that aired on The Independent Film Channel (IFC) in August, 2007. The series investigated a vast range of highly controversial topics relating to how sex is presented to the public, from underage sex, to censorship, taboos, fetishism, and sexual extremes. Repetitive, stylistic representations of teen sex, bondage, and

homo-erotica, which are infused with tactile patterns and a hot, fiery color palette, demonstrate a tasteful, yet bold approach and attitude that captures the diversity and heat of the series, and gives viewers a sense of voyeurism. According to Zoa Martinez, ZONA's creative director, "The zipper on the black leather bustier opens to expose a series of sexually-charged images—a sensual kiss, the interlocking of fingers while in the throes of passion, bondage, the graphic element of the condoms, which I wanted to represent the lights and neon of sex shops, but also to portray safe sex. The muscular male nude ('live boys live') and the repetition of his image is a stylistic representation of random sex. Lolita and her lollipop depict teen sex, and, of course, the suggestive opening and closing of a woman's gartered legs are as titillating as the move was in *Basic Instinct*. In addition, as sexuality infuses the sense, we wanted some of the graphics to have a tactile feel, so we added the leopard and red satin graphic patterns to the mix." With regard to the logo design, the graphic shape representing cut film was juxtaposed with gestural letterforms in order to create a contrast that generates "the energy of this thing we call sex" (**2.21**).

Studio Blanc, a Canadian graphic design agency, developed an opener for a television series on Radio-Canada television about places around western Canada. The sequence, which portrays traveling through BC, Alberta, Saskatchewan, and Manitoba, is infused with iconography representing Canada's western provinces. Delivered in a modern style, the opening's kitsch, colorful journey leads you into Radio-Canada's *À la carte* program hosted by Jacky Essombe (**2.22**).

2.21
Frames from the opener to *Indie Sex*. Courtesy of ZONA Design.

2.22
Frames from the opener to *À la carte*. Courtesy of Studio Blanc.

2.23
Topical news opening frames for ABC/Channel 9 and WATE/Channel 6. Courtesy of Giant Octopus.

Show openers for news programs are often referred to as *topical openings,* since they are designed to inform viewers of upcoming stories or events (**2.23**). They often integrate live-action video, still photography, typography, and graphics (including the station ID) to enhance their entertainment value. Design strategies and storytelling devices, such as cropping, angle of view, and montage, are used to organize the clarity and readability of information and frame the veracity of the news by reinforcing the truth value of the coverage and the reputation of the station.

show packages

A *show package* is a "video information system" containing an assortment of design elements that are used to promote a program. These elements must demonstrate a visual synergy, although the vibe and pacing between them may be slightly different. For example, ZONA Design's branding package for NBC-TV's reality series *LOST* includes an opening, a series of bumpers, mortises, lower thirds, maps, and a logo for print and on-air design. The show, which has been deemed as a global adventure with unexpected twists and turns, depicts six strangers who are paired off, blindfolded, and shipped to an undisclosed location to find their way back to the Statue of Liberty. ZONA devised a look that captures the sense of being confused and disoriented. A multilayered explosion of bold graphic elements and a fast editing pace exudes a heart-pounding kinetic energy. International signage, transportation symbols, and bold graphic icons, such as grids, arrows, and numbers, were incorporated as textural devices to express the feeling of billboards being peeled away. Throughout the piece, the words "lost," "north," "south," "east," and "west" appear in various languages, including Chinese, Russian, and Arabic (**2.24**). According to Creative Director Zoa Martinez: "Our design had to convey the excitement of the unknown, that envelops both the competitors and the audience. The contestants' starting points are strictly concealed. They are in a race against time and they must confront and conquer any barriers in their path." Zoa further continued: "We designed a crisp, modular system from global, continent, country, and local specific maps complete with team comparisons and actual footage. We gave them a very stylized look in a neutral palette contrasted with vibrant colors for punctuation . . . there is nothing peaceful about the series and our designs are meant to keep the viewer on edge as well."

2.24
Frames from branding package
for NBC-TV's reality series *LOST*.
Courtesy of ZONA Design.

Kids' Choice Awards is Nickelodeon's annual flagship awards show honoring the year's most popular television, movie, and music acts, as voted by children who watch the Nickelodeon cable channel. Each year, the theme of the show changes in order to appeal to Nickelodeon's teen audience. In 2006, Nickelodeon hired the motion graphics company Blur to develop a rock 'n' roll circus theme. The concept was inspired by psychedelic poster art and vernacular typography from the 1960s (**2.25**). In Blur's awards show package for Black Entertainment Television, the graphics and rich color palette intended to portray the luxury and expense of being a celebrity. An open mortise was used in the opening segment, and a keyable (versus a full screen) logo was placed over the live footage in the show opening and was also used in bumpers that were aired between commercial breaks. A combination of header and lower thirds is used to introduce the best female R&B artists (**2.26**). Blur's show package for FOX's *2005 Teen Choice Awards*, which was televised on FOX and on Global TV in Canada, was based on Venice, California's skateboard/surf boarding "dogtown" culture during the 1970s. The gritty, raw look of graffiti and spray paint was applied to combinations of gothic and hand-drawn elements. The theme behind the package depicted reggae and rock safari culture with a younger teen twist involving live-action shoots of models surfing. The hand-made quality of the lettering, in the spirit of doodling, is effective in making the feel of the package accessible to the show's target teenage audience (**2.27**).

2.25
Frames from Nickelodeon's
show package for Kids' Choice
Awards, 2006. Courtesy of Blur.

2.26
Frames from Black Entertainment Television's awards show package, 2006. Courtesy of Blur.

2.27

Frames from the opening for FOX's *Teen Choice Awards 2005* show package. Courtesy of Blur.

2.28
In a distinctive network redesign for Court TV's daytime show, the image of Lady Justice, blindfolded, with a sword and scale, was used as an icon. Strong typography, at times abstracted, along with a sharp color palette, adds a high degree of depth and energy. Courtesy of ZONA Design, Inc.

interstitials

Interstitials are 30- to 60-second mini-programs that appear between movies or other events, each having a specific objective. For example, some are designed to highlight key issues, people, or events to establish a show's sense of context. Others might function from a commercial standpoint to promote a network's brand by creating a link with an existing program. For example, Freestyle Collective designed and animated a new character named "Squidley" to be used for Cartoon Network (**2.29**). Noggin's interstitials are presented as special mini-

shows hosted that are by various characters such as Moose and Zee. Others may feature hands-on demonstrations of signature sports "moves" from star athletes or interviews with the stars on premium movie channels.

News interstitials are used to inform viewers that a top story is about to be featured, or to suggest developing or continued coverage of a story. They also provide a convenient way to transition from the anchor or studio into a live or prerecorded story. This form of interstitial is typically no more than 1–2 seconds in duration.

bumpers

A bumper (or bump) is a brief presentation that transitions between a program and a commercial break. Bumpers typically are between 2–5 seconds in duration, and in most cases, the name or logo of the show is displayed and is accompanied by an announcement that states the title (if any) of the presentation, the name of the program, and the broadcast or cable network. Late night bumpers often produce quirky and amusing presentations that play on pop culture. For example, an episode of *Late Night with Conan O'Brien* depicted Conan as Hermey the Elf in the televised Christmas special *Rudolph, the Red-Nosed Reindeer* (1964). In children's television, it is a common practice for a bumper to distinguish between the program and a paid commercial, because of the fact that children are not always able to discern the difference between the two.

Digital Kitchen, a motion graphics studio based in Seattle, Chicago, and New York, designed two compelling bumpers for the Sundance Film Festival in Park City, Utah. Using the theme of fire as a metaphor for the process of filmmaking, these innovative bumpers were shown onscreen between films to identify the sponsors and to promote Sundance. "Ignite" provides a visual story of how ideas ignite or come to fruition by showing a dance between fire and water. Live-action footage of flames, water, and explosive elements was filmed at a high speed to achieve a slowed down "hyper-real" look, providing an analogy to how filmmakers come up with vision by feeding the creative fire. The mechanical look of "Industry," which also incorporates fire, illustrates how ideas are generated in a "factory-filled brain." Both compositions succeed in symbolizing the creative fervor, passion, and power of storytelling through the moving image (**2.30**).

2.29
Frames from "Squidley," an interstitial for Cartoon Network. Courtesy of Freestyle Collective. © Cartoon Network.

2.30
Frames from "Ignite" & "Industry."
Courtesy of Digital Kitchen.

2.31
Frames from a bumper for *Flux Television*. Courtesy of twenty-2product. © 1994 Flux Television.

Figure 2.31 illustrates a bumper for *Flux Television*, a music television program on digital culture that featured techno and future culture music during the mid-1990s. A bright, highly saturated color palette, in addition to flat, highly stylized graphics and looped live-action footage, reflected the northern California aesthetic and technological flavor of the pre-dotcom era.

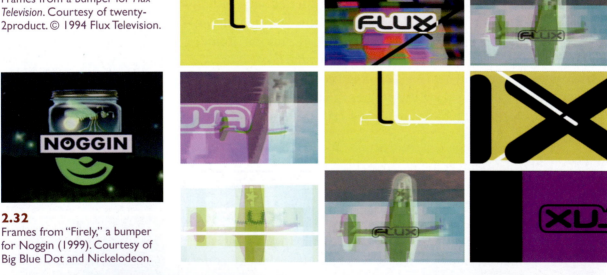

2.32
Frames from "Firely," a bumper for Noggin (1999). Courtesy of Big Blue Dot and Nickelodeon.

2.33
Frames from a bumper pitch for MTV. Courtesy of Joseph Silver.

lower thirds

Lower thirds are combinations of graphics and text that appear on the bottom portion of the screen to identify the station, the presenter(s), and the content being aired. They most commonly are found in news production and sometimes in documentaries. In most cases, lower third graphics do not occupy a full third of the screen, especially when the only requirement is a name and title. In cases where the programming necessitates additional information, a side panel is usually added. Lower thirds can range from simple graphical elements to complex animations that add impact in a subtle and tasteful manner that does not interfere from the main programming. Text and graphics often animate as they arrive on screen and then stay still; sometimes animated backgrounds consisting of subtle shapes, colors, and patterns are designed to loop while the underlying video continues to play.

2.34
Lower thirds are often arranged in tiers. In these news-related scenarios, one-tiers identify the presenter; two-tiers identify the person on the first line and the news program below it; three-tiers include a heading, sub-heading, and a locator identifying where the story is taking place. These examples also identify the channel and network.
© 2007 Jon Krasner.

2.35
In a promotional package for CW Connect Beverley Mitchell, the lower thirds design complements the style of other insert elements, including a close and map. Courtesy of Susan Detrie

2.36
This lower third design for the FUEL TV Experiment, a two-year program that launched in May, 2004 to support up to ten aspiring action sports filmmakers. Courtesy of FUEL TV.

2.37
Lower thirds design for Black Entertainment Television's awards show package. Courtesy of Blur.

2.38
In a lower thirds template for KTVK's news program, the animated 3D structure from the background of KTVK's end tag (2.46) is placed in the foreground on a smaller scale. Courtesy of Reality Check Studios.

mortises

Mortises—full screen graphics that are used to frame live footage—are sometimes used in combination with lower thirds. In a mortise for KTVK (**2.39**), Phoenix's twenty-four hour news channel, the design maintains the graphic continuity of KTVK's end tag (**2.46**). Repeated three-dimensional structures from the channel's logo and live video footage of moving clouds appear again in the background, this time within a more compressed horizontal space. The color scheme, consisting of deep red, yellow, and magenta, is also carried over.

2.39
Mortise for KTVK. Courtesy of Reality Check Studios.

In most awards shows, mortises are used to showcase individual talent being featured. In an awards show package for Black Entertainment Television, an open mortise was used in the opening segment (**2.40**). The design is effective in that all graphic elements carry over between the mortises representing each person, while at the same time, the general arrangement of the mortise's elements vary. In Blur's package for Nickelodeon's *Kids' Choice Awards*, the ending compilation of the show's best moments consists of a hybrid lower thirds mortise (**2.41**).

2.40
Mortise for Black Entertainment Television. Courtesy of Blur.

In **figure 2.42**, the mortise for Fox's *Action Sports Awards* was designed to work closely with the theme of the television show's opening, which took viewers on an "intense journey through a monumental world of action sports iconography," according to Shilo. The overall design package employed oversized background elements to create a whimsical 3D character animation context that departs from the typical grunge graphics that are often associated with this subject matter.

2.41
Mortise for Nickelodeon's *Kids' Choice Awards*. Courtesy of Blur.

2.42
Mortise design for Fox's *Action Sports Awards*. Courtesy of Shilo and Fuel TV.

lineups and upfronts

A lineup is a full screen graphic that informs viewers about a network's upcoming program schedule by displaying the names of the shows, dates, and times. An upfront is a marketing piece that is designed to promote a network's shows to advertisers. Upfronts also unveil the following season's lineup to give viewers a first glimpse of what shows are returning, which have been cancelled, and what new series have been picked up. Similar to an awards show, they often involve stage presentations that may feature comedy routine and star walk-ons. Both lineups and upfronts have become more elaborate, dictating the need for supporting, eye-catching motion graphics.

2.43
Frames from an upfront for Country Music Television. Courtesy of Nailgun*.

2.44
Lineup designs for *Unprotected Sets* and *Stacked Sundays*. Courtesy of FUEL TV.

2.45
Frames from a lineup for Sports 5. Courtesy of Flying Machine.

tags

A tag is a succinct, 3–4 second presentation that occurs at the beginning or end of a spot, news opening, or commercial. For example, FUEL TV's wide variety of tag designs have been used to promote the unique personalities and the epic moments of action sports (**2.47**). In commercials, tags are customized to reinforce a particular brand of the product being described, recap its directive, and inform viewers where to go for additional information by providing a phone number or Web site address. The end tag in a promotional spot for Verb, a youth campaign designed by Saatchi & Saatchi to help teenagers lead healthy lifestyles by increasing and maintaining physical activity, simply provides viewers with a URL in a colorful and refreshing animated presentation. The end tag for WPRI/Channel 12's news open also functions as a *legal ID*—a quick message that is aired at the top and bottom of every hour, indicating the station's call letters and city of license (**2.48**).

2.46
End tag frame for KTVK, an independent news station in Phoenix. Courtesy of Reality Check Studios.

2.47
A variety of network tags are used by FUEL TV to promote the unique personalities and the epic moments of action sports. Courtesy of FUEL TV.

2.48
Frames from the end tag of promotional spot for Verb, a campaign to help teenagers lead healthy lifestyles. Courtesy of Nailgun*.

network packages

Similar to a show package, a network package is a complete "video information system" that is comprised of promotional elements including station identifiers, bumpers, lower thirds, and mortises.

New York-based design studio, Freestyle Collective created a network launch for MTV K, the first premium channel under the MTV World family geared toward young Korean-Americans. Like its intended

audience, the MTV K network package presents dreamlike visions with brilliant colors and vibrant 2D and 3D graphic animations. The provocative combinations of live-action video, still photos and vibrant 2D and 3D animations evoke the young, cool lifestyle that has become synonymous with MTV culture. According to Elizabeth Kiehner, executive producer on the project, "This is not MTV Korea . . . [it] is a premium, commercial-free network that features between 70 and 80% Korean music videos, and is specifically meant to speak to Korean-Americans aged 13 to 30. That is a very diverse group, so there was a great deal to consider when we were coming up with our package." (The team rented a nightclub and karaoke bar in Manhattan's Koreatown, and cast a variety of young talent.) The resulting package was not stereotypically Korean, but covered different niches of Korean-American lifestyles" (**2.49**).

2.49
Frames from MTV K.
Courtesy of Freestyle
Collective.

2.50
Frames from BET J.
Courtesy of Freestyle
Collective.

Freestyle Collective also created a full network rebrand for BET J, a spin-off cable channel of Black Entertainment Television, to showcase jazz music-related programming. Conceptually drawing on the soul and funk of jazz, the design conveyed all the ideas the network wanted to achieve and introduced a modular system offering a limitless set of possibilities (**2.50**).

2.51
Frames from a network package for Comedy Central. Designed and produced by Imaginary Forces. © Comedy Central.

Kemistry, a branding and communications agency in the United Kingdom, developed an identity package across all in-flight channels for KLM Television's Royal Dutch Airlines, based in the Netherlands (**2.52**). (This Netherlands-based subsidiary of Air France is the oldest carrier in the world that continues to operate under its original name.) According to the company's Web site, the project demonstrated "a new spin on mile-high entertainment" by violating their own strict branding guidelines in deconstructing KLM's logo. Although the client was initially reluctant, he was eventually delighted with the final product.

Kemistry's branding, identity, on-air graphics, and news set design helped launch National TV, a TV station in Romania that features everything from live news bulletins, to magazine shows, dating shows, horoscope programs, reality TV, and sports coverage. The channel was launched by Vorel Micula, a Romanian food and drinks businessman, whose most famous product is his Transylvanian Vodka. He harnessed

2.52
Frames from KLM network package. Courtesy of Kemistry.

the best Romanian talent with experts from the United Kingdom, and contracted with the on-air design company Kemistry, to help him get the channel off the ground. In less than six months the television station became transformed into an on-air reality with its own offices, studios, and top quality technical infrastructure (**2.53**).

2.53
Frames from the network package launching National TV in Romania. Courtesy of Kemistry.

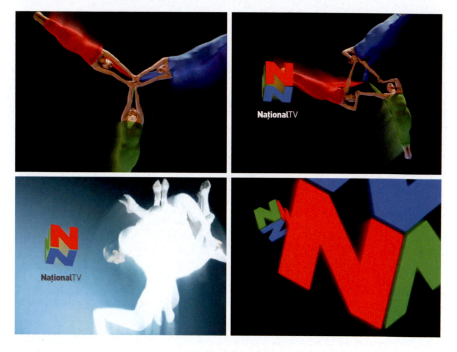

In 2006, NBC decided to reinvent its on-air image across its prime time, daytime, news, sports, and online divisions, with a consistent new look for the 2006–07 season. This look would be based on the idea of convergence of digital and broadcast television, and the presence of content on the Internet. After an intense competition between design and advertising firms, NBC's in-house design department, MAGIC, was hired. Its mission was to give the network a distinctive, interactive feel by using a single feather from the original "peacock logo" as a navigational device (similar to a cursor or a mouse pointer) to guide viewers through informational content pertaining to show names, dates, and air times. This concept speaks to the idea of rebranding the peacock network for the digital age. Additionally, their challenge was to make the identity flexible enough to be customized and paired with the tone and personality of different shows and genres and to adapt to changing schedules. Capacity TV was then hired to implement their vision. "It was our challenge to figure out a way to bring personality to the peacock feather as it accessed information, selected characters, and

navigated between shows," explained creative director Ellerey Gave. Capacity delivered hundreds of variations for the prime time motion graphics alone, and the final network package consisted of show openers, bumpers, tags, identifications, transitions, and trailers (**2.54**).

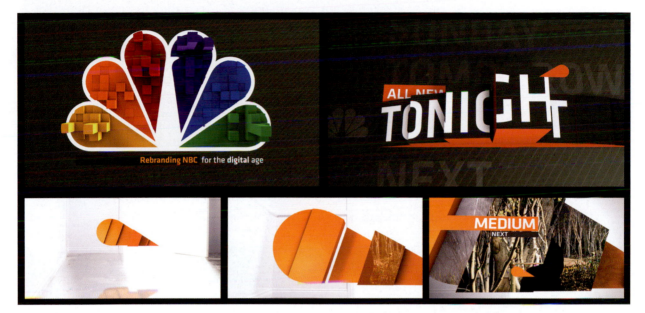

In 2006, award-winning design studios Onesize and yU+Co collaborated to rebrand the G4 Network, a fast-growing Los Angeles-based network viewed in approximately 61 million homes (**2.55**). (Onesize, based in Delft, the Netherlands, is internationally recognized for its work in design, animation, visual effects, and direction for commercials, broadcast, and film. yU+co, with offices in Los Angeles and Hong Kong, is also considered an industry leader in television show opens, network graphics packages, film titles, television trailers, theatrical logos, and commercials.) As an entertainment-based network, G4 features shows about technology, gadgets, video games, and web culture to appeal to a demographic of males between the ages of 18–34. The concept involved an array of 3D photo-realistic and abstract images, such as an iPod, a video game joystick, and a hip cell phone floating around a silhouetted box containing G4's logo. A bold color palette is accented by a circular pattern that visually suggests a tornado of iconic images—complete with wires dangling everywhere—coming together inside the G4 logo and tagline "TV That's Plugged In." This unique visual style offered a high degree of control over the design, which empowered G4 to internally create their own specialized, program-

6.54
Frames from Capacity's 2006 rebranding of the peacock network. Courtesy of Capacity™. Creative Director: Ellerey Gave; Executive Producer: Jennifer Gave; Producer: Jill Marklin; Designer/Animator: Ellerey Gave and Gene Sung; Editor: Benji Thiem; Music: Dave Hummel.

specific animation sequences. The key to the design is that it never has to look the same way twice. Every aspect, from the color of the background textures to the specific imagery, is customizable, with Onesize and yU+co creating hundreds of animation sequences that can be stacked in any way imaginable. According to Rogier Hendriks, co-founder and creative director of Onesize: "We wanted to create a look that would encapsulate all of the network's components into one iconic image, while at the same time give them everything they needed to create their own specialized short animations within the framework of our design," says Hendriks. "Basically the redesign is a big toolkit consisting of about 300 different animation sequences." Although it's unusual for two design companies, who might normally compete against each other, to collaborate so closely, Garson Yu, owner of yU+co, stated that this is the future for the global minded design studio—"It helped us grow as a company to work with new people with different ideas and ways of communicating."

2.55
Frames from G4's network package. Courtesy of Onesize and yU+co.

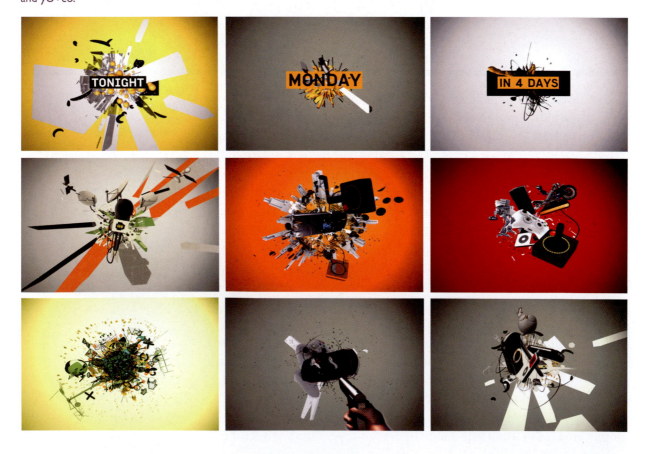

Sky, an Italian satellite platform in Milan and Rome, began its launch in 2003 with over 130 television, interactive, and pay-per-view channels. Micha Riss, founder and creative director of New York design agency Flying Machine, attempted to give Sky's Cinema Classics' movie channel a new look while maintaining the integrity of the network's programming. He developed a concept that pays homage to stylized film posters of the 1930s through the 1980s. These cinematic elements were carefully crafted into a nostalgic presentation (**2.56**). On Thursday evenings in Milan and Rome, SKY Cinema Italia airs *Spazio Italia* (Italian Space), which features classic Italian movies through the 1970s for native Italian audiences. Micha directed an extensive video shoot in Rome that tells a story of a man posting vintage film posters to the walls of a theatre. The scenes are intercut with real moments from famous movies, and written names of famous directors and actors that animate on the screen are deliberately flipped upside-down so that the viewer's attention would not be detracted away from the main story.

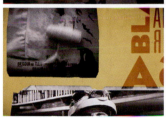

2.56
Frames from Sky's *Spazio Italia*.
Courtesy of Flying Machine.

2.57
Frames from Sports 5's 2001 network launch. Courtesy of Flying Machine.

Sport5, Israel's premiere sport-caster, commissioned Flying Machine to execute the channel's first major rebrand since 2001 in its seventeen-year history. This emotionally-driven package not only celebrates the glory of sports, but brings local fan culture to the forefront of the channel's branding.

Launched in 2003 by Fox Cable Networks, FUEL TV is one of the first action sports networks dedicated to surfing, skateboarding, snowboarding, BMX, motocross, and wakeboarding. Within FUEL's series of channel identifiers are Signature IDs, which function to associate the channel with a well-known athlete, promote artistic endeavors, and inspire new artists in art or music (**2.58–2.59**).

2.58
Frame from "Chris Pastras Signature Series." Produced by Brand New School, LA; Creative Director: Chris Pastras; Music: Echo Park. Courtesy of FUEL TV.

2.59
Frame from "Chris Yormick Signature Series." Produced by Todd Dever; Creative Director: Chris Yormick; Music: Barrington Levy. Courtesy of FUEL TV.

2.60
Elements from show package for Nicktoona. Courtesy of Joost Korngold and Renascent.

This spin-off of Nicktoons features quirky, bizarre-style cartoons. The package includes a show open, credit roll, lower thirds design, and bug (or station logo) which maintains the familiar Nickelodeon "Splat" that had been a Nick trademark since the network relaunched in 1984.

promotional campaigns

Promotional campaigns are designed to make the public more aware of a product, brand, or service. Getting the right message across and making sure it is clear is vital to a campaign's success. This involves developing a brief outlining the campaign's objectives, identifying and examining the intended target audience related to gender, age,

occupation, leisure pursuit, and lifestyle, and assessing marketing opportunities and communication channels such as personal sales presentations, print, radio, or television advertisements. Developing a promotional message usually requires a collaborative effort to create the content, appeal, structure, format, and source of the message.

In television, promotional campaigns have been around since the 1970s and have opened up many artistic opportunities for broadcast designers. In 1977, ABC launched "Still the One," a promotional campaign that was used on several television networks around the world. The slogan was originated by the American Broadcasting Company (ABC) and later adopted by the Nine Network in Australia, Channel 2 in New Zealand, and Sky Television (now British Sky Broadcasting) in the United Kingdom. The spots that were created featured a version of the 1976 song by the group Orleans called "Still The One."

In the Cartoon Network's campaign to mark Valentine's Day special promotions, Susan Detrie experimented with numerous found objects, from candy boxes to flowers, and arrived at the image of a cupid as the ultimate Valentine's Day symbol. Crayons on Color-aid paper were added to make the background look like a handmade valentine, and the cupids selected were from old Victorian cut-out books (**2.61**). The globe was then added to signify love round the world.

2.61
Frames from "Cupids," a promo for the Cartoon Network. Courtesy of Susan Detrie.

In the spirit of "indie" film, Freestyle Collective developed a dynamic spot promoting the Independent Film Channel's *Cinema Red Mondays*. The initial storyboard concept involved developing an environment containing various "pods" comprised of video-photographic collages. Each pod was designed to represent an aspect of Target and IFC's weekly indie film presentations. The spot imitates the organic, textural look of collage by layering 16-millimeter film footage ranging from a cinema marquee to unfurling plant tendrils with still photographs of nature, such as blooming flowers, flying birds, ferns, and tree silhouette. Additionally, the spot also incorporated cinema-related graphics, such as a 16-millimeter film cameras and typed and handwritten pages from a screenplay. Textural depth was achieved by bringing certain elements to the foreground and placing others in the background. Throughout the promo, Target's presence is branded through the use of red, white, and black—the colors of Target's bull's-eye logo. Additionally, the logo appears in different forms such as an old-fashioned film countdown, a rising sun, and a stream of floating bubbles (**2.62**).

2.62
Frames from a spot promoting the Independent Film Channel's *Cinema Red Mondays*. Courtesy of Freestyle Collective.

Blur, a motion graphic design studio located in Venice, California, developed a promotional network campaign for Kids' WB, the Saturday morning cartoon portion of The CW Television Network's weekend programming. The campaign comprised of twenty-two spots, all of which were built around the crazy, quirky, Kids' WB logo and the studio water tower, the main elements of the network's previous branding. Blur Studios' goal was to develop a novel, Japanese anime look that incorporated kids into a 3D animated environment, while retaining

core elements of a brand that has been successful over many years. Each spot features a backlot, or stage area, and Pokémon-type characters that are transformed from the network's logo. The water tower graphic is also transformed into an anime-type robot (**2.63**).

In 2004, Blur created an on-air promotional campaign for the film, *Lemony Snicket's A Series of Unfortunate Events* (2004), starring Jim Carrey. Aired on Nickelodeon, these promos humorously portray the dark, morbid, yet eccentric nature of the popular children's mystery book series written by Daniel Handler (under the pseudonym of Lemony Snicket) and illustrated by Brett Helquist. The imagery reflects the woody nature of the books (**2.64**), and the mood is synonymous with the flavor of the film, which one reviewer at amazon.com describes as "a highly stylized mixture of Edwardian times and the 1950's . . . where death is ever present and where the whole world has conspired to make the Baudelaire children's life a misery."

2.63
Frames from a promotional network spot for Kids' WB. Courtesy of Blur.

In 2005, Onesize was given complete creative liberty to develop the format and style for a series of "cromos" (or commercial promos) for Kentucky Fried Chicken (**2.65**). Three spots aired on MTV Productions in the Netherlands over a period of three months. The first spot was a call for entries that invited the MTV audience to submit videos of what they can do best; the second displayed the video clips that were submitted and encouraged viewers to vote for the best video online; the third broadcasted and rewarded the winner.

2.64
Frames from an on-air promotional campaign for *Lemony Snicket's A Series of Unfortunate Events*. Courtesy of Blur.

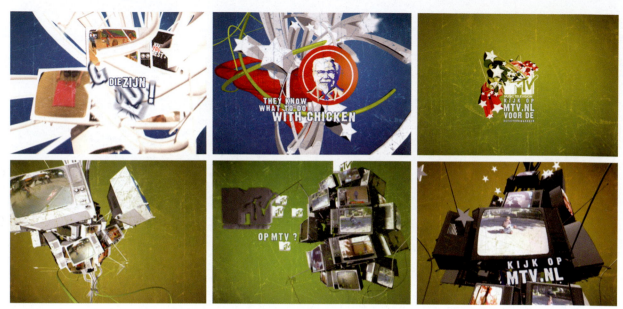

2.65
Frames from a series of KFC
spots. Courtesy of Onesize.

Commercials

Television commercials are one of the most desired campaign vehicles and one of the most effective methods of generating brand recognition to facilitate product sales. Most commercials today, which sell everything from household items to political campaigns, can range from 5–10 seconds to hour-long infomercials. (30-second commercials are often referred to as *spots.*) The vast expenditures that television studios spend on advertising—according to wikipedia.org, the average cost of a single spot during the Super Bowl has reached approximately $2.6 million—has resulted in elaborate productions, many of which can be considered miniature movies.

In 2005, Stardust Studios, a creative design firm in New York, teamed up with McCann Erickson, a global advertising agency in San Francisco, to create the largest branding effort in the history of Microsoft Windows, reaching eleven countries over a period of fifteen months. The Windows "Start Something" campaign, a series of nine 30-second spots, was designed to support the global launch of Windows XP (**2.66**). Stardust Studios also designed a spot for Nokia in Singapore that aired in global broadcast outlets and in theaters. In the spot, a man and woman find inspiration from the phones of the Nokia L'Amour Collection (**2.67**).

2.66
Frames from the Windows' "Start Something" campaign. Courtesy of Stardust Studios.

In a televised spot for KEXP, a Seattle-based radio station featuring musical styles ranging from bluegrass to electronica, Digital Kitchen developed a concept that involved translating a static print campaign for a band or solo artist into a time-based context. Low-tech graphic representations of bands and independent artists, which emulate the style of wheat-pasted posters displayed in the city, along with stop-motion, communicates the independent nature of the station's music. The words "from" and "to" continuously appear to show the range of diversity among the artists that are represented (**2.68**).

2.67
Frames from an ad for Nokia. Courtesy of Stardust Studios.

2.68
Frames from a spot for KEXP. Courtesy of Digital Kitchen.

Since the 1960s, the gap has narrowed between programming and advertisements. Due to the introduction of digital video recorders, and services such as TiVo and On-demand, which allow users to skip advertisements, many media critics speculate that TV commercials will be replaced by the actual content of television programs.

Public Service Announcements

A *public service announcement (PSA)* is a noncommercial spot that aims to raise public awareness about specific issues such as energy conservation, global warming, homelessness, and drunk driving. PSAs are also used to promote nonprofit organizations such as United Way, Red Cross, and American Cancer Society. One of the most memorable PSAs of the 1970s was the "Crying Indian," sponsored by Keep America Beautiful, an environmental organization founded in 1953. Launched on Earth Day in 1971, it became an iconic symbol of environmental responsibility and has been deemed one of the most successful PSA campaigns in American history. Anti-smoking campaigns during the 1970s were also effective, in that smoking rates declined when the tobacco industry withdrew cigarette advertising when Congress declared it illegal after 1971. (Although cigarette consumption rose when the spots disappeared, public health professionals credit them with having saved millions of lives.) "This is Your Brain on Drugs" was a large-scale anti-narcotics campaign launched in 1987 by Partnership for a Drug-Free America. As a result, teenagers and young adults quickly popularized the phrase, "This is your brain on drugs." Since 1989, NBC Universal's "The More You Know" campaign has featured personalities from various NBC programs during its prime time, late night and Saturday morning programming. Topics include anti-prejudice, HIV/AIDS, seat belts, and child abuse, to name just a few. Other examples of U.S. network campaigns are "CBS Cares" and ABC's "A Better Community."

Motion graphics have played an increasing role in television PSAs. David Carson's "Partnership for Drug Free America" spot offers an example of how a powerful concept and effective broadcast design can persuade and educate parents on how to help their children cope with this critical social issue. According to Carson, "It was just a novel way to do a very 'tired' subject. It caused me to think about things in a different way and that's what made it good. Very clever solution."

The Diabetes Fonds in the Netherlands, enlisted Addikt, a motion graphics company based in Amsterdam, to raise awareness about related health issues among diabetes patients. The advertisements were designed to encourage fundraising for further diabetes research (**2.69**).

2.69
Frames from a public service announcement for the Diabetes Fonds. Courtesy of Addikt.

2.70
Frames from a PSA for Unicef to raise AIDS awareness. Courtesy of DesignOMotion.

2.71
Frame from TV12's "ICBC Roadsense," a PSA promoting vehicle safety. Courtesy of Tiz Beretta and Erwin Chiong.

2.72
Frames from a PSA for the national literacy hotline. Courtesy of twenty2product.

Music Videos

Cinematic traditions that have been carried over from film into music videos have been enhanced with the incorporation of special effects and animation. For example, a live singing or dancing performance may be placed in a setting that is literally suggestive of the lyrics. On the other hand, they have deviated from narrative conventions, where traditional notions of past, present, and future are lost in an incoherent flow of pictorial content, and contradictions in meaning between lyrics

During the 1980s, the music video was a cinematic art form that contributed the transformation from narrative to nonnarrative film. Although music videos were predominantly filmic in nature, they broke the norms of traditional cinematic realism and allowed video artists to explore new visual possibilities of integrating animated and live-action imagery.

2.73
Frames from "Go Down" by The House Keepers. Courtesy of abstr^ct:Groove.

and images, along with the use of suggestive metaphors, have been designed to invoke thought. When used well, this approach can produce a poetic experience. However, the larger the gap is between the lyrics and the imagery, the more challenging it becomes to discern the context. Other times, music videos are intended to function as pure "eye candy" to create a temporal experience in which meaning is interpreted subjectively.

In 2004, abstr^ct:Groove, a design studio based in Milan, produced a music video for "Go Down" (by The House Keepers) for Net's Work International, an Italian record company specializing in electronic, hip hop, and pop music. In this provocative arrangement, which won the "Italian Videoclip Award" for best editing in the independent video category (the only official Italian music video award), a sushi man, a hair stylist, and a supermodel share a strange, surreal world composed of inanimate objects and abstract motion graphics (**2.73**).

In 2004, Stardust Studios designed a music video for the band Incubus and its Sony/Epic Records label. The live footage for "Megalomaniac," the debut single for the band's forthcoming album, was shot over two days in downtown Los Angeles. This five-minute piece integrates the video with animated sequences that incorporate historical footage to barrage viewers with imagery complementing the song's powerful message. Ten designers handled the project over a three-week schedule to create the dark aesthetic the director sought. "Making a music video is tough on any level; to animate four minutes, tougher still," explained Jake Banks, Stardust's founder and creative director (**2.74**).

Acclaimed music video director Thomas Mignone commissioned the Los Angeles-based studio Heavenspot to create the motion graphics for the song "Dress Like A Target," by New Orleans-based heavy metal/thrash band Superjoint Ritual. The look and feel of the footage, in addition to the powerful graphics and pulsating editing style, effectively portrays the heavy metal genre. This video was frequently aired on MTV's "Headbanger's Ball" and Fuse Network (**2.75**).

The motion graphic studio Shilo produced award-winning music videos for the bands Angels and Airwaves and H.I.M. The sensuous lighting and color treatment in the video for "Do It For Me Now," by the band Angels and Airwaves, is a stylistic departure from the common trend of fast-paced, complex mixing of images in many of today's videos (**Chapter 6, figure 6.24**). The beautifully melodramatic video to

"Love Said No" expresses the dark and tumultuous nature of H.I.M., the first and only Finnish rock band to sell a gold record in the United States. This epic performance-based piece blurs the line between fantasy and reality by seamlessly combining striking photography and animated typography (**2.76**).

2.74
Frames from the music video for "Megalomaniac." Courtesy of Stardust Studios.

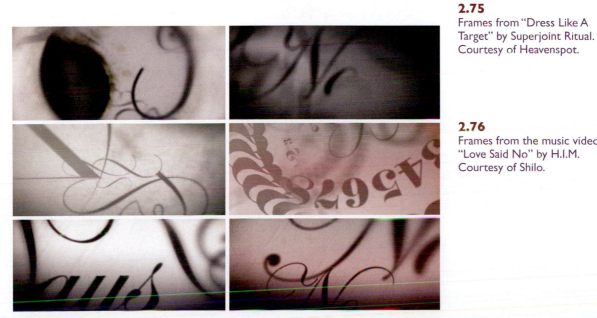

2.75
Frames from "Dress Like A Target" by Superjoint Ritual. Courtesy of Heavenspot.

2.76
Frames from the music video for "Love Said No" by H.I.M. Courtesy of Shilo.

Summary

Since the 1950s, film title sequences have been designed to create the context of a film and arouse an audience's anticipation of the events that are about to unfold.

In more recent years, television networks have become increasingly image conscious, and increased competition for viewers has driven the need for more sophisticated and compelling on-air motion graphics. This is evidenced in station identifications (or station IDs), show openers, interstitials, show packages, network packages, television campaigns, public service announcements, and music videos.

A *station identification* is what identifies a network's call letters, city of license, and channel number. Many television stations have developed clever ways to utilize their station IDs as promotional tools to brand their network. A promotion for an upcoming show or newscast can fulfill its identification requirements while building its audience by telling viewers to tune in to an event. Station IDs must be able to apply the aesthetics of effective logo treatment to a time-based environment, consider contextual design elements, and explore story structure.

A *show opener* sets the stage for an upcoming program and helps promote a network's identity. Topical openings for news programs are designed to inform viewers of upcoming stories or events and often integrate live-action, photographic, and typographic elements (including the station identity) to enhance the entertainment value of the broadcast. A *show package* is a "video information system" that contains an assortment of designs that are used to promote a particular program. These designs must demonstrate a visual "synergy."

Interstitials are mini-programs that appear between programs or other events. Some are designed to highlight key issues, people, or events, while others function to promote a network's brand by creating a link with an existing show. News interstitials inform viewers that a top story is about to be featured, or suggest developing or continued coverage of a story. They are also used as transition from the anchor or studio into a live or prerecorded story.

Similar to a show package, a *network package* is comprised of a set of promotional elements that, today, dictate the need for supporting, eye-catching motion graphics. *Bumpers* (or *bumps*), for example, are brief

2- to 5-second transitions between programs and commercial breaks. *Lower thirds* are combinations of graphics and text that appear on the bottom portion of the screen to identify the station, the presenter(s), and the content being aired. They can range from simple graphical elements to complex animations. *Mortises*—full screen graphics that are used to frame live footage—are sometimes used in combination with lower thirds. *Lineups* inform viewers about upcoming programs by displaying their names, dates, and times. *Upfronts* are used to promote shows to advertisers and give viewers a glimpse of a network's upcoming schedule. *Tags* occur at the beginning or end of a spot, news open, or commercial, to inform viewers on how to get additional information, by providing a phone number or Web site address.

Television campaigns have been around since the 1970s and have opened up many artistic opportunities for designers. Television commercials are one of the most desired mediums for campaigns and one of the most effective methods of generating brand recognition to facilitate product sales. The vast expenditure that production studios spend on advertising has resulted in elaborately produced commercials, many of which can be considered miniature movies.

Public service announcements (or *PSAs*) are noncommercial spots that strive to raise public awareness about issues such as global warming, energy conservation, and drunk driving. Motion graphics are playing an increasing role in the design of television PSAs.

Last, motion graphic animations have had an increasing presence in music videos, which are now considered multifaceted forms of art and popular culture.

3

motion graphics in interactive media
an overview

Late nineteenth century optical inventions were the first to entertain audiences through persistence of vision. These evolved into sophisticated devices that were capable of displaying animating figures over static backgrounds. These eventually gave way to the Lumiere brothers' contributions to modern cinema. Approximately one century later, advancements in computer processors, desktop video and animation software led to a repeated evolution from a slide show format to superimposed elements over static backgrounds, and finally to full-screen moving images—a complete reinvention of cinema on the computer screen.

"Once you made it, it stayed put. Great care was taken to get everything in just right spot, just the right relationship. Now, increasingly, the output is a variable, not a constant."
—Chris Pullman

Today's digital interfaces provide highly engaging sensory experiences that facilitate our ability to access and process information. The concept of motion in interactive media has introduced new design possibilities and has afforded motion graphic designers opportunities to exercise their talents beyond the motion picture and television screen.

00:00:00:03

The Interactive Environment

For centuries, books have been used to deliver information. As linear information systems, they imply continuity through a prescribed beginning and end. In contrast, interactive environments redirect information into a structure that is branching and nonsequential; as a result, the user's role shifts from passive viewer to an active participant. Many paths through the material can be taken, and inputting information through mouse selections, keystrokes, controllers, or voice commands can control the manner in which content is displayed.

Incorporating motion graphics into the interface has introduced new design possibilities and has afforded designers opportunities to exercise their talents beyond the film and television screen. (Ironically, it has had a major impact on design trends in the film and broadcast industries.) Motion graphics can enhance the user's sensory experience if they are designed well and are logically integrated. Depending upon the complexity of interactivity, motion can enhance the navigational process by entertaining users while emphasizing the hierarchy of information.

Motion Over the Web

Facilitating real-time animation over the Web has had its technical challenges over the years, and designers have been forced to overcome the limitations of connection speed and bandwidth. The lack of an industry-standard animation format also remains a concern. Some types of animations require browser plug-ins, while others can run on their own. Despite these limitations, motion graphic designers continue pursuing their artistic vision while waiting for the Web to mature. The development of higher bandwidth connections and streaming video has made the prospect of motion over the Web enticing, allowing designers to push their artistic envelope beyond the movie and television screen. Many view today's constraints as creative guidelines and welcome the opportunity to communicate beyond national boundaries and help shape our growing global visual language.

Today, the incorporation of dynamic information into Web sites can enhance the user's experience if it is designed well and is logically integrated into the interface. Many graphic design studios that showcase their work online have used motion effectively as a vehicle to heighten

3.1

During the late 1990s, a group of independent filmmakers conceived of the idea of an online film festival site to showcase the work of independent filmmakers and video artists. Recognizing the potential that the Web had to offer for online distribution of films, hillmancurtis, inc. developed the Manifestival, an online film festival Web site that features independent digital film and video shorts. This site was notable for its innovative use of Flash, which at the time, was limited in its capacity to handle live-action video. Courtesy of hillmancurtis, inc.

3.2

The unique Web interface for Kranestyle.com, the online portfolio of Taras Lesko, offers a rich palette of images that animate in response to the user's horizontal mouse movements. Courtesy of LeskoMedia.

visual interest and enhance viewer longevity. For example, Studio Dialog, a design agency in Calgary, Alberta, represents its multidisciplinary work in a professional "drawing board" format that integrates subtle types of animation (**3.3**). The site begins with three pale orange, green, and blue horizontal bars moving across the screen from the right edge, leaving their "tail ends" visible on the left edge of the enclosed frame. Simultaneous to this movement, the header displays a succession of vertical rectangles which close from right to left in the manner of a window blind. As they close, the bars shift from a pale blue to an orange hue, then disappear to reveal one of the company's featured works. Thin blue lines animate to refresh page content in response to activating a link. The "window blind" effect in the heading's opening is echoed in the site's contact page in which two sets of horizontal bars that close from top to bottom reveal a listing of clients and agencies. Overall, the dynamic movement of the site's elements, tempered by smooth graphic transitions and a clear, sensible navigation system exude firm control over the work and its online presentation.

"There are no masters of Internet animation. Yet. But it's only a matter of time before people start to establish themselves as animators exclusive to the Internet. By coming up with new, mind-bending, Web-savvy ways to present its content and improve the medium as a whole, this new guard of animators will truly set itself apart."

—Anna McMillan

3.3
Frames from Studio Dialog's Web site. Courtesy of Studio Dialog.

Nessim Higson's online portfolio, IAAH (I Am Always Hungry), embraces a variety of styles and genres, ranging from clean contemporary to heavily layered, textured elements that appear distressed and worn. Images slide in smoothly from every edge, and the background's colors and content (including the site's identity) randomly changes, offering us a multitude of compositional possibilities. This unique approach attests to the wide range of work that this award-winning Los Angeles graphic designer from Birmingham, Alabama produced. In a never-ending sea of online portfolios, this dynamic site stands out as an island of graphic innovation. Its progressive, yet intuitive, interface features a wide gamut of sophisticated print, identity, and collage designs, as well as original typography that includes hand-drawn fonts (**3.4**).

3.4
The Web site for IAAH (I Am Always Hungry) represents the multidisciplinary design studio and portfolio of Nessim Higson. As an advocate of converging media, Nessim claims "...I am always hungry for life..." and dedicates his work to New Orleans, which he describes as "The city that care forgot and the people that called it home."

Made In Space features April Greiman's multidisciplinary design firm in Los Angeles, California (**3.5**). Referred to as "a visual, verbal think tank," the site's bold, kinetic exploration of image manipulation, type, and color are rooted in an innovative fusion of technology and design.

Resn's company's interface consists of large images from their show reel flickering behind a simple, typographic navigation structure (**3.6**). This interactive design agency in New Zealand won the Business for Profit category for their innovative "Resn 2B2" Web site at South by Southwest's 10th Annual SXSW Web Awards Ceremony in Austin, Texas.

3.5
Frames from Made In Space
(http://www.madeinspace.la).
Courtesy of April Greiman.

3.6
Resn's use of animation in their
company's interface won them
the Business for Profit category
at the South by Southwest's 10th
Annual SXSW Web Awards
Ceremony in Austin, Texas.
Courtesy of Resn.

In contrast to Resn's site, the trend in many business-to-business Web
sites has shifted tomuch more simple and delicate presentations. An
example of this is April Greiman's Web site design for RoTo Architects
(**3.7**). RoTo Architects' collaborative practice, headed by Michael
Rotondi, is invested in the study of how natural and social conditions
form the spatial conditions of everyday life, serving potential clients
and providing opportunities for individuals who embrace architecture
to share their work and ideas. Like architecture, the site is treated as a
spatial medium which, through layering motion and change, reflects
the collaborative nature of artistic process. The interface presents a
delicate balance of typography, graphics, and images in a visual land-
scape that we, as viewers, can travel through to access a large archive
of information including sketches, notes, and snapshots. (This was one
of the most important aspects of the site, because it shows the process
of ideation.)

3.7
April Greiman's design for RoTo
Architects (http://www.rotoark.
com) illustrates a growing trend
toward simplicity in Web design.
The site's interface realizes April's
vision of how ideas and im-
ages can be treated as objects in
space. Courtesy of April Greiman.

*April Greiman has been acclaimed
as a pioneer of digital design and
has been internationally recognized
as one of the most innovative and
influential designers of the twenti-
eth and twenty-first centuries. Since
the early 1980s, she has been
instrumental in embracing digital
technology in her radical experi-
ments with the Apple Macintosh
and Quantel Paintboxes.*

*April considers the computer to
be a vital element to the design
process. Her unique "Transmedia"
approach considers successful
design solutions to be capable of
expression in any delivery format
including Web sites, print, motion
graphics, textiles, surfaces, video,
and three-dimensional design. Pres-
ently she heads the Los Angeles-
based design firm Made in Space
(http://www.madeinspace.la).*

animation formats

Java

In the early 1990s, Sun Microsystems introduced Java to the Internet.
This network-oriented programming language enabled Web developers
to create applications called *applets* that users could download and
apply to their Web pages. Today, Java continues to be used to produce
interactive animations and to incorporate movement into Web page
designs. Java applets can generate successive frames that play back at
relatively high speeds, and can range from typographic animations
to stylish cartoons and 3D motion graphics. The advantage of Java's
platform independence ensures that they can run on any supported
hardware or operating-system platform. However, many designers
avoid Java as an animation format, because it requires programming
knowledge (Java derives much of its syntax from C and C++).

animated GIF

Among rapidly developing Web technologies, animated GIFs continue
to be one of the most popular low-tech options for adding motion to
Web pages since the advent of the Gif 89a format. Built into a single
file, sequential images are displayed in succession like a traditional
frame-by-frame animation. The GIF format is supported by all
browsers and does not require special plug-ins for viewing. Additionally,
programming skills are not needed to create GIF animations, giving

this format significant advantages over other formats that have been introduced to the Web.

The size and bandwidth requirements of animated GIFs are smaller than those of noncompressed RGB images since they are color-indexed from an 8-bit (256) color palette. This palette can be derived from Web-safe colors, the Macintosh or Windows color systems, or an adaptive palette. Reducing the number of colors can result in smaller file sizes and faster download times. The most effective GIF animations utilize colors that appear consistent on all video displays and play back smoothly on all platforms.

GIF animations can be used on a Web page as navigational buttons, links, or image maps. Looping offers an efficient solution of holding a viewer's attention while he or she waits for other material to download. Alternatively, GIF animations can play back for a specified, finite number of times at designated frame durations.

Animated GIFs can be produced in any motion graphics application. Alternatively, the individual frames can be generated in imaging software, such as Adobe Photoshop, or by traditional hand-executed methods. Criteria for determining file size, download time, and play-back efficiency include frame dimensions, timing, the number of frames, and color depth. All of these factors can affect the smoothness of the motion, as well as the file size, which in turn affects playback efficiency. Successful GIF animations do not necessarily need large numbers of frames. Reducing the frame number to a minimum can maintain the illusion of movement while conserving file size. Additionally, large areas of flat colors and horizontal patterns compress better than color blends, shadows, and vertical patterns. The most effective GIF animations contain solid geometric shapes, horizontal lines, and single colors (i.e., logos and informational graphics).

> *Animated GIFs "stream" in the sense that they begin to play before they fully download.*

Flash

Today, the majority of graphic designers consider Adobe Flash (formerly Macromedia Flash) to be the most effective interactive animation tool for delivering vector-based content to Web pages. Its capacity for full-screen playback on all monitor sizes and across multiple platforms, in addition to its video integration capabilities, have made it an enticing Web distribution format. The Flash player comes bundled with most browsers to date.

Flash evolved from a simple, Web-deployed animation tool to a complete interactive media development tool for creating CD/DVD-ROMs, interactive games, and Internet applications. Ironically, it is even used to create motion graphics in the broadcast and film industries.

One of Flash's many advantages is its ability to scale vector images without loss of resolution. This allows motion graphic designers to simulate the effects of camera zooming with minimal effort. Flash-based content downloads quickly, especially if it is composed of vector graphics (versus bitmapped or pixel-based images). Action Script, Flash object-oriented programming language, offers endless possibilities of integrating interactivity and motion. Mouse events—such as rollovers and rollouts—can be designed to set variables, and trigger certain behaviors and actions.

Despite these advantages, Flash content can be difficult to update and to index by search engines. For this reason, many e-commerce, business, and database-driven Web sites incorporate Flash into HTML pages in the form of animated banners, navigation systems, and transitions, versus using it as a running platform. Since Flash uses streaming to transfer data, animations that play smoothly on systems connected to the Internet through a DSL or cable modem may stutter when being received by slower transmissions. For this reason, users with slow modem connections need to be considered. Using vector images can take advantage of Flash's low bandwidth requirements, since bitmaps are bandwidth-heavy. Alternatively, bitmaps can be converted into editable, scalable vector paths with tools such as Flash's Trace Bitmap function or Adobe Illustrator's Autotrace feature.

Although Flash's integration of QuickTime has significantly improved, adding video capabilities to Flash-based presentations over the Web can impede download time. A link to a QuickTime movie or employing an alternative viewing method, such as an animated GIF or image map, may be a better technical solution.

dHTML
During the release of 4.0 browsers, another programming development that occurred was Dynamic HTML (dHTML). Composed from a combination of complex programming languages, dHTML allowed Netscape to display hierarchical layers and provided a sophisticated way of handling text through the use of Cascading Style Sheets (CSS). Although dHTML was not developed to provide animation, it can be used to animate HTML elements on a Web page. For example, a dHTML script can tell the browser to change the placement of an image, allowing it to travel around the page.

Like the animated GIF, dHTML animation is recognized by most Web browsers and does not require users to download extra components. It is, however, limited in its animation capabilities and is challenging to code. Although applications, such as Macromedia Dreamweaver or Adobe GoLive, can produce the script, it is not always consistent between browsers.

video over the Web

The predominant Web video formats over the Internet today are Quick-Time, Windows Media Player, and RealPlayer. All of these formats allow data to be delivered over the Web through downloading or streaming. *Basic download* involves copying the content from a server to a local computer and playing it from the local machine's hard drive. *Progressive download* places the most critical information at the beginning of the file structure. Duration is no longer a determining factor for download time; the viewer only has to wait for the first portion of data to be copied. As this portion plays, the second portion downloads, and so forth. If the user's connection is within the animation's data rate, the piece plays smoothly from beginning to end. If the user's bandwidth is too slow, delays in playback may occur during download. Once the entire piece is downloaded, it can be played back repeatedly without being hindered by a slow connection speed or network congestion. *Streaming* allows animations to be delivered almost immediately, without the hassle of downloading. Since the user's computer stays in constant contact with a dedicated server running the movie, the content begins playing as soon as the download process begins. New data continues to stream during playback, while old data is automatically discarded after it is viewed. If the client's connection is slow, or if there is network congestion, data transfer rate is reduced and frames are dropped in order to preserve real-time playback. This method delivery is best suited for situations where audience attention span is a factor or for long animations that are over two minutes in length. Download-ing, on the other hand, is the better solution for short works, since it usually offers higher quality video. It is your responsibility to under-stand your audience and choose a method that suits their needs.

Connection speed and bandwidth are the largest factors in determin-ing an animation's data transfer rate, the amount of data that can be delivered each second for the animation to play back smoothly. Digital video is one of the most bandwidth-intensive assets that are delivered over the Internet. Because of bandwidth constraints, there is still not

Common display sizes for Quick-Time or Video for Windows files are 320×240, 240×180, and 160×120, while standard frame rates are between 8–15 fps.

Codecs are capable of reducing video file size significantly by eliminating data redundancy, such as areas of the image that remain the same over time and large areas of similar colors or values. Most codecs are lossy, resulting in some degree of image degradation. The type of content being animated, the speed in which elements move, and the size of the images relative to the frame can help determine which codec is most appropriate for your particular situation. Cross-platform QuickTime codecs differ with regard to how compression is performed, and some allow the degree of compression to be adjusted to provide control over balancing between image and playback quality. The decreasing cost of storage capacity and network bandwidth may eventually obviate the need for lossy codecs in the future.

enough "horsepower" to deliver rich, full-screen video presentations on the Web. Until the technology matures and public data networks change, the prospect of a purely video-driven Web site seems far off in the future. For now, motion designers are forced to make compromises and decide where to place their priorities. For example, if motion is the most critical goal, frame dimensions may need to be sacrificed in order to facilitate smooth playback. (Most QuickTime movies on the Web use frame sizes of 320×240 or smaller.) Data compression through the application of a Codec (Compression/Decompression algorithm) is usually necessary to achieve reasonable download times. If image details are of prime importance, decreasing the frame rate may be a necessary trade-off for retaining acceptable picture quality. (In fact, frame rates between 8–12 fps are acceptable for collage and cutout animations that are intended to look disjointed and jerky. A limited-movement approach transfers well to the Web environment, where file size and bandwidth are critical agents.)

animated navigation systems

Successful navigation design provides an infrastructure that supports and directs users in a meaningful, logical way through the complexities of a Web site. It considers the interface—the intermediary between users and content—as well as the message, client, users, and medium.

Incorporating motion into the navigational structure of a Web site can entertain and inform users. Animated icons, buttons, and text links can help place emphasis on items that users might otherwise over-look. Additionally, entire menus can be animated and accompanied by sounds to enhance a user's level of interactivity or to simply entertain.

Animated navigation offers an infinite amount of interactive, kinetic design possibilities. For example, the simple typographic menu in Nessim Higson's IAAH portfolio is accompanied by a subtle black arrow that moves in from the left edge of the frame, signifying the selected item (**3.4**). In Studio Dialog's Web site, moving the cursor over a text link generates a quick movement of the type in a slightly upward direction to the right. This motion is accompanied by the appearance of an underlying bar that changes in weight from thin to thick (**3.3**). In contrast, LeskoMedia's Web site for The Plumbing Joint uses representational images with less subtle motions that mimic the physical experience of turning on a faucet handle or pulling a stopper from a drain. In addition to activating menu items with a mouse-over or click, the

navigational graphics are choreographed to animate during the brief transitional periods between pages (**3.18**). A similar approach is Taras Lesko's award-winning site entitled "Stickman On Fire," which is based on a bizarre, yet clever concept of personified matchsticks that allow users to view photographs and movie clips of intimate, hand-made stick figures and fire. As navigational elements, the matchsticks pop up and down when the user mouses over them. A giant matchbook, which serves as the main showcase, closes after a new menu item is selected and re-opens to feature updated content (**3.8**).

3.8
Web site for "Stickman On Fire." This Web site's innovative idea which was conceived by Jenny Solima at Omar College of Design won several prestigious industry awards for its bizarre content and originality. What started out as a simple, school project grew to become an instant online hit, attracting over 70,000 unique visitors within a month after its inception. Courtesy of LeskoMedia.

In Belgian movie director Philipo's Web site, the navigation structure is a group of bound cards. When one is activated by a mouse click, it moves to the foreground and shifts its position and orientation to align with the frame's edges. During the course of its motion, an extension of the "photos" or "videos" card slides out to reveal a series of thumbnail images. Activating one of these images with a mouse click generates a second window that slides out to display the selected photograph or video clip. The user can control the navigation by clicking any of the cards in the upper left corner or selecting the typographical items at the bottom of the frame (**3.13**). This type of animated, interactive navigation system creates an entertaining presentation and provides a straightforward, convenient way for users to retrieve information.

3.9

Web site for Philipo, a Belgian film director. Courtesy of Dizynotip.

3.10

Prototype navigation design, by Heather Reno, Fitchburg State College, Professor Jon Krasner.

Navigational items potentially function as video clips that play in response to a mouse rollover.

3.11

Giant Octopus' Web site. Courtesy of Giant Octopus.

Floating menus move as if they are suspended in water when they are activated.

3.12
Navigation designs, by Matthew Brunelle, Chris Roux, and John Brissette, Fitchburg State College, Professor Jon Krasner.

This assignment involved creating a set of icons and corresponding rollovers to establish an identity for a fictional, music-based Web site. All of these designs have the potential to be animated.

animated transitions

The Internet is a virtual space that consists of complex levels of information. In a Web interface, animated transitions can be effective in moving users between various levels of detail while maintaining the original context of a site. Brookfield Properties' interface design for Bankers Court, for example, uses two-dimensional lines and simple geometric planes that act as sets of windows or architectural structures that rotate, change position, and slide open to reveal new content when a link is activated. The compositional possibilities that result from the framing of these transitions look similar to the paintings of Dutch De Stijl artist Piet Mondrian. The smooth, visual changes in composition and content that occur in this simple design solution make the site stand apart from other local office Web sites (**3.13**).

3.13
Brookfield Properties' Web site for Bankers Court, an office tower development for downtown Calgary, Alberta. Courtesy of Studio Dialog.

In Studio Dialog's Web site, activating a link triggers a pair of thin, horizontal blue lines that move vertically in opposite directions to the top and bottom of the screen. Once they reach their destination, new interactive content is featured. A compelling video wall presentation of company work features striking graphic transitions across the frames to display a large image associated with a particular mouse-over. In tandem with this transition, a blue rectangle slides out from the frame to identify the client, title of the work, and design category (i.e., motion, print, interface, etc.) according to a simple legend (**3.14**).

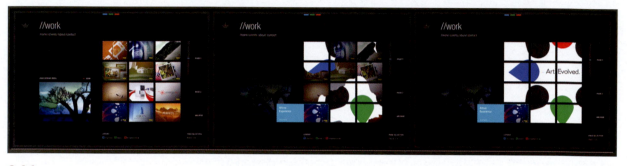

3.14
Frames from Studio Dialog's Web site. Courtesy of Studio Dialog.

Manuel Piton of DizyNotip, an interactive design, print, and photography studio in Brussells, uses Flash's animation abilities to achieve subtle, yet highly innovative animated transitions in his Web designs for commercial arts studios in Belgium. In particular, his site LB.o - lentillebioptique, a film company specializing in independent shorts, affirms that motion can enhance both the form and functionality of an interface. Aside from three simple text links that feature the writing, technique, and production aspects of filmmaking, the orange-highlighted "Choix du menu" (menu choice) allows you to choose upcoming events, achievements, filmmakers, and relevant links. The "Nos realisations" (achievements) link generates an animation of Polaroid photographs that move inward from the edges to fill the frame. Meanwhile, a larger foreground image of a video/DVD cover featuring the short film *Le Sens De L'Orientation* (2006) moves and rotates into position from the right to the left edge of the screen. Clicking anywhere on the screen triggers a shift in the position of background photos to accommodate scrollable text content and links to related images, videos, and music. Choosing a different film from the floating, secondary navigation menu produces the same transition with different Polaroid shots relating to the film (**3.15**).

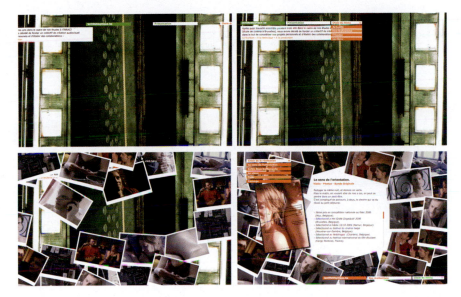

3.15
Web site design for LB.o -
lentillebioptique, a Belgium film
production company specializing
in independent, collaborative
shorts. Courtesy of DizyNotip.

Resn's lush Web interface design for the New Zealand band, The Black
Seeds, (**3.16**) offers another example of how animation can serve as a
means of changing content. The site is an engaging kinetic collage of
cheeky, cutout photographs, flat and linear graphic images, and gold
type superimposed over a black background. In response to selecting a
navigation item, varieties of animals, plants, and props, such as musi-
cal instruments and disco balls, move on and off the frame to change
the composition's scenery, similar to how stage props might be updat-
ed to accommodate the scenes of a live play. The images and anima-
tion create the feeling of a Pacific dance floor, an atmosphere that well
suits the fun, laid-back nature of the music. The aim of this project was
simply to help the band earn global exposure and recognition. Accord-
ing to Resn director Steve Le Marquand, "It's one of those sites that you
either love or you hate, because it's quite in your face."

3.16
Web site design for The Black
Seeds, a New Zealand band that
fuses blend of reggae, funk, soul,
and dub. Courtesy of Resn.

3.17

Web site for The Plumbing Joint, a privately owned plumbing business in Alabama. Courtesy of LeskoMedia.

The idea of water provided a clever design solution to transitioning between pages. Many graphic elements, including the site's navigational items, the main backdrop, and the header, were carefully choreographed to animate during the transitions.

3.18

Storyboard pitch for a Web site's opening for The Devereux Group. © Jon Krasner 2007.

The opening animation shows an atural transition into the site's home page. © Jon Krasner 2007.

splash page animations

Splash pages are introductory pages to a Web site that appear before the main content of the site loads. Similar to traditional book covers, their purpose is to set a mood, reinforce a brand, intrigue visitors, and entice them into entering the site to learn more. They may also provide users with technical viewing requirements and give them a choice of how to enter the site (i.e., html, Flash). Splash pages that employ motion graphics are typically 5 to 10 seconds in length.

The popularity of splash pages has declined due to the complaints of users who experience unnecessary download time. Usability tests, focus groups, and Web analytics data have indicated that target audiences respond negatively to the presence of a splash page; in particular, first-time visitors are often turned away because of the time commitment of waiting for the splash page to load before the site's main content loads. Further, the graphic appeal of a splash page quickly drops when repeated users make subsequent visits to a Web site. Statistics have also shown that splash pages can decrease search engine rankings. Most search engines rank Web pages according to their HTML code, text content, and links. Because splash pages typically lack body text and only provide a link to a site's home page, search engine spiders only recognize the home page or ignore the site entirely. META tags with keywords and descriptions can help spiders index splash pages, however, the absence of links and content may be detrimental to a Web site's overall search engine ranking. Since search engine spiders usually only crawl through a site's first three levels when indexing and ranking, splash pages can hide valuable content by adding another level.

In lieu of these circumstances, splash pages can present information quickly and ensure that viewers see the information at least once. Design studios and advertising agencies that sell creativity can benefit from a well-designed splash page that boasts their design skills and level of creativity. For example, "be-Designer" is a site created for two Belgian interior architects who specialize in commercial and residential architecture, interior design, and furniture design. Its intriguing animated introduction begins with a single, large green number "4" which spins into view over a background of elegant grey patterns. The number fades to a dark grey as the title "be-designer" animates in from the frame's right edge to its final position. Clicking on the "enter" link generates a clever animated progress indicator consisting of a smaller version of the number "4" gradually filling up with a bright green color

fill, similar to how liquid fills a glass. Once the green color reaches the top of the number, the screen suddenly changes to display a series of horizontal wipes that introduce the site's main content (**3.19**).

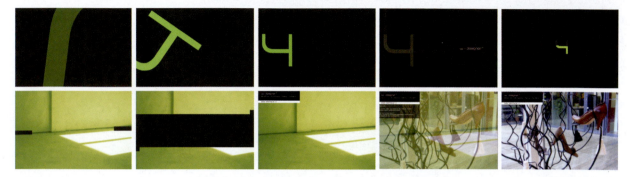

3.19
Frames from a Flash opener for "be-Designer," a Web site for Belgian interior architects Stephanie Simov and Gilles Fostier. Courtesy of Dizynotip.

Like motion picture title sequences, splash pages can establish mood and atmosphere. For example, the site opening to Salon de Fatima, a New England chain of hair salons and day spas, animates an elegant mix of typography and natural images, such as water droplets, flower petals, and steam, to convey the feel of a nurturing environment (**3.20**). Depending on a site's demographics, viewers may be willing to tolerate the download time in exchange for being enticed and entertained.

3.20
Frame from the splash page to Salon de Fatima, a New England chain of hair salons and day spas. © Jon Krasner 2007.

An elegant mix of typography and natural images, such as water droplets, flower petals, and steam, convey the feeling of a nurturing environment.

Businesses that take into account audience demographics and measure site traffic usually request an "Enter" or "Skip" link if they have a legitimate reason to use a splash page on their site. This allows users to forge ahead to the site's main content instead of waiting for the animation to load. Often, splash pages embed a script that checks for cookies that can redirect repeated visitors to the site's home page. This solution is more effective than relying on the client's audience to bookmark the site's home page on their own. Further, the content of splash pages is usually optimized to ensure the quickest possible download time. Most splash animations utilize vector-based images, since bitmaps and QuickTime video clips take longer to download.

banners

Banners are often a key element of Internet advertising campaigns. As marketing devices, their strategy is to establish a strong, professional Web presence and create a favorable and lasting impression on those who view its content. A banner design that successfully brands a company's image can generate a higher "click-through" rate (CTR) to generate more traffic to a Web site.

As a form of advertising, banner design mandates a strong marketing approach involving extensive research on the subject being advertised, including its benefits, features, competitors, and past campaigns. Designers must understand what the banner needs to accomplish, its specific requirements, its key communication points, and intended audience. Additionally, they must be aware of the hosting sites that the banner will be running on and other banners that may be placed on the same page.

The dynamic application of motion graphics to banner design can help attract the attention of a site's users. Studies have shown that animated banners generate higher click-thru rates than static banners.

The two principle animation formats that are used for animated banners are animated GIF and Flash. Although animated GIFs have been extensively used in Web advertisement banners, Flash-based banners have become quite popular, due to Flash's ability to easily generate motion, along with their smooth playback rates and small file sizes. Further, Flash banners can be designed to be interactive, involving visitors directly. (Designers that submit a Flash banner for a banner ad campaign are often asked for the animated GIF version as well.)

Effective banner design can make or break a campaign. Studies have shown that typical Web surfers spend less than 10 seconds viewing the top portion of a Web page. Therefore, banners that get the point across quickly through concise, direct communication are often the most successful in their advertising. Incorporating motion can be an effective device to draw users in; however, it should be kept simple and subtle, since its purpose is to attract visitors, not irritate them. Additionally, it should blend in naturally and not clash with the design of the hosting page. The animation's length should be between 3–5 seconds, keeping in mind the differences in browser speeds. Since animations that loop endlessly can be distracting, they are often designed to loop four or five times before displaying the main message on the last animation frame. Text that is displayed should be clear and legible, and should take no longer than two seconds to read. (On the screen, serif fonts are often difficult to read at sizes below 14 points.) All of these criteria take into careful account the interest and patience of the viewers.

3.21
These banner styles and sizes are some of the most accepted ones that are used today as outlined by the Standards and Practices Committee of the Internet Advertising Bureau.

Note: These sizes only show relative proportions and not at 100% scale.

As a rule of thumb, standard "healthy" file sizes for banners that are 468×60 pixels large are typically between 4–25K. Small button banner styles may range between 1.5–3K.

leaderboard
728 x 90 pixels

full banner
486 x 60 pixels

vertical banner
120 x 240 pixels

hald page ad
300 x 600 pixels

half banner
234 x 60 pixels

skyscraper
160 x 600 pixels

square
125 x 125 pixels

rectangle
180 x 150 pixels

From a technical standpoint, file size is a critical factor. File sizes that are too "heavy" can result in slow downloads and choppy playback. File size depends on several factors, including the duration of the animation, the delivery method (Flash or animated GIF), and the dimensions. GIF and JPEG optimization processes that involve data compression and color depth reduction can significantly reduce file size without changing the content's integrity. Once the animation is optimized, it is best to test it on different browsers, platforms, and connection speeds to ensure maximum and consistent results.

Some designers have expressed frustration with the limitations that banner design imposes, while others feel inspired to push the limits and make the content work in their favor. Taras Lesko of LeskoMedia designed and produced eye-catching motion graphics for a series of banner advertisements and surrounding header graphics for Anthrax's official reunion Web site (anthrax.com). Each banner was individually tailored to a theme that corresponded to a different album cover. These designs, which were animated to bring life to the album cover art, can be accessed through the site's theme selection feature, giving viewers the option to customize the look of the Web site (**3.22**).

Businesses often require banner ads to go through a period of testing, which involves running the banner over a period of time and measuring the CTRs and resulting sales. They may slightly alter the design and run the banner again to measure the results. Unless the designer has conducted thorough research on his or her audience preferences and behavior patterns, it is unlikely that a single banner is sufficient for an ad campaign. Since CTRs tend to drop significantly after two weeks, most designers start with 6 to 10 banners, allowing the client to rotate them in order to measure the click-thru rates.

3.22
This series of Flash banners for the heavy metal band Anthrax was used to promote the band's official reunion site, anthrax.com. Courtesy of LeskoMedia.

3.23
Frames from an online
advertisement for Lycos.
Courtesy of hillmancurtis, inc.

advertisements

Web advertisements, like television commercials, are designed to make viewers captive to information that might be missed in a banner ad. They appear for approximately 5–10 seconds before the expected content page loads or may appear between a main page and its secondary pages. Web advertisements are typically display sizes that are smaller than the destination page and must be viewed in their entirety, unless the user takes a step to remove it from view. (Many include a "Skip" option to accommodate viewers who choose not to wait.)

Two principal types of Web ads are PopUp and inline interstitials. *PopUp advertisements* (currently the most popular form) appear as temporary windows in the foreground, while the destination page's content loads in the background. *Inline interstitials*, which occur in environments such as Shockwave, Java, or VRML, are usually interactive with the intention of keeping users occupied during the intended download.

Due to the active participation that users engage in online (versus the passive role of television audiences), many Web advertisers have reduced the level of intrusiveness and disruption of online ads. Design formats, such as interstitials and video-based ads, are faced with the challenge of getting the message across to users as quickly as possible while maintaining their involvement with the experience. For example, Hillman Curtis's online advertisement for Lycos delivers the message quickly with only a few thin, green, vertical lines, six photographic images, and simple animated text (**3.23**). The letters to the word "discover" fade in one by one as they are introduced by two green lines that animate across the screen from left to right. The letters perform a 360° rotation, spinning into the word "fun," which then fades out to reveal "educate" and "share," as one of the empty frames at the bottom shows a young girl opening the lid to her laptop and then turning to smile at the camera. Other words, such as "research," "inspire," "interact," "future," "headlines," and "global," follow in sequence as they are accompanied by other photos. In an interview for Adobe's Web Gallery by Susan Davis, Hillman stated, "The emotional message is simply that Lycos has something for everyone, even your daughter . . . we made the text very futuristic to add to that simple picture."

Hillman's promotional advertisement for Roger Black's Interactive Bureau is also effective in quickly informing us that the Bureau combines the power of traditional graphic design with fluency in the latest

technology (**Chapter 5, figure 5.44**). His online interstitial for Softcom, an Internet communications company specializing in e-business, also succeeds in describing the company's working process in a matter of seconds (**3.25**). Last, Hillman's approach to straightforward communication is evident in his online interstitial for Cysive, Inc., a provider of Interaction Server software. The objective of this animated, interactive piece was to promote the company's principal activities in building and developing Web, wireless, and voice-activated technologies (**3.24**).

"I don't think any animation is worth a 30-second download."

—Hillman Curtis

3.24
Frames from an online advertisement for Cysive. Courtesy of hillmancurtis, inc.

3.25
Frames from an online advertisement for Softcom. Courtesy of hillmancurtis, inc.

Many designers feel that as the Internet continues to grow, it will adopt more traditional television formats to make the future of online advertising more engaging. The appearance of online advertisements has already improved through the incorporation of animation, video, and high-quality sound, making them look more like television commercials. As our comfort with the Web continues to grow, advertisers will continue searching for more effective ways to get their messages across. This, in turn, will give motion graphic designers more opportunities for growth.

Motion in Informational Kiosks

Public information facilities have become effective communication vehicles because of their ability to transmit messages in a nonlinear, multidimensional fashion. The education, entertainment, and advertising industries have made extensive investments in digital communications technologies, enabling rich sensory experiences to be delivered across the world. The advancement of interactive display technology has created exciting new opportunities for motion graphic designers. Informational kiosks, for example, are interactive digital displays that can provide information to the public and retrieve information from individual users based on a variety of input devices involving touch,

voice, and even body movement. Like Web sites, kiosks can be tailored toward the types of content being delivered, the languages it supports, and the feel of the surrounding environment. Today's advanced kiosk systems are capable of displaying high resolution images and dynamic information. They can also communicate in multiple languages, stream live video content to consumers, and drive interactions between customers and sellers.

Like computer mice, keyboards, pushbuttons, and trackballs, touch-screens are devices that are capable of displaying and receiving information on the same screen. This technology allows a screen display to be used as an input device for interacting with content, removing the keyboard or the mouse as the primary input device. These systems, which can be attached to computers and networks, have assisted in the development of the PDA and cell phone industries, making these devices more advanced and user friendly. Since Dr. Samuel C. Hurst's invention of the electronic touch interface in 1971, touchscreen technology has become commonplace in retail settings, on ATM machines, and on PDAs. The integration of touchscreens into kiosk design has allowed users to perform a wide variety of operations from online transactions, to collecting money in exchange for merchandise, to entering and retrieving information. The increased popularity of information appliances, such as smart phones and portable game consoles, is continuing to drive the demand for touchscreens.

Motion in Multimedia

The advent of film and television allowed motion graphic designers to deliver high quality moving images, combined with sound, to their audiences. Due to the high cost of producing and showing films and videos, newer and less expensive technologies, such as multiple projector slide shows, were developed. On the computer screen, animation and interactivity began with applications such as Hyper-Card, SuperCard, and Director.

Today, motion graphics are an integral component of interactive CD-ROM and DVD-ROM titles. Education, business, and entertainment are the most popular forms of multimedia, all of which utilize new ways of informing and entertaining users through the integration of text, audio, graphics, animation, video, and interactivity. In education,

computer-based training courses (or CBTs) and reference books, such as encyclopedias and almanacs, allow users to access various informational formats about a particular topic. Educational CD-ROMs can challenge users to move to higher levels of performance by accumulating points or by inputting a correct answer. In the business sector, promotional CD-ROMs have been used to advertise company services to new customers or provide information to repeated customers.

3.26
Concept sketch for an informational kiosk for Total Entertainment Network. Courtesy of twenty2product.

Candle Corporation, a leading developer of software solutions for networked businesses, requested an interactive CD-ROM to promote its IntelliWatch management software that was designed to automate the daily administration processes of a Lotus Notes network (**3.27**). The interface's primary navigation system features four individuals —an administrator, an information technology director, and a small and large business manager—all of whom represent potential users of the software. Mousing over an image activates a transition in which a larger version of the person escapes from the rectangle to occupy more screen real estate, while the rest of the navigation palette shrinks down into a smaller menu. The right portion of the frame displays a motion graphics sequence in which the chosen individual explains his or her daily pressure and the need for a Notes network management system. For example, the administrator informs us of the daily

The informal term "edutainment" is used to describe the integration of education and entertainment in multimedia industry.

frustrations he encounters with network crashes and their effects on email users, business managers whose applications quit midstream, and large attachments clogging the mail path. An omnipresent voice responds to his need by pitching the power of Candle's Intelliwatch for Notes software. During this dialogue, multiple static poses of the administrator show various facial expressions and body gestures in response to the dialogue. These poses, juxtaposed over a rich animated background consisting of moving typography, emulate camera moves that pan or zoom into graphic landscapes, while screen shots of the Intelliwatch software pass by. The bottom navigation also features motion sequences that depict IntelliWatch's integrated software and consulting services.

3.27
Screens from Candle Intelliwatch CD-ROM. Concept, design, and motion graphics by Jon Krasner. Courtesy of Candle Corporation and The Devereux Group.
© Candle Corporation.

In the entertainment industry, the cinematic experience has become more interactive. Over the past decade, a myriad of portable video game consoles and interactive entertainment applications have been developed to revolutionize home entertainment. Examples include Sega's Dreamcast, Nintendo's Game Cube, Microsoft's Xbox, and Sony's PlayStation. As a result, the demand for video game designers to develop dynamic, interactive content has grown dramatically.

In 1999, Sony Computer Entertainment developed the PlayStation 2 (PS2), the successor to the PlayStation (1994). The PS2 introduced a new concept called "Emotion Synthesis" and devised an authentic 128 bit processor, the "Emotion Engine," that could perform complex calculations to support its graphics demands. This processor allows the movements of characters to be determined by interactive events, as opposed to the playback of prerecorded data. For example, *NBA Shoot-Out* (2003) emulates a lifelike NBA presentation. The player's movements are the result of over a dozen NBA stars being motion-captured in dribbling, passing, shooting, and performing signature dunks (**3.28**).

3.28
Opening for PlayStation®2, "Emotion." Courtesy of Humunculus. © Sony Computer Entertainment America Inc. All rights reserved.

In 2006, Sony released the PlayStation 3 in Japan and North America as part of the seventh generation of video game consoles. Considered by many to be the most commercially successful home console in video game history, PS3's Cell architecture integrates more evolved graphic expressions, live-action video, 3D animation, and high-fidelity sound. A software market of over 13,000 titles has already been developed, and high expectations for continued game development should offer a full range of artistic opportunities for motion graphic designers.

The specialized field of game design requires a strong foundation in aesthetics, conceptual and imaginative thinking, and interactive and motion design experience, an understanding of the dynamics of gameplay, and the ability to work in a team-based environment. Many schools and universities offer courses in interactive game design, most of which emphasize the artistry (versus the programming) involved.

The Cell Broadband Engine™, developed by Sony, Toshiba, and IBM, is a breakthrough processor that has had a major impact on motion graphics in game design. The PlayStation 3 video game console uses this technology to produce a more vivid experience through sophisticated special effects and artificial intelligence that can make objects or actions behave unpredictably.

Motion in DVD-Video

When DVD-Video replaced the LaserDisc in the mid 1990s, the motion picture industry aimed to use digital media as a means of presenting full-length feature films. As an alternative to standard VHS, the image quality of DVD-Video is superlative, and the content does not degrade over time. Like the Web, its nonlinear, interactive navigation structure can allow users to use a remote control or a joystick as a means to view individual scenes of a movie, access additional bonus information, and customize settings such as multi-angle viewing, surround sound, and random shuffle playback to create a more engaging experience. Personal biographies, directors' commentaries, playlists, Web links, and interactive DVD-ROM content can be viewed on a personal computer.

Although some users only judge DVD titles on usability, others attribute their success to the design of the menus and consider attractive, stylish menus to be a large part of their initial visual appeal. Given the nature of DVD menu graphics for movie pictures, independent films, bands, documentaries, and training programs, most designers would agree that if the content on a DVD is worth watching, then the supporting menu structure should be equally engaging.

DVD titles typically consist of a background and a menu system. Background animations usually last between 15–30 seconds. Motion menus are typically short, lasting between 15 seconds to a minute. Motion can enhance the navigational process and add to the viewing experience, similar to how the opening titles to a film can set the mood beforehand. Many animated menus are designed to loop until the user makes a selection. This time limit is partly due to the DVD's storage capacity and to the length of the background animation or soundtrack.

Motion menus can be customized to incorporate animation or a moving preview of the DVD's contents. Special effects and video compositing techniques can be applied, and the video can be edited to be a compilation of different scenes. Additionally, any type of interactive menu item can be blended into the background or designed to conform to a nonregular shape. These approaches can open up many intriguing design possibilities that break away from many of the template-based packages on the market.

The clever introduction to the DVD title for *Gunshy* (2000) features navigational items, such as bullets that fly into the frame in succession. In keeping with the theme of this action/adventure film, an animated sequence of a target moving over the free-floating characters loops seamlessly until a menu is activated (**3.29**).

3.29
Frames from the DVD title of *Gunshy* (2000). Courtesy of Berretta Design.

3.30
Motion menus for *Macross II* (2000). Courtesy of Berretta Design.

These menus effectively reflect the style of this Japanese anime cartoon. Seamless loops of dynamic character poses, animated sound levels, flying aircraft and space ships are contained inside graphic shapes over a high tech, futuristic background consisting of subtle kinetic shapes, lines, and bands of color.

Figures 3.31 and **3.32** illustrate DVD titles that were designed by undergraduate graphic design majors in an interface design class. Daniel Dumont presented a collection of visuals depicting his family heritage based in Lowell, Massachusetts. He deliberately chose to incorporate a minimal amount of text, since representation through photographs

of family and events, news clippings, and images of natural incidents, such as the flooding of the Merrimack River over the Bridge Street bridge (down the street from the house where he was raised) would arouse the curiosity and motivate users to dig through his family's past. Executed in a "grunge style," menu items would move slowly across the background of an old postcard that was mailed to a family

member from Daniel's great-great-uncle who served in the military. When a user highlights a link, it would shake to generate a subtle earthquake effect to indicate what it might feel like to travel backward in time. Upon entering a scene, yellow silhouettes of birds would be flying intermittently across the background. Each new scene would transition into the frame with a fade and exit the frame through a quick wipe when a new link is activated. Again, the new content would fade into the foreground.

3.31
DVD title design by Daniel Dumont, Fitchburg State College, Professor Jon Krasner.

John Brissette's *Cathedral* tells a fictional story about a single piece of architecture and how its mere existence shapes human lives around it. Each scene represents a specific period in time, ranging from the building's construction, to its inevitable demise, and finally to its "rebirth." More than just time periods, the scenes also represent emotional themes, from harmony to chaos to isolation to fear, and so on. The cathedral occupies the same position and scale in every scene, giving us the sense that we are shifting between time periods from a single vantage point. John envisions incorporating narration by using the voices of actors who would assume the role of a character living in his respective time period.

In each of the scenes, various positions and body movements of static figures in the foreground would fade in and out, signifying lapses in time. For example, the foundation of the building in 600 AD would be accompanied by images of laborers fading in and out, hauling and shaping stones, cutting lumber and smelting iron. 1225 AD depicts the oath of a knight defending the cathedral from its enemies. While he stands alert and vigilant in the foreground, images of knights patrolling the building and worshippers entering and exiting from the left would become part of the visual landscape. The scene in "Forgotten" (date

unknown) reveals the cathedral abandoned in the winter. Cloud cover would animate in the background, and drifts of snow would occasionally blow across the frame from the right. 1996 AD shows a working father whose complicated life and stress level is elevated by the unwelcome ringing of church bells. Images of him returning from work and entering his home would accompany an animated flock of geese migrating across the skies to symbolize that change is needed. 2065 AD shows the ruins of the cathedral in a futuristic cityscape. An unknown enemy has wiped out most of the population, but a resistance has been using the cathedral's underground chambers to seek refuge and coordinate efforts to defend themselves. Figures would move in shadows across the middle-ground, while an airship would hover in the background sky looking for potential targets.

3.32
Frames from Cathedral by John Brissette, Fitchburg State College, Professor Jon Krasner.

Summary

Interactive environments can redirect linear information into a branching, nonsequencial structure, allowing the user's role to become active. Incorporating motion graphics into an interface introduces new design possibilities and affords motion graphic designers opportunities to exercise their talents beyond the film and television screen.

The development of higher bandwidth connections and streaming video has made the prospect of motion over the Web enticing, and many designers welcome the opportunity to communicate beyond national boundaries while waiting for the Web to mature.

Today, the most common Web animation formats are Java, animated GIF, Flash, QuickTime, Windows Media Player, and RealPlayer. Since the 1990s, Java *applets* have been used to produce interactive animations in Web page designs. Although Java's platform independence ensures that they can run similarly on any supported hardware or operating-system, many designers avoid Java because it requires some programming knowledge. Animated GIFs continue to be a popular low-tech option since all browsers support the GIF format. Additionally, animated GIFs do not require plug-ins for viewing, and programming skills are not necessary. Many designers consider Flash to be the most effective interactive animation tool for delivering vector-based content to Web pages, due to its capacity for full-screen playback on all monitor sizes and platforms and its ability to scale vector images without loss of resolution. Action Script, Flash object-oriented programming language, offers endless possibilities of integrating interactivity and motion. Despite these advantages, Flash content can be difficult to update and index by search engines. dHTML animation is recognized by most Web browsers and does not require users to download extra components. It is, however, limited in its animation capabilities and is challenging to code so that it plays consistently on all browsers. QuickTime, Windows Media Player, and RealPlayer formats can deliver video data over the Web through downloading or streaming. Since video is one of the most bandwidth-intensive assets, the prospect of purely video-driven Web sites seems far off in the future.

Successful navigation design supports and directs users through the complexities of an interface. Incorporating motion into a menu structure can enhance a user's level of interactivity and place emphasis

on items that users might overlook. Animated transitions can help move users between various levels of detail while maintaining the original context of a Web site. Likewise, animated splash pages can set a mood, reinforce a brand, and entice visitors into entering a site. However, their popularity has declined due to their download time and hindrance to a Web site's search engine ranking.

The application of motion graphics into banner design can help attract a site's potential users. Since concise, direct communication is most effective in advertising, animations should be kept simple and subtle. Banner animations are often tested on various browsers, platforms, and connection speeds to ensure maximum and consistent results.

Web advertisements, like television commercials, are designed to make viewers aware of information that might be missed in a banner ad. Design formats, such as interstitials and video-based ads are faced with the challenge of getting a message across quickly. Many designers feel that as the Internet continues to grow, it will adopt more traditional television formats to make online advertising more engaging.

Public information facilities have become effective communication vehicles, in that they are capable of displaying high resolution images and dynamic information. The integration of touchscreen technology and the increased popularity of smart phones and portable game consoles continues to drive the need for motion designers.

Motion graphics have also become an integral component of multimedia authored media. In education, computer-based training courses and reference books allow users to access various informational formats. In the entertainment industry, the cinematic experience has become more interactive, and the demand for video game designers has increased.

Like the Web, the nonlinear menu structure of DVD video titles can create engaging, interactive experiences. The integration of motion into DVD menu design can enhance the navigational process and add to the viewing experience. Motion menus can be customized to incorporate animation or a moving preview of the DVD's contents. They can also be blended into the background or designed to conform to non-regular shapes. These approaches can open up many intriguing design possibilities that break away from templates that are on the market.

motion graphics in the environment

an overview

We live in a time and culture where all of our sensory experiences are challenged by the bombardment of information. The potential of motion graphics in our physical world has finally been realized and is helping to shape the landscape of environmental interior and exterior design. Public informational systems, performance art, memorial and donor recognition programs, and contemporary video installations are vehicles that have opened new doors for motion graphic designers.

"What made people stop painting frescoes and start painting on panels and stretched canvases anyway? And what if corporations moved away from fixed logo-type signage on the outside of their building facilities and put big video screens up there instead?"
—Terry Green, twenty2product

00:00:00:04

New Technologies

Digital technologies are playing a much greater role in shaping our visual, public landscape. Video wall systems, which can display very large images without compromising screen resolution, are thriving throughout the world in almost every arena, including trade shows, shopping malls, corporate lobbies, casinos, showrooms, nightclubs, retail stores, restaurants, and sports arenas. Pier 39, located in Fisherman's Wharf in San Francisco, is visited by millions of affluent consumers annually. As a prime target for advertisers, they experience a 9' × 15' video wall, developed and installed by San Francisco Outdoor TV. The LED screen operates seven days, featuring headline news and sports programs, weather, and trivia in San Francisco and the Bay Area.

The technology behind most video walls is similar. A video signal feeds into a processor that alters and splits a signal across multiple monitors. Today's systems can also process multiple signals to produce images from numerous sources. Behind the scenes, a control processor feeds video, image, and data signals to the individual screens. Depending on the sophistication of the software, separate data sources can be programmed to split a single image across all the screens, magnify a single image across the screens, or merge multiple images together to create a unique, eye-catching, dynamic display.

A major benefit of video wall architecture is that it is scalable and interchangeable, allowing many screen sizes and horizontal or vertical configurations. The X-Wall, for example, is designed specifically for the expanding requirements for large scale visualization and presentation systems. Another advantage is that as a video wall's size increases, the number of available pixels (resolution) and overall brightness per square foot remains constant. (This is not true of projection systems.) A 2' × 2'model, for example, involves four monitors or cubes to be placed side-by-side on top of another two. The configurations can grow to 3' × 3', 4' × 4' and so forth.

Media critics believe that video wall technology will continue developing along with the demands of more sophisticated public entertainment and information systems.

Over the past decade, advanced display technologies have used light to transform public spaces, build brands, and invoke imagination by allowing motion graphics to become a physical part of our environment. Large companies, such as Daktronics—one of the world's largest suppliers of large screen video displays and electronic scoreboards—are trendsetting in the sphere of Light Emitting Diodes (LED) technology. LED lighting systems have increasingly become the choice of architects and designers who are transforming environments with "intelligent light." Unlike traditional "flat" LCD or plasma displays, LEDs can be customized to any size and aspect ratio, allowing many possible geometric configurations. These displays are manufactured with perfectly square corners, having little or no seams apparent between

modules to allow seamless configurations of content. Another advantage of LED displays is that they are visible in front windows, since they are bright enough to compete with sunlight. They can also have viewing distances less than 3 feet, since the pixels are densely placed.

Immersive Environments

Immersive environments shape a sense of place by providing order, ambience, comfort, and insight to a physical or virtual space. They are a unique confluence of architecture, interior design, images, motion graphics, and sound that operate holistically to provide aesthetic, meaningful experiences and enhance social interaction. They are also used to communicate products, services, or messages by merging interactive digital technologies with tangible and physical spatial experiences. Today, immersive environments are designed to blend physical and imaginary worlds in which moving images, text, and audio can respond to humans. The artistic and expressive qualities of animation is appearing more frequently in hotel lobbies, trade shows, retail spaces, and museums, as well as in complex public environments such as airports and theme parks.

Historical Perspective

During the 1920s, French film director Abel Gance experimented with a three screen version of Napoleon. In the 1960s, Cinemascope's elongated proportion was extended by Cinerama to a concave screen that curved to embrace audiences. The New York World's Fair of 1964 marked the apotheosis of the giant screen frenzy. Pavilions competed for the most breathtaking displays: the circular Kodak theater, the GE "sky-dome spectacular," General Cigar's "Movie in the Round," and Charles and Rae Eames' "View from the People Wall," a nine screen projection on the ceiling of the IBM building. These were the precursors to today's IMAX theaters.

During the 1970s, multiimage slide projectors allowed multiple, dissolving images to be displayed in an array of wide ratios. Those slide shows also relied heavily on film processing, glass mounting, and slide tray loading. Electronic imaging surfaced in the mid 1980s. The slide screen was put aside for video wall monitors and new, exciting possibilities of video display technology. During the 1990s, digital signal processing and high-resolution projection cubes were developed to compete with brighter projector technologies. By this time, video walls were so popular that all kinds of companies were joining the production arena.

The concept, design, and fabrication of immersive environments must take into account how information is perceived and processed by an audience, the application of graphic style to the information, and the needs of diverse audiences—including individuals with physiological and cognitive disabilities. Color, typography, composition, and movement must also be considered in order to communicate information clearly, concisely, and consistently.

interior design

The infusion of motion graphics into interior spaces has become a vital component in establishing mood and atmosphere. In corporate lobbies or waiting rooms, for example, they can be used to reinforce a brand, change content to support various messages, and define an ambiance that might be unattainable with other mediums, while maintaining the design integrity of the space. Motion graphics in retail and event spaces can add a unique dimension to the space, provide drama and suspense in entranceways, attract outside traffic by presenting the content in display windows, and support a product theme or a brand. Casinos, restaurants, and hotels have also used motion graphics to create engaging immersive experiences for patrons, provide conversation pieces to stimulate guest interaction, and provide unique content as a substitute to mundane television programming.

4.1
Computer-generated rendition of an installation for Nielsen Media Research's head office in New York. Concept and design by Dyske Suematsu and KSK: STUDIOS. Production by New Vision Comunications, New York.

Nielsen Media Research analyzes the behavior of media audiences, including television, radio, and newspapers. (Since the 1950s, the Nielsen TV Ratings have statistically measured what programs are watched by different segments of the population.)

Spanning across the width of the lobby of Nielsen Media Research's head office in New York, a row of ten projection screens plays video presentations that are looped throughout the day (**4.1 and 4.2**). The architect who designed the lobby chose rear projection (versus plasma) screens, allowing them to line up seamlessly without any frames around them. For exhibition and convention projects of this nature, it is challenging to predict how the video will look large-scale, since the wall may not actually be implemented until after the content is designed. (In this case, the wall was built just two weeks before the opening.) Additionally, the wall's large size made it difficult to gauge how it would look in the lobby just by watching a small preview movie.

A video installation for John Levy, an international lighting design firm headquartered in Los Angeles, was used inside several casinos with the simple goal of providing entertainment for the casino's patrons. The installation consisted of five 15' tall screens. The motion graphics composition, entitled "Lava," was an amalgamation of various beach scenes including surfing, underwater imagery, and water sports (**4.2**).

4.2
Frames from a looped video installation for Nielsen Media Research's head office.

4.3
Frames from "Lava." Courtesy of Reality Check Studios.

In 2004, Imaginary Forces designed a permanent video installation for the lobby of New York's Museum of Modern Art. The installation randomly selects artworks from the museum's collection and animates them on nine 30" screens in tandem with changing content on events and exhibitions to provide both information and ambience. The system architecture, consisting of high definition LCD monitors and a network of ten computers, algorithmically selects from a repertoire of images and action sequences, such as fast blurring, slow scaling, and cross-fading and applies them to the screens. The museum updates the system with text and new images of temporary shows and the permanent collection on a regular basis, so that the content always changes. According to Kurt Ralske, who designed and implemented the system and co-designed the image sequences, the original idea for the installation involved playing back video from a hard drive. Because of the amount of data needed to display the content at high resolution, the use of still images in motion could be created by moving, transforming, scaling, and blending them in real-time (4.4).

4.4
MoMA display screens, 2004.
Courtesy of Imaginary Forces.

In addition to the use of flat screens, many animated interior designs have utilized curved LED displays. For example, Radio Shack's corporate headquarters in downtown Fort Worth, Texas utilizes a circular configuration of LED displays to line the 64' interior circumference of its rotunda (**4.5**). Each screen measures 4' high × 22' in diameter. A combination of vivid live-action and graphic content, theatrical lighting, and sound gives patrons a distinctive, sensory experience and conveys Radio Shack's dominance in the consumer electronics market. The Grand Court at the Mall at Millennia in Orlando, Florida houses a circle of twelve, freestanding LED displays that represent the Neolithic majesty of Stonehenge (**4.6**). The screens are thrust 30' in the air, each measuring 10' high × 4' wide with a 40° arc. Since they can be viewed from behind, the cosmetic appearance of the rear surfaces had to be aesthetically pleasing and continuous. This celebration of American consumerism on a grand scale provides an entertaining, informative environment for its patrons.

4.5
The rotunda at Radio Shack's corporate headquarters in Fort Worth, Texas. Photo courtesy of Daktronics, Inc.

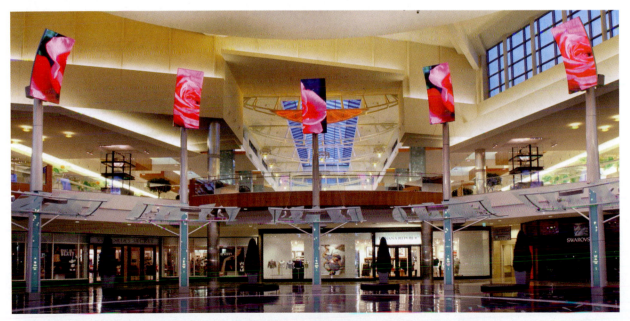

The cosmetic appearance of the Executive Suite at Goldman Sachs' global headquarters is enlivened with a digital media installation that features a rich display of live data reflecting the firm's visionary technological innovations, industry knowledge, and global insights. This compelling communication experience shares Goldman Sachs' position in the world financial markets in an instantaneous and sophisticated way that engages their executive staff and impresses

4.6
LED displays at the Grand Court at the Mall at Millennia in Orlando, Florida. Photo courtesy of Daktronics, Inc.

their visitors. Unified Field, a privately held media design company in New York City, implemented their "Evolving Screen" technology to transform this public space into "living architecture" by providing a self-evolving movie that interweaves the history, culture, and people of Goldman Sachs with current events, global financial data, and news in a virtual 3D landscape. The information— which takes on many forms including live footage, text, images, real time news, data feeds, and data-driven 4D models—continually changes in response to market and business activities, ranging from trading patterns of individual stocks to informed decisions of personnel worldwide (4.7).

4.7
Frames from the screens at the Executive Suite of Goldman Sachs' global headquarters. Courtesy of Unified Field, Inc.

Unified Field, Inc. (http://www. unifiedfield.com) is a privately held media design company in New York City that develops state-of-the-art visualization and display solutions for business, education, and culture. 4D-Visual, a division of Unified Field, Inc., develops advanced multidimensional visualization and simulation systems for real time data streams for public information environments. One of their products, The Evolving Screen™, is a high tech media installation that transforms public spaces into living architecture. Multimedia elements may include movies, text, images, real time news and data feeds, and data-driven 4D models.

Billijam, a video art and motion graphics company in New York City specializes in creating distinctive animation sequences that bring life and culture to public spaces that require ambiance enhancement (**4.8**). Founded by entrepreneurs Marya Triand and Pat Lewis, the company has helped define brands in the hotel industry by providing aesthetic, immersive environments that can be displayed on plasma screens or be projected onto almost any surface. Additionally, they can be timed to generate different ambiences for patrons throughout the day. Marya's captivating work has been displayed in settings such as The Times Square Hilton, the Marriott Marquis, the New York Barclay Hotel, Hotel 41, Club Avalon, and the Remote Lounge.

4.8
Marya Triand's dynamic animation sequences are imbued with colorful and textural video and graphic images to create ambient environments for public spaces. Courtesy of Billijam.

4.9
Frames from a community video wall for Washington Mutual's Manhattan retail space. Courtesy of twenty2product. Copyright 2003 Washington Mutual, all rights reserved.

exhibit design

Today, the field of exhibit design combines graphic design, interactive media, motion graphics, and product design. Exhibit designers typically have backgrounds that include a variety of disciplines, such as industrial design, architecture, interior design, graphic design, and theatrical design. They must demonstrate strong creative skills and sensitivity to basic aesthetic principles, such as color, composition, and perspective, as well as a knowledge of materials, lighting, and the ability to work independently or as part of a team.

An imaginative, well-designed exhibit creates a memorable and lasting impression on its viewers. Its success is judged by the effectiveness in which its content meets the aesthetic and spatial requirements of a site. The design must incorporate the essence of the individual products or brands being featured, while tying them into a cohesive, unified environment. Other considerations involve the creative use of lighting and architectural elements such as stairways, lounges, reception desks, entranceways, conference rooms, flooring, ceilings, walls, and so forth. Further, materials can range from sand and tree bark to synthetic materials such as translucent concrete or fiberglass.

The McCormick Tribune Freedom Museum in Chicago's Tribune Tower is our nation's first museum dedicated to strengthening our awareness of the First Amendment. Throughout 10,000 square feet of space, a 30' video wall, kiosks, and installations of diverse sizes and configurations engage visitors to explore their freedom by expressing their opinions and comparing their views to the views of others in a relevant and unbiased context.

The Samsung Experience, located on the third floor of The Shops at Columbus Circle in the Time Warner Center, is one of the strongest examples of digital convergence in an immersive environment. A remarkable 10,000-square-foot interactive emporium of virtual reality experiences and technology integrates various technologies to demonstrate to visitors how Samsung's brand and latest products can enrich everyday life. (Samsung's partners, including MIT Media Lab, Parsons School of Design, Napster, and Sprint PCS, are featured.) As an educational resource, this seamless world of sights, sounds, and sensations communicate the life-enhancing benefits of digital technology without the pressures of a sales environment. Giant rotating LCD screens feature interconnected virtual worlds. Interactive workstations allow users to create digital collages in real time. In the space outside of the Samsung Experience is an interactive map of Manhattan that can be viewed and manipulated with hand gestures, facilitating a user's experience of digital lifestyle in New York. Of particular interest is The Cyber Brand Showcase, a participatory Web site that blurs the boundary between real and virtual space by allowing visitor information to be exchanged between the physical environment and the online environment through cyber conduits.

Elan was the premier sponsor of the 9th International Conference on Alzheimer's Disease at the Pennsylvania Convention Center in Philadelphia. KSK:STUDIOS hired a environmental designer, Adrian Levin, to design the booth, and a branding specialist, Anita Zeppetelli, to establish the visual identity for the convention. Video signage was presented on six plasma screens that were installed around the main tower. Instead of playing the same video on all six screens, a computer-based video device allowed six independent streams of video to be displayed in sync, so that elements could move all across the screens. The most challenging aspect of this project was that the screens were configured in a hexagonal arrangement, meaning that the video could have no discrete ends horizontally. Within a 3D program, six cameras were aimed at the same objects from different angles (**4.10**).

4.10
Exhibit design for an International Conference on Alzheimer's Disease. Courtesy of Dyske Suematsu and KSK:STUDIOS.

BrainLAB, a German medical technology company, showcased their orthopedic products at a trade show convention using twelve plasma screens that were configured in a row, each representing a specific product (**4.11**). Rather than playing independent videos simultaneously, they wanted certain elements to move across the screens. At KSK:STU-DIOS, Dyske Suematsu designed the motion graphics and harnessed a computer-based video server to play twelve streams of video in sync. Since the screens had to act as one, the dimensions of the original design were enormous (10,368×486 pixels to be exact).

art installations

At the Wexner Center for the Arts at the Ohio State University, "Overture" is an example of how motion graphics are becoming an increasing component of fine art installations. Similar to the manner in which title sequence sets the tone of a film, the installation, designed and implemented by Imaginary Forces, served to establish the theme of a much larger exhibit on contemporary architecture and design entitled "Suite Fantastique." This show spanned "the practices of sculpture, architecture, and film titles," assuming "the musical metaphor of a symphony." The installation was devoted to seven of Imaginary Forces'

4.11
Installation for BrainLAB. Courtesy of Dyske Suematsu and KSK:STUDIOS.

title sequences to films including *Se7en, Donnie Brasco, The Island of Dr. Moreau,* and *Sphere.* Museum visitors were drawn in by a sequential configuration of four elevated, ascending screens that were designed in collaboration with architect Greg Lynn. The images played in concert with the main display, a 17' high-definition screen (**4.12**).

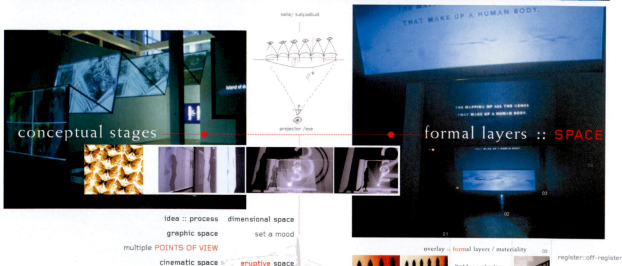

conceptual stages

formal layers :: SPACE

idea :: process

graphic space

multiple POINTS OF VIEW

cinematic space

sequence

narrative space

interwoven :: intersected

dimensional space

set a mood

eruptive space

tension

overlay :: formal layers / materiality

light :: shadow

transparency

scrims

patterning

imprinted screen surfaces

moire/filter/lens/blur

imprint :: over-print

register::off-register

4.12
"Overture," from the exhibition "Suite Fantastique." Wexner Center for the Arts, Ohio State University. Courtesy of Imaginary Forces and the Wexner Center for the Arts.

Nir Adar, a New York-based chef, food stylist, and artist, was commissioned to create a large-scale video installation for an annual dining design show at the Salone Internazionale del Mobile, a large restaurant in Milan (**4.13**). At the entrance to the pavilion were two screens (24' × 7') that projected images that created a wallpaper of transforming food patterns. Across from the entrance was a 72' × 7' wall consisting of five screens that featured photographs of Nir's food sculptures slowly morphing into each other, in combination with video footage of foods getting squashed between sheets of glass. According to Nir, the footage "had a tension between beauty and repulsion, and had a hypnotic quality to it. When you look at it as mere abstraction, the colors, shapes, and motion are stunningly beautiful, but when you think of the fact that it is foodstuff being squashed, you feel repulsed by it." Some of images were time-reversed, while others were flipped vertically or horizontally to produce a kaleidoscopic effect. This perfect alchemy of food, fashion, and design resulted in a visual odyssey of form, color, and texture that made the food seem touchable and engaging. Nir further explained: "My idea was to feature and reflect the synergy between food, architecture, design and fashion . . . I created the pattern's effect, the food sculptures symbolized architecture, and the food on plates represented the dining."

4.13
Frames from "Heat As Directed," a large-scale video installation by Nir Adar. Commissioned by Adam Tihany for his "Dining Design" show at the Salone Internazionale del Mobile in Milan. Courtesy of KSK Studios and Dyske Suematsu.

4.14
A dynamic media installation at
Goldman Sachs' Learning Center.
Courtesy of Unified Field, Inc.

educational installations

In recent years, motion graphics have played a significant role in interactive educational installations. For example, multidimensional forms and patterns move and change in size and color on several giant screens in response to people's traffic patterns in Goldman Sachs' new Learning Center in New York City. Unified Field developed a dynamic media installation that uses an advanced 4D visualization program and Intelligent Recognition Inference System (I.R.I.S.) to simulate the patterns and fluctuations in which twenty-first century market environments, like Goldman Sachs, operate. Data on the history of the stocks in the world's capital markets is layered with information, such as days of the week and historical events, giving visitors a visceral experience and inviting them to extrapolate their own conclusions on the markets. As a leader in global investment banking, Goldman Sachs wanted to evoke an inspirational learning environment while communicating their commitment to building skills, transforming attitudes, and encouraging new thought and behavioral patterns. This complex installation used Unified Field's 4D visualization software on an SGI supercomputer and Windows NT server. Four curved, frosted panels and a 42" plasma screen are mounted on four wing-shaped aluminum poles. Ten feet in front of the panels and embedded in the ceiling is a tracking video camera that monitors the motion of viewers and interfaces with a high-speed image processing board containing gesture recognition software (**4.14**).

In the atrium of New Jersey's Liberty Science Center is an exhibition entitled "Vital Signs," which features an interactive, streaming media centerpiece that disseminates breaking news about our planet and the museum's themes of environment, health and invention. A mystical, wraparound display of LED screens is interspersed with projections of 3D forms and interpretive text that move in space to produce a poetic and engaging blend of science, technology, and art. The installation delivers a rich sense of timelessness that inspires observation and inquiry by allowing visitors to select topics, upload information, and view streaming content from all sides of the atrium. Unified Field envisioned this "as a node in a knowledge network, where data from internal and external sources feed multidimensional representations to make the intangible visceral, while powerfully illustrating the ever-changing nature of science and technology." These "sculptural media" elements were designed to function as part of a digital narrowcast

network, a digital sign system, a messaging system, and interactive exhibits. Visible from every location in the museum, they effectively alert and inform visitors of the presence and wonder of science (**4.15**).

4.15
"Vital Signs," a media installation at the Liberty Science Center. Courtesy of Unified Field, Inc.

retail environments

In retail spaces, immersive environments can create genuine, emotional branding experiences by putting guests into new intuitive and exotic worlds. An example of this is the HBO Shop in HBO's New York headquarters in Manhattan. A combination of large-scale installation, and motion graphics transform the store into an architectural canvas onto which large-format video projections, choreographed lighting, and audio work together to create a unique visual experience (**4.16**). The Los Angeles design agency Imaginary Forces collaborated with the architectural/design firm Gensler to transform this 750' retail space into an immersive, animated interior and exterior design that features HBO's award-winning programming. From the outside, four parallel, large-format video displays appear to recede into an open, deep space from the storefront window to the back, leaving a lasting impression on nearby pedestrians. The store is encased in acid-etched, white glass walls that serve as a projection surface and soak up the changing colors of overhead lights. The LED screens, which appear to be suspended in mid-air, attract the attention of shoppers and entice them into entering the store. Inside the store, they are treated to themed

environments that continually change, as the merchandise plays a secondary, supporting role. Behind the main displays are three high-resolution 65" plasma screens in portrait mode. In addition to the storefront displays, a 33'-long LED ribbon display is set back into the wall about 1½' to create an inlet that acts as a backdrop for props from the shows. The continuous animation displayed draws shoppers toward the back of the store. Further, two ceiling-mounted projectors throw 6'-high × 8'-wide video imagery onto facing walls. Lighting was given strong consideration to make the store's 14' walls change color. (For example, when the displays feature scenes from *The Sopranos*, the walls would turn blood red.) Lighting designer Michael Castelli and the design team experimented with various lighting fixtures to see how different types of glass would absorb colored light and chose back-painted glass with an acid-etched surface that allowed for extreme color saturation to emulate the look of a high-resolution monitor.

4.16
As a clever marketing tool, the HBO Shop's audio, lighting, projection, LED, and plasma displays create multimedia-driven immersive environments for its shoppers. The content it displays is designed to lead shoppers to the store's checkout area.

Interactive Architecture dot Org is a weblog about the emerging practice within architecture that aims to merge the digital virtual with tangible and physical spatial experience.

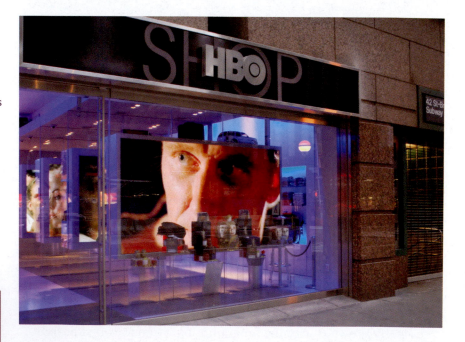

It seems likely that, as technology continues to advance, motion graphic designers will have more creative opportunities to play a greater role in designing the content for these types of public spaces.

Animated Exteriors

Today, motion graphics are playing a much greater role in shaping our architectural, urban landscape, due to the rapid advancement of LED technology. Integrated software/hardware systems can stream and scale live video content from various media sources, including servers, DVD players, camcorders, and computers, to accommodate large-scale architectural installations.

Chanel Tokyo is a 10-story building in the Ginza district of the Japanese capitol that was designed in 2004 by Peter Marino Architect, an internationally acclaimed architectural firm based in New York City. Part retail store and part giant electronic billboard, the building's light metallic edifice is covered with 700,000 computer-controlled LED units that are capable of flashing messages or patterns that adjust to the store's changing image. Additionally, they can be programmed to emulate a giant swatch of Chanel's tweed fabric or display video from Chanel's fashion show. The building's facade also served as a screen for photographer Michal Rovner's video installation entitled "Tweed, Tokyo," which captured the perpetual movements of pedestrians outside the stores from a bird's-eye view (4.17).

The building at 745 Seventh Avenue, in New York City, offers another compelling example of the growing symbiotic relationship between large-scale motion graphics and architecture. Three sides of the building are wrapped with distinctive 7'-high by 133'-long LED display bands, accentuated by a 40'-high video monolith positioned at the building's west entrance. Advanced engineering, state-of-the-art technology, and innovative, artistic vision makes this building a showpiece for combining aesthetic form with practical function (**4.18**).

Because conventional, high-resolution video screens are often impractical due to their cost, low-resolution video grid systems are becoming more popular and affordable solutions to large-scale installations and architectural projects. An excellent example of how low-resolution video can be applied to a surface is a massive, 11,700 sq. ft. video screen that wraps around Aspire Tower, the tallest building in Doha, Qatar (**4.19**). Color Kinetics, a leading innovator in LED lighting, completed the unique, suspended video display that curves with the tower's architectural design. The facade's cylindrical screen was constructed from a wire mesh composed of approximately 156,500 nodes of light.

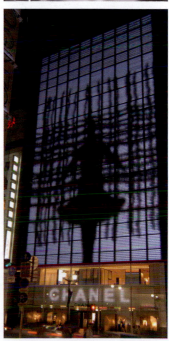

4.17
Chanel Tokyo building in Tokyo, Japan. Artist: Michal Rovner; Photographer: Takashi Orii; Architect: Peter Marino.

The company's custom-engineered Chromasic® microchip allows each node to function as a programmable pixel unit. Live coverage of the Asian Games was fed directly to the nodes through an integrated software/hardware system to project the images. The building's facade served as a real-time medium for sharing broadcast coverage of the 2006 Asian Games and has provided the public with a dynamic canvas for future video content.

4.18
745 Seventh Ave, New York City.
Photo courtesy of Daktronics, Inc.

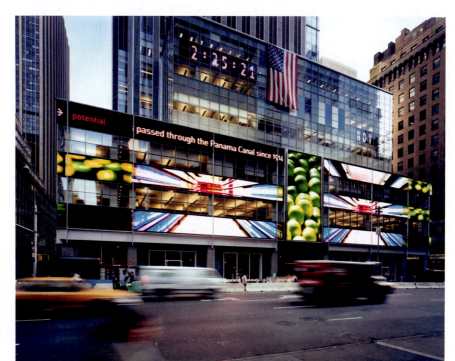

4.19
An intelligent LED lighting system by Color Kinetics forms an 11,700 sq. ft. video screen that wraps around Aspire Tower in Doha, Qatar. Photo credit: Lumasense. Courtesy of Color Kinetics.

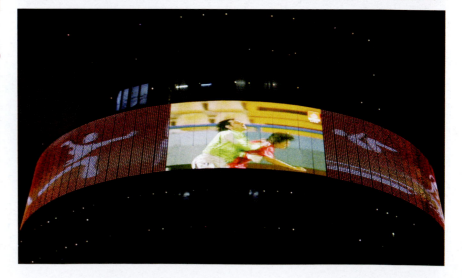

The Yoshikawa Building served as a perfect canvas for Japan's stunning installation that installed strands containing thousands of controllable, thimble-sized LED nodes behind an exterior glass wall running vertically from the 3rd to the 10th floor (**4.20**). Color Kinetics' highly developed control system (Light System Manager) was able to showcase customized light show animations that were built in Adobe Flash. Onlookers were mesmerized by the building's holiday theme show of light as artistic expression. Animations included swirls of changing colors, geometric shapes, and rushes of color climbing up the facade.

The intricate, animated patterns on the tower of Harrah's Atlantic City Resort & Casino are generated from 4,100' of anodized aluminum bands of programmable LED lights that wrap around each level of the building. A wide variety of animated effects include color wipes, sunbursts, and large simulations of simple graphic shapes. According to Dave Jonas, president of Harrah's, the lighting effects "have forever changed the skyline of Atlantic City" (**4.21**).

4.20
Yoshikawa Building, Tokyo. Photo credit: Nacasa & Partners. Courtesy of Color Kinetics Japan.

4.21
An intelligent LED lighting system by Color Kinetics creates a dynamic, animated facade for Harrah's Atlantic City Resort & Casino. Photo credit: Stone Mountain Lighting Group. Courtesy of Color Kinetics.

Located next to Milan's famous il Duomo cathedral is La Rinascente, Italy's largest department store, known for its stylish clothing and world-renowned former employee/designer, Giorgio Armani. Its theme, "Shopping Requires Inspiration," is expressed through its sophisticated interior design and dazzling window displays. Recently, the building's facade was transformed to a dazzling series of intricate design effects and patterns of light to create a unique and embracing entrance that would inspire Milan residents and visitors to shop. Cibic & Partners' exterior lighting scheme used Color Kinetics' 12,000 flexible LED strands that were installed across two exterior walls of the

building. The nodes were spaced in 12" increments, and each could be individually controlled to generate logos and images. Panels of frosted glass were mounted over the installation to diffuse and magnify the appearance of each node (**4.22**).

4.22
An intelligent LED lighting system allows individually controllable points of light to form a unique window display for high-end department store La Rinascente in Milan, Italy. Photo credit: Piero Comparotto, Arkilux.

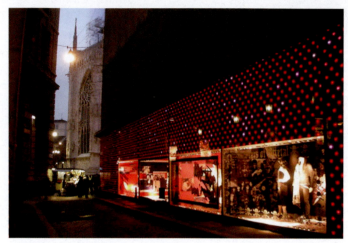

Digital Signage

Digital signage—one of the fastest growing marketing opportunities in the world today—ranges from sports scoreboards to giant video screens in large public spaces such as shopping malls. As a "real-time" messaging medium, it is used to present many forms of content over high-speed networks to video displays in public venues. Interactive digital signage solutions, such as touch-screen kiosks, can deliver dynamic, timely messages that can impart information or influence consumer behavior. In advertising, its marketing content can be crafted based upon specific information that consumers provide or from the purchases that they make. *Dynamic digital signage*—typically composed of a server, a monitor, and software—is emerging as a new generation of sign technology in the advertising industry. It is capable of delivering dynamic visual content to multiple locations, meaning that advertisers can communicate a brand or message locally or around the world to employees and customers from a central location (**4.23**).

In response to the demands of advertisers to reach more audiences, and to the decline of prices in LCD, plasma, and projector displays, the need for digital signage has accelerated. Wal-Mart, The Gap, and Foot Locker have already adapted dynamic digital signage technology to

NASDAQ, the largest U.S. electronic stock market, displays the action on Wall Street by displaying the colorful company logos of its 5,600 securities, as well as live video, news broadcasts, global market information, and advertising on the MarketSite Tower, the 8-story-high video screen located in the heart of Times Square.

promote their brands nationwide. In 2006, a partnership between Latin America's most dominant companies, Grupo Televisa and Wal-Mart de Mexico (or "Wal-Mex"), launched an in-store media network covering Wal-Mex stores across Mexico. More than 5,000 LCD displays and touchscreen kiosks have enhanced the store's appeal to shoppers and have assisted them in making purchasing decisions. Shopping malls have also adopted digital signage technology as a strategy to keep consumers informed, entertained, and more likely to buy. The Adspace Mall Network—the largest network of mall-based digital displays in the U.S.—consists of 8-foot-tall "smart screens" that feature "Today's Top Ten" specials, events, and commercials. Further, the use of digital signage at airports and museums has also become more extensive.

Digital Art Spots (DASs) are a core component of the Business Sponsored Art Program™ developed by the company Billijam (**4.24**). They are original digital artworks that are sponsored by advertisers to support their brand by displaying their logo or tagline, which provides the advertisers with PR buzz and public attention of pedestrians. These artworks can be commissioned for in-store displays, shopping mall displays, digital billboards, digital street networks, or large-scale content (e.g., billboards, wallscapes, spectaculars, street media and transit media). During August through September, 2005, Clear Channel and Billijam partnered to bring DAS to the streets of Manhattan through its digital display network. Businesses could sponsor original artwork to be displayed on eighty LED video screens that were strategically placed at the entrances of major subway stations throughout the city.

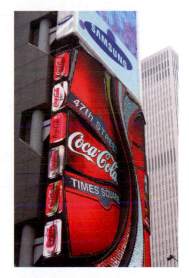

4.23
Coca-Cola display in Times Square, New York City. Courtesy of Daktronics Inc.

4.24
A Digital Art Spot from New York City's Business Sponsored Art Program™. Courtesy of Billijam.

Performance

The integration of motion graphics into live performances, including musical concerts, ceremonies, and awards shows, has increased substantially over the past decade. As staging becomes more extravagant, the prospects of giant illuminated video screens and elaborate lighting facilities call for new methods of choreographing data to synchronize with the changing scenery or music being performed.

In a performance of Blue Man Group at a custom-designed, 1,800-seat theater at The Venetian Resort Hotel and Casino in Las Vegas, Nevada, a matrix consisting of LED displays gave audiences a dynamic, multisensory performance that merged artistic expression with technology.

Accompanying a rectangular video display that hung in the center of the stage were five circuit board displays mounted on different levels of the stage. The performers could access the levels by running up a spiral staircase behind each platform. When lit, they not only convey video content of text and images, but also provide s a light source to backlight the performers with different colors and act as a palette to change the mood of the set (**4.25**).

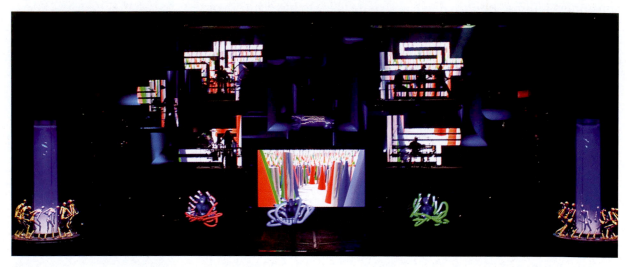

4.25
Blue Man Group performance at The Venetian in Las Vegas, Nevada. Photo courtesy of Daktronics, Inc.

4.26
Blip Festival. Photo courtesy of Element Labs.

Each year, the Blip Festival celebrates the work of international artists who are exploring the musical potential of low-bit technology. Element Labs designed a series of fluctuating and abstracted geometric patterns to accompany the rhythmic melodies of "small sounds at large scales pushed to the limit at high volumes" produced by ancient Nintendo and Atari videogame consoles, Game Boys, Sega hardware, and Commodore computers (**4.26**).

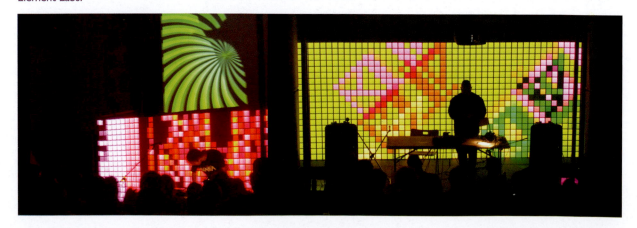

Alternate Spaces

Motion graphics have become an increasing entity in virtual spaces that were made possible by computer technologies during the 1990s. Virtual Reality (VR) technology—which allowed viewers to enter into a dimension that was set apart from their immediate physical space—dissolved the boundary of the frame, allowing designers to break away from familiar compositional devices. The full potential of motion graphics in today's immersive virtual spaces remains to be realized.

The potential of motion graphics in today's *augmented space* (or *augmented reality*)—physical space that is amplified with electronic and visual information (e.g., static images, typography, animation, and live-action content)— seems even more promising. Many of the scenarios discussed in this chapter, including exhibit designs, museum installations, video wall architecture, and animated interiors and exteriors, are all examples of augmented space.

Larger and flatter video displays, 3D technologies, and network technologies are actively entering our immediate, physical world, presenting us with kinetic and context-specific information that can change at any time. Video surveillance technologies, which are becoming ubiquitous, can deliver and extract data (for example, a user's interests and work patterns) to and from a physical space. AR glasses can layer content over our own visual field. On a much smaller level, "cell space" can hold customizable data that can aid users in checking in at a hotel or in retrieving information about a particular product in a store. Unlike virtual reality, which removes the content being presented from real life, augmented reality re-appropriates physical space through media. This enables us to acquire information in much more engaging ways and increase social connections and self-expression in public spaces. For example, *RhythmFlow* is a collaborative, video-based system that encourages new interpretations of ways of re-adapting to public spaces through body movement. Created by Karl Channell, a digital media and motion graphic designer, this reactive projection system was framed to visualize people's rhythms in public dance recreation culture. Since dance typically exists in an open space, unconstrained by walls, the design of this system adapts to the idea of "fat free" design, reducing elements down to their essence and focusing on human-centered approaches to problem solving. A video projector is mounted from above and is projected downwards onto a dance circle

4.27
RhythmFlow, by Karl Channell.

(**4.27**). Infrared lights that are projected downward onto the circle are reflected back to an infrared sensitive camera that detects and follows the dancer's changing shadows. As a result, the history of the dancer's movements leaves trails of painted pixels behind. Fast movements produce thin lines, while slower ones leave thick blotches remnant of a pen being held to paper. As lines cross paths, they react by changing colors and causing the pixels to become more energized or agitated. As the drawings of older patterns fade away, new patterns are drawn simultaneously. The style of the visuals can be altered, depending on which system the user selects. According to Karl, "The focus remains on the dancers, but with a layer of virtual content and expressiveness on top of them and their surrounding dance territory."

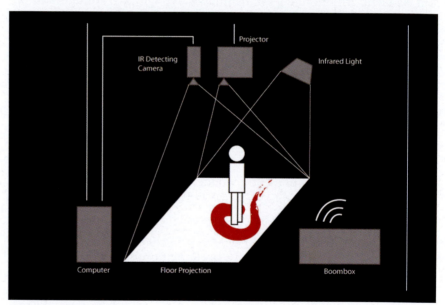

Summary

The potential of motion graphics in our physical world has been realized and is helping to shape the landscape of environmental design.

New digital technologies are playing a greater role in shaping this visual, public landscape. Video wall systems, which can display very large images without compromising screen resolution, are thriving throughout the world in almost every arena, including trade shows, showrooms, nightclubs, retail stores, restaurants, and sports arenas. New display technologies have used light to transform public spaces,

build brands, and invoke imagination by allowing motion graphics to become a physical part of our environment. Light Emitting Diodes (LEDs) have increasingly become the choice of architects and environmental designers who are transforming environments with "intelligent light." Unlike traditional LCD or plasma displays, LED displays can be built to any size and aspect ratio to allow customized geometric configurations. These displays are visible in front windows, since they are bright enough to compete with sunlight, and can be viewed from distances less than 3 feet.

Motion graphics in interior spaces have become a vital component in setting mood and atmosphere. In corporate lobbies or waiting rooms, for example, they can be used to reinforce a brand, change content to support various messages, and define an ambiance that might be unattainable with other mediums, while maintaining the design integrity of the space. In retail and event spaces, they can add a unique dimension to the space, provide drama in entranceways, and attract outside traffic by presenting the content in display windows. Casinos, restaurants, and hotels have also used motion graphics to stimulate guest interaction and provide unique content as a substitute to mundane television programming.

Immersive environments are designed to blend physical and imaginary worlds in which moving images, text, and audio can respond to humans. The artistic and expressive qualities of motion are appearing more frequently in exhibit designs, retail spaces, and art installations, as well as in complex public environments such as airports and theme parks. Additionally, they are playing a greater role in accommodating large-scale architectural installations and digital signage systems, which are capable of delivering content to multiple locations.

The integration of motion graphics into live performance increased substantially over the past decade. As staging becomes more extravagant, the prospects of giant illuminated video screens and elaborate lighting facilities call for new methods of choreographing data to synchronize with the changing scenery or music being performed.

Although the full potential of motion graphics in today's immersive virtual spaces remains to be realized, their potential in today's augmented environments seems even more promising.

PART 2

pictorial and sequential design

:Motion Montage Prototype 1" © 2007 Jon Krasner

motion literacy
choreographing movement

As a powerful storytelling device, motion can be choreographed to impart knowledge, communicate information, convey emotions, and express pure aesthetic beauty.

Early twentieth-century pioneers of experimental animation have proved that even with the most simple, mundane shapes and images, motion can deliver compelling and meaningful messages. Today, graphic designers highly regard motion as the most fundamental component of their work.

"The ability to deconstruct a movement and reassemble it in a new or convincing way is the animator's territory. Many artists have realized their visions using animation as a means to externalize their inner thoughts and unique points of view. Animation gives the viewer the opportunity to gaze at a frozen moment of thought and to experience another person's rhythms."
—*Christine Panushka*

"All of a sudden it hit me—if there was such a thing as composing music, there could be such a thing as composing motion. After all, if there are melodic figures, why can't there be figures of motion?"
—Len Lye

00:00:00:05

The Language of Motion

Motion is a universal language. In motion graphics, it can have more impact than the actual content being animated. The method that you choose to move an element across the screen can enhance its meaning. For example, a line of text that animates slowly across the frame while fading up from black might imbue it with a sense of mystery and calmness. If the same text flips over and then whizzes across the screen, it may express a sense of playfulness, urgency, or perhaps, instability. The motion itself can be the message.

Motion linguistics can be traced back to the early days of character animation, experimental abstract film, and avant-garde cinema. Today, motion literacy is one of the most fundamental storytelling devices in motion graphic design.

Motion Literacy

By Jan Kubasiewicz, in: The Education of a Graphic Designer; *edited by Steven Heller; 2nd Edition.*

Since motion is a constant in everyday life, then isn't motion integral to design? Of course Motion has already been explored within different disciplines of art and science, but with the easy accessibility of kinetic tools, motion and communication design are more than ever integrated into one discipline. And since designers are becoming more concerned with injecting motion into their work, motion literacy—the act of trying to understand how motion can be used to communicate more effectively—is essential.

From a technical viewpoint, making type, an illustration, or a diagram move on a screen is a relatively easy task. However, achieving clarity of communication through the language of motion proved more challenging for many designers than achieving fluency in kinetic tools.

Communicating via motion involves issues of both "what" is moving across the screen—typographical, pictorial, or abstract elements—and "how" that something is moving.

The "how" question refers to the kinetic form and its grammar, defined by both space and time dimensions of motion such as velocity and amplitude. Kinetic form itself may convey a broad spectrum of notions and emotions: from a sensible gesture, through a dramatic tension, to a violent collision. Of course, motion in combination with pictures and words (and sound, if available) multiplies those irresistible opportunities in making meaning.

The meaning of motion on a screen, similar to all other aspects of communication design, relies on conventions and artistic techniques. A cross-fade of two scenes conveying a lapse of time, or a split screen meaning simultaneous happenings, are just two examples adopted from the cinematic vocabulary—the source of inspiration for motion designers. The language of cinema in its century-old history evolved into

a complex, universal system of communication, combining the visual, sonic, and kinetic aspects into a synchronized, multi-sensory experience, and that language now becomes a new realm of communication design.

While perceiving visual/sonic/kinetic information simultaneously through multiple channels and over a period of time, the mind attempts to organize these discrete messages into a story, however abstract that story might be. A story must have its beginning, middle and end, but a story does not necessarily need to be told in this order. Therefore, the designer's awareness of different timelines—the one of the story and another one of the storytelling—is essential. Equally essential is the designer's awareness of the "plasticity" of time, and consequently, the designer's ability of manipulating time—real time, its representation, and perception—through motion, sequentiality, and multiple-channel correspondence (multimediality). Time, as intertwined with motion, becomes the structural design element, as well as the subject of design.

One of the most spectacular historical examples of the design process for a multimedia structure is a post-production diagrammatic storyboard for *Alexander Nevsky*, a 1938 film by Sergei Eisentstein, a Russian film director and one of the first theorists of the medium. That storyboard is a timeline in which visual representation of the film components are precisely synchronized into a sequence of "audio-visual correspondences" including film shots, music score, a "diagram of pictorial composition," and a "diagram of movement." The "diagram of movement" represents specifically the camera work resulting in on-screen motion. Choreographed very precisely, in fact to a fraction of a musical measure, this "diagram of movement" attests to how essential on-screen motion and its

meaningful integration with all other elements of his vocabulary was for the cinematographer. The same challenge of integrating motion as a meaningful component of communication design should remain the focus of research and practice for contemporary designers.

Currently, the integration of motion and typography is perhaps the most extensively exhibited practice of motion design. Kinetic logos and taglines very successfully "scream" their brand names and services, even from the muted TV screens. But a great potential of type in motion is not limited to TV commercials and film titles. Adding motion and time dimensions to typography is to add new possibilities to the imaging of verbal language. Kinetic typography complements traditional typography by exploring "real-time" visualization in a spirit of phonetic properties of spoken language, such as spontaneity, intonation, etc. The dynamic visualization of these properties, possibly codified at some point and customizable, would promote the user's personal preference of on-screen, typographical "behavior" of words and lines in such cases as closed captioning, for instance.

The concept of the kinetic "behavior" of an on-screen design object—such as typography, an illustration, or a diagram—especially the behavior triggered interactively by a user, is one of the central issues of motion literacy. For a user, such kinetic behavior may be perceived as a dynamic transformation of some spatial properties of the initial object, which occurred as a result of pointing, dragging or clicking. For a designer to design a kinetic behavior means to define a matrix of specific dynamic parameters of transformation of that object mapped to specific variables of input. Injecting motion into interactive design means entering the environment of algorithmic thinking, and that is why

suddenly the language describing it became very technical.

Integration of motion with information graphics has a tremendous potential of contributing, through interactive visualizations, to various disciplines of science, economy and education. Dynamic diagrams, charts, and timelines seem to be the only practical solutions for understanding complexity of large-scale information structures. However, translating complexity of data into clarity of visual information will not be easy on designers, since increasingly sophisticated computational imaging requires new conventions and strategies for dynamic visualization, and very often, the solutions adopted from traditional information design do not work successfully in interactive environment.

Interacting with complex data within hypertext structure is a special kind of motion involving the concept of multiple representation of information—dynamically linked text, image, audio, video, etc. Multiple representation of information is the real advantage for the user and a challenge for the designer, since in the context of interactive media, information is not fixed, but fluid. According to Lev Manovich,

it is "... something that can exist in different, potentially infinite versions." Therefore, interaction is supposed to give the user a sense of the unique process of walking a personal path through databases to the most appropriate form of content delivery, according to the user's own individual preference or special needs. And since this unique path to knowledge is a result of action and reaction, a stimulus-response loop repeated ad infinitum, designers must always ask themselves how much motion is appropriate to their audience, to the content, and context. After all, motion is not the purpose for its own sake but a way of serving the purpose of communication, and since design requires equilibrium of nonmotion and motion, absence of motion is just a case of potential motion. And yes, motion is integral to design.

Jan Kubasiewicz is a professor of graphic design at the Massachusetts College of Art (massart. edu), Dynamic Media Institute (dmiboston.org).

Spatial Considerations

Spatial considerations, such as the positioning, size, and orientation of elements, the direction that they travel, the manner in which their motions influenced other motions, and the relationship of their movements to the boundaries of the frame, are all important factors that should be considered when choreographing animation. Additionally, the device of frame mobility, created by physical or simulated camera movement, can determine how space is viewed and interpreted in a digital environment.

spatial transformations

Spatial transformations describe the conditions of elements with regard to their positioning, orientation, size, and relative scale inside the frame. These factors play a considerable role in determining how their movements affect the space they "live" in.

Animating an object's position (a process that is also referred to as *translation*) involves moving it along a predetermined horizontal (x) and vertical (y) axis in a 2D environment and an x, y, and z axis in a 3D environment. Rotation involves changing the angle that the object faces around a central point of origin. A wider circumference of rotation results when the anchor point is moved away from its center of origin (**5.2**). In **figure 5.3**, an anchor point's positioning on an object's corner allows the object to rotate specifically from that point, like a robot arm.

5.1

Animating an object's position involves moving it along a horizontal (x) or vertical (y) axis in a 2D environment and an x, y, and z axis in a 3D environment.

5.2

A wider circumference of rotation results when the anchor point is moved away from the object's center of origin.

5.3

Positioning the anchor point on an object's corner allows it to rotate from the corner.

In a dynamic typography assignment at Fitchburg State College, students applied this principle to achieve several types of mechanical types of rotations. In **figure 5.4**, for example, the letter "T" was rotated 90º from its base to create a vertical plane that pushes the remaining letters off of the screen. In **figure 5.5**, each letter's point of origin of rotation was moved to the left or right edge, allowing it to open like a hinge. Scaling involves resizing an object uniformly to maintain its horizontal and vertical proportions. Nonuniform scaling results in horizontal or vertical distortion (**5.6**).

5.4
above: Frames from a dynamic typography assignment by Brian Adair. Fitchburg State College, Professor Jon Krasner.

5.5
below: Frames from a dynamic typography assignment by Carolyn Kosinski. Fitchburg State College, Professor Jon Krasner.

These types of spatial transformations can be combined, allowing you to animate an element's position, scale, and rotation properties simultaneously. At the Ringling School of Art and Design, Cielomar Cuevas choreographed several rotations of an identity to be followed by individual rotations of the parts closing in to form a single unit, similar to the manner in which the blades of a Swiss army knife would fold in. The letterforms "tbs" then animate in vertically from the top edge of the frame to conclude the logo (**5.7**).

direction

The direction or "route" that elements travel is also an important consideration with regard to how movements will occur across the frame. There are two types of directions that elements can move— *linear* and *nonlinear*— in a straight line or on a curve. Mechanical

5.6
Uniform scaling maintains tyhe original proportions, while nonuniform scaling results in horizontal or vertical distortion.

5.7
Frames from an assignment entitled "Branding Gymnastics" by Cielomar Cuevas. Ringling School of Art and Design, Professor Eddy Roberts.

objects, such as pendulums and wind-up toys, travel in predictable, linear directions. On the other hand, living subjects and phenomena that are affected by natural forces, such as tree branches, water, and grass being affected by the wind, behave and move in unpredictable, erratic ways. They can also change their spatial orientation as they travel. For example, a kite flying through the sky may change the direction it faces in response to alterations in air current.

motion paths

Motion paths are one of the most powerful devices that allow you to specify the course of travel that elements take over a given time interval. They are represented as straight lines, curves, or a combination of lines and curves. Both linear and curved paths can be modified to control the direction that objects travel in a composition.

arcs

With the exception of mechanical devices, most actions travel in *arcs*—slightly circular paths. Because the human body is composed of many rotational joints that allow the limbs to rotate freely, a natural walk cycle shows a figure moving up, down, and forward to create an arc in space. Gravity is also accountable for this. When we move forward, our bodies are pushed down by gravity, creating a slight arc in our direction of travel. This animation principle can be used to support the quality of physical realism in accordance with the laws of gravity and inertia.

frame mobility

The study of movement is not just confined to how elements travel inside the frame; it also involves the *perceived* motion of the viewer with regard to how the content is framed over time. Frame mobility, which

5.8
Frames from a kinetic typography assignment. Courtesy of Nicole Mercado, Fitchburg State College, Professor Jon Krasner.

The smaller letter follows the direction of a curved motion path to create the effect of traveling along the route of the larger letter.

Historical Perspective

After World War I, French Impressionist filmmakers developed innovative ways of portraying psychological states of mind through mobile framing. These included using awkward camera movements to depict characters in drunken or ill states. They even went as far as fastening their cameras to moving vehicles, amusement park rides, and machines that could move through space. Surrealist and Dada filmmakers also experimented with experimental camera techniques to emphasize abstraction and create shock value. The camera's positioning would often change to provide a new outlook on subsequent portrayals of a subject to intensify the audience's curiosity. During the late 1950s, bumpy camera movement became a common practice in documentary filmmaking. In the movie *Vertigo*, Alfred Hitchcock popularized what is known as the vertigo shot, which involved synchronizing the movement of the subject with a zoom. As a result, the subject stays the same size, but the background changes.

5.9
Dziga Vertov's film *Man with the Movie Camera* (1929) features a full spectrum of creative possibilities in camera motion to transform reality and traditional narrative cinema.

is achieved through *actual camera movement* or *simulated camera movement,* can breathe life into scenes and achieve various compositional framings.

When used judiciously, the basic types of camera movements described here can be combined in an endless variety of ways to alter an audience's mood and perception of space.

One of the most common camera techniques is *panning,* which involves moving the camera horizontally to create the impression of a subject being scanned. A slow pan of a panoramic scene can approximate the motion of moving one's head from side to side to take in the view. A *whip pan* (also referred to as a *flick pan, zip pan* or *swish pan*) is an extremely brisk side-to-side movement that produces the effect of blurred, horizontal motion. This simulates the action of the human eye abruptly moving from one subject to another. (Whip pans were commonly used in action genres such as kung-fu movies during the 1970s.) *Tilting* produces the effect of scanning a subject or space vertically from top to bottom or vice versa. It can enhance the subject's height and depth by showing small increments of it at a time. A long, slow tilt in an upward direction can express the sheer bulk of a subject. Tilting can also be used to change the angle of framing or to gradually reveal offscreen space. This can produce suspense or anticipation as the camera's motion forces our attention in a precise direction without knowing when it will cease and what will be revealed. *Tracking* (also referred to as *dollying*) involves changing the camera's position in relation to the subject so that it travels forwards, backwards,

diagonally, circular, or from side-to-side in the frame. This action can bring viewers physically closer to or further away from a subject or make subjects appear as though they are being followed. The movement of foreground and background past the periphery of a shot can create a sense of tension or excitement. *Crane shots*, such as helicopter and airplane shots, allow the camera to travel up and down. *Zooming* increases or decreases the camera's field of view, magnifying a portion of the scene without moving the camera. (Zooming is fundamentally different from camera movement, because the optical properties of the lens change subtly.)

"I am kino-eye, I am mechanical eye, I, a machine, show you the world as only I can see it."
—*Dziga Vertov*

 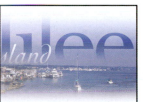

5.10
In this combination of live-action and kinetic type sequence, panning is used to emphasize the sheer vastness of the scene and the grandeur of the type.

Mimicking natural head and eye movements can involve an audience, giving them a sense of motion through space as if they are physically transformed from their world into the one displayed on the screen. At Rochester Institute of Technology, Kim Miller brings us on a visual journey in an assignment involving the creation of a personal, abstract video diary. A combination of zooms, tilts, and pans accompanied by graphic transitions contributes to the formal and emotional language of the piece, making us feel as if we are experiencing her inner world from a subjective point of view (**5.12**).

Figure 5.13 illustrates how incorporating the device of perspective into mobile framing can generate considerable tension and excitement. A series of trailers takes us on a dynamic, three-dimensional journey as if we were in a Sci-Fi action movie or on a Disney ride, twisting, turning,

5.11
Tilting is used to enhance the subject's height by showing small increments of it at a time.

5.12
Frames from a personal video diary, by Kim Miller, Rochester Institute of Technology, Professor Jason Arena.

5.13
Frames from a series of trailers. Courtesy of onedotzero.

and plummeting on various trajectories in a multidimensional world. In a worldwide television ad campaign for Hugo Boss Green, Jake Banks of Stardust Studios designed a series of advertisements introducing the new cologne for men. His blending of live-action and 3D animation allowed him to construct impossible environments that we can travel throughout as observers (**5.15**). **Figure 5.14** shows a different example of how frame mobility can be used to build intensity. Several sequences of camera movements showing various camera angles and spatial distances are linked together to take us on an adventurous, journey through a complex, three-dimensional environment where we can experience the multi-faceted nature of the television industry.

Mobile framing can influence how we perceive the movement of elements in space. The horizontal and vertical pivoting motions of panning and tilting, for example, can change the way we react to an image moving across the field of view.

Like music, mobile framing can have expressive qualities ranging from fluid (legato) to shaky (staccato). These qualities can generate visual patterns of motion that evolve and repeat over time to complement the rhythmic possibilities of music videos and other types of motion graphics compositions that embrace rhythm. An example of this is Fuel TV's show opening to *Cutmasters*, a television series where contestants race against the clock to edit the best video segment featuring action sports professionals. Combinations of zooms and pans varying in speed and direction emphasize the sporadic motions of elements. Additionally, the moves are organized incrementally in perfect

5.14
Frames from TVN Unwaga, a
German television network.
Courtesy of Velvet.

5.15
Frames from a TV campaign for
Hugo Boss Green. Courtesy of
Stardust Studios.

synchronization with the percussive, steady rhythm of the soundtrack
(**5.16**). Likewise, a series of zooms were choreographed to match the
beat of the music in a show package for ABC NEWS' *20/20* (**5.17**).

The device of frame mobility can be used to set a mood or arouse
emotional feelings to support a story's narrative structure. In the open-
ing to *Arte Metropolis*, a political evening program on Franco-German

5.16
Frames from the show open to
Cutmasters. Courtesy of Fuel TV.

culture, shaky camera movements enforce the concept of political entanglement and depict the show's disjointed, fragmentary nature. Disturbing, unstable camera motions, in coordination with juxtaposed camera angles, abrupt jump cuts, and tempo changes, were choreographed to accompany a wide range of body gestures that the actors play to symbolize their dual roles of puppets being pulled on strings and the masters who are pulling their strings (**5.18**). Similarly, the frenetic camera movements that are used in David Carson's music video for Nine Inch Nails support the fleeting, multilayered imagery to convey the energetic, rebellious nature of the soundtrack (**5.19**).

5.17
Frames from a show package for ABC NEWS' *20/20*. Courtesy of Nailgun*.

5.18
Frames from *Arte Metropolis*, a European culture magazine program. Courtesy of Velvet.

Camera movements can also express a person's or an object's subjective point of view, for example, Shilo's station identifications for AMC's twentieth anniversary. One particular vignette entitled "twenty years of scary movies" portrays an iconic scene from a horror movie into a graphic sequence shown from the first person narrative. The "camera's" implied viewpoint depicts a heart-stomping race in which we

run through a moon-lit cemetery and fall into the ditch, only to be met by an open coffin and its door slamming closed upon us. Another segment based on "killer thrillers" casts us into the role of a voyeur who suddenly realizes that he has been caught in the act (**5.20**). In a broadcast commercial for Le Tour de France, Digital Kitchen's use of camera movements and subjective camera angles make us feel as if we are a participant in the race (**5.21**).

On the other hand, frame mobility can be utilized from a purely aesthetic, formalist point of view with the objective of exploring new compositional possibilities or establishing mood. This may occur with or without consideration of the story's content and narrative structure. A story being expressed through camera movement may run concurrently to the story that is associated with the visual content.

Finally, frame mobility can be used as an alternative to editing in constructing the sequential composition as discussed in Chapter 12.

5.19
Frames from a music video for Nine Inch Nails' "The Fragile." Courtesy of David Carson.

5.20
Frames from station IDs for AMC's 20th anniversary. Courtesy of Shilo.

5.21
Frames from Le Tour De France. Courtesy of Digital Kitchen.

Temporal Considerations

time

Choreographing motion requires a fundamental understanding of how time is measured. Depending on if you are designing for film, video, or digital media, each format has its own standard for measuring time.

time standards in film and video

In film and video, time is described numerically as frames per second (fps). This *frame rate* describes the maximum speed that animations can play to create the illusion of continuous, believable motion.

Film has a frame rate of 24 fps, which, today, continues to be the standard for commercial motion pictures. In 1953, the National Television Standards Committee (NTSC) designated a frame rate of 29.97 fps for broadcast video in the United States. The EBU (European Broadcasting Union) standard is used throughout Europe and Australia, where color television systems are based on PAL and SECAM systems.

Video that is produced by SMPTE standards applies a drop-frame method in order to match the footage of NTSC time code. The first two frames are reassigned a number after every minute except for every tenth minute. For example, at 1:06:59:29 (one hour, six minutes, fifty-nine seconds on the twenty-ninth frame), the next frame will be 1:07:00:02.

In 1967, the U.S. Society of Motion Picture and Television Engineers (SMPTE) adopted a rate of 30 fps and introduced *timecode*, a method in which time is calculated in the form of an eight-digit, 24-hour clock consisting of 0 to 23 hours, 0 to 59 minutes, and 0 to 59 seconds. (For example, 00:02:23:15 means 0 hours, 2 minutes, 23 seconds, and 15 frames). Seconds are subdivided into frames, and the number of frames varies, depending upon the specified frame rate. Time code is often encoded onto videotape to enable precision in editing and in the synchronization of sound and image. This efficient system continues to be used today in identifying frames for video editing, enabling you to coordinate the timing of elements from different video sources.

The frame rates mentioned above are sufficient to achieve believable motion for film and animation, although frame-by-frame animations have been produced at much lower speeds (between 6 and 15 fps), though they usually contain less detail. However, if the frame rate is too slow, an animation can appear to be choppy. If the playback rate is set to a higher value than the rate that the original material was created or captured, frames will be duplicated, and a slow motion effect will result. If the playback rate is set to a lower value than the original speed, the result will be choppy, as frames will be skipped or dropped out.

time standards in digital media

Frame rates for multimedia (CD-ROM and DVD-ROM) and Web delivery can vary between 8 and 30 fps, due to technical factors associated with playback performance such as processing speed and storage requirements. Today, a frame rate of 12–15 fps usually yields adequate results over the Web, enabling smooth and consistent playback across all platforms.

velocity

Velocity is the speed in which elements move or change over time and space. This is a considerable determining factor in achieving dynamic, lifelike animation. Like direction, velocity can be linear or nonlinear.

linear velocity

If the velocity of an element's motion is linear, it proceeds at a steady, uniform rate. Devices such as clocks, CD players, gears, and electric fans are a few examples in which the rate of motion progresses at a consistent incremental pace. Although linear velocity does not lend itself to lifelike animation, it may be applicable to the subject matter or to your conceptual message.

Linear movement can be applied to motion graphics presentations that are intended to look fluid or mechanical. An example of this is Velvet's identification design for Kabel 1 News, one of Germany's most popular commercial television channels. The mechanical movements of the circular, ribbon-like structures that are layered at varying opacities appropriately reflect the corporate, clean atmosphere and soundtrack. The faster movements of the short vertical and horizontal lines that surround the logo complement the slower revolving motions of the larger structures (**5.22**). Another example is a series of motion tests that twenty2product created for Adobe's Expert Support trade show, which focused on Adobe's premium technical support services. Fluid, linear motions were used to express the synthetic nature of new digital technology and supported the look and feel of how Adobe's logo and titling could be animated in an orthographic space with a flattened perspective (**5.23**).

Linear velocity also works well with animations that involve objects that travel in linear directions on linear motion paths. If an element follows a complex path that changes direction dramatically, maintaining a constant rate of speed from one key frame to the next can be

> *Studies have shown that the human optical system can capture images 18–20 times per second. The higher frame rates of motion picture film and broadcast video were developed to provide a more convincing illusion of motion.*

5.22
Frames from a television
identification for Kabel I News.
Courtesy of Velvet.

5.23
Frames from motion tests for
Adobe's Expert Support trade
show. Courtesy of twenty-
2product. Copyright 2004 Adobe
Systems, all rights reserved.

challenging. In **figure 5.25**, the spatial distances between key frames on a motion path vary, due to the path's dramatic shift in direction. (This is also indicated in the distances between the key frames on the animation's timeline.) The dots along the path indicate that abrupt changes occur in the rate of speed over the element's course of travel.

nonlinear velocity

It is seldom that living things in the natural world move at a constant, linear pace. Natural movements of living things typically begin slowly, speed up, and slow down, unless an obstacle interrupts them. Human and animal motion, as well as motion caused by natural forces, is very erratic and unpredictable, involving acceleration and deceleration. Newton's laws of motion state that objects that have mass naturally accelerate as they move through space. It is highly unusual for things to start or stop instantaneously without acceleration or deceleration. Inexperienced animators may overlook this fact and produce motion that feels too "linear." In contrast, some of the most sophisticated animations contain subtle, less predictable changes in the way things move. The result is a more gradual, fluid-looking animation in which the content assumes a more dynamic, realistic persona.

5.24
The linear velocity of this element's motion occurs in steady time increments as indicated between the spatial distances between the dots along the motion path.

5.25
The dots along this motion path indicate that the rate of speed changes abruptly over the element's course of travel.

The motion profiles in **figure 5.28** illustrate how nonlinear velocity can vary. A straight line climbing upward or pointing down represents a sudden change from a static state to an active state (an abrupt acceleration) and an abrupt halt at the end of the motion. A curved motion profile, however, represents a more gradual, realistic transition in speed from start to finish.

Applying nonlinear movements to objects in animation requires careful analysis of living subjects and knowledge of how to apply your observations through analog or digital means.

In a television spot promoting the Brazilian bank, Banco Real, collections of colorful images are brought to life through the use of nonlinear movements. Groupings of nonrepresentational graphic shapes seem to mimic cellular organisms with lively, natural movements as they playfully spring up and down and dance around. At one point, a pair of wireframe shoes walk briskly across the screen, emulating the natural, erratic way that human feet would naturally walk (**5.27**).

5.26
Motion profiles of acceleration and deceleration. A straight line represents an abrupt change from a static state to an active state and an abrupt halt at the end of the motion. A curved line represents a gradual, realistic transition in speed from start to finish.

5.27
Frames from "Esteria," a TV spot promoting the Brazilian bank, Banco Real. Courtesy of The Ebeling Group.

altered velocity

Throughout the history of cinema, changing the speed of filmed events has been a powerful device in moving audiences. In Kurosawa's *Seven Samurai* (1954), for example, slow motion is used to contrast the emotional rescue of a child with the death of the man who kidnapped him. Dziga Vertov's film *Man with a Movie Camera* pushed the envelope of the optical printer's possibilities and utilized overcranking or undercranking to render sports events in slow motion. The invention of time-lapse cinematography allowed lengthy natural events (for example, the sun setting or a flower blooming) to be condensed into short sequences that may last seconds. High-speed cinematography has been used to slow down fast events, such as a sequence of ripples resulting from a water droplet or a bullet shattering a piece of glass.

In motion graphics, the techniques of slow and fast motion, reverse playback, and freeze-frame are effective for emphasizing and exaggerating actions. They also can support an underlying rhythm, contribute toward the mood, and alter our sense of objective and subjective time.

Introducing slow motion has the effect of interrupting a composition's flow, because it presents a close-up of time. Perceptually, it can provide a clearer view of the content, allowing us to appreciate subtle visual details. Because it violates the physical laws of gravity, motion is intensified, making the appearance of actions more powerful than normal. In **figure 5.28**, a promotional television spot for Al Jazeera Sport, a Middle Eastern network, exemplifies this powerful effect. METAphrenie,

an award-winning design firm in Berlin, Germany, integrated actual athletes into unique, dream-like visual landscapes. The spot depicts a duality between player and landscape, giving us a unique perspective into the "beautiful game." The playback velocity is slowed down to emphasize body movements and the dynamic impact of the player's actions. According to Andrea Dionisio, one of the company's founders: "Our strategy was to take sports and the athletes that play them, and isolate these two elements, stripping things down to the bare essentials."

Contrary to slow motion, fast motion yields a different aesthetic effect that seems to accelerate objects forward in time. Their movements are shown faster than normal, at times resulting in an erratic, jumpy appearance that is known to induce laughter or create drama. In the opening to *Arte Metropolis* (**5.18**), velocity changes occur in the introductory sequence featuring a pair of hands spinning an illuminated globe. Abrupt increments of accelerated motion are accompanied by echoes of whispers from the soundtrack, both of which contribute toward the program's theme of political entanglement. This effect is consistent with the wide range of body movements and gestures from the actors that occur throughout the composition. In a later sequence, a series of shots reveal various pairs of hands restlessly interacting with the strings from an implied ball of yarn. Their abrupt, accelerated movements further accentuate the effect of panic and anxiety (**5.29**).

Last, the technique of *freezeframe* can be used to show arrested motion or a pause in an object's movement, versus no motion. Like slow motion, it interrupts a composition's flow, presenting a close-up of time and providing a clearer view of the content's subtle details. This effect is exemplified in "In The Details," a captivating network ID that was created for Fuel TV. The illusion of a slow moving freeze frame creates a surreal, hyper reality in which events that would normally go unnoticed in the flash of an eye are emphasized. By combining static images and camera mobility, this effect tells a simple story of a skateboarder performing a trick on a flight of stairs. As the world slows down to a snail's pace, the resulting distortion of time allows us to hone in on the "Details" of the scene. We navigate through 3D space, taking in scenic details that would normally be ignored, including the reflection in the skateboarder's mask, a close-up of the sole of his sneaker, and his exhalation in the winter's cold evening air. This all magically occurs during the few seconds that his trick progresses (**5.30**).

5.28
Frames from various promotional television spots for Al Jazeera Sport, a Middle Eastern network. Courtesy of METAphrenie.

5.29
Frames from a show opening
for a themed political evening
program for the Franco-German
culture arte. Courtesy of Velvet.

Whether the effects of velocity change are created during capture or
creation, they can be applied to the motions of one or more elements,
entire animated sequences, and live-action content that contains real
movement. In a sting for DNACreative, a design studio in Dublin, Ire-
land, a synthesis of fast and slow motion, reverse playback, and
accelerated transitions is consistent with the somewhat disturbing, yet
hilarious, nature of the content (**5.31**).

5.30
Frames from "In The Details," a
network identification created
for Fuel TV. Produced by Shilo.
Courtesy of FUEL TV.

5.31
Frames from "Experience."
Courtesy of G'Raffe.

Coordinating Movement

basic animation principles

Understanding the linguistics of motion mandates an awareness of some of the earliest animation principles that were established back in the days of Disney. These have played a significant role in animation and can be applied to the realm of motion graphics. The concepts that are described here were derived from *The Illusion of Life* by Frank Thomas and Ollie Johnston.

squash and stretch

In the physical world, most natural objects deform as they move. For example, when a rubber ball hits the ground, it becomes temporarily squashed before propelling itself into the air while being stretched. When a figure crouches down, it appears to be squashed; when it leaps into the air, it looks stretched. Before diving off a cliff, a diver looks around, and as her arms swing up, her knees bend. As she springs up, her arms raise and her knees straighten to commence the action.

The technique of squash and stretch can help establish the physical basis of objects that have mass, giving their motions the illusion of weight and volume through distortion. This type of distortion can range from subtle to extreme. In traditional character animation, this principle has been useful for animating dialogue and for mimicking facial expressions by exaggerating the degree of squash and stretch. **Figures 5.32** and **5.33** illustrate how the principle of squash and stretch can be used to personify letterforms and breathe life into their actions.

Animator/Director Terry Gilliam's motion collages for Monty Python's Flying Circus were known for their quirky charm in their disjointed, jerky movements and combinations of ludicrous photographs of animal heads and bodies.

Hans Richter used slow and fast motion to present a fantasy version of time. In his Dadaist film, Ghosts Before Breakfast, he used fast motion to demonstrate a blossoming tree branch blooming. Story time, which might unfold over a matter of days, was reduced to a matter of seconds. In a scene with a tray of tea cups that come crashing to the ground, he slowed down the speed to intensify the impact of the shattering china. Additionally, Richter played parts of the film back in reverse. Shards of the teacups form back together, water goes back into a hose, and so forth. These tricks allowed him to take his viewers on a journey into the world of fantasy.

5.32
Frames from an assignment involving the personification of the student's first and last initials.

Principles of anticipation and squash and stretch were combined to convey natural, lifelike movements. Courtesy of Alex Wall, Fitchburg State College, Professor Jon Krasner.

5.33
Frames from an assignment involving the personification of the student's first and last initials.

Principles of squash and stretch were incorporated to breathe life into the action. Courtesy of Nicole Mayou, Fitchburg State College, Professor Jon Krasner.

anticipation

Most lifelike actions have an opposite preceding action. Before leaping off the floor, the dancer executes a backwards motion before moving forward. Before swinging a golf club, the golfer twists his body into a coil, bringing the club over his head. Before throwing a ball, a pitcher rears his arm back to allow his arm to throw with more force. In all these cases, the word "before" is key; it denotes the idea of pre-action or implied action. Anticipation creates a sense of natural movement while dictating to the viewer that an upcoming action is about to occur. A commercial for Asics footwear, advertising the Onitsuka line of shoes, illustrates the virtues of strength, agility, and speed in a segment where anticipation is applied to the snake just before it lunges at the main character (**5.34**).

follow through and overlapping

Follow through and overlapping actions enable the flow between actions to be carried smoothly. These subtle techniques can be used to make an element's motion more believable by adding a little detail.

Follow through involves the continuation of an action past its termination point. For example, when a woman swings her head, her hair continues moving after the main head movement ceases. In the case of a complex object that consists of different moving parts, each of

5.34
Frames from an animated commercial for Asics footwear advertising their Onitsuka Tiger™ brand of sports shoes. Courtesy of Belief.

those parts may move at different times and at different velocities in relation to the object's main mass. When an object's motion comes to an abrupt halt, the movements of its parts continue to catch up to the object's main mass. In character animation, for example, the hip region of a moving figure leads and is followed by the leg and then the foot. Lighter elements such as the arms, hair, tail, and parts of clothing also follow through with the main body's path of action.

Overlapping occurs when an element changes its direction when it is in motion, and its smaller parts assume the new direction of motion a few frames later. In the case where a complex object consists of multiple moving parts, slightly varying the timing and speed of those parts when the object's main mass changes direction maintains a continual flow between the actions, making the movements seem more natural.

Timing is critical to the effectiveness of follow through and overlapping action. If it is too slow, it may appear too obvious, making the primary action look awkward. If it is too fast, it may not be obvious enough.

pause
The pause can be a powerful communication tool when it is properly used. In jazz, pauses between riffs are often used as an important part of phrasing during improvisation. In grammar, commas are used to allow readers to pause between phrases, and semicolons are used to

allow them to compare two related ideas. In the natural world, a pause occurs when a person stops walking and changes direction. (This is like a semicolon in grammar, while a definite stop is like a period.) On a swing, there is approximately a half-second pause at the top of each arc. In animation, pauses can prevent movements from appearing too frenetic or mechanical, allowing viewers to catch their breath between actions. Further, they can create expectations and tension.

timing

In animation, timing involves choreographing how actions are spaced out according to the sizes and "personalities" of elements. Timing can affect how we perceive an object's size or mass. For example, a large object that moves at a slower pace than a small object may take more time to accelerate or decelerate. In frame-by-frame animation, timing is achieved by controlling the number of frames between motions. The more drawings there are, the slower and smoother the action will be. Fewer drawings produce faster and clearer movements.

Timing can also contribute toward mood or atmosphere. Fast movements typically produce snappy, energetic effects, while longer movements can feel more deliberate and dignified.

acceleration and deceleration

The principles of acceleration and deceleration, which were discussed earlier in this chapter, can help to soften lifelike movements, making them appear more natural.

In frame-by-frame animation, emulating natural movements may involve creating a large number of drawings near an object's starting pose, fewer drawings in the middle, and more drawings near the next pose. As the object approaches the middle pose, it begins to accelerate, and each calibrated distance it travels is further than the previous one. As an action begins, fewer drawings at the starting point and more drawings near the end of the action produces a sudden burst of acceleration, which gives way to a gradual slowing down toward the end. In digital interpolation animation, velocity changes that create the effect of acceleration and deceleration are established through key frames.

secondary action

Most movements in the physical world are the result of cause and effect. For example, when a basketball hits the rim of the backboard, the rim wobbles back and forth. Human figures typically swing their arms back

and forth while walking. These actions work together in support of one another. With this in mind, the secondary actions of the basketball rim and the swinging arms result directly from the primary or action.

In animation, secondary actions can be used to heighten interest or add realistic complexity by supplementing and reinforcing the primary action. Keep in mind that an object's secondary action should subordinate or compete with its primary action.

5.35
Frames from Marlboro Manufacturing's Web site introduction. ©
2007, Jon Krasner.

"Manufacturing" rotates from its left edge downward prior to accelerating upward to hit the word "Marlboro," creating an impact when knocking the letter "O" off the frame.

exaggeration

The origin of exaggeration as an animation concept lies at the heart of traditional figurative animation, where character movements and facial expressions are distorted to create a more lifelike appeal.

In rotoscoped graphics that are accurately traced from live footage, exaggeration can be used to make the movements appear less stiff and mechanical. Canadian animators Carol Beecher and Kevin Kurytnik employed the techniques of exaggeration to express "the uneasy coexistence between life and Mr. Death" in their award-winning figurative animation entitled *Mr. Reaper's Really Bad Morning*. This is apparent in the movements of the figures as they chase after their prey. Additionally, anticipation is evident in the movements of the animal prior to running and in the backward motion of the hunter preparing to throw his weapon (**5.37**).

5.36
Frames from a personification assignment, by David DiPinto, Fitchburg State College, Professor Jon Krasner.

The object's impact is established through acceleration. Movements are then carefully choreographed to emulate those of an inch worm slithering out of the frame.

Exaggeration can help communicate ideas more effectively while making the content enjoyable to watch. On the other hand, excessive use of this device can make actions appear too theatrical or contrived. Determining the degree of exaggeration to apply to movement relies on intuition, experimentation, and patience.

choreographing relative motion

No color stands alone; the way we perceive a color is affected by the presence of another color. Like color, motion is relative. Our perception of one motion can be influenced by the presence of a different motion in the same environment. With this in mind, combining and choreographing different types of movements puts you into a role that is similar to that of a musical conductor.

In **figure 5.38,** a pair of concept sketches for a Web site pitch for Sky Bridge, an interactive broadband communication company, suggests myriad possibilities in which the movements associated with live-action footage and animated lines and shapes could be coordinated. The graphic lines and shapes could be assigned nonlinear, progressive movements that complement the video or be choreographed to move in a linear, mechanical fashion to conflict with the imagery. Graphics and type might animate in a manner that makes the interface look controllable, letting viewers know that they have the option of zooming into the image or panning into off-screen space. The row of small circles near the bottom could potentially be interactive; when each is highlighted with a mouse-over, a line might scan across the screen as a transition to feature updated live-action content. Alternatively, these shapes could animate in a manner that implies an upcoming change of live-action content or trigger a transition such as a wipe or a fade. Lines might animate in from the edges of the frame, pause at a point of intersection, then slide across the field in opposite directions to reveal an updated video image. The entire box encompassing the video might move to either side, in counterpoint to the screen, to signal a change in scenery. All of these scenarios suggest carefully designed motion choreography to create strategic relationships between the elements.

Isadora Williams' animated poster assignment at the Massachusetts College of Art effectively integrated nonlinear and linear movements to create a believable race car scenario. The green, white, and red arrows from Max Huber's Swiss poster for the Monza races were animated in precise synchronization to the accompanying soundtrack. The piece

5.37
Frames from *Mr. Reaper's Really Bad Morning* (2003). Courtesy of Carol Beecher and Kevin D.A. Kurytnik. © Fifteen Pound Pink Productions.

Exaggeration of motion is applied to the movements of the figures as they chase after the animal.

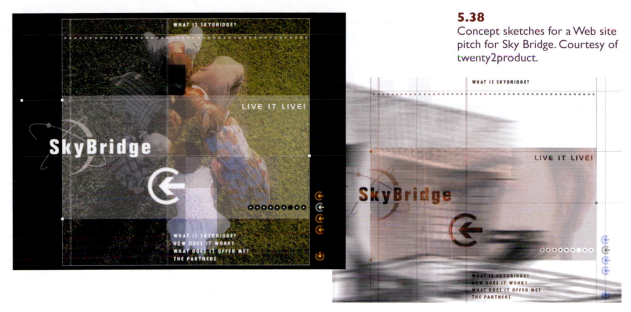

5.38
Concept sketches for a Web site pitch for Sky Bridge. Courtesy of twenty2product.

begins with three green, white, and red arrows being introduced into the frame, where they shake to the trumpet of the soundtrack like turbo engines being revved. After accelerating off of the bottom edge of the frame one by one, a blue arrow is displayed in three incremental sizes to the accents of the musical notes. The original arrows reappear from the right edge of the frame and move mechanically from right to left in a linear fashion. After reaching the center of the frame, they suddenly accelerate around the bend as they change course and speed once again to disappear off the bottom edge of the frame (**5.39**).

At the Iceland Academy of Art, Helga Arnalds had been experimenting with images connected to prehistoric figures. Influenced by the style of animator Len Lye, she created a mesmerizing musical journey in which elements move to a carefully choreographed "dance."

5.39
Animated Poster "Monza-Milano," by Isadora Williams, Professor Jan Kubasiewicz, Massachusetts College of Art.

Stylistically, the simple, abstract nature of her imagery allows us to pay considerable attention to variations of movement that occur throughout the composition as the images sway, undulate, and twist to a rhythmic, hypnotic melody of percussive instruments (**5.40**).

5.40
Frames from "ORGI," by Helga Arnalds, Iceland Academy of Art, Professor Kristín Ingimarsdóttir.

5.41
Frame from a spot for Music One Classic. Courtesy of Tavo Ponce and Monkey Revolution.

Likewise, the structure of Tavo Ponce's promotional spot for Music One Classic in Madrid, Spain lies in the personification of form through motion. Clusters of colorful, abstract shapes swim and jump around like schools of fish as they pass across the frame to form the typographic content (**5.41**). In a group of station identifications and bumpers for The Voice, a Scandinavian music television network based in Denmark, hard-edged, geometric ribbon structures also move in a lifelike manner. As forms move and unfold erratically against a patterned backdrop of stripes, their movements are echoed in an abrupt change of the background pattern at the very end of the composition, creating an explosive and edgy visual language (**5.42**).

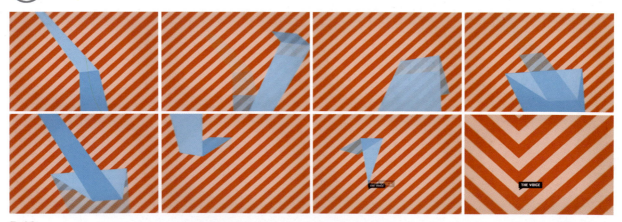

5.42
Frames from station ID for The Voice, a Scandinavian music network based in Denmark. Courtesy of Daniel Jennett.

birth, life, and death

When coordinating motion, important consideration should be given to the manner in which actions begin, the duration that they occur, and the manner in which they end. Elements can move into and out of the frame from any of its four edges, fade in or out, or grow larger or smaller. Additionally, they can be introduced by other elements, transformed through morphing, or constructed piece-by-piece.

Summary

Motion literacy is essential to the discipline of motion graphic design. It involves an understanding of spatial properties such as positioning, scale, orientation, and direction. These determine the physical relationship of elements to the frame. Frame mobility or secondary motion, which is achieved through actual or simulated camera movement, can be used to control our perception of space by allowing the framing of objects to change over time. Mimicking natural head and eye movements can give audiences a sense of motion through space or a sense of omnipresence. Incorporating perspective into mobile framing allows us to construct environments that viewers can travel through as observers or active participants in interactive environments. Frame mobility can impart information by establishing visual hierarchy through emphasis and can connect elements to each other and to their surroundings.

Temporal considerations, such as time and velocity, play a considerable role in choreographing motion. Nonlinear movements that proceed at steady, uniform rates can mimic mechanical devices, while nonlinear, unpredictable movements that involve acceleration and deceleration can achieve more lifelike animation. Altering velocity through the techniques of slow motion, fast motion, reverse playback, and freeze-frame can emphasize or exaggerate movement, enhance rhythm, set mood, and alter our sense of objective and subjective time.

Coordinating movement involves understanding traditional motion principles. *Squash and stretch*, for example, can establish the physical basis of objects that have mass, giving their movements the illusion of weight and volume. *Anticipation* creates a sense of natural movement by dictating that an upcoming action is about to occur. *Follow through* and *overlapping* enables the flow between actions to be carried out smoothly. *Acceleration* and *deceleration* can soften lifelike movements, making them appear more natural. Secondary actions can heighten interest or add realistic complexity by supplementing and reinforcing the primary action. Movements can be combined to give nonrepresentational content the appearance of living subjects. The manner in which movements begin and end (*birth* and *death*), as well as their duration (*life*), should also be given consideration.

5.43
Frames from an online advertisement for Lycos. Courtesy of hillmancurtis, inc.

Groups of vertical lines animate horizontally across the screen to introduce each heading.

5.44
Frames from an online ad for Roger Black Interactive Bureau. Courtesy of hillmancurtis, inc.

Several geometric structures come together from opposite edges of the frame to form symbols that eventually fade out.

Assignments

The following assignments are intended to help you develop a better understanding of motion literacy. Share your work with others and discuss the subtleties of motion with respect to spatial and temporal considerations, tempo, rhythm, and basic animation principles from Frank Thomas and Ollie Johnston's *The Illusion of Life*. Consider how these projects could potentially be applied to "real world" assignments.

** A few of these projects require video recording. If you do not own a camcorder, use a cellular phone that has video capabilities. (Alternatively, disposable video cameras are inexpensive and can be purchased at most convenience stores.)*

natural motion: study #1

overview
You will create a rotoscoped animation based on a motion study of Eadward Muyridge.

objective
To develop an increased awareness of natural, lifelike movement.

stages
Download one of Eadward Muytridge's photographic motion studies from the Web or scan one in from *The Human Figure in Motion* or *Complete Human and Animal Locomotion* (Dover Publications). In Photoshop, separate the images and save them as separate files, naming them with sequential numbers. Import the sequence into a program that offers onion skinning, such as Flash. Create a sequence of simple line drawings from the frames, loop the sequence, and play it back at an adequate frame rate. (Alternatively, you can draw over the images with a pencil and tracing paper, scan in the artwork, and play the frames back on the computer.)

considerations
Pay close attention to the subject's natural, nonlinear movements.

natural motion: study #2

overview
Human motion, animal motion, and motion caused by the forces of nature is erratic and unpredictable. You will create a rotoscoped animation from video footage that demonstrates natural movement.

objective

To develop an increased awareness of natural, lifelike movement and to explore how it can be enhanced through animation.

stages

Download from the Web a 3–4 second video clip of one of the following:

- plant growth (time lapse)
- a butterfly opening and closing its wings
- a person or an animal walking or running

Render the footage as a QuickTime movie with a frame rate between 6–8 fps. (Four seconds = 24–32 frames.) The movie's dimensions should be set to 720 x 480. From the footage, develop a sequence of simple line drawings that capture the subject's basic movements. In After Effects, you can export the QuickTime as a Filmstrip, open it in Photoshop, and draw on a separate layer above the video. You can then delete the frames from the background layer, flatten the file, resave it in the Filmstrip format, and play it back in After Effects. (Be sure not to draw on or delete the background's frame markers containing the timecode.) In a duplicate file, enhance the drawings, keeping in mind the basic animation principles that were discussed in this chapter.

considerations

Consider how basic animation concepts, such as exaggeration, anticipation, acceleration, deceleration, pause, and timing can be applied.

natural motion: study #3

overview

Hands are unique, and the way people express themselves with their hands may offer insight into their personality. You will create a rotoscoped animation of your hands dancing to a short excerpt of music.

objective

To increase your awareness of motion by translating human movements into animation.

stages

Choose a 3–4 second excerpt of music, and choreograph a dance for your hands. After listening to the excerpt several times, experiment with various movements that express your interpretation of the music. Be imaginative and daring with your concept!

Plan and practice your choreographed sequence several times, and then videotape it. Digitize the footage, and render it out as a Quick-Time movie with a frame rate between 6–8 fps. (Four seconds will yield 24–32 frames.) The dimensions of the movie should be set to 720×480. From the footage, develop a sequence of simple line drawings that capture the basic movements of the content. In you are working in After Effects, you can apply the same process that was mentioned in the previous exercise.

motion and gravity: study #1

overview
You will create a rotoscoped animation from a short segment of live-action footage that demonstrates the effect of gravity on movement.

objective
To develop an awareness of how motion is affected by natural gravitational forces.

stages
Download from the Web a 3–4 second clip of one of the following:
- a ball bouncing down a slide
- a ball bouncing down a staircase
- a ball in a racquetball court

Render out the footage as a QuickTime movie with a frame rate between 6–8 fps. (Four seconds will yield 24–32 frames.)

From the footage, develop a sequence of simple line drawings. If you are working in After Effects, apply the same process that was mentioned in the previous exercise.

motion and gravity: study #2

Create a rotoscoped sequence that demonstrates the effect of gravity on movement based on one of the following:
- a feather falling to the ground
- a paper clip falling and bouncing off of a hard surface
- a rubber eraser falling and bouncing off of a hard surface

Share your work with others, and discuss what animation principles from Frank Thomas and Ollie Johnston's *The Illusion of Life* apply.

relative motion

overview
The way we perceive an element's motion can be influenced by another element's motion, just as our perception of a color can be affected by the presence of another color.

objective
To develop a sensitivity toward relative motion by exploring how two or more animated elements can be choreographed to create meaning.

stages
In a motion graphics application of your choice, create two simple graphic images. These may be lines, abstract or geometric shapes, or a combination of lines and shapes. In a 10–15 second animation, choreograph their movements so that they complement each other. Create a second animation, this time choreographing the movements of the elements so that they conflict with each other.

considerations
Consider how supporting and contradictory motions influence your overall perception of the animation. How can both scenarios potentially communicate a concept with further development? How might they work together to heighten the viewer's interest?

kinetic typography: letter personification

overview
This assignment involves developing an animation that is based on the first and last initials of your name.

objectives
1. To personify the letters by assigning them nonlinear, lifelike motions that are consistent with the laws of gravity;

2. To create physical interactions between elements through motion choreography.

specifications
You are restricted to using one sans-serif typeface and are allowed to use only black and white. Colors, shades of gray, drop shadows, and special effects are strictly prohibited so that you can focus on the kinetic aspects of the type.

The duration of the composition will be 10 seconds. As a designer, it is critical that you are able to tell your story within a specified time frame, so be sure to adhere strictly to this parameter.

Specify your frame dimensions and frame rate according to the final format of delivery.

stages

Start out by developing a rough storyboard sketch that shows the chronological order of events. View and critique this sketch as you would critique a film script, and develop a tighter, edited iteration that conveys your story's events more clearly.

It may be necessary to develop an animatic to resolve some of the motion ahead of time. You may also decide to create an animatic prior to implementation. Should you pursue either of these options, be aware that you are not just presenting an animated slideshow of the initial sketches; rather, you are clarifying the types of movements, camera angles, and transitions that will occur in the final production.

Keep an open mind and be prepared to deviate, to an extent, from your original ideas as you animate. You may decide to go back to your initial sketches if you are not satisfied with the results or if you wish to explore other possibilities.

considerations

The kinetic aspects of this assignment should be given top priority. Consider the course of travel and velocity that the letterforms move in relation to each other. Contrasting speeds, directions, linear, and nonlinear motions can add interest and create dynamic visual relationships. The manner in which the elements appear, live, and disappear in the frame (birth, life, and death) should also be given strong attention early on. Last, consider the pictorial aspects of the animation including shape, geometry, size, spatial orientation, positive and negative relationships, and the association, and possible interaction, of the letterforms with the frame's edges.

from print and motion

overview

The pictorial aspects of composition can impact how messages are communicated. In a time-based environment, the kinetic and sequential aspects of composition can also shape the way messages are

constructed. Motion designers are often challenged with the task of translating existing content into kinetic information.

You will animate a print design of your choice, keeping in mind its pictorial arrangement, style, purpose, and target audience.

objective
To investigate how the static aspects of composition can be conveyed through motion.

stages
Choose an example of print design, and create a rough storyboard sketch that demonstrates how the piece could be animated according to its pictorial and spatial qualities. Critique the sketch, and develop a revised edition that clarifies the sequence of events and the types of movements and transitions that will occur. Do not hesitate to develop a new set of sketches if you wish to explore other possibilities. If you decide to develop an animatic, be willing to deviate from it, to an extent, during production.

Digitize the piece, and separate its elements or create them digitally. Import the components into a motion graphics application and animate them.

specifications
You must use every element from the original design. Additional images or type are prohibited. You may use each element only once. The duration of the composition should be between 15–20 seconds.

considerations
The style of the motion should complement the design that you chose. Be experimental and innovative, yet consistent, with its original style, purpose, and target audience. Be sure to give attention to the birth and death of the elements and to their relative durations in the frame. Consider how the device of frame mobility might be used to add interest and create visual hierarchy.

6

images, live-action, and type
design considerations

The visual power of images, the connotative power of typography, and the union between these elements are the foundations of effective graphic design. These dynamic elements function as a visual language when they are combined on the printed page or in a time-based environment. In contrast to static designs, which can imply or inspire stories, imbuing visual and verbal information with the dimensions of motion and time can tell stories with expression, clarity, and meaning.

"When type meets image, there is automatically a dialogue between them, and each can pull the other in many different directions."
—Nancy Skolos and Tom Wedell
(Type, Image, Message: A Graphic Design Layout Workshop)

00:00:00:06

6.1
Frames from *Opus IV* (c. 1924) by Walter Ruttmann. This animated film expressed a minimal style that was characteristic of the Bauhaus. From *Experimental Animation*. Courtesy of Cecile Starr.

Visual Properties

It is critical that graphic designers understand the symbolic language of aesthetics as it applies to images and typography.

form

In addition to line, form is the most basic element of visual communication. Whether it is purely graphic, photographic, or typographic, it can be strategically used to symbolize or suggest ideas, or convey moods or emotions. It can also imply spatial depth, provide emphasis, and help organize information by directing the viewer's eye throughout the frame.

Geometric forms have always fascinated designers because of their identifiable qualities and mathematically-defined parameters. Culturally derived shapes such as the octagon which means "stop," or a starburst which can identify something new or powerful, have been used to represent literal objects or ideas. Ubiquitous images, such as a vertical rectangle with a folded corner or a hollow circle with a diagonal line running through it, have become universally recognized.

Natural forms, which are often derived from organic elements such as water droplets, flower petals, and microbial organisms, offer a sense of freedom and spontaneity. Structures such as honeycombs and crystals display geometric qualities of symmetry and pattern. Natural forms are often seen in Chinese calligraphic writing and in the Ukiyo-e and Art Nouveau movements.

abstract form

Modern art was founded on the exploration of pure, nonobjective abstraction, and the basis of visual experience was the perceptual effect of form and color on the viewer. Form became the content, and its expressive qualities were often developed from intuition.

An emphasis of abstract form was evident in early German avant-garde films from the 1920s that made the transition from nonobjective painting to animation. Artists such as Hans Richter and Walter Ruttmann saw abstraction as the basis of the film's form. Hans Richter's motion studies explored the linguistics of rhythm and motion through the use of geometric structures. *Rhythmus 21* explored the manipulation of elemental square and rectangular shapes, and *Rhythmus 23* experimented with negative reversals and crisscross patterns (**6.3**).

Walter Ruttmann's Opus series investigated how converging abstract shapes could exhibit playful animated qualities. Viking Eggeling's films demonstrated a painstaking analysis of linear forms and their positive-negative interplay (**Chapter 1, figure 1.13**).

6.2
"Suprematist Composition," (1915) by Kazmir Malevich. Wilhelm Hack Museum, Ludwigshafen © Erich Lessing/ Art Resource, NY.

Kazmire Malevich's Suprematist style is founded on the extreme reduction of images to elemental geometric shapes.

6.3
Filmstrips from *Rhythmus 21* (1921) and *Rhythmus 23* (1923) by Hans Richter. Courtesy of Cecile Starr.

Animators who followed in the footsteps of these early experimental filmmakers have continued the tradition of abstraction in both independent animation and commercial motion graphics. Processes such as drawing, painting, stop-motion, cut-out, and direct-on-film allowed animators to create kinetic abstractions that moved to the rhythm of a soundtrack. Stan Brakhage's film entitled *Mothlight* (1963) was produced by randomly adhering the wings of moth bodies to a strip of clear film and duplicating the results on a negative. When projected on the screen, the positions of the wings change between frames, and a flickering effect of the changing shapes is produced. Although these images came from a realistic source, the end result is semiabstract in nature (**6.4**).

3D form

3D modeling and animation have been used in motion graphics since the 1970s in opening movie credits and in early animated station identifications. Today, the integration of 2D and 3D imagery has become a major practice in film titles, network packages, and digital interfaces. Common desktop applications, such as Cinema 4D (Maxon), Light-Wave (NewTek), Maya (Autodesk), and Motion (Apple), have become more affordable and more sophisticated with respect to modeling, rendering, object animation, and camera animation. They have also become more intuitive, allowing designers to see their results in real time and make adjustments during playback without having to render.

6.5
Frames from the Web site of Giant Octopus, a broadcast motion graphics studio located in Clearwater, Florida. This entertaining 3D animation is used as an introduction to the company's news reel. Courtesy of Giant Octopus.

6.4
Frames from *Mothlight* (1963), by Stan Brakhage. Courtesy of the Estate of Stan Brakhage and Fred Camper (www.fredcamper.com).

Each year, Blur Studios produces an in-house opening animation for its demo reel. On a recent trip to Venice, Italy, the design team was awed by structures such as St. Marks Cathedral and the Rialto Bridge. Inspired by this imagery and the two-dimensional look of Italian woodblock prints, they hired Adam Schwaab to model and animate elements, such as the lion, the gondolas, and the bridge, in Cinema 4D. The final production is an astounding graphic interpretation of Venice, California and Venice, Italy (**6.6**).

6.6
Frames from "Design Intro: Blur Venice." Courtesy of Blur Studios.

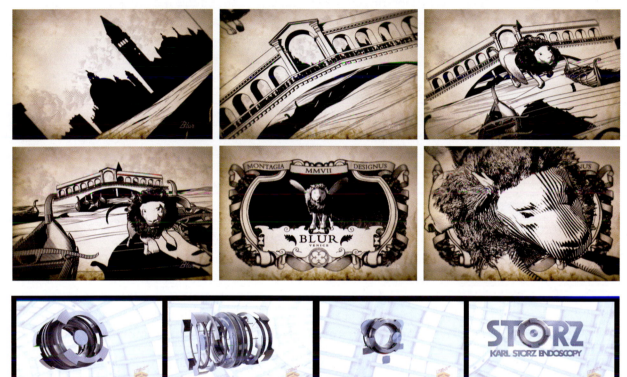

value and color

Value, one of the strongest methods of visual contrast, measures the lightness or darkness of an image's tones or colors. It can enrich visual messages and can be used to create focal points in a composition. Next to value, color has the ability to create mood, symbolize ideas, and express emotions to produce a desired audience response. Studies have indicated that most human beings make a subconscious assessment about what they see within 90 seconds of initial viewing, and that their evaluation is based on color alone.

Managing color can be complex in its technical application and conceptual and aesthetic direction. As graphic messages are being designed globally, color selection and coordination takes on a special burden in psychological and social contexts. Familiarity with basic color principles and the psychological and cultural aspects of color can help you simplify color decisions and make intentional color choices to foster a desired audience response.

6.7
Frames from an animated identification for Karl Storz Endoscopy, a leading enterprise of endoscopic instruments equipment. Courtesy of Reality Check Studios.

This well-crafted animation derives an endoscope from the letter "o" and gives us an entertaining, exploded view of the contents of the instrument.

6.8
In traditional analog color theory, hues are referenced by their angle on a color wheel.

6.9
The top two hues share the same brightness but differ in saturation. The bottom hues share the same saturation but differ in brightness.

6.10
Decreasing a hue's saturation level eliminates its "purity," bringing it closer to a muted gray value.

the components of color

Color can be divided into three components: hue, saturation, and value. *Hue* denotes colors with regard to their identification (e.g, orange, green, red, cyan). *Saturation* (or chroma) measures a hue's purity or intensity. Reducing a color's saturation by adding gray or by mixing a complementary hue on the opposite end of the color wheel has the effect of becoming muted (**6.10**). *Value* (also referred to as *tone* or *brightness*) describes a color's lightness or darkness. Decreasing value produces the effect of adding black pigment, while increasing its value gives the effect of adding white. Every hue has a different value range. Yellow, for example, has a lighter tonal range than blue.

emotional, gender, and cultural associations

Psychological reactions to color vary, depending on the demographics of the target audience. Understanding how color can evoke different emotional responses can help dictate color decisions that we make as designers. Universally, light red is commonly associated with cheerfulness; however, bright or dark red can induce irritability. We commonly associate yellow-green with freshness and youth while sometimes associating a dark shade of olive with death and decay. A light blue sky can produce tranquility, while a deep indigo can induce melancholy.

Color preferences and perceptions also vary with respect to gender and culture. Studies have shown that men are attracted to dark, saturated colors, while women prefer cool colors and softer tints. North American mainstream culture associates red with urgency, heat, love, blood, and danger, and green with nature, health, money, and abundance. Chinese culture represents death with white, while Brazilian culture depicts death with purple. Greek culture often interprets yellow as sadness, while the French associate it with jealousy.

The color palette used in MOJO, a male-oriented entertainment network, was carefully selected to reflect the upscale nature of its programming. Deep crimson, black, and white serve as signature hues, while subdued variants of blue and orange function as secondary colors (**6.11**). In the show package for Black Entertainment Television, a rich color palette of gold, royal blue, and magenta was intended to portray the luxury of being a celebrity (Chapter 2, figure 2.26). In a music video for "Decent Days & Nights" by The Futureheads, fluorescent colors were used to express the band's part vintage rock and part progressive nature. "Analog" color washes were used to give it a late '70s, early '80s appeal (**6.12**).

Although color choices are often subjective, designers must exercise appropriate color usage according to certain conventions that have been established. Within those conventions, however, they should be willing to experiment and take risks.

texture and pattern

In addition to value and color, surface texture and pattern can add contrast and depth to a composition while providing viewers with the sensory experience of touch. Since the days of cartoon marker renderings, film animators have scratched, painted, and chemically altered the surface of film to achieve rich, tactile-looking content.

Motion graphic designers have also simulated textural effects to add richness and depth to their compositions. For example, Susan Detrie's bumper for TBS Network incorporates a rich palette of digitally generated 3D textures into the letters of the identity (**6.13**). In a promotional animation for an experimental project called Promsite In Motion, Ritxi Ostariz, a young digital designer from Bilbao, Euskal Herria, employed colorful patterns to add a sense of texture to his animation (**6.14**).

6.11
Frames from MOJO. Courtesy of Flying Machine.

6.12
Frame from "Decent Days & Nights." Courtesy of Stardust Studios.

6.13
Frames from "The Big Screen." Courtesy of Susan Detrie and DesignEFX.

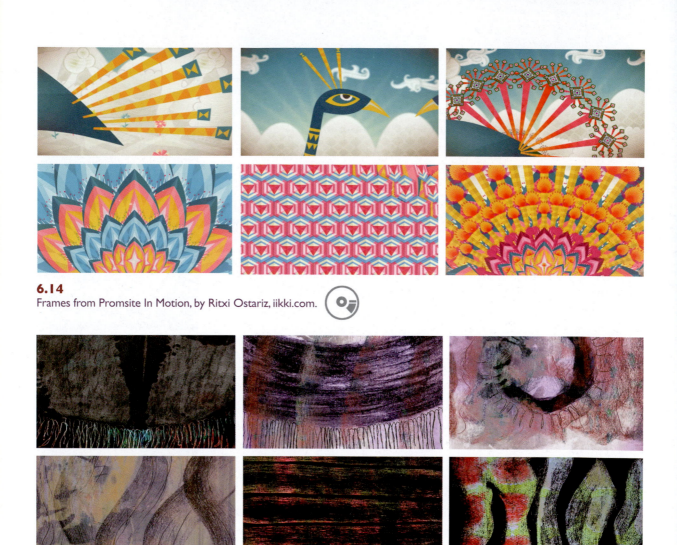

6.14
Frames from Promsite In Motion, by Ritxi Ostariz, iikki.com.

6.15
Frames from "ORG1," by Helga Arnalds, Iceland Academy of Art. Professor Kristín María Ingimarsdóttir. Images consisting of rich textures dance to a percussive rhythm.

Image Considerations

Choosing the appropriate images is critical to supporting a concept, message, or mood. Images can take on many visual characteristics ranging from graphic to textural, sketchy, blended, whimsical, realistic, abstract, or layered. Cropping, distortion, value and color alteration, deconstruction, and effects can enhance their expressive properties before they are animated. In **figures 6.16–6.18**, simplification and

exaggeration were used to translate the most dominant forms of images into pure, elemental structures. The resulting slightly abstract, graphic depiction of the subject matter yields a very different result than a detailed, realistic illustration or photographic representation.

Club RTL, a Belgian network, needed to refresh its daytime programming to appeal to a younger audience. German designer Daniel Jennett borrowed the shapes and colors of the existing identity (**6.19**). In his station identifications for *The Voice*, the image treatment was dictated by the product's existing brand. Stripes and ribbons were a primary component of the network's style, and these elements needed to fit its brand and technical requirements (**Chapter 5, figure 5.42**).

6.16
Metamorphosis study, by Donna Tappin, Fitchburg State College. Professor Jon Krasner.

This assignment involved creating a graphic interpretation of two different objects and choreographing smooth transitions between them in a storyboard.

6.17
Frames from JWT "CET re-launch." Courtesy of L.inc Design and JWT Worldwide.

6.18
Mechanical object studies by Ferah Ileri and Aimee Lydon, Fitchburg State College, Professor Jon Krasner. Students were encouraged to exaggerate the geometry and relative sizes of the forms.

Historical Perspective

German Expressionist films shared many of the qualities of Expressionist painting, the most common one being stylized imagery. Many of the image's details were reduced through extreme tonal contrast, allowing viewers to pay attention to the main forms that were often exaggerated and distorted. The actors often wore heavy make-up and moved with exaggerated gestures to enhance the film's expressive quality.

6.19
Frames from a channel redesign for Club RTL. Courtesy of Daniel Jennett.

Hatmaker, a Boston-based broadcast design studio, created a realm of cinematic splendor by integrating highly stylized images, halftone dot patterns, lush colors, and dimensional lighting to reflect the grandeur of "the event" befitting Cinemax's initial showing of the latest hit movies. In a spot for Cinemax's prime movie slot, Hatmaker put a fresh spin of the concept of the film projector lens by showing the emergence of light and color from darkness (**6.20**).

6.20
Frames from Cinemax's "See It Sunday." Courtesy of Hatmaker.

Live-Action Considerations

Over the past decade, live-action content has had a stronger presence in motion graphics due in part to the growing cinematic vocabulary of designers and to technical advancements in digital compositing. Today, motion graphic designers are expected to have a basic understanding of cinematic principles as they relate to film and video. Whether live-action content is appropriated, filmed, or recorded, its qualities must contribute toward the concept being communicated. Additionally, it must work aesthetically with other graphic elements, regardless of the space that it occupies in the frame.

Factors that should be considered when working with live-action content include the form or context of the project, filmic properties, and cinematic properties such as tone, contrast, lighting, depth-of-field, focus, camera angle, shot size, and mobile framing.

filmic form

While film scholars consider the narrative, the documentary, and the experimental film to be the three major forms of filmmaking, most commercial forms of motion graphics are narrative. For example, public service announcements address topics, such as global warming, homelessness, and energy conservation, to modify public attitudes and raise social awareness. Title sequences establish the context and set the tone of a movie.

Narrative forms of motion graphics can be realistic or abstract. For example, Kemistry, a branding and communications agency in the UK, filmed eighteenth century writing tools to express the distance between two sisters who exchange letters in the opening credits to *Mansfield Park* (**6.21**). In contrast, the abstract qualities of David Carson's television advertisement for Nike fulfill the commercial's narrative purpose and enhance the emotional impact of power and speed (**Chapter 8, figure**

6.21
Frames from the opening title sequence to *Mansfield Park* (1999). Courtesy of Kemistry.

8.18). Here, formal devices of shape, color, and texture serve as a basis for the composition's form.

Being aware of the form of your project is critical in determining the type of live-action content that will be used, how the content will be treated, and how it will fit into the larger motion graphics composition.

Historical Perspective

Experimental forms of filmmaking have been a significant part of the history and legacy of motion graphics. Experimental films are often characterized by the absence of a linear narrative, giving priority to formal design elements, such as line form, value, color, texture, and composition, over story. One of the oldest examples of experimental filmmaking is Man Ray's lyrical Surrealist film, *Emak Bakia* (1926), which interwove bizarre fragments of live-action elements, such as dancing pins, swimming figures, dancing legs, and electric turntables, with out-of-focus light forms, silhouettes, and revolving type.

Narrative films simply tell stories. Traditional, fictional narrative films have been around since the invention of modern cinema. The documentary is a continually evolving film form that attempts to document reality. Biographies of living or nonliving individuals, live performances, interviews, footage compilations from government sources, particular topics, and spoofs (or "mockumentaries") all qualify as nonfictional documentary film. Early documentaries, such as those by the Lumiere Brothers, depicted real images of life, such as a train entering a station or factory workers leaving a plant. Modern day documentary films include A Brief History of Time (1992), Extreme (1999), Madonna: Truth or Dare (1991), This is Spinal Tap (1984), and Best in Show (2000).

filmic properties

tone and contrast

Tonality and contrast are visual, filmic properties that affect the reception of the image. Tonality refers to an image's full range of values between extreme dark and light. Contrast, in this context, refers specifically to the ratio of dark to light values. For example, "high contrast" films that utilize low-key lighting are used in genres such as the horror film and the film noir, while many motion picture films use low contrast to achieve naturalistic lighting.

Like still photography, exposure, lighting, image processing, and digital manipulation can control tone and contrast. Exposure can be manipulated by widening or narrowing the lens' aperture to govern the degree of light that passes onto the film. Narrow apertures that allow less light produce underexposed images, while wider apertures can result in overexposure. Lighting can also control tone (as described in the next section). In film processing, the chemicals used, the manipulation of the optical printer, and techniques, such as tinting and hand-coloring, can also change the tonal and chromatic appearance of black-and-white and color film stocks. Further, the range of tools and techniques for digital alteration offer endless visual possibilities.

lighting

Lighting is one of the most important aspects of visual storytelling in cinematography. It must serve the story or concept and in some cases, even can become the story.

Although lighting can be subjective (some film directors prefer to shoot in natural light, others depend on the effects of artificial lighting), over-lit scenes or deficient lighting can be blatantly obvious and detract from the story. Effective lighting, by comparison, is "invisible" to viewers, since it melds with the story.

Lighting is usually established during the time of capture, although lighting effects can be applied digitally during production and post-production. *Key lights* establish a subject's main illumination. High-key and low-key lighting can vary the emotional impact of the subject considerably. *Fill lights* are used to soften the contrast of the key light and provide illumination for the areas of an image that are in a shadow to bring out subtle details (**6.24**). A fill light that is at least half the intensity of the key light will produce flat, low-contrast tonalities, while lower intensities can produce high-contrast images.

Key-to-fill ratios can vary to establish different effects. Low key-to-fill ratios, for example, are sometimes used for interior scenes that consist of white or highly reflective surfaces, as well as overcast or snowy out-door scenes. High key-to-fill ratios are used in night scenes to produce dramatic, suspenseful effects. Experimenting with the positioning of

6.22
In a public service spot for safe sex, the quality of low-resolution video footage has a dark under-tone and graininess that conveys the urgency of the topic at hand. Courtesy of twenty2product.

6.23
Alexander Alexeieff's and Claire Parker's pinboard animation technique produced dramatic tonal and textural effects that resembled traditional etchings. In their film, *Night on Bald Mountain* (1933), the forms have 3D, chiaroscuro-like qualities as they dissolve from and into space. Courtesy of Cecile Starr.

Traditional filmmakers have altered exposure to achieve atmospheric effects. In the American films noirs of the 1940s, images were often underexposed to express darkness. Glass and gelatin filters on the camera's lens or printer have also been used to manipulate the range of values and colors. Hollywood films of the 1930s often employed diffusion filters in glamour shots of women. The speed of the film stock also offers different tonal possibilities. Slow black-and-white film produces a wide range of mid-tone tonal detail and soft contrasts, while faster film speeds yield a greater image contrast, resulting in a reduced range of mid-tones.

the key and fill lights can accentuate shadows to create the illusion of depth and texture. *Back lights* are used to illuminate foreground elements from the rear to visually separate them from the background. This technique often creates a defining edge between the element and the background and sometimes causes the edges to glow (**6.25**).

6.24
The sensuous low-key lighting in the music video "Do It For Me Now," by Angels and Airwaves, contributes to the emotional mood of the soundtrack. Fill lights are used to soften and extend the key light's illumination in order to bring out subtle image details. Courtesy of Shilo.

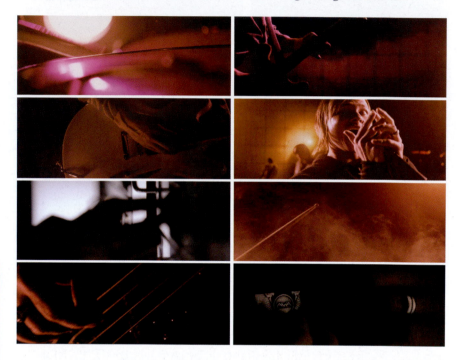

6.25
Frame from *ZOOM*, a network package for Times India's Zoom Channel. Back lighting is used to provide a separation between the subject and the background. Courtesy of Belief.

Traditional three-point lighting (or *portraiture-style lighting*) positions a key light overhead at approximately 90º downward and 45º to the side of the subject. The fill light is typically eye level and is angled approximately 45º toward the opposite side of the subject. A back light is positioned between the subject and the background at a 45º angle to the subject's left or right shoulder (**6.26**).

depth-of-field and focus
The devices of depth-of-field and focus can be used to enhance the emotional nature of an image or scene.

Depth-of-field is the distance in front of and beyond the part of a scene that appears to be in sharp focus. This property can be controlled by lighting, lens aperture, and *focal distance*—the distance between the lens and the object that is in focus. High-key lighting and wide-angle lenses tend to produce images with very large depths-of-field, while close-up shooting in low light conditions often produces shallow

depths-of-field. As an alternative to cutting, restricting depth-of-field can focus an audience's attention on a particular aspect of a scene.

Focus refers to the "sharpness" of an image as it is registered in a scene. It is directly connected to, but not to be confused, with depth-of-field, which involves the extent to which the space represented is in focus.

Giving elements at very different spatial depths or planes the same degree of focus produces *deep focus*. Restricting the depth-of-field to keep only one plane in sharp focus produces *shallow focus*. Shallow focus can direct the viewer's attention to a particular element of a scene and is quite common in close-up shots to suggest psychological introspection, where the actions or thoughts of a character prevail over everything else. *Racking focus* involves changing the focus of a lens so that an element occupying one plane goes out of focus and an element in another plane comes into focus. This technique can steer audiences through a scene or link two subjects or spaces. Its effect is often used to mimic a brief, fleeting glance from one subject to the other (**6.31**).

camera angle and shot size

Changing a camera's angle can affect the appearance and function of a shot and help determine the audience's point of view. A "bird's-eye view," for example, provides an aerial perspective of a scene, allowing us to feel as if we were hovering above a subject. High camera angles can make characters appear smaller, younger, weak, or harmless. Eye level shots from five to six feet off the ground provide a frame of reference and capture the clearest view of a subject. Frontal angles tend to flatten three-dimensionality, while three-quarter or profile angles reveal a greater degree of depth. Placing a camera below eye level and angling it upward establishes a low angle shot. This effect is typically used to exaggerate the impression of height and inspire awe or excitement, making subjects appear larger, stronger, or nobler.

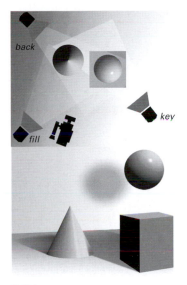

6.26
Traditional three-point lighting.

6.27
Restricting depth-of-field can be achieved by shooting close-up in low lighting conditions.

6.28
The technique of racking focus can create psychological links between elements.

Shot size (or *camera distance*) identifies how large an area is visible within the frame. An *establishing shot,* such as a "bird's-eye view," is taken from a great distance to establish an overall context. A *long shot* portrays a subject from a lesser distance to reveal aspects of the environment, such as architectural details. *Medium shots* typically frame people from the waist up and are used to focus attention on the interaction between two people or objects. Medium-wide shots are wide enough to show the physical setting where the action is taking place, yet close enough to reveal facial expressions. *Over-the-shoulder shots* are used to focus the viewer's attention on one actor at the time during their interaction. *Close-up shots* are designed to direct the audience's attention on facial expressions or object details and are among the most powerful storytelling devices. An extreme close-up fills the screen with the details of the subject.

6.29
In an in-store video for Nike, an unusual low camera angle was shot from below to express the power and endurance of the Air Max line of running and training shoes. Courtesy of twenty-2product. Copyright 1994 Nike, all rights reserved.

integrating live-action

Whether live-action content occupies the full frame or is incorporated as smaller elements into a larger frame, its presence can accentuate the message and mood being communicated.

In the film "Crossword," Karolina Novitska created a cinematic visualization of Alzheimer's disease by revealing video content through layers of torn paper and fabric that are peeled away. The partially concealed quality of the video accentuates the dreamlike, disoriented feel that is associated with this disease (**6.31**).

6.30
In D.W. Griffith's film *Intolerance,* slow crane shots of the setting were employed to create the feeling of majesty and monumentality.

In her other short film "Sound Inside Out," Karolina takes us on a visual 3D journey inside a pair of headphones where the elements of sound are broken down, translated into human dance, and displayed in different spaces. In this experimental approach to visualizing music, the treatment of the live-action image sequences was critical. Content is contained inside of windows which we, the viewers, can travel between. Unusual color combinations, image negatives, and mirrored body parts create strange, surrealistic visions that punctuate the style and mood. Additionally, Karolina played with accelerated time, carefully synchronizing the movements to the beat of the music. At the end of the experience, we are pulled outside of the headphones from a colorful world of fantasy into a darker, sepia-toned reality (**6.32**).

The humorous title sequence to a music video competition called "Handle The Jandal" demonstrates a seamless integration of live-action figures into compositional spaces that contain a rich, eclectic mix of graphic information by shooting them against a green screen (**6.34**). In contrast, combinations of small, free-floating, and contained live-action elements were seamlessly integrated with photography, illustration, and 3D graphics in the television show opening to *The Hungry Detective* (**Chapter 2, figure 2.18**). The idea of containing live-action images inside of specific shapes is also evident in Kemistry's identity package for KLM Television's Royal Dutch Airlines, based in the Netherlands (**Chapter 2, figure 2.52**) and in Onesize's commercial

6.31
Frames from "Crossword" by Karolina Novitska, Massachusetts College of Art, Professor Jan Kubasiewicz. (Winner of 2006 Adobe Design Achievement Awards).

"Videographers must be prepared to learn the language that film shooters have built over the last 100 years. It's a language made up of camera movements, filtering techniques, subtleties of focus, and depth of field. And it's a language coming into the video world through the gateway of high-definition television."

—*Pierre de Lespinois*

promos for Kentucky Fried Chicken which was aired on MTV (**Chapter 2, figure 2.65**). Corey Hankey's approach to integrating live-action in the design of a video diary assignment also restricted the images to "live" inside of specific shapes (**6.36**).

6.32
Frames from "Sound Inside Out." Written, performed, filmed, directed, and edited by Karolina Novitska, Massachusetts College of Art, Professor Jan Kubasiewicz.

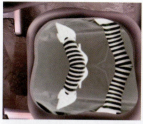
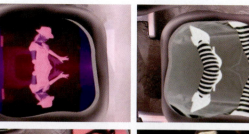

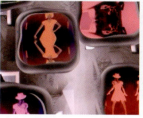

6.33
Frames from "a video diary," by Corey Hankey, Rochester Institute of Technology. Professor Jason Arena.

6.34
Frames from "Handle The Jandal." Courtesy of Krafthaus.

A very different type of live-action treatment is illustrated in the captivating opening sequence to *Voxtours*, a popular German travel program that is known for reporting authentic and cultural aspects of holiday destinations (**6.36**). Velvet, a German broadcast and film design firm, effectively integrated numerous live-action elements with stunning graphic visuals and type. The scale of the footage elements, which all retain a traditional 4:3 aspect ratio, varies throughout the composition as they play and animate inside the pictorial space of the frame, establishing visual contrast and hierarchy. Some of the clips play in real time, while others have been slowed down to emphasize the romantic quality of the subjects.

Nori-zso Tolson of twenty2product expressed the importance of live-action images and graphic elements looking like they belong together visually. In the concept sketches for Sky Bridge (**Chapter 5, figure 5.38**), the video and graphics were designed to perform a "dance." If this project had been carried to production, the movements of both live-action and graphic content would have been coordinated so that they look connected. For example, the translucent rectangle might be treated as a sliding window that moves across the footage, revealing it or obscuring it. It becomes part of the overall pattern, like a tapestry that weaves the live-action and graphic image content together, as opposed to slapping a box on top of a picture. The half grayscale, half

6.35
Manifestival's online film festival Web site incorporates small, sequential static images to emulate the look of live, low resolution video. This clever integration of live-action derived imagery effectively contributes toward the site's experimental, artistic flavor. Courtesy of hillmancurtis, inc.

6.36
Frames from the show opening to Voxtours, a German travel program. Courtesy of Velvet.

color aspect of the video adds diversity and interest to the composition. In the other sketch, a larger, screened back video clip occupies the background space behind the rectangle containing the more recognizable footage. The duality between these footage elements could suggest the same image shown from a different point of view or scale, or two juxtaposing images that deliberately conflict.

Typographic Considerations

Type is one of the principle means of constructing messages in graphic design. The meticulous craft of typography lives on in our digital millennium, and experimental forms of type design have leapt off the page and onto the screen. Numerous examples of typography in print, film, television, and digital media have demonstrated that the expressive treatment of letterforms can enrich visual messages.

"Graphic design is painting with typography."
—Paul Rand

6.37
Storyboard design for Sprint's (RED) campaign to raise awareness and money for the fight against AIDS in Africa, by Chris Swenson, California Institute of the Arts.

Today, text is no longer limited to static, spatial forms of communication; it is also governed by time and motion. These added dimensions further enhance its communicative power.

The typographic milestones that have been made in print design have lead to new innovations and forms of expression in the area of motion graphics. During the 1980s and 1990s, the impact of film titles helped kinetic typography become mainstream in the eyes of the public. The opening credits to the Warner Brothers film *Altered States* (1980) used a simple transformation of two words to express the film's theme. The sequence begins with a transparent pattern of the title's words slowly overlapping each other as they move across the screen. Superimposed against them, the film's credits appear in white. The title's letterforms become smaller against the dark background, causing the effect of the camera pulling away. Finally, the complete title, "Altered States," sits alone against a vast, black background. In the film *True Lies* (1994), four faint blue streaks of light begin rotating in space, revealing the letterforms of the word "true." These letters continue rotating in space as four individual three-dimensional cube-shaped forms, revealing the word "lies," which is reversed on black on the adjacent face of each cube. Such a simple effect succeeds in illustrating the title's oxymoron. Kyle Cooper deliberately manipulated the film credits and names of the cast in David Fincher's psychopath serial killer thriller *Se7en* (1995) to make it look scratchy and carelessly handwritten. In addition, the type was placed in and out of focus with a play of camera angles.

Distinctive handwriting became one of the trademarks of Cuban-born filmmaker Pablo Ferro, who earned his reputation as a master of title design, along with Kyle Cooper and legendary designer, Saul Bass. Ferro is best known for the revitalization of hand-lettered movie titles. In the classic *Dr. Strangelove* (1964), he conceived the idea of filling the film frame with lettering of different sizes and weights. Ferro's elongated, hand-drawn lettering is also apparent in his more contemporary film titles such as *Stop Making Sense* (1984), *Beetlejuice* (1988), *Good Will Hunting* (1997), *Men in Black II* (2003), *For Love of the Game* (1999), and *My Big Fat Greek Wedding* (2002).

typographic form and motion

The role of expressive kinetic typography is to represent a concept in a visual format. Rather than being literal, it can convey an intended emotion through its unique graphic impact and its movement in space.

In many cases, it no longer reads as text but is perceived as physical shapes that create complex semiotic experiences through metaphor and motion. An example of this is the opening animation to *Black Day to Freedom* (2005), a 100-page book and DVD released by Beyond™, a company that aims to raise a greater awareness of social issues through design, illustration, and motion. The motivation behind this project was to help educate people and raise awareness of the global displacement of people and the challenges they encounter in obtaining their freedom. Shown in animation festivals worldwide, this short film portrays the displacement of refugees, asylum seekers, and immigration detainees by showing a city in turmoil and the loss and tragedy of a young family. Dutch graphic designer Joost Korngold of Renascent created an emotionally charged animation that combines typographic form and motion to expressively communicate the tension and discomfort associated with the DVD's content. The words "liberty" and "beauty" race across the frame, as if determined to escape from a prison-like background of dark lines and shapes that loop with abrupt back-and-forth movements. An emulated camera zoom then brings us closer to the words "darkness," "violence," and "kill," which fade into the foreground space and animate off the left edge of the frame in succession. As we zoom back out, the red letterforms "l," "a," and "c" fly off of the word "black" in the title, and portions of the title are intercepted with stuttering, nervous movements. The composition's dark, underlying tone, coupled with the deconstructed treatment of the type, serve as a metaphor for the frustration and despair that displaced people encounter as a result of the unfair and discriminatory practices (**6.40**).

In a graduate assignment entitled "Memory and Recollection," Eddy Roberts's subtle use of projected typography addresses childhood games and their deeper meaning. "Axis & Allies," leads the viewer into a shifting interior, representing the psychological space of distant memory. The subsequent sequence recalls games of youth and the embedded emotions associated with them. The texts examine the underlying power structures inherent in many children's games and their implications in the adult world: dominance and submission, aggression and passiveness, winning and losing (**6.39**).

Throughout her film "Crossword," Karolina Novitska expressed the mental and emotional state of Alzheimer's disease by manipulating handwritten words and phrases in an environment consisting of images of shattered glass, poured liquids, and layers of fabric and torn

"Typographic communication today is not a tutorial, not a how-to. It's a critical review of twentieth century typographic design. It aims to open eyes and minds to the potential power of typography..."
—I-Hsuan Wang

6.38
Inspired by the hand lettering of film title designer Pablo Ferro, Yuji Adachi developed a font called Major Kong.

6.39
Frames from "Axis & Allies" by Eddy Roberts, University of Houston, Professor Beckham Dossett.

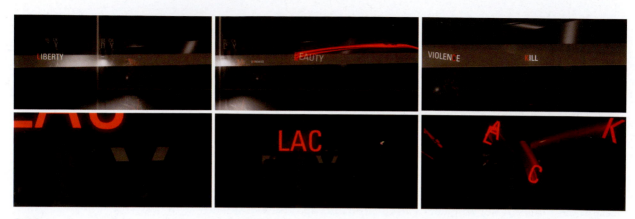

6.40
Frames from the open to *Black Day to Freedom*. Courtesy of Renascent.

paper. At times, words are crossed out and appear partially concealed with overlying images and textures to portray the conceptual element of confusion. (This is further enhanced by the soundtrack, which plays in reverse during the film's "dream" sequence.) Variations of scale, orientation, transparency, and the speed in which the type animates, are well choreographed to interact with the moving and changing image content (**6.31**).

"Type is like actors to me. It takes on characteristics of its own. When I was younger, I used to pick a word from the dictionary and then try to design it so that I could make the word do what it meant."
—Kyle Cooper

Apart from communication, typographic form and motion can be explored on a purely formal, aesthetic basis. For example, a distinctive combination of both clear and abstracted letterforms, along with a sharp and bold color palette, helped position Court TV's daytime show branding by adding depth and energy to the composition (**6.41**).

We have been conditioned to view typography as being distinct from images. One of the keys to innovative design is to consider text elements as pure forms that consist of positive and negative shapes. For example, letters such as "d," "g," and "o" contain closed shapes, while others such as "s," "f," and "w" are open shapes. Closed and open spaces emerge when letterforms are juxtaposed or superimposed. Additionally, letterforms that are in close proximity create negative shapes between them, which are sometimes referred to as counterforms.

6.41
Frames from Court TV's daytime show package. Courtesy of ZONA Design, Inc.

6.42
In a beginning-level typography assignment, students investigated the aesthetic qualities of form by developing studies that integrated display type, body text, and a symbol from the Greek alphabet. Design by Michael Michaelides, Fitchburg State College, Professor Jon Krasner.

6.43
Closed and open spaces emerge from positive and negative shapes and spaces of letterforms. Letterforms that are in close proximity create negative shapes or *counterforms*.

In a motion graphic design class, students were asked to animate their first and last initials to create dynamic relationships of form and space. They were encouraged to consider pictorial issues such as asymmetry, positive and negative, scale contrast, and the abandonment of figure-ground (**6.45–6.46**).

6.44
Frames from the opening title sequence to *Lawbreakers*, a show on the History Channel. Courtesy of ZONA Design, Inc.

The treatment of the letterforms corresponds to the visuals of shattered glass and aged sepia-tone photographs.

6.45

Frames from a kinetic typography assignment. by Takafumi Fujimura, Fitchburg State College, Professor Jon Krasner.

Takafumi Fujimura combined the properties of position, rotation, and scale to give the characters believable, lifelike movements.

6.46

Frames from a 4D type project, by Kathy Beck, Fitchburg State College, Professor Jon Krasner.

Accelerated movements of the small letterforms appear to be trampling down the larger letter.

6.47

Typography assignment based on a symbol from the Greek alphabet, by Becky Foden, Fitchburg State College, Professor Jon Krasner.

Typographic form, dynamic motion, and visual hierarchy were given strong attention.

Sigma is the 18th letter of the Greek alphabet in the system of Greek numerals it has a value of 200. When used at the end of a word, and the word is not upper case, the final form is used. The letter is ultimately derived from Phoenician Sin. However its name derives from Smekh. It stands for the summation operator.

SIGMA

The upper-case letter Ω is used as a symbol; it is also used often outside its Greek alphabetical context in literature, advertising and other forms of human expression. Omega is the 24th and last letter of the Greek alphabet.

OMEGA

6.48

Frames from an online advertisement for Lycos. Courtesy of hillmancurtis, inc.

6.49

In a dynamic type assignment, students were challenged to convey a word's intrinsic meaning in print through implied motion. Fitchburg State College, Professor Jon Krasner.

6.50

Frames from a "self referential type" assignment by Ryan Hammond, Ringling School of Art and Design, Professor Eddy Roberts.

6.51

Frames from a "self referential type" assignment by Jonah Page, Ringling School of Art and Design, Professor Eddy Roberts.

6.52

Frame from an animated creative writing project, by Amanda Woodward, Ringling School of Art & Design, Professor Eddy Roberts.

6.53

Frames from "Invisible Cities," by Ryan Duda, Professor Jan Kubasiewicz, Dynamic Typography (2003), Massachusetts College of Art.

A combination of 2D and 3D elements heighten the composition's spatial depth and give the type a highly textural flavor.

expression through typeface

In addition to a font's ability to look good and move smoothly is its ability to match the style and tone of the other elements in a composition. For example, Dutch motion graphic designer Joost Korngold is specific in his preference for simple, sans serif fonts, such as Universe Condensed, to complement the style of his work (**6.54**).

6.54
Frames from *Archetype*, "an inherited pattern of thought or symbolic imagery derived from the past collective experience and present in the individual unconscious." Courtesy of Joost Korngold. © Renascent.

On a conceptual level, choosing typefaces that appropriately express the message is key to achieving effective communication. "Planted," a motion identity for Capacity™ design agency in Los Angeles, involved designing a full typeface, Capacity Light, which was based on the company's logo-type (**Chapter 9, figure 9.3**). The team wanted a font that could be used for all design purposes and incorporated it into their Web site (www.capacity.tv). In Capacity's 2006 rebranding of the peacock network, NBC Magic's choice font was Klavikac (**Chapter 2, figure 2.54**). According to creative director Ellerey Gave, "It's usually bad news to hear that we have to use a certain typeface, but in this case, we were actually really pleased with their selection. It was designed within the last few years and has seemed to lend itself well to the interactive feel of the branding without trying too hard to be digital." (*Digital Arts* magazine, Neil Bennett)

In 2007, Viewpoint Creative, an award-winning design agency in Boston and Los Angeles, was given the task of creating a new and unusual typographic treatment for the third season's opening to Discovery Channel's *Deadliest Catch* television series (**6.55**). This documentary-style series depicts the incredibly brutal conditions and lifestyle that commercial crab fishermen experience aboard their fishing boats in the Bering Sea during the Alaskan and Opilio crab fishing seasons. Discovery requested a bold and crisp look that conveyed the content of the program from a human perspective. After experimenting with at least ten different fonts, styles, weights, lowercase, and a mixture of lowercase and capitals, Viewpoint decided that an uppercase typeface would yield a more powerful cinematic experience. The distressed, eroded quality of the letterforms, along with their traditional looking old style serifs, gives the typeface a physical, tactile quality that reflects the hardships that the fishermen encounter out at sea. The type's centered alignment and positioning is straightforward in accordance with the visuals. Its transparency allows the background images of sky and sea to partially show through. This treatment effectively conveys the ominous and mysterious atmosphere of the series.

"I've seen beautiful commercials where the photography is unbelievable, but then some graphic designer comes in and throws on some cheesy animation or bad type. They've taken this wonderful series of images and made it pedestrian."
—Kyle Cooper

6.55
Frame from the opening title sequence to *Deadliest Catch*. *Deadliest Catch* is a trademark owned by Discovery Communications, LLC. Image courtesy of Viewpoint Creative and Discovery Communications, LLC and used under permission by Discovery Communications, LLC.

type anatomy 101

The basic anatomy of letterforms began over 500 years ago, when monks were hunched over in scriptoriums engaged in the painstaking process of hand lettering Bibles. Understanding the "anatomy" of letters gives you an appreciation for the integrity of typeface design and makes it easier to identify and select a given font in order to make purposeful design decisions.

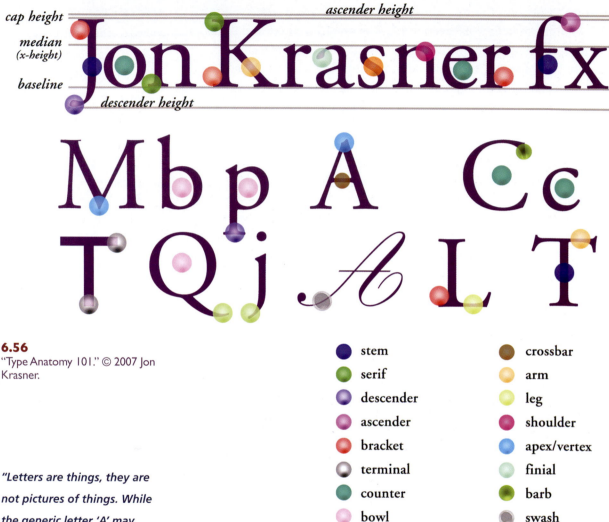

cap height

median
(x-height)

baseline

ascender height

descender height

6.56
"Type Anatomy 101." © 2007 Jon Krasner.

- ● stem
- ● serif
- ● descender
- ● ascender
- ● bracket
- ● terminal
- ● counter
- ● bowl
- ● spine
- ● crossbar
- ● arm
- ● leg
- ● shoulder
- ● apex/vertex
- ● finial
- ● barb
- ● swash
- ● tail

"Letters are things, they are not pictures of things. While the generic letter 'A' may indicate a variety of sounds, the lowercase 'a' as rendered in Bembo is a specific character, different in form and sensibility from the lowercase 'a' rendered in Bauer Bodoni, Serifa 55, Helvetica, or Futura. All five convey the idea of 'A'; each presents a unique esthetic."

—*Eric Gill*

typeface classifications

A well-combined variety of typefaces can contribute to overall message or story, set the stage or emotional tone, and bring expression and harmony to a design. Since every typeface has distinct aesthetic and functional qualities with regard to its proportions, line weights, widths, directional slants, and so forth, it is important to understand basic classifications of fonts. The classifications that are described in this section demonstrate a response to advancements in technology, commercial needs, and aesthetic trends. Within these classifications, each typeface has its own expressive personality.

Blackletter:

Blackletter typefaces are derived from handwritten manuscripts in Europe during the Medieval era. The Gutenberg Bible, the first book to be printed with movable type, was set in a Blackletter face to emulate the look of these illuminated manuscripts. Examples include Cloister Black and Goudy Text. Approximate date: 1450.

Oldstyle:

Oldstyle typefaces were developed during the Italian Renaissance to replace the heavy gothic feel of the Blackletter style. Based on ancient Roman inscriptions and lowercase letterforms used by humanist scholars for book copying, they are characterized by bracketed serifs and a low contrast between thick and thin strokes. Examples include Bembo, Garamond, Caslon, Jenson, and Palatino. Approximate date: 1475.

Italic:

Italic typefaces mimic the look of Italian handwriting. This classification has unique features not found in upright roman faces. Venetian printer Aldus Manutius and his type designer, Francesco Griffo are credited with creating the first italic typeface. From a practical standpoint, this condensed style allowed more words per page. Approximate date: 1500.

Script:

Script typefaces have been designed to replicate engraved calligraphy. Due to their high degree of embellishment, they are not recommended for lengthy body text. Examples include Kuenstler Script, Mistral, and Snell Roundhand. Approximate date: 1550.

Transitional:

Transitional typefaces were designed to refine Oldstyle letterforms as a response to advances in casting and printing. Thick-to-thin relationships are exaggerated, and bracketing between the stem stroke and the serif is lightened. Examples include Cloister Black, Goudy Baskerville, Bulmer, Century, and Times Roman. Approximate date: 1750.

Modern:

Modern typefaces were developed in the late eighteenth century as a further rationalization of Oldstyle fonts and continued through most of the nineteenth century. They are characterized by extreme contrasts between thick and thin strokes. Examples include Bodoni, Didot, Bell, and Walbaum. Approximate date: 1775.

The following type foundries can be used as a resource for learning more about and purchasing typefaces:

Adobe Type Library
http://store.adobe.com/type

Bitstream
http://www.bitstream.com/

Linotype
http://www.linotype.com

Castletype
http://www.castletype.com

Identifont
http://www.identifont.com

Square and Slab Serif:

In response to needs of advertising in commercial printing, Square Serif fonts were designed with heavy bracketed serifs with minimal variation between thick and thin strokes. When the brackets were eventually eliminated, this style became known as the "Slab Serif." Examples of Square and Slab Serif fonts include Clarendon, Memphis, Rockwell, and Serifa. Approximate date: 1825.

Sans Serif:

First introduced by William Caslon IV in 1816, Sans Serif typefaces became widespread beginning in the twentieth century. These fonts are described in five classifications: Grotesque, Neo-Grotesque, Geometric, Humanist, and Informal. Within each classification, these fonts share similarities in stroke thickness, weight, and basic geometry. Examples include Helvetica, Arial, Futura, Univers, Frutiger, Gill Sans, Meta, and Akzidenz Grotesk. Approximate date: 1900.

Serif/Sans Serif:

Serif/Sans Serif typefaces are the most recent development, based on the notion that a family of fonts can be designed with and without serifs. Examples include Rotis, Stone, and Scala. Approximate date: 1990.

Integrating Images, Live-Action, & Type

The possibilities that exist when animated images, live-action, and typography are combined are endless, and they can push the limits of artistic experimentation and expression. In a Sunday morning show package for *Breakfast With The Arts*, ZONA Design moved away from a classical mindset toward a younger demographic by integrating live-action, images, and expressive typography (**6.57**). The piece begins with a coffee mug that is lifted, leaving a ring on the table. According to creative director Zoa Martinez, "The exhilaration, the caffeine syndrome begins. Typography evolves and comes jetting out from under and behind the mug enumerating the many subjects covered in the programming; music, performance, the Arts. The combination of this typography and images of performers—juxtaposed with arrangements of flowers, film strips, unusual perspectives, action painting, an architectural stage, and a DJ spinning wax, provide the color and texture that give the package its youthful exuberance."

In **figure 6.58,** Blur's show package for Nickelodeon's *Kids' Choice Awards* 2006 combined 3D imagery, such as ribbons and smoke trails, with 2D graphics. These elements were carefully choreographed and composited in After Effects to create a Rock 'n' Roll circus theme that embraced psychedelic poster art from the Fillmore in San Francisco in the 1960s. This piece was geared toward kids between the ages of 8–13.

ZOOM, Belief's comprehensive network package for Times India's Zoom Channel is another example of how live-action images can be integrated with three-dimensional graphics and type. A cross between "E!" and "Fine Living," this example of India's expanding airwaves offers a behind-the-scenes look into celebrity lifestyles. A surreal discotheque environment, combined with slick, exotic images of glamour and glitz, conveys the sexy feel of this new Indian network (**6.59**). In the first sequence, Belief shot the car on a black stage to avoid any reflection or spill problems. Next, they

6.57
Frames from *Breakfast With The Arts.* Courtesy of ZONA Design.

6.58
Frames from a graphics package for Nickelodeon's *Kids' Choice Awards* 2006. Courtesy of Blur.

filmed various types of moving foreground and background elements to provide flexibility for the compositing stage. The studio was split into three areas to obtain the amount of shots needed: a green screen area on rises to get low camera angles, an enclosed area covered in black that allowed the team to wet the floors and control the smoke while shooting the cars, and the interior nightclub set where they suspended large metal sheets on revolving motors. According to Mike Goedecke, Belief's founder/executive creative director, "What's really unique about Zoom is the fact that it's an Indian network, but the execs there wanted it to evoke a very western sensibility in style and design. We definitely achieved this with our upscale nightclub/lounge setting." Richard Gledhill, Belief's creative director, stated: "It was imperative that the look and feel of this new channel be glossy and exclusive, yet mysterious. By shooting the talent in a dark environment with lots of hard edge lighting, we were able to achieve that effect. The exotic car and limousine really helped to pull off the exclusive, VIP nature of this new channel."

6.59
Frames from *ZOOM*, a network package for Times India's Zoom Channel. Courtesy of Belief.

6.60
Frames from the show opening to *À la carte*, a television series on Radio-Canada television about places around Western Canada.

Two-dimensional graphics and type were animated and then composited with live-action video clips that run throughout the piece. Courtesy of Studio Blanc.

Summary

The union of images and typography can function as a visual language in a time-based environment.

Form can symbolize or suggest ideas, imply spatial depth, and help organize information by establishing hierarchy. Value and color can create mood, symbolize ideas, and express emotions to produce a desired audience response. Understanding methods of color contrast and how color can evoke different emotional responses according to individual, gender, and culture can help dictate how we make color decisions. Texture and pattern can also add contrast and depth to a composition while providing viewers with the sensory experience of touch.

In recent years, live-action images have had a stronger presence in motion graphics due to the growing cinematic vocabulary of designers and technical advancements in compositing. Filmic properties such as tone and contrast and cinematic properties such as lighting, depth-of-field, focus, camera angle, shot size, and mobile framing must serve the story and in some cases, even can become the story. Motion graphic designers have become liberated to "think outside of the box" and experiment with new ways of incorporating live-action content into motion graphics compositions.

Kinetic forms of typography can convey emotions through graphic impact and movement. In many cases, type no longer reads as text but is perceived as physical shapes that create complex semiotic experiences through metaphor and motion.

We have been conditioned to view typography as being distinct from images. One of the keys to innovative design is to consider text elements as pure forms that consist of positive and negative shapes. Choosing typefaces that appropriately express the message is also critical to achieving effective communication. Understanding the basic anatomy of letterforms and general classifications of fonts gives you an appreciation for the integrity of typeface design and makes it easier to identify and select fonts in order to make purposeful design decisions.

The unusual creative possibilities that exist when animated images, live-action, and typography are combined can push the limits of artistic experimentation and expression.

Assignments

image and motion #1

overview
Visual style can have an enormous impact on the messages that images convey. In a time-based environment, movement can also convey messages and emotions.

The self-portrait is one of the earliest methods of communicating inner feelings and emotions to the outside world. Since shoes can say a lot about their owner, you will create an animated self-portrait based on your shoes. You are to choreograph the movement according to the subject's visual characteristics of line, form, color, texture, and pattern. The animation will demonstrate a dynamic interplay between image and motion.

objectives
1. To investigate how time-based images can create meaning.
2. To discover how motion can strengthen visual messages.

stages
Begin by creating a storyboard sketch that demonstrates how the animations will be tailored toward the style of the shoes. Critique the

sketches, and develop revised editions that clarify the events and types of movements and transitions that will occur.

Image the shoes from one or more direct scans or scanned photographs. Alternatively, you may recreate them using any one or combination of conventional or digital processes such as drawing, painting, rubbing, collage, photocopy, and digital manipulation. Be sure to stay true to the integrity of the original image.

If you decide to develop a motion test or an animatic, be open to new ideas during production. You may go back to your initial sketches if you wish to explore other possibilities.

Animate the imagery using any combination of frame-by-frame and interpolation processes discussed in Chapter 10.

specifications

You may use any combination of traditional and digital media to create the illustrations. Background elements or supplemental images and type are prohibited, since your goal is to focus on the style and movement of the image alone. You may, however, use the image more than once, if necessary. The duration of the composition should be between 15–20 seconds. It is critical that you are able to tell a story within a specified time frame, so be sure to adhere to this limit.

considerations

Consider how the style of the movement complements the image's visual style. Lifelike, nonlinear motions that accelerate and decelerate will generate a different feeling than mechanical, uniform motions. Be sure to give attention to the birth and death of the image, and how the device of frame mobility might be used to accentuate the style of the image's visual and kinetic qualities.

Last, consider the association and possible interaction of the image with the frame's edges as it moves throughout the composition.

image and motion #2

overview

You will create an animation based on a group of objects that have sentimental meaning to you.

objectives

1. To investigate how animated images can create meaning.
2. To discover how motion can enhance visual messages.

stages

Collect 5–8 small artifacts that describe your past, present, or future. Write a short 30–50 word explanation of each item. Be descriptive, yet open to interpretation, allowing the readers to use their imagination. Your description may be literal or metaphorical. Consider the roles of language, gender, inflection, and mood.

Recreate the artifacts using any combination of conventional and digital processes including drawing, painting, rubbing, collage, photocopy alteration, and digital manipulation. Keep in mind that the treatment of the content will set the mood or tone of the piece. Images may be symbolic, metaphorical, or iconic and can range from realistic to abstract or any form in between. Free experimentation is highly encouraged.

Animate the imagery using any combination of frame-by-frame and key frame interpolation processes discussed in Chapter 10.

specifications

The content should be created and scanned at a size that is large enough to ensure stable quality if they are to be scaled up in the animation.

considerations

Consider the inherent meaning of these artifacts with respect to your written descriptions. Consider how visual style and motion style can support and enhance the other. Be imaginative and expressive!

animation and live-action

overview

You will investigate kinetic relationships between animation and live-action content.

objectives

1. To become aware of how animated motion can influence how natural, live-action movement is perceived.
2. To explore how motion can be choreographed to support live-action.

stages

Videotape 10–15 seconds of a figure moving in space. Import the footage

into a motion graphics program of your choice, and create 2–3 additional graphic images. These may be lines, simple abstract, geometric shapes, or a combination of lines and shapes.

In a composition integrating the live-action and graphics, animate the graphic elements in a way that relates to the movements of the live-action footage. Create a second study, this time choreographing the animation to complement the live-action motion.

considerations

Consider how supporting and contradictory motions influence your overall perception of the animation. How can these scenarios potentially communicate a concept with further development? How might the relationships between the animated motions and live-action motions work together on a purely formal, aesthetic level to heighten the viewer's interest?

type as kinetic form

overview

We have been conditioned to view typography as being distinct from images. Considering text elements as pure geometric forms that consist of positive and negative shapes is a key to innovative design.

You will develop an animation using the first and last initials.

objective

To investigate pictorial and kinetic relationships between positive and negative forms.

specifications

You are restricted to one sans-serif typeface and black and white. Colors, gray tones, drop shadows, and effects are prohibited, since your goal is to focus on the form and motion. The duration will be 10 seconds. It is critical that you are able to tell a story within a specified time frame, so be sure to adhere to this limit. Specify your frame dimensions and frame rate according to the final format of delivery.

stages

Develop a rough storyboard sketch and critique it as you would critique a film script. Then develop an edited iteration that conveys the events more clearly.

If you decide to develop an animatic, be sure to clarify the types of motion, camera angles, and transitions that will occur.

Keep an open mind and be prepared to deviate, to an extent, from your original ideas. You may decide to go back to your initial sketches to explore other possibilities.

considerations

Top priority should be given to positive and negative form as it changes through motion and transition. Asymmetry, scale contrast, and the abandonment of figure-ground should also be considered. The manner in which elements appear and leave the frame (birth and death) should also be considered. Last, consider the interaction of the letterforms with the edges of the frame.

"typographic fortunes"

overview

You will create a self-portrait based on your fortune using only letterforms, numbers, and punctuation marks.

objectives

1. To use typographic form and motion as expressive tools.
2. To explore typography as image.

stages

Enjoy a good meal at your favorite Chinese restaurant! Be sure to get a fortune cookie on your way out, and read your fortune.

Recreate the fortune by cutting out letters from newspapers, magazines, and other printed sources, and scan them.

Animate the type using any one or combination of frame-by-frame or interpolation processes as discussed in Chapter 10.

specifications

You are only allowed to use type. Images are prohibited. All elements must be appropriated from physical sources such as books, newspapers, magazines, and other printed materials. You may duplicate elements in your animation as many times as you wish.

considerations

Typographic elements should represent your concept by virtue of their unique geometric qualities and their movement in space. Consider how

motion can enhance the intrinsic meaning of the concept. Since you are allowed to mix and match different fonts from appropriated sources, be deliberate in choosing typefaces that best express the message.

metamorphosis: form and transition

overview
You will develop a metamorphosis based on two illustrations that express two different meanings to create a third meaning or tertium quid.

objectives
1. To communicate the meaning of a concept by synthesizing two ideas.
2. To imply motion and transition in a print-based context.

stages
Choose two different objects and create a graphic interpretation of each. You may use black marker, assemble them from cut-out pieces of construction paper, or generate them digitally. They should show a high level of refinement by reducing detail and simplifying form.

Create a five-step metamorphosis that illustrates smooth transitions between the images. The fourth image should demonstrate a 50/50 synthesis of the first and last.

specifications
Each composition must be the same size and should be no larger than 10" vertically or horizontally. Use black, white and a maximum of two gray tones. Colors, outlines, patterns, and shading are prohibited, since the focus of this assignment is on form and implied motion.

This project requires careful planning through the development of thumbnail sketches. The more possibilities you exhaust on paper, the more dynamic the composition will be.

considerations
Be creative and allow your imagination to run wild. Don't be afraid to interject humor. Consider implied primary motion versus implied secondary or camera motion. Consider how figure and ground will be treated, and give attention to the relationship of elements to the frame's edges. The background should also be given attention. Background shapes can be static, or they can imply movement or change. Last, consider repetition and variation of positive and negative, and visual contrast of shape, size, and spatial orientation.

7

the pictorial composition
designing in space

There are many ways that pictorial compositional space has been interpreted, constructed, and deployed in motion graphics compositions. Innovative creative strategies have given designers the potential of overcoming the homogeny of the fixed rectangular frame that has been associated with conventional film and television production.

"The painter's canvas was too limited for me. I have treated canvas and wooden board as a building site, which placed the fewest restrictions on my constructional ideas."
—El Lissitzky

00:00:00:07

Space and Composition: An Overview

The formal aspects of pictorial composition can be compared to the grammar of a language. In writing, good literature and poetry is about organization, sentence structure, and style, as opposed to just words and subject matter.

Space is interpreted through the prism of composition—in this case, pictorial (versus sequential) composition. Spatial composition is the blueprint from which elements are organized. In painting, it describes the two-dimensional canvas. In graphic design, it is the viewing area of a poster or an interface. In motion graphics, it describes the environment containing the action—the frame.

Through history, artists have explored different types of space because of its affinity with the content they are trying to express. *Primitive space* (or *flat space*), for example, is characterized by a flat surface that has little or no depth or perspective and is devoid of three dimensions. Utilized by many early and untrained artists, it often has a decorative quality, emphasizing pure design, flat colors, and repetitive patterns. During the late nineteenth century, many French painters and poster designers were influenced by Japanese prints and began an evolution toward using primitive space in western painting, a tradition that continues today. *Illusionistic space* (also referred to as *Renaissance space* or *traditional space*) was developed during the Italian Renaissance by painters such as Piero della Francesca, Filippo Brunelleschi, and Leonardo da Vinci, who used the devices of linear and atmospheric perspective to depict forms receding into space. (Brunelleschi is credited with inventing linear perspective.) *Modern space* was developed by the Post-Impressionist painter Paul Cezanne during the early twentieth century. His unique method of comparing and contrasting planes of color combined, resulted in a combination of primitive and illusionistic space, which had a major impact on twentieth century art. Modern space was further developed by Jackson Pollock, whose drip paintings resemble an infinite or all-over space.

Compositional styles have differed across cultures and across art movements throughout history. Japanese painting, for example, delights in the generous use of negative space and intuitive placement of objects within an asymmetrical layout. Art Nouveau, Arts and Crafts, and Vienna Secessionist artists were characterized by their use of arbitrary compositional arrangements, while De Stijl and Constructivist painters carried abstraction to its furthest limits in their quest for rational, geometric order.

In animation, experimental film pioneers of the 1920s gave high regard to the manner that pictorial space was organized. Hans Richter, for example, saw animation as a logical step for expressing the kinetic interplay between positive and negative forms and considered the film frame as a space that could be divided and "orchestrated" in time. In films like *Rhythmus 21* and *Rhythmus 23*, motion was choreographed in horizontal and vertical movements and scale changes of the forms to establish depth. Nonobjective lines and rectangles move in alignment, as figure-ground is broken from the changing interplay between positive and negative space. Taken out of context, individual frames from Richter's *Rhythmus* series demonstrate a liberal use of negative space, an interplay between figure and ground, and a purposeful alignment of shapes to the frame's edges (**Chapter 1, figure 1.12**).

Principles of Composition

Today, designers continue to explore how compositional principles can be used to express concepts and emotions and to establish clear and effective communication.

unity

Most of us seek unity in our day-to-day experiences to make order of "the big picture." In design, unity is an underlying principle that refers to the coherence of the whole—the sense that all of the parts are working together to achieve an overall harmony. It creates a sense of cohesiveness within a composition and is one of the primary ways designers create stability.

gestalt theory

Originating in Germany around 1912, the Gestalt school of psychology explored how visual elements in a composition could be comprised into an integrated "whole" to achieve a sense of harmony. The conviction of this theory is that the whole is greater than the summation of its parts. A guitar, for example, is made up of strings, a body, a neck, tuning knobs, and so forth. Each of these components is unique and can be examined individually. The guitar as a single unit, however, has a greater presence than its individual components. This overall perception gives a sense of purpose and completeness to an object or to a composition through certain visual cues such as balance, proportion, and proximity.

Theorists have indicated that humans have a propensity to group things together unconsciously by formulating connections and relationships among and between elements in a design.

case studies

Pictorial unity in motion graphics can be established through consistency in the use of elements and their visual properties such as value, color, and texture. Additionally, it is achieved in the treatment of elements with regard to their relative scale, positioning, orientation, and proximity in the frame.

In a teaser for Artevo, the largest, most organized, fine art collection in North America, the shapes of the logo are cleverly repeated and animated in various themes that occur throughout the composition. Each theme creates a different mood and ambience through changing backgrounds, colors, and typography. The consistency in the use of the logo and similarity of background imagery, as well as the repetition and variation of both background and foreground elements and colors maintain a sense of order and unity (**7.2**).

7.2
Frames from a teaser for Artevo.
Courtesy of Studio Dialog.

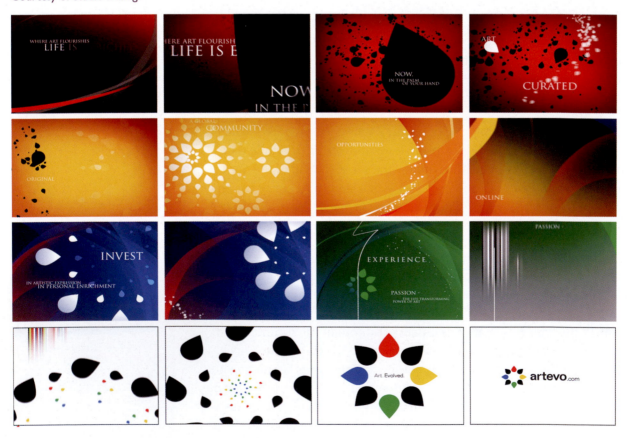

The program opener for *Entertainment Weekly's* "The Biggest Little Things of 2004" (**7.3**) achieves unity through repeating patterns of stripes that are interwoven between graphic silhouettes of figures. Between each transition, there is consistency in the relationships of colors, patterns, and subjects that are presented in each scene.

7.3
Frames from the show opener to *Entertainment Weekly's* "The Biggest Little Things of 2004." Courtesy of Nailgun*

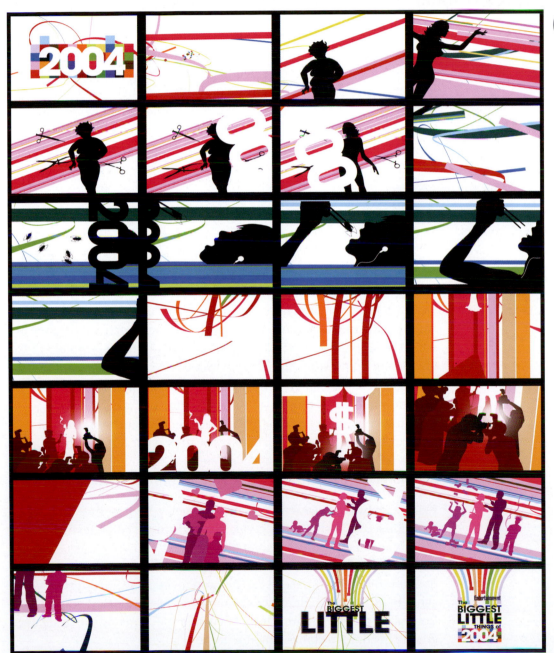

7.4
Because there is a wide variety of images that range in graphic style, color, size, and proximity, a large background element helps to establish unity. © Jon Krasner.

In **figure 7.4**, various images ranging in graphic style, shape, color, size, and spatial proximity are unified by a large screened object in the background. This solution is commonly used in complex compositions containing multiple levels of information.

balance

Balance is a primary component of our day-to-day lives and one of the primary methods of achieving unity. We seek balance in our experiences to make order out of work and play, finances, family life, and so forth. Within the frame, balance suggests a sense of cohesiveness. It is one of the primary devices that designers use to create stability or instability.

Symmetrical balance is the division of a space into parts that are equal in size and weight. As human beings, we are symmetrically balanced on a vertical plane. Synthetic objects, such as cars, tables, and chairs, also exhibit symmetry. In the early days of film, titles were usually placed symmetrically in the center of the frame. *Radial balance* is a type of symmetrical balance in which images are emitted from a central focal point (i.e., ripples emanating from a stone thrown into water). *Crystallographic balance* (also referred to as "all over" balance) contains numerous focal points that are strategically arranged into a repeating pattern. Quilts, for example, consist of crystallographic patterns that are organized into gridlike designs. The random effect of scattered confetti also produces a sense of crystallographic balance that is evenly distributed throughout. However, there is too much uniformity without enough variety.

Balance does not always necessitate symmetry. For instance, a small object in a composition that is visually engaging in color, texture, or shape can balance a much larger object that is visually less exciting. *Asymmetrical balance* is an informal type of balance that achieves a dynamic division of space. It can be used to create a more dynamic sense of organization or establish emphasis. Asymmetrical compositions allow a more dynamic use of negative space, giving the designer greater freedom in composing the frame.

figure and ground

Ground (also known as the *picture plane*) defines the surface area of a composition; *figure* refers to the subjects that occupy the foreground space. Throughout history, works of art have ranged from clearly defined delineations of foreground and background elements (for example, a figure posing in a landscape) to the complete eradication of figure and ground, where space becomes ambiguous to the viewer. Abstract Expressionist and Cubist paintings have continuous two-dimensional space, where negative and positive forms are interchangeable (7.8). In motion graphics, figure and ground relationships can change as the positioning, orientation, and sizes of elements vary over time. For example, the compositions in **figures 7.7** through **7.9** emphasize the structural and dynamic use of positive and negative shape interaction. As the positioning of the elements shift in the frame, foreground and background spaces become interchangeable.

7.5
In this asymmetrical composition, varying shapes and spaces are unevenly dispersed, creating an active and energetic picture plane. Color is used to counteract the dissimilarity of shapes, sizes, and positions to achieve balance.
© Jon Krasner.

7.6
left: "Eketete and Erbeybuye."
top right: "Igbo and His People."
bottom right: "Chaos." Courtesy
of the Harmon Foundation
Collection and NARA.

These three paintings vary from
a clear interpretation of figure-
ground in which foreground and
background relationships are
clearly defined to its extreme
obliteration through the use of
heavily layered visuals that vary
in color, texture, and opacity.

7.7
Frames from a network
re-launch for SCI FI Channel.
Courtesy of Flying Machine.

7.8
Frames from a fictional station ID
assignment, by Jim Reynolds,
Fitchburg State College, Professor
Jon Krasner.

The black shape on the red
ground becomes the ground that
holds the red shapes.

negative space

Related to figure and ground is the concept of positive and negative
space. Positive spaces are areas that are occupied in a composition;
negative spaces are areas that are unoccupied or empty. Negative
space (also referred to as ground) is analogous to white space in print
design and is evaluated using the same criteria that applies to the rest
of the elements in a design—unity, balance, contrast, etc. Negative
space can add to or detract from a composition's overall balance and
rhythm and can provide visual emphasis and eye movement.

Dramatic or subtle, negative space can affect the viewer visually and
emotionally. In a series of network identifications for the Middle
Eastern network Al Jazeera Sport, live footage of athletes are isolated
from their natural environment and integrated into minimal, dream-
like landscapes to depict duality between figure and space, allowing
us to focus on the subject's "bare essentials" (**Chapter 5, figure 5.28**).
Designers often use extensive negative space to create a feeling of
sophistication and elegance for upscale brands of clothing, shoes, and
cosmetics to express their high level of quality to viewers. An example
of this is German designer Daniel Jennett's in-store video presenta-
tion for ESCADA, an international luxury fashion group specializing in
women's fashion (**Chapter 9, figures 9.25-9.26**).

From an aesthetic standpoint, negative space provides breathing room
for the eye, making the frame feel less dense, confusing, or overwhelm-
ing. It is important to realize that negative space is not just empty

*"One can furnish a room
very luxuriously by taking
out furniture rather than
putting it in."*
—Francis Jourdain

*Foundation drawing classes often
disregard the fundamental principle
of composition. Although students
are taught to master proportion, to
model through light and shadow,
and to be expressive with the medi-
um, they are seldom provided with
adequate information on how to
plan their picture space. As a result,
negative space is poorly planned
and does little to contribute toward
the expression of the piece.*

7.10

Frames from a series of program IDs for *Unsolved History* (2002–2003). Courtesy of Discovery Channel and Viewpoint Creative.

space that serves as a ground for positive components; rather, it has weight and mass and should be deliberately planned. In a series of program IDs for *Unsolved History*, a show on Discovery Channel that investigates mysteries of the past, negative space is strategically constructed to organize free-floating photographic images, graphic images and symbols, and typographic information (**7.10**).

size and scale

Many compositional possibilities can be derived from manipulating size and scale. *Size* relates to the format (or the frame) that elements are placed in; *scale* describes the relative relationships that exist between elements. Objects that are in scale give the appearance of belonging together; objects that are out of scale exhibit a visual imbalance. Whether objects are static or moving, both devices play a major role in composition. Size can contribute conceptually to the message being communicated by establishing weight or mass. For example, an object may appear "heavier" or "lighter" depending on the dimensions of the frame it occupies. Size can also help improve composition. The use of large elements gives you the opportunity to divide a frame into a variety of positive and negative structures. These, in turn, can establish a more active sense of "architecture" from which other elements can be positioned and directed to move along.

edge

Throughout art history, edge relationships have been a fundamental component of design. They define a composition's parameters and play a critical role in establishing eye movement and hierarchy. Early Egyptian manuscripts, which established consistent design formats with rigid sets of compositional rules, strongly emphasized the relationship of visuals to the borders of the picture plane. Edges were given

7.11

An image can appear "heavy" or "light" depending on the dimensions of the frame it occupies.

considerable attention with regard to the placement of illustrations and hieroglyphics. Horizontal bands containing small illustrations were often placed across the top, while larger images and adjacent hieroglyphic text columns hung from the top border (**7.12**).

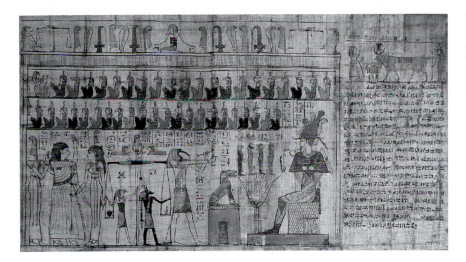

7.12
Psychostasis (weighing of the souls). Book of the Dead of Tsekhons. Ptolemaic period. Museo Egizio, Turin © Erich Lessing/Art Resource, NY.

In motion graphics, the frame's edges provide you with four possible points of entry and exit into. For example, an object can touch an edge, and its movement can be strategically aligned to it, reinforcing the vertical or horizontal nature of the frame. In a television commercial for Citibank, David Carson's alignment of elements to the edges of the frame emphasizes its horizontal and vertical structure. (**7.13**).

direction

7.13
Frames from a commercial for Citibank. Courtesy of David Carson.

Direction has powerful control over how a viewer's eye moves within a space. It helps establish a composition's sense of purpose by providing a point of entry and exit for the viewer, and in complex compositions, can be used to organize, connect, or separate dominant and subordinate elements. Direction can also be used as a means of counteracting motion in order to stabilize eye movement within the frame. For

example, the movement of a figure in one direction can be neutralized by another figure's movement in the opposite direction. In **figure 7.14**, the horizontal motion of an element is stabilized with a vertical wipe that exposes a new background image. In **figure 7.15**, a large letterform animates from the bottom left corner toward the top right edge of the frame. A series of smaller typographic items, aligned parallel to the image's path of motion, animate into the frame from the left edge, reinforcing eye movement diagonally upward.

7.14
A horizontal movement across the frame is counteracted by a vertical transitional wipe.

contrast

Visual contrast is one of the most important principles of graphic communication and expression. It can introduce variety into composition, clarify or simplify information, intensify meaning, or refine the message being communicated. The most standard types of contrast are scale, value, color, shape, surface, proximity, and orientation.

on of motion

direction of motion re-enforced by the items

Scale is the most elemental and widely used form of contrast. Along with value and color, it can emphasize a point of interest or create the illusion of spatial depth. In visual perception, smaller objects naturally appear to recede into the background, while larger objects appear to project closer to the viewing picture plane. Extreme scale differences can capture the imagination of the viewer. For example, taking an object out of its original context and juxtaposing it with other objects that have been altered in size can dramatize its impact, as evidenced in **figures 7.19** through **7.21**. In these compositions, scale differences create the illusion of depth, accentuate the impact of the subject, and enhance the visual impact of the frame. In the opener for *Arte Kurzschluss*, a weekly TV program that features short, experimental films on the Franco-German TV network, the extreme scale between human figures and film equipment fracture our logical sense of space (**7.16**). The opening to a teen-targeted identity package for Cosmopolitan Television also employs scale contrast in the juxtaposing of spirited, joyful young women and iconic objects to suggest a playful, liberating atmosphere (**7.17**).

direction of motion re-enforced by the alignment of items to the letter's path

7.15
The alignment and repetition of structures tilt the eye toward the top right edge of the frame.

7.16
Frames from *Arte Kurzschlus*. Courtesy of Velvet

Value, which measures the lightness or darkness of an image's tones or colors, is also a widely practiced form of contrast. (As newborns, we first distinguish objects in black and white.) It can enrich visual messages and can be used to create focal points in a composition. In the title sequence to the film *Magnolia* (1999), an image of a blooming magnolia flower is superimposed with street maps and content from the film, producing a dynamic blending of tonal ranges. This interplay between light and dark helps express the concept of people's lives overlapping and intersecting. On an aesthetic level, it helps clearly differentiate the elements in the frame (**7.18**).

Next to value, color contrasts can be used to create mood, symbolize ideas, and express emotions to produce a desired audience response. It is important to understand that color is relative to its surroundings; a color that stands alone in a visual field is perceived differently than a color that is surrounded by other colors. For example, *value contrast* between light and dark tonalities is the strongest method of distinguishing colors. Generally, colors containing a greater range of values produce more contrast than those that are close in value. *Temperature contrast* between warm and cool hues has been used to suggest spatial proximity and depth. The recessive qualities in the cool blue-green spectrum can indicate distance, while warm ranges in the red-yellow spectrum can express closeness. *Complementary contrast* occurs when colors that are opposite from one another on the color wheel are placed in close proximity to produce dramatic or shocking effects.

7.17
Cosmo Fun Zone. Courtesy of Cosmopolitan TV and Hearst Entertainment & Syndication.

French chemist Chevreul discovered that color inconsistencies in dyed fabrics were the result of viewing conditions. Areas of cloth that had similar colors appeared different from one another, depending upon the colors that surrounded them.

7.18
Title frame from *Magnolia* (1999).
© MXMXCIX, Fine Line Features.
All rights reserved. Photo by Peter
Sorel. Photo appears courtesy of
New Line Productions, Inc.

7.19
Temperature contrast is evident
in an animated banner ad for
Washington Mutual. Courtesy of
twenty2product.

In **figures 7.20** and **7.21**, the program opening for Hallmark Channel's,
Crown Cinema and television spot for Espirit Kids both demonstrate
complementary color contrast. *Simultaneous contrast* occurs when a
neutral gray tone assumes the complementary hue of a color that is
in close proximity. For example, if a gray tone is close to a green hue, a
neutralization process makes it appear as warm, reddish gray (**7.22**).

7.20
Frames from *Crown Cinema* (2001).
Courtesy of Viewpoint Creative. ©
Hallmark Channel.

7.21
Espirit Kids was aired throughout
Japan and in several boutiques.
Courtesy of April Greiman,
Made In Space. © Espirit.

Contrast in the graphic representation of texture and pattern can also add spatial depth and emphasis. In **figure 7.23**, Stephen Seeley, creative director of Studio Dialog, employed a unique background texture that makes the images look as if they have been silkscreened or stamped in ink. This quality heightens the impact of the contrasting polished shapes and lines that are characteristic of the foreground images that animate on top of the background. Fuel TV's signature network identity in **figure 7.24** incorporates images of aged fabric as fills for the background and foreground elements. The unique, tactile characteristics of the patterns create an aesthetically engaging contrast against the flat, graphic imagery and typography.

7.22
Simultaneous color contrast.

7.23
Frames from Stephen Seeley's motion design reel. Courtesy of Stephen Seeley and Studio Dialog.

Shape contrasts can be deliberately arranged in a composition to create visual conflict in the frame. In a "Visual Music" assignment at the Massachusetts College of Art, students created mesmerizing soundscapes of live-action images to represent sound. Ted Roberts's composition entitled "Organic Unit" combined natural, abstract forms of filmed liquids with hard-edged forms of buildings in cityscapes (**7.25**). In an opening for the Travel Channel's *Destination Style*, a program that features a behind-the-scenes look at the people who work on fashion photography shoots around the globe, dissimilar shapes can create interest by introducing visual conflict (**7.26**).

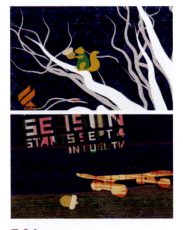

7.24
Frames from Fuel TV's signature network identity for its fall season. Courtesy of FUEL TV.

"All colors are the friends of their neighbors and the lovers of their opposites."
—*Marc Chagall*

7.25
Frames from "Organic Unit" from an assignment entitled "Visual Music" by Ted Roberts, Professor Jan Kubasiewicz, Dynamic Typography (2003), Massachusetts College of Art.

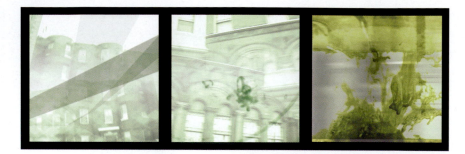

7.26
Frames from *Destination Style*, a show opening for the Travel Channel. Courtesy of Susan Detrie Design.

Dissimilar shapes create interest by introducing visual conflict.

Contrast in the proximity between objects and their relative positioning to the frame's edges can also increase their distinction. Further, the direction that objects point can vary to distinguish different types of graphic information and to create emphasis (**7.27**).

7.27
Varying the orientation of objects throughout the frame draws our eye in different directions.

In addition to these standard forms of contrast, other methods can be considered: line versus mass; symmetry versus asymmetry; ornamental versus simple; representational versus nonobjective; premeditated versus spontaneous; deliberate versus chance; ordered versus random; cerebral versus emotional; duplicated versus varied; cohesion versus disparity; clarity versus ambiguity; and open versus closed. Graphic designers who are starting out in the field should explore all of these methods to find out what suits their temperament and sensibility.

hierarchy

A principle that is related to contrast is hierarchy. (In fact, it is usually dependent upon contrast.) Most viewers rely upon visual clues to direct their attention. Visual hierarchy is a product of their need for direction. It allows you to organize complex information and direct a viewer's attention throughout the frame on an informational and a visual level.

The most artistically innovative designs can function on an aesthetic level but fail to communicate the information. In contrast, compositions that demonstrate effective hierarchy are organized in a clear, systematic, and easily understood manner by differentiating elements by their order of importance. In a publication design, headings, subheadings, paragraphs, and side notes are clearly differentiated with regard to their typeface, size, spacing, color, and so forth. In motion graphics, the primary, secondary, and tertiary elements form the basis of their visual communication. The primary, most important elements in the frame must capture the immediate attention of viewers and lead them into the design. They should offer the most important information and create a mood or emotional response, based on what is being communicated. Viewers should then be drawn to the secondary components, which should reinforce the overall message and enhance the impact of the design. Finally, tertiary elements should also support the primary and secondary elements and overall message.

Visual hierarchy can be achieved by establishing contrasts in shape, scale, value, weight, positioning, scale, orientation, color, and proximity. In **figure 7.28**, for example, shape is used to establish visual hierarchy by connecting or separating visual information. The most dominant shapes act as directional tangents to help our eye move throughout the frame, while smaller graphics function as accents to contribute toward the composition's secondary hierarchy.

7.29
"Suprematist Painting: Aeroplane Flying," 1915, by Kazmir Malevich.

The Russian Suprematist art movement gave size and scale considerable attention in establishing spatial relationships and hierarchy between objects

repetition and variety

Repetition is the recurrence of one or more elements in a composition. With subtle variations, repetition can inject a provocative, visual beat. Pop artist Andy Warhol's paintings, for example, demonstrate a monotonous repetition of images to convey the idea of consumerism. In furniture design, the articulation of surfaces through decoration and ornamentation can be visually engaging because of their repeating

7.28

Prototype splash page design for Salon de Fatima, by Jon Krasner. © Jon Krasner.

A large semicircular background shape is used to help organize the most important information while balancing and unifying the composition. Smaller graphics function as accents to contribute toward the composition's secondary hierarchy.

7.30

Cubist painting of the Brooklyn Bridge (c. 1917–1918), artist unknown. Courtesy of NARA.

7.31

Composition study by Mike Cena, Fitchburg State College. Professor Jon Krasner.

forms and textures. In painting and static design, repetition can be achieved through the spacing of elements. In a Cubist painting of the Brooklyn Bridge, for example, a rhythmic vocabulary of architectural, volumetric forms is established in the manner in which the image is fragmented into overlapping geometric planes (**7.30**).

The pictorial recurrence of elements can also create spatial rhythm, as seen in a show opener for Fine Living Network (**7.32**). AMC's 20th anniversary station IDs employ repetitive geometric forms to emphasize the concept of "twenty years of big-screen battles." In "twenty years of romantic movies," the repetition of similar patterns provides rhythm, pictorial continuity, and compositional balance to the frame (**7.33**).

Within repetition, variety can break predictability by introducing change. Repeating shapes that differ in scale, color, orientation, or proximity can enhance visual interest by adding variety to what might be an otherwise monotonous or boring design. Together, repetition and variation can contribute to a composition's pictorial rhythm. In *Loop* (2003), a short, animated film that expresses a romantic view of alternative energy, pictorial rhythm is established through repeating images that vary in shapes, texture, and pattern of motion (**7.34**).

7.32
Frame from *Live Like You Mean It*.
Courtesy of Detrie Design and
Another Large Production.

7.33
Frames from a series of station
IDs promoting AMC's 20th
anniversary. Courtesy of Shilo.

7.34
Frames from *Loop* (2003), by Terry Green and Nori-Zso Tolson. Courtesy of twenty-2product.

This piece was inspired by a cover design for *Hemispheres*, a United Airlines in-flight magazine. Live footage of wind farms, sunsets, and cityscapes were combined with 2D graphics to communicate solar energy and to reinforce the piece's overall continuity.

7.35
Evenly spaced lines on a ground establish a repetitious rhythm. Varying their proximity produces a more dynamic rhythm.

Pictorial rhythm can range from monotony to chaos, depending on the degree of variation that is introduced. It is important to recognize the distinction between pictorial rhythm and sequential rhythm. Pictorial rhythm considers the distances that elements are repeated in the space of the frame; sequential rhythm considers the continuity and recurrence of elements *between* frames.

Constructing Space

juxtaposition and superimposition

Juxtaposition and superimposition are two methods of constructing space. *Spatial juxtaposition* is the placement of two or more elements that are related or unrelated in meaning in close proximity to suggest a new meaning. During the Modernist era, the Surrealist movement employed bizarre juxtapositions of objects in unusual settings and in

absurd situations. Pop artists juxtaposed fragments of popular culture in painting. *Superimposition* involves overlaying one element on top of another. (In broadcast production, a title can be "supered" over live background footage.) In collage, superimposition allows the original identity of found objects to be maintained in tandem with the new meaning that each takes on in association with other objects. In photomontage, it provides a method of combining two or more images to create a new image or scene. In motion graphics, digital compositing has allowed designers to create unique framic combinations of moving images and type through these techniques, which are at the heart of today's film titles, network IDs, show openers, and so forth.

grids

A grid is a formal, underlying structure that can serve as a guide to making purposeful design decisions regarding the placement, sizes, and proportions of elements in a composition to maintain a sense of organized unity.

Today, more casual grids are used in print to provide consistency in column widths, margin sizes, the space surrounding images, and the placement of repeating elements such as body text, headers, and footers from page to page. Web designers have also embraced the grid as an alignment tool for graphics and type positioned inside tables or layers. In motion graphics presentations that are tailored for interactive interfaces (e.g., Web, multimedia, DVD-Video titles), grids can be used to align elements in the frame and provide consistency between pages or scenes by ensuring continuity in the positioning of elements. When used in conjunction with aesthetic intuition, they can help organize complex information and achieve balance between visuals in the frame to allow information to be communicated clearly.

The modern grid is the result of an evolutionary process that can be traced back to the inception of graphic design in Mesopotamia 4,000 years ago. Consisting of horizontal and vertical lines, grids have been used as a reliable method of organizing diverse information into logical, coherent arrangements of text and images.

Should you decide to use a grid, it is best to sketch it out on paper first and then implement it in the application that you are using. (Most motion graphics programs provide guidelines that can be adjusted and locked to position elements into vertical or horizontal alignment.)

Inspired by Cubism, Dutch De Stijl painter Piet Mondrian broke down his subjects into scaffoldings of interlocking lines and flat planes of color. Over time, he became increasingly interested in the formal interplay of geometric forms and moved toward greater abstraction, rejecting diagonal lines and relying less on objective subjects. He embraced the principles of stability and spirituality through balancing horizontal and vertical lines, shapes, and spaces. The work of De Stijl painters such as Piet Mondrian and Theo van Doesburg inspired Swiss designer Josef Muller-Brockmann, whose reductivist style was derived from mathematics and rationalism. Along with sans serif typefaces, the use of the grid provided him with a unified sense of compositional balance and proportion. Muller-Brockmann's book, Grid Systems in Graphic Design (Arthur Niggli), has been highly influential to generations of graphic designers.

Once a grid system has been established, you can deviate from it to add visual interest or emphasize particular elements. While certain objects may be aligned to specific regions of the grid, others may break away.

A grid system should be guided by the design concept and the content. It should only act as a guide—not as a substitute for creative intuition.

7.36
The "Rule of Thirds" uses a grid to divide a space into three equal segments, where the points of focus are at the intersections of the grid lines. This strategy can prevent elements from being placed in the dead center of the composition. © 2007 Jon Krasner.

7.37
This CD-ROM presentation for Ascential Software suggests the use of an underlying grid to ensure continuity in the alignment and placement of images and text. Courtesy of Corporate Graphics. © Ascential Software.

7.38
Underlying grid structures used in print and Web design can be applied to motion graphics to provide pictorial order to a kinetic composition. Here, action-safe and title-safe regions have been incorporated.

breaking spatial conventions

It is important to identify with the imposed rectilinear parameters that the "frame"—which remains the basis of traditional cinematic composition—circumscribes, as we struggle to find opportunities for creative expression on the screen. As new, nonconventional approaches to composition involve spatial, rather than framic, arrangements, the frame has moved to a subsidiary position, and restrictions that have been imposed by spatial norms of film and video become eliminated.

The fact that film and television screens are rectangular does not imply that your work must conform to the frame's rectangular format! (In fact, many interactive motion graphic artists feel confined by the fixed aspect ratios and zoning laws of film and television screens.)

"Photography is all right . . . if you don't mind looking at the world from the point of view of a paralyzed cyclops— for a split second."
—David Hockney

Historical Perspective

Since the beginning of the twentieth century, artists have challenged classical assumptions of space in order to break the homogeny of the rectangular frame. Throughout the modern era, Cubist and Constructivist painters gravitated toward nontraditional approaches to composition by investigating multiple viewpoints, asymmetry, and diagonal eye movement. During this period, graphic designers also began to deviate from popular spatial conventions. Russian Constructivist painters and designers broke away from vertical and horizontal arrangements in favor of diagonal layouts. Later, Swiss and Dutch postmodern designers began pushing scale contrasts, angular forms, and dramatic camera angles in their compositions.

Attempts to break the rectangular format were striking during the early twentieth century. Modern artists such as Robert Delaunay, Piet Mondrian, and Giorgio de Chirico were among the first to introduce circular, diamond, and triangular compositions. Eventually, painters began to investigate ways to extend their content beyond the confines of the frame. Many negated the idea of enclosure and considered borders as virtually nonexistent (or self-defining) visual devices. Frank Stella's mixed media, decorative abstractions from the 1970s broke the deadlock of the pictorial surface by leaping off the wall onto the gallery floor. His book *Working Space* (1986) has challenged artists to rethink how space can be manipulated. Influenced by Cubist aesthetics, American photographer David Hockney brought to the late twentieth century an increased desire for spatial exploration. His photocollages, which were constructed from 35mm prints, were compiled to create a "complete" picture by eliminating the idea of a fixed field.

7.39
Byzantine painting (476–1453).
© Erich Lessing/Art Resource, NY.

7.40
Frames from Candle's Intelliwatch
CD-ROM by Jon Krasner. Courtesy
of Candle Corporation and The
Devereux Group. © 2004 Candle
Corporation.

nonrectangular boundaries

Since paintings during the early Renaissance were created strictly for religious purposes, artists took into consideration the structures that existed in ecclesiastical vaults of churches (**7.39**). When the context shifted from religious to secular, canvases were needed to display artwork. As a result, the rectangle became the most widely accepted picture format.

Recently, designers have become liberated to "think outside of the box." Although the viewing area may remain fixed in the case of film and television compositions, nonrectangular structures inside the frame can serve as "compositions within a composition." In **figure 7.40**, the motion graphics in a CD-ROM interface were designed to conform to a nonconventional shape, rather than to the frame's boundaries. The client requested an entertaining design that conveyed the idea of information management software while holding the audience's attention. With this in mind, I felt compelled to push the envelope and became intrigued with the possibility of using masks to frame animations that were part of the interface. Members of the production team, who had little regard for artistic experimentation, were grounded on the supposition that live-action video should *always* be presented in a 4:3 aspect ratio format. I politely ignored their beliefs, and with a little client convincing, I finally arrived at an idea that worked!

absence of boundaries

In motion graphics compositions, space can also be suggested, rather than defined by the hard-edged physical boundaries that the screen imposes. This allows the eye to consider the possibility of time passing through an infinite, undefined viewing area that continues in all directions. For example, the backdrop of the inner city playground in **figure 7.41** abandons the idea of boundaries within a fixed frame. The five main figures leap forward out of the inner circle, providing a feeling of continuous space without borders.

7.41
Mural painting in Hell's Kitchen, Manhattan, New York. Courtesy of the EPA and NARA.

In the opening titles to a fast paced top ten countdown for *ZeD*, a CBC Television program that showcases Canadian films and music, the majority of the action is composed to occur within or break out of the skewed image of an index card, which serves as the backdrop for the composition. Free-floating cutout silhouettes and abstract symbols demonstrate a complete disregard for the frame (**7.42**). The dark and edgy motion graphics for *ZeD's* third season ignores the frame's rectangular format by giving us a "slice" of the action inside a narrow, horizontal strip (**7.43**). In a rich, action-packed trailer for the Slamdance Film Festival, America's most prominent festival "by filmmakers for

Los Angeles Pop artist David Hockney, one of the most influential artists of the twentieth century, invented an alternative way of constructing space by combining Polaroid photographs to show multiple viewpoints of an image or an event. His work suggests an absence of boundaries that might be imposed by traditional framing.

filmmakers," the frame only serves the purpose of "housing" an open compositional format. Similar to **figure 7.42**, images seem unbound by the composition's rectangular constraints (**7.44**).

7.42
Opener to *ZeD*, season 4, CBC Television. Courtesy, Studio Blanc.

7.43
Show opener to *ZeD*, season 3, CBC Television. Courtesy of Studio Blanc.

7.44
Frames from Slamdance. Designed by Brumby Boylston and Elizabeth Rovnick. Courtesy of FUEL TV.

Immersive VR environments naturally eradicate the familiar compositional devices that a rectilinear border provides. The boundary of the frame is completely eliminated as viewers enter into the action and become totally immersed in an all-enveloping experience.

frame division

Dividing up the frame can fracture time and space, allowing viewers to use their peripheral vision to observe several actions and perspectives simultaneously. In the opener for *Movie Magic*, a television show that gives audiences a behind-the-scenes look at how things are made, segments of live-action footage of physically constructed letterforms and intimate close-up shots of silkscreening, welding, carving, and sand blasting are duplicated in the frame as multiple video windows. The relative positions and scale relationships of the windows changes in each scene, emphasizing the sensitivity and complexity of these artistic processes used to handcraft the three-dimensional letters of the composition's title "movie magic" (**7.45**). Susan Detrie's pitch for ESPN expresses the concept of a runner who pre-visualizes himself crossing the finish line. Splitting the composition reinforces the nature of sports footage, which is often presented in a divided frame format to

give viewers a chance to observe the action from multiple viewpoints. The type, which reads "small is beautiful," refers to the fact that a tiny fraction of a second can separate winning from losing (**7.46**).

7.45
Frames from *Movie Magic*. Courtesy of Velvet.

7.46
Frames from a 15-second spot for ESPN. Courtesy of Susan Detrie.

7.47
The motion in Rockshox's 2000 Web site was composed to work within a split screen format. Courtesy of twenty2product.

Historical Perspective

The concept of the divided frame was explored in the 1880s during the English Arts and Crafts movement by graphic designers such as Selwyn Image, who used this device to organize his compositions, which were packed with graphic detail.

In the motion picture industry, the divided screen was one of the oldest effects to be used during the silent film era to depict telephone conversations between people. Filmmakers that were a product of formal modernist aesthetics also entertained its concept. Abel Gance's three-screen classic titled *Napoleon* (1927) used a process that he called "Polyvision." Gance predicted that the capacity of the viewer to navigate through multiple images was a result of an increasingly shortened attention span. During the 1960s, underground filmmakers such as Jordan Belson and the Eames brothers projected multiple images in light shows in galleries, planetariums, and public settings. Their technique of superimposing images with as many as seventy individual projectors became known as the *expanded cinema* (a quintessential method of expressing the effect of a hallucinogenic

drug trip). Pop artist Andy Warhol also applied a split-screen technique in *Chelsea Girls* (1966), the first double-screen film to be commercially released.

During the 1970s, multi-image slide projection allowed numerous dissolving images to be displayed in unison with sound. Video wall technology during the 1980s elaborated on this idea by offering modular, multi-screen systems that could display large images without sacrificing picture resolution. Exciting compositional possibilities could be attained as signals from different sources could appear across adjacent monitors or be divided up, repeated, and shown separately in various shape and size configurations.

Today, prime-time television shows and motion pictures have embraced split-screen juxtaposition. In Mike Figgis's film, *Timecode* (2000), four panels depict four interconnected personal experiences that unfold in real-time. Stephen Hopkins's television drama *24* also uses this technique to depict a range of viewpoints and camera angles in as many as six simultaneous scenes.

mobile framing

Changing the framing of a composition by simulating camera motion can guide our perception of onscreen and offscreen space. It can give us a sense of mystery, as important elements that were once concealed gradually become visible within the frame. For example, in an assignment that challenges students to animate a famous poster from the history of graphic design, Mike Sokol investigated several compositional possibilities through various camera angles and movements that expose us to the components of Bruno Monguzzi's typographic poster. We travel on various trajectories through space in a graphic landscape of two-dimensional planes and letterforms. At the very end, all the elements of the full poster are presented in the frame (**7.49**).

Frame mobility can link elements and emphasize relationships between elements and their environment. For example, zooming in or forward tracking moves elements off the edges of the screen, while images and overlooked clues that exist beyond the frame's boundaries are revealed. This alternative to cutting or transitioning between the views arouses our curiosity about the story, since we anticipate what the result of the zoom will yield. Camera motion can also function to keep our attention focused on a moving element by following it. For example, a tracking shot may follow a bird in flight, or a crane shot may pursue an object plummeting to earth.

7.48
Mural painting for the Harlem Art workshop. Courtesy of the Harmon Foundation Collection and NARA.

The concept of spatial division functions as a means to show multiple views of Harlem.

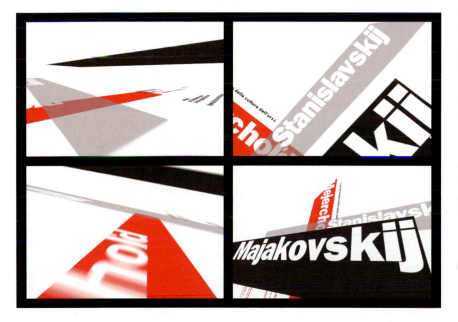

7.49
Frames from "Monguzzi Poster," an animated poster by Mike Sokol, Professor Jan Kubasiewicz, Dynamic Typography (2005), Massachusetts College of Art.

In her short film entitled *About Face*, animator Marilyn Cherenko employed the cinematic techniques of dollying and zooming to allow viewers to follow the cat from room to room at spatial distances ranging from wide shots to extreme close-ups (**7.50**). In **figure 7.23**, we are led throughout the composition by a graphic of an apple that moves in coordination with a long, emulated camera tilt downward. The apple fades out, and a −90 degree frame rotation changes our eye movement to a horizontal direction, which supports the movement of the type off the right edge of the frame. In both these cases, reframing was achieved by adjusting the camera angle, height, and distance to accommodate the subject as it shifts its position in space. Additionally, reframing allowed the composition's balance to be maintained as the movement of the main subject changed.

7.50
Frames from *About Face* (2000),
by Marilyn Cherenko.

Frame mobility can be used to impart information by establishing
visual hierarchy and emphasis. In a PSA designed to engage private
companies to help fight against AIDS in Africa, Ryan Leonard
employed camera movement to establish a clear legibility and
sequential hierarchy of information (**7.51**).

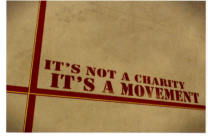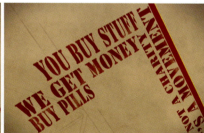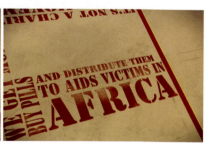

7.51
Frames from a PSA promoting
joinred.com, by Ryan Leonard, Art
Institute of Philadelphia, Professor
Genevieve Okupniak.

3D space

Although the fixed rectangular frame may be restricting in its top,
bottom, left, and right edges, there are fewer limitations to what can be
achieved in three dimensions. Three-dimensional space moves our eye
into a realm that is less constricting than the frame's two-dimensional
parameters. Visual advance, recession, frontal view, and oblique view
from any location, as well as the device of perspective through the use
of lines and angles, allow us to create the illusion of three dimensions
within a two-dimensional framework.

In Reality Check Studios' 2007 show reel, overlapping, transparent
square shapes from the company's logo emphasize the illusion of
depth. Two-dimensional lines, planes, and typographic elements are

positioned at various angles in a digital three-dimensional space to give us a sense of deep perspective. Further, the use of mobile framing enhances their positioning as they animate on different spatial trajectories (**7.53**).

New York's motion graphics company Flying Machine was hired to design a graphics package for two shows, *CNET News.com* and *CNET TV.com*, both of which feature news and business reports on information technology. CNET, Inc., a San Francisco-based media company specializing in computers, the Internet, and digital technologies, wanted a "techno" feel that maintained the human connection to technology. The graphic design incorporated a variety of live-action content and computer-generated backgrounds and elements, while picking up on the yellow and red color scheme from CNET's branded Internet network. In a spot for CNET's television news program, three people engage in a playful journey along the information superhighway. They interact with various handheld devices, video displays, and touchscreens in a three-dimensional space that conveys the effect of technology in the workplace, the home, and in daily life (**7.54**).

7.52
"The Modern Poster" (1985), The Museum of Modern Art Collection. Courtesy of April Greiman Made in Space.

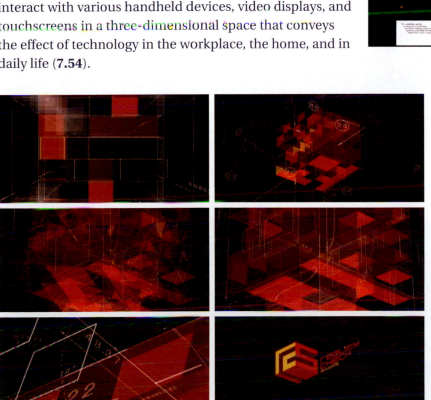

7.53
Frames from the introductory animation to Reality Check Studios' show reel. Courtesy of Reality Check Studios.

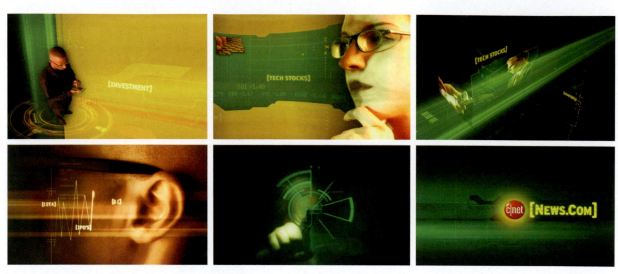

7.54
Frames from a spot for CNET's news network (http://news.com.com) and television program. Courtesy of Flying Machine.

7.55
Frames from "Infotainment," a branding video for Harman International Industries, Inc. Courtesy of Humunculus.

In a branding video for Harman International Industries, Inc., an audio and electronics systems manufacturer, a combination of perspective and frame mobility emphasizes the relationships between elements in their environment. Humunculus, an advertising and broadcast design company in Venice, California, produced a spot that demonstrated Harmon's twenty-first century technological capabilities in providing information and entertainment through a single delivery system. The concept involved a single pixel becoming the source of the universe with the company logo in the center of the "big bang." Camera movements allow us to navigate through a vast, 3D universe to observe how communications technologies (i.e., email, satellite, voice activation) and Harman's client brands are interconnected. The use of 3D space and mobile framing allowed Humunculus to take a complex, multi-tiered message and communicate it in a visually stunning way (**7.55**).

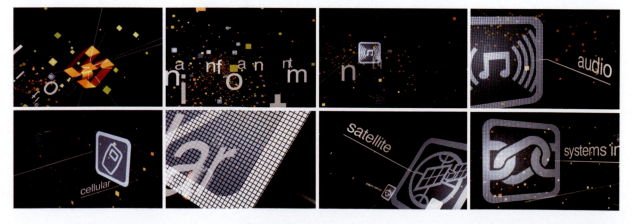

Summary

Through history, the artistic approach to space and composition has differed across cultures and across various art movements. Today, designers continue to explore how compositional principles can be used to express concepts and emotions and to establish clear and effective communication.

Design principles such as *unity*, figure and ground, negative space, visual contrast, hierarchy, juxtaposition, and superimposition can all be used to construct space.

Nonconventional approaches to composition involve spatial, rather than framic, arrangements. Space can be suggested rather than defined by the physical boundaries that the screen imposes. The technique of frame division can fracture time and space, allowing viewers to use their peripheral vision to observe several actions and perspectives simultaneously. Mobile framing, or camera movement, can also guide our perception of onscreen and offscreen space.

Emphasizing spatial depth moves our eye into a dimension that is less constricting than the frame's two-dimensional parameters. Visual advance, recession, frontal view, and oblique view from any location, as well as the device of perspective, allow us to create the illusion of three dimensions within a two-dimensional framework.

Assignments

line, plane, asymmetry, balance

overview
The objective of modern, asymmetrical composition is to encourage the viewer's eyes to explore and move about the frame. You will create a series of studies that demonstrate how line and plane can be used to choreograph an asymmetrical changing space.

objective
To explore line, plane, asymmetry, and balance in a time-based context.

stages
Create two square compositions measuring 500×500 pixels. Create a black 400×400 pixel square, and animate its position and rotation

properties over ten seconds, keeping it away from the center of the composition. Your goal is to maintain an asymmetrical chaging space.

Incorporate this animation into another into another 500×500 pixel composition, and place a black line measuring 200 pixels in length. Animate the line over ten seconds, keeping it away from the center of the composition. (Again, your objective is to maintain a dynamic sense of asymmetrical space.) Be deliberate in how the line's positioning, spatial orientation, and direction of travel changes in relation to the changing space of the first study. Consider how this element can enhance asymmetry, but at the same time, be used to establish balance.

Incorporate your animation into a third 500×500 pixel, 10-second composition, and animate a second line, keeping it away from the center of the composition. Think carefully about how this third element can contribute to asymmetrical balance.

specifications

Avoid using any 3D transformations that involve a z axis, since the illusion of depth can detract from the purpose of this assignment—to choreograph two-dimensional, asymmetrical space. You are not allowed to scale the elements.

considerations

Give attention to relationships between positive and negative space. As space changes over time, consider how the supporting element of line can be used to achieve compositional balance. How can balance and imbalance potentially work together on a conceptual or purely formal, visual level to heighten the viewer's interest?

Consider how the elements of line and plane relate to and/or interact with the edges of the frame.

animated space: figure and ground #1

overview

You will develop an animated space that changes over time with regard to its figure and ground relationships.

objectives

1. To develop a sensitivity to positive and negative structure.
2. To explore the interchangeability of figure and ground in animation.

stages

Create three compositions based on the formats listed below:
- square: 480×480 pixels
- horizontal rectangle: 720×480 pixels
- vertical rectangle: 480×720 pixels

In each composition, create a simple square measuring 720×720 pixels. Animate the square's position and rotation properties of the square within a 10–15 second time limit.

specifications

You are not allowed to duplicate the square or change its dimensions.

You are allowed to use only black and white. Colors, shades of gray, drop shadows, and special effects are prohibited, since your goal is to focus on form and space.

The duration of each composition should be 10–15 seconds.

considerations

Your goal is to establish interchangeability between figure and ground over time. Consider how the frame's division of positive and negative space can be choreographed to establish new figure and ground relationships. Give attention to the absolute and relative positioning of the shapes and their relationship to the edges of the frame.

animated space: figure and ground #2

In this assignment, you are to substitute the square from the last assignment with a simple graphic of a mechanical object that has an interesting combination of shapes that vary in geometry and size. Give careful consideration to establishing an interchangeability between figure and ground over the given time period. Consider the positioning of the shapes and their relationship to the edges of the frame.

typographic hierarchy: early letterform

overview

You will develop three typographic animations based on a letterform from the Phoenician or Greek alphabet.

objective

To explore multiple design solutions to achieving typographic hierarchy.

stages

Research a symbol from the Phoenician or Greek alphabet and find approximately 3–4 phrases of text that pertain to its history. Create three compositions based on the symbol, its display type (e.g., phi, sigma, delta), and the copy. In the first, the symbol should be the most dominant element. In the second, the display type will be the prominent focus. In the third, the copy should be given emphasis.

specifications

The dimensions of each composition will measure 720×480 pixels. Images are prohibited. However, you may perform alterations through traditional or digital processes or a combination of the two. However, the legibility of the type must be maintained.

Use no more than two typefaces that complement each other. You may duplicate the elements as many times as you wish and vary their sizes, spatial orientation, colors, shades, transparency, and letter spacing values to establish visual hierarchy.

considerations

Consider how the relative positioning, scale, orientation, and spatial proximity of elements contribute to hierarchy.

PSA: juxtaposition and superimposition

overview

You will compose an animated PSA that combines disparate images in a manner that conveys the meaning of a message.

objective

To investigate how juxtaposition and superimposition can help create meaning between two or more unrelated images.

stages

Choose one of the following topics: global warming, drunk driving, domestic violence, or depression. Find a minimum of three photographic images. You are encouraged to use your own photos or found objects.

The following categories of text are to be included in your composition:
- title
- subtitle
- word list (for example, statistics relating to drunk driving)
- Two quotes associated with your topic

specifications

You may work in color or grayscale. Images should be digitized at a resolution that will accommodate scaling.

considerations

Consider how the meaning of your original images creates a new meaning when they are juxtaposed or superimposed in the frame.

continuity through the grid: storyboard design

overview

Choreographing how things move and change over time and space requires careful planning during the early phases of storyboarding.

You will design a storyboard to be used for a potential television bumper based on a concept or theme of your choice.

objective

To explore how grids can help organize content clearly and systematically.

stages

Once you have gathered or created the images and type elements, develop an initial storyboard comprehensive that portrays the major events and transitions. Observe the relative placement of elements in each frame, as well as their directions of travel and their alignment to each other and to the frame's edges. Develop a rough grid structure on paper that relates to your observations.

In Photoshop, implement your grid system using guides. Keep an open mind and be prepared to deviate from the grid in order to add visual interest or emphasize particular elements. While certain elements may be aligned to specific regions of the grid, others may break away.

specifications

The storyboard will consist of eight frames, each measuring 4 × 5 inches. All eight frames can fit into one tabloid size (11 × 17 inch) document. The frames can then be cut out and pasted onto a scored 2-fold bristol board.

considerations

Consider how the placement and alignment of elements and their relationship to the frame's edges is influenced by the structure of the grid. Also consider how the directions that elements move can adhere to or deviate from this structure.

the sequential composition
designing in time

Every story must have a beginning, middle, and end. The visual and sonic experience of images, actions, and sounds over time can allow it to unfold in its natural order of events. On the other hand, the story can be told in a different order, according to a completely different timeline.

Similar to musical conductors who choreograph sounds, motion designers orchestrate sequences of events and the manner in which images and type move and change over time, appear and disappear off the screen, and transition from one event into the next in every story.

"Animation's ability to instantly dissolve the representational into the abstract, to leap associatively with ease, and to render simultaneously a flood of images, perceptions, and perspectives, makes it an unparalleled form of cinema."
—Tom McSorely

00:00:00:08

Sequential Composition: An Overview

The mind compartmentalizes visual information, motion, and sound into units. For example, in musical compositions, we structure sounds into predefined arrangements. In dance, we organize patterns of movement into highly refined sequences. The same is true in motion graphics; we "orchestrate" events into units or sequences that unfold over time and across space through movement and transition. This allows us to create order, build excitement, or arouse anticipation.

Sequential composing is a developmental process that, with dedicated thought and adequate planning, can enhance artistic expression and conceptual impact. The language of cinema can be used to tell stories in effective, meaningful ways.

Forms of Continuity

Continuity throughout a composition generates the feeling that space and time are fluid and continuous. During the 1930s and 1940s, many narrative American films were produced and edited according to the classical continuity editing style. The approach was guided by explicit rules to maintain a clear, logical narration and relied heavily on spatial and temporal relationships between shots. Subsequent films, such as *Singing in the Rain* (1952) and *Persona* (1956), demonstrate a strict adherence to these continuity standards.

8.1
Frames from a Flash-based Web interstitial for SquarePig TV. This composition demonstrates an effective use of traditional cinematic continuity principles. Courtesy of hillmancurtis, inc.

The application of continuity editing to motion graphics can allow you to be clear in your storytelling and delivery of information.

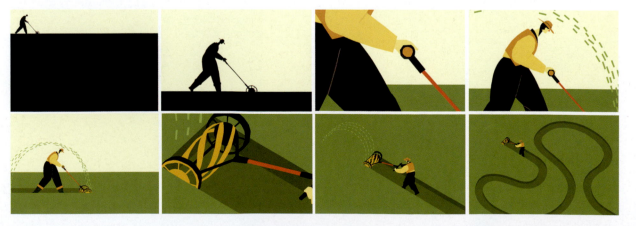

spatial continuity

Continuity can be used to structure both onscreen and offscreen space in a way that preserves the viewer's cognitive map. This means, simply, that the viewer's sense of where things are in the frame and outside of the frame is coherent and constant throughout the composition. There should be a common space between consecutive sequences so that the viewer's flow of attention is maintained without disruptions.

establishing context

Establishing a context prior to cutting between elements facilitates the preservation of spatial continuity. For example, if you establish a context of two people looking in the same direction, subsequent frontal close-up shots allow to us to perceive the direction of their gaze as continuing into offscreen space (**8.2**). In **figure 8.3**, frontal close-ups of two people looking at each other continue the converging vectors that were previously established in a prior medium shot. When the context establishes diverging vectors, subsequent frontal close-ups continue our perception that they are looking away from each other (**8.4**). In the title sequence shown in **figure 8.5,** a humorous shot of two figures combating a fictional monster cuts to a frontal, close-up shot of one of the figures, revealing his expression of dread. The context that was established in the first scene allows us to interpret his gaze as being directed toward the monster—not at the viewer.

8.2
Spatial continuity of continuing vectors in subsequent close-ups.

8.3
Spatial continuity of converging vectors in subsequent close-ups.

8.4
Spatial continuity of diverging vectors in subsequent close-ups.

8.5
Frames from "Handle The Jandal,"
an opening title sequence for
DIY NZ music video awards.
Courtesy of Krafthaus Films
(New Zealand).

8.6
Frames from Heritage (Phase 3),
by Jon Krasner. © Jon Krasner..

index and motion vectors

Index vectors are powerful structural elements that provide stability in a composition. In the sequential composition, they can preserve our sense of spatial continuity between consecutive images, actions, or events. The application of a continuing index vector in **figure 8.6** is shown in a medium shot of a person looking to the right followed by a close-up in which the direction of her glance is maintained.

In traditional continuity style editing in live-action film, scenes are constructed along an imaginary *axis of action* (also commonly referred to as the *vector line* or *line of conversation*), where the subjects are recorded from one side of a 180-degree line. The goal: to stabilize space. Although the cuts can vary between long shots and over the shoulder shots, they ensure a consistent screen direction in which viewers can predict where the subjects are with respect to the event.

The axis of action can also be used to establish relationships between two interacting subjects, for example, a speaker and an audience. Cutting between two views on the same side of the 180-degree line establishes a *converging index vector* that creates the sense that the speaker and the audience are looking at each other. Cutting between views from opposite sides of the line, however, would produce a *continuing index vector* that make them appear to be looking at a third party. In a motion graphics environment, this principle is illustrated in the music video for the song "Megalomaniac" by the band Incubus. This dark piece, which barrages us with historical live-action footage and animated sequences, makes use of both converging and continuing index vectors to complement the song's powerful message (**8.7; Chapter 2, figure 2.74**).

As a general rule, maintaining the positions of major elements in the frame between shots preserves the viewer's cognitive spatial "map." Maintaining the directions that elements move from scene to scene also preserves continuity from onscreen and offscreen space. **Figure 8.8** illustrates this principle in Velvet's recent design package for Nova TV, the first Croatian commercial television network. A male figure occupies the right side of the frame, while the female figure is located on the left. Their positioning in the frame is maintained in subsequent views, preserving a sense of spatial continuity. This partially compensates for the abrupt transitions between the shots. A quick cut to a close-up of the male figure's feet followed by a zoom out and a quick

360º rotation shows the male figure floating away from the woman. Their angle of direction is preserved in the diverging motion vector that is created in his movement. **Figure 8.9** shows another humorous sequence in which the donkey's position adheres to the left side of the frame, while the woman's location remains fixed to the screen's right half. When we cut to a close-up of the donkey resisting its owner, the motion vector continues toward the right edge of the frame and into the offscreen space that we presume the woman occupies.

8.7
Frames from the music video to "Megalomaniac" by Incubus. Courtesy of Stardust Studios.

8.8
Frames from a package redesign for Nova TV, the first Croatian commercial television network. Courtesy of Velvet.

Spatial continuity is maintained in the consistent diverging motion vector of the male figure.

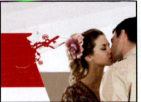

8.9
Frames from a package redesign for Nova TV. Courtesy of Velvet.

In this humorous sequence, spatial continuity is maintained in the continuing motion vector between the woman and her donkey.

Figure 8.10 illustrates a different example of how continuing motion vectors can achieve spatial continuity. The bottom of the uppercase "E" in "innovate" extends outward to the right, leading our eye into the next scene. The view is then zoomed and rotated to feature the detective character. The wide tracking between the letters "NHANCE" points our eye to the right, in concert with the camera's pan to the next scene.

8.10
Frames from "Adobe." Courtesy of IAAH.

In the Pink Panther-style opening for *The Man Who Knew Too Little* (1997), a motion vector is established from the character's flick of an image to the left. After a cut to the next scene, the image's gravitational motion continues toward the left before bouncing off of the rim of the trash receptacle. The next scene features the character's hand unrolling a blueprint toward the right-hand edge of the frame. The motion of the image established from the impact of the trashcan enters the frame from the left and continues off the right edge of the screen (**8.11**).

8.11
Frames from the opening titles for *The Man Who Knew Too Little* (1997), a comic film starring Bill Murray. Courtesy of Kemistry.

frame mobility

The effect of mobile framing (or camera motion) on the sequential aspects of a composition can preserve spatial continuity. An example of this is the Web "teaser" for artevo.com (**Chapter 7, figure 7.2**). Different scenes are presented through several emulated camera moves. A pause or a deceleration between each move is used to emphasize the most important aspects of the concept in words or phrases such as "a global community," "opportunities," artists," and "invest in artists of the world." In **figure 8.12**, a single continuous pan is used in an in-store motion graphics sequence for Telecom, maintaining the viewer's cognitive spatial map.

In a TV ad for Miller Genuine Draft, constant camera motion is employed throughout the composition to maintain both spatial and motion spatial continuity between segments (**8.13**). As we follow the movement of the soccer ball in the opening sequence, we cut to the next scene to observe its continued motion from a different perspective. In another instance, frame mobility gives us a sense of omnipresence as we are shifted in space from a straight on, medium view, to a bird's-eye view of the drummer. As the frame continues to pull us in an upward direction, the flying drumsticks provide a natural transition into the next scene of a flying suitcase that closes on them in midair. The framing of the last sequence of the composition makes us feel as if we are riding the waves with the surfer.

8.12
Frames from an in-store looped animation for Telecom, based on Xtra Broadband's new communications technologies. Courtesy of Gareth O'Brien of Graffe.

graphic continuity

Graphic continuity considers the inherent visual properties of line, form, value, color, and texture. For example, instead of employing a fade to link two segments, you might decide to zoom into a shape that matches a shape in the following segment.

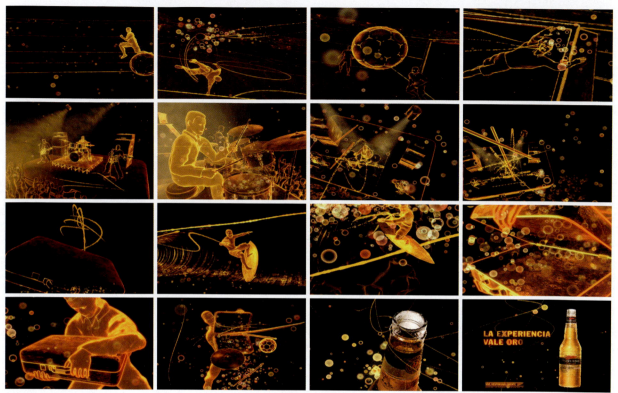

8.13
Frames from "Collector."
Courtesy of The Ebeling Group.

8.14
Frames from a film festival trailer.
Courtesy of onedotzero.

In **figure 8.14**, the graphical sequences in a trailer for an annual digital film festival are linked together with straight cuts to match the sonic component of the soundtrack. As similar mechanical structures are repeated, variations of forms, values, colors, textures, and movements maintain our interest. The trailer's smooth, fluid sense of pictorial continuity feels similar to a piece of well-constructed classical music.

Graphic continuity can also function as natural transitions to move you between motion graphic sequences. For example, in Hillman Curtis' online advertisement for Craig Frasier/Squarepig.tv (**Chapter 12. figure 12.17**), zooming into a portion of a scene allows us to focus on a simple geometric shape. We then cut to a similar shape and zoom out to show the same event from a different viewpoint. This transitional effect creates a smooth linkage between the two scenes.

temporal continuity

Temporal continuity controls the timing of the action and contributes to a plot's manipulation of story time—the way the order of events is presented. Events can be organized in chronological order or, through editing, can alter temporal succession to bring the viewer into the past, present, or future. It can achieve a sense of cause and effect, suspense, or surprise. Classical continuity editing presents sequences of actions in their logical order, and each action is displayed only once. Occasionally, flashbacks and flash forwards are used to enhance the viewer's awareness of prior events and their relationship to the present. Cutaways are also sometimes used to show related events to the main action. In *Strike*, Sergio Eisenstein made frequent use of temporal expansion through overlapping shots to prolong the action and reinforce the drama of the event. In *October*, he combined overlapping shots of rising bridges to demonstrate the event's impact.

Using dissolves, as opposed to cuts, aids continuity because temporally, they act as a time bridge, producing thematic or structural relationships between events. For example, dissolving between a long shot of the wind blowing through several trees, a close-up of leaves blowing on the ground, and wind blowing through a woman's hair shows a thematic relationship. Dissolving between tree branches blowing in the wind and a woman's hair blowing in the breeze represents a structural relationship.

Temporal ellipsis can condense small to large quantities of time with the purpose of omitting unnecessary pieces of information that would normally detract the viewer's attention from the main story. Typical examples of temporal ellipsis during the 1930s and 1940s include spinning newspaper headlines, book pages fluttering, and clock hands dissolving. In Stanley Kubrick's film, *2001*, the sequence of the bone flying through the air cuts directly to a graphic match of a sequence containing a nuclear weapon in space orbiting the earth. Millennia are

automatically eliminated in less than a second. Many times, dissolves, fades, or wipes are used to indicate temporal ellipsis so that viewers can recognize that time has passed. Brief portions of footage can be linked to compress a lengthy series of actions into a few moments.

action continuity

The actions of animated graphic elements and live-action images can be carried smoothly across cuts and transitions to preserve both spatial and temporal continuity.

The following tips can help preserve action continuity:

1.) Cutting just before or after an action will emphasize the beginning or end of the action, rather than on the *flow of the action* between sequences. Cutting from a sequence containing a static element to a sequence where the element is in motion will create the effect of the element suddenly accelerating awkwardly through time. On the other hand, if you cut from a sequence that contains a moving element to one where the element is static, the element appears to come to an abrupt halt. Therefore, it is better to avoid the above scenarios and cut *during* an action to ensure maximum continuity. **Figure 8.15** illustrates this principle in a sequence of shots that show different views of a tennis player. Employing cuts during the action preserves continuity

2.) Cutting between different types of actions that move in the same direction will preserve continuity.

3.) When cutting during a camera move, such as a pan or zoom, continue the same motion in the following sequence.

4.) If you are panning with a moving element, continue the pan in the same direction at the same velocity in the following sequence. This will maintain the camera movement *through* the cut, as opposed to interrupting the cut. Otherwise, there will be a sudden distraction in the flow of movement, and this might appear as a mistake rather than an intentional decision.

8.15
Frames from Flying Machine's Sci-Fi reel. Courtesy of Flying Machine.

Forms of Discontinuity

Discontinuity editing offers an alternative approach to editing using techniques that are considered to be unacceptable to traditional continuity principles. Although the classical continuity system has been the most popular historically, violating this system can produce aesthetic effects that may weaken the narrative but intensify its context. In fact, discontinuity editing is guided more by emotion rather than story. It can be used to enhance anticipation or arouse anxiety. David Carson's music video for Nine Inch Nails, for example, is composed entirely of fleeting, disjointed images that convey the energetic, rebellious nature of the soundtrack. The abandonment of space or time lends itself to what appears to be the band's underlying themes of rage, self-loathing, and technological hype (**Chapter 5, figure 5.19**). A montage for the title sequence illustrated in **figure 8.16** demonstrates how mismatching spatial and temporal relationships are deliberately used to express the dynamism and power of the Formula 3 race car. In **figure 8.17**, the motion graphics sequence for Kia Magentis' Web site also uses discontinuous space and time to establish the mood.

narrative and non-narrative forms

Discontinuity has been explored in both narrative and non-narrative forms of cinema and motion graphics. In traditional cinema, narrative alternatives to continuity editing have created unusual ways of telling stories and have become integrated into mainstream culture and practice. Accelerated editing, for instance, has been used to create tension when a story builds to an emotional climax. Crosscutting between simultaneous actions that occur in different locations was considered a radical innovation at the time and is still used frequently today.

8.16
Frames from a title for *Formula 3*.
Courtesy of Krafthaus Films

8.17
Frames from Kia Magentis' Web site. Courtesy of Tavo Ponce.

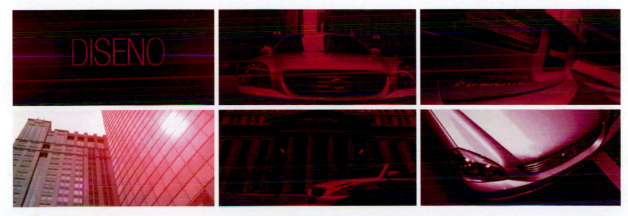

During the 1920s, many European avant-garde painters became the pioneers of avant-garde cinema and have taken the most daring steps in establishing alternatives to continuity editing. Non-narrative forms of discontinuity continue to allow motion graphic designers to focus not on content, but rather on aesthetic form and process.

graphic considerations

A myriad of graphic and rhythmic possibilities exist when you break away from the limitations of spatial, graphic, temporal, and action continuity. Images, actions, and sequences of events can be joined together by virtue of their formal graphic and rhythmic qualities.

In cinema, Bruce Conner's experimental films, such as *Cosmic Ray, A Movie*, and *Report*, for example, joined segments of found newsreel footage, film leader, and old clips with regard to their graphic qualities and patterns of movement.

Many discontinuity practices in early twentieth-century cinema have inspired generations of filmmakers and motion graphic designers in film, broadcast, and interactive motion graphics. David Carson's intuitive use of kinetic images and typography is similar to his print work, in that it is expressive, experimental, and multilayered. He reinforces content with form, and his use of subtle shape and color contrasts effectively communicates the feel of the subject matter, often eliciting an emotional response from the viewer (**8.18**).

8.18
Frames from a YV commercial for Nike. Courtesy of David Carson.

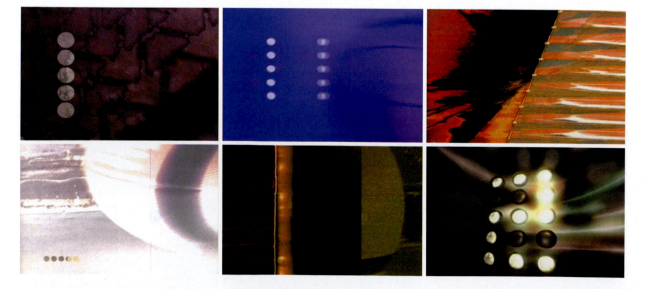

Historical Perspective

Modern art movements, such as German Expressionism, Dada and Surrealism, have employed various forms of discontinuity in film to engage audiences on a purely visceral level. Erich Pommer's German Expressionist film, *The Cabinet of Dr. Caligari* (1919), was groundbreaking in that it merged avant-garde techniques with conventional storytelling. Throughout the film, continuity was often sacrificed to make viewers aware that the irrational environment depicted a world of insanity that the main character was experiencing.

Surrealist filmmakers after World War I attempted to express dreams and the subconscious by juxtaposing and superimposing ordinary images and events that occur in daily life in unusual combinations. Their spontaneous and undirected approach to editing allowed them to arrive at far-fetched analogies and bizarre personal fetishes. Many of these films continue to be highly regarded as works of art. Luis Bunuel's *Belle de Jour* (1968) provides a voyeuristic view into the subconscious mind of a troubled heroine. Salvador Dali's *An Andalusian Dog* (1928) presents several disturbing events that are intentionally unrelated on a conceptual level. Hans Richter's *Ghosts Before Breakfast* (1927) presents an actor wearing a hat in one shot, immediately followed by a bareheaded shot of the same actor. Similar types of changes throughout the film shatter the illusion of graphic and pictorial continuity.

In Russia during the 1920s, Soviet filmmakers, such as Sergei Eisenstein and Dziga Vertov, also experimented with spatial and temporal discontinuity with the objective of shocking their audiences out of passive spectatorship, inviting them to make conceptual connections between events.

Although narrative can take a back seat when priority is given to visual and conceptual criteria, a composition's graphic possibilities can help enforce its underlying theme. The ending title sequence to *Stranger Than Fiction* (2006) is an example of this. The theme of the film depicts how the concept of life can imminently play out like a story. The monotonous existence of an IRS agent hears the voice of an esteemed author inside his head, ominously narrating his life. When the author narrates that he is going to die, he becomes anxiously determined to find her and convince her to change the story. In this credit sequence, quick camera movements and rapid, restless movements of elements entering and leaving the frame completely throw off our sense of space and time. Unrelated spaces and events are shown with different color tints or at unusual angles (sometimes upside down). They appear to occur simultaneously as they are juxtaposed temporally through frame mobility or spatially through superimposition.

When you watch a film that does not obey classical continuity, turn off the sound in order to develop an increased awareness of its underlying editing patterns. Observe one editing aspect at a time, such as the frequency between shots, or the manner in which space is constructed and broken.

Without seeing the film, we see what appears to be a kinetic collage of unrelated images and events. We are forced to appreciate it from a purely formal perspective in terms of its shapes, layering, color, and movement.. After hearing about the film's concept, it becomes apparent how this stylistic approach enforces the underlying theme. The method in which the composition is sequenced gives us an insight into the world of the author (or of authors in general). When writing a fictional story, authors often pull disparate ideas out of a "hat" and experiment with ways that they could fit together. The disjointed feel of "possibilities" is expressed in the discontinuity of image, time, and space to illustrate the struggle of the author (**8.19**).

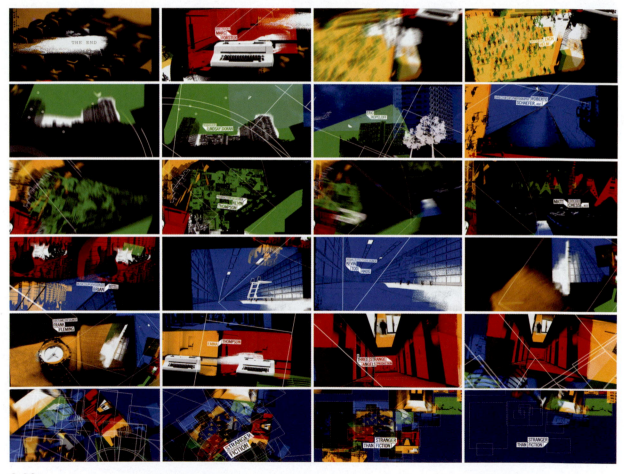

8.19
Frames from the ending titles to *Stranger Than Fiction*. Courtesy of The Ebeling Group. Producer: Keith Bryant; Director: MK12.

subjectivity

The use of subjectivity through *point-of-view editing* can enhance a story's narrative structure by representing the viewpoint of one or more characters. This approach tends to evolve through developing psychological connections that violate believable space and time that is inherent to traditional continuity editing.

In Stanley Kubrick's *2001: A Space Odyssey* (1968), the Star-Gate scene representing Keir Dullea's cosmic journey through time and space is historically one of the most conceptually imaginative sequences in narrative cinema. It confounds our expectations of character point of view by breaking free from the conventions of linear time and space, inviting us to engage in the mysteries of human life and the universe on a deeper level than an average narrative film is capable of.

In motion graphics, many popular film title designs utilize the device of montage to create an emotional environment that allows audiences to connect or identify with the main character. For example, in David Fincher's crime film, *Se7en* (1995), Kyle Cooper's renowned opening credit sequence creates a state of mind, whereby unusual camera

8.20
Frames from Addikt's promotional film leader, 2007. Courtesy of Addikt.

Discontinuity between sequences of lines and shapes enhances this composition's aesthetic impact.

Historical Perspective

After World War I, point-of-view editing allowed French Impressionist filmmakers to portray psychological states of mind. Out-of-focus and filtered shots with awkward camera movements and unusual angles were used to depict the state of mind of drunken or ill characters. They also invented ways of fastening their cameras to moving vehicles, amusement rides, and machines that could move. Experimentation with editing patterns, lenses, masks, and superimpositions allowed a character's inner consciousness to be expressed. The use of flashbacks was also quite common, and sometimes, the majority of the film was a flashback.

In Abel Gance's romantic melodrama, *La Roue* (1923), techniques, such as rapid cut montage, extreme and low-angled close-ups, tracking, and superimposition establish a rich psychological portrayal of the film's main character. In the French silent film, *La Souriante Madame Beudet* (1923), director Germaine Dulac paints his character's emotional feelings of anxiety, entrapment, and disillusionment through slow motion, distortion, and metaphorical juxtapositions of images (8.21). Scholars and theorists regard this psychological narrative as one of the first "feminist" films. It influenced Hollywood directors, such as Alfred Hitchcock, as well as popular American genres and styles.

8.21
Frame from Germaine Dulac's *La Souriante Madame Beudet* (1922).

angles and manic, unstable movements of typography and live-action elements mimic the psychological nature of a character driven by obsession. The imagery appears as if it "were attacked with razor blades and bleach," according to an interview with Kyle ("David Fincher: Postmodern Showoff," by Renee Sutter). In another interview, he stated that somebody told him "I don't know what that [film] was about, but I felt like I was watching somebody being killed."

In an animated identity for Film4Extreme's channel launch in the UK, "stylized shots of things that make you squirm" are combined with the themes of "sex, drugs, and tattooing." Particular portions of the sequence feel similar to the opening titles in *Se7en* with respect to seeing through the eyes of a character. Abrupt cuts and disjointed, disturbing images of the tattooing process allow us to connect with the bizarre female figure who appears at the very end of the sequence (**8.22**).

spatial discontinuity

Breaking spatial continuity allows you to reconstruct an environment that partially relies on the imagination of the viewer. This can be used to establish the viewpoint of a character or intensify the emotional impact or mood of the concept.

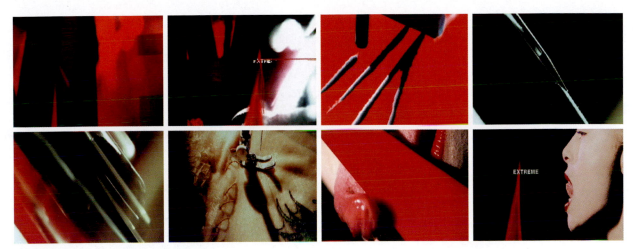

8.22
Frames from a motion identity
for Film4Extreme. Courtesy of
Kemistry.

In Sergio Eisenstein's film *October* (1927), a scene of crouching soldiers precedes a shot of a descending cannon. This juxtaposition creates a violation of space, forcing us to depict the figures as if their government was crushing them. A shot of a cannon hitting the ground gives way to an image of starving women and children. Once the wheels hit the ground, we cut to a shot of one woman's feet in the snow. The repetitive use of cannon imagery makes it difficult to decipher if multiple cannons are being lowered or if one descending cannon is showed several times. Again, we have no choice but to formulate our own interpretation of the event, versus being fed the narrative.

Violating the 180-degree rule can intentionally disorient viewers by throwing off their cognitive spatial map to weaken their impression of an objective world. In Surrealist filmmaking, the 180-degree principle was often abandoned in favor of cutting between opposite sides of a subject's index vector. This allowed filmmakers to create fantasy worlds that expressed the irrational thoughts of the subconscious mind. The opposing screen directions could effectively portray a character's troubled condition. In **figure 8.23**, this strategy adds visual interest to a scene that might otherwise have been too predictable if edited in traditional Hollywood-style. Giant Octopus' promotional interstitial for the Sundance film channel, which portrays a female figure posing next to a movie screen with the channel's identity projected onto it, commences with a medium-close-up shot of the figure seductively pulling her glasses downward. This subtle motion is accompanied by an abrupt frame stutter effect that lasts for a few frames. An abrupt shift to a long shot and a zoom in to the figure gives us a cognitive spatial map of the

The internationally acclaimed Japanese film director Yasujiro Ozu is known for constructing a 360° space in which the action was filmed in the center. Film cameras could be moved around to any point in the circle's circumference to achieve various spatial distances and camera angles of the subject. This violation of spatial continuity can be seen in films such as *An Autumn Afternoon, Floating Weeds,* and *Late Autumn.*

environment. Our logical sense of the space is, however, interrupted as another frame stutter is followed by a bird's-eye view of the scene. A rotating film reel occupies the foreground plane, and a line of type moves across the frame. Another cut reveals a camera tilt upward from the figure's waist to her face. This motion is intercepted by another long shot in which an animated filmstrip plays next to the figure in the foreground. A cut to a close-up of the projected channel identity is followed by a final long shot that shows the movie screen from a side angle. The varied frame duration between these scenes contributes to the composition's overall sense of discontinuity.

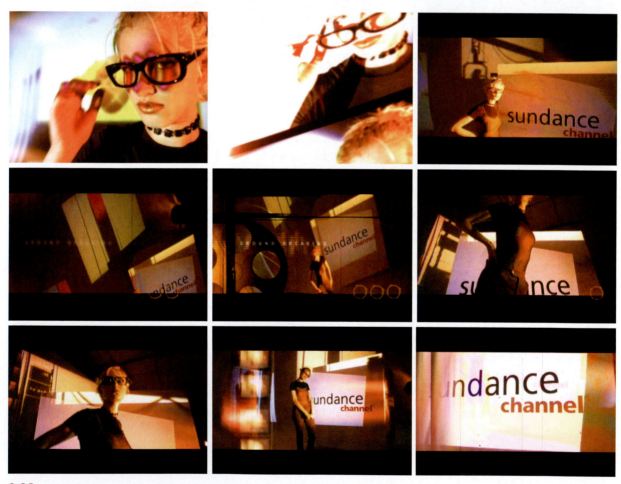

8.23
Frames from an interstitial for the Sundance film channel. Courtesy of Giant Octopus.

In Velvet's package for the political evening program for the Franco-German culture *arte*, the theme of political entanglement, symbolized by a labyrinth and a ball of yarn, is expressed through the spatial discontinuity between the shots. The backdrop of the labyrinth, similar to an Escher drawing in which space defies the laws of physics, reinforces this concept. Throughout the composition, spatial discontinuity is maintained by mixing camera angles in coordination with the chaotic body and hand movements of the actors (**Chapter 5, figure 5.18**). In contrast, the re-branding of a German children's television program in **figure 8.24** illustrates how spatial discontinuity between scenes is used to express the feeling of haphazard, spontaneous play. The goal of the package was to appeal to children between the ages of 3–14 years.

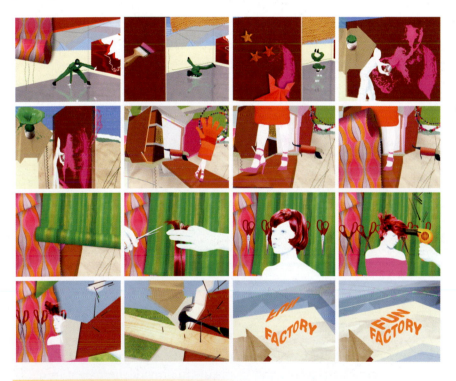

8.24
Frames from the re-branding of ZDF-TIVI, a German national television program for children. Courtesy of Velvet.

temporal discontinuity

Breaking temporal continuity also allows you to deliberately create ambiguity, build tension, and intensify emotional impact.

Sergio Eisenstein conceived of film as a vehicle for experimental editing, and he aimed to alter the viewer's consciousness by refusing to present a story's events in their correct, logical order. Likewise, Hans Richter strove to alter our sense of chronological time in his *Ghosts*

Before Breakfast (1927). Mismatched cuts and unexpected transitions present shots of men with and without beards, creating the effect that their beards magically appear and disappear in the frame. Teacups fill by themselves, hats fly around, and a man's head detaches itself and floats in the air. At times, characters even move in reverse.

jump cuts and flash cuts

In classical continuity-style editing, jump cuts and flash cuts (Chapter 12) are considered technical flaws, because they violate temporal continuity. However, they have become part of today's cinematic vocabulary because of their ability to show an ellipsis of time, arouse tension, or create disorientation by break ing the flow of events. For example, the promos for *Chappelle's Show* employ jump cuts to illus-trate the sharp, defiant humor of the series (**Chapter 12, figure 12.25**).

8.25
Frames from "Melting Point," a fictional television show opening by Corey Hankey, Rochester Institute of Technology, Professor Jason Arena.

Jump cuts are used with choppy camera movements and abrupt transitions to create the hip atmosphere of a realty TV show.

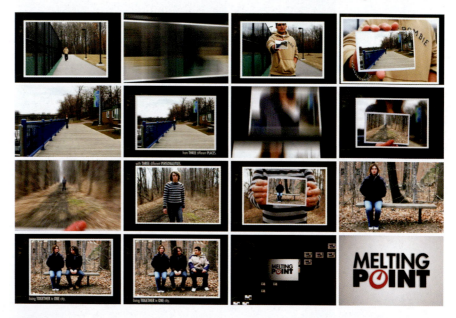

The captivating opening titles to the FearMakers film, *Death4Told* (2004) combines jump cuts and flash cuts to provide an insight into the mind of a voyeur whose presence is only suggested. Viewers are induced with fear and anxiety as they witness startling evidence of the character's madness from a trail of items that he has obsessively collected. In one particular segment, a pan of a brick wall containing various crime scene paraphernalia is followed by a flash cut to the dark face of a woman emerging from the background as the first credits be-gin to appear. Another cut presents an eerie image of a doll's face that connects us to one of the piece's vignettes, "The Doll's House" (**8.26**).

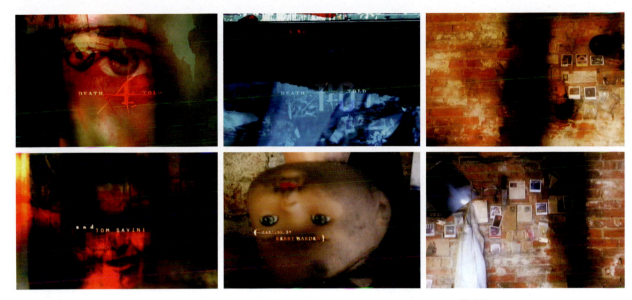

8.26
Frames from the opening titles
for *Death4Told* (2004). Courtesy
of Steelcoast Creative.

8.27
Frames from *Box*, a Surrealist
film. Directed by the Toronto-
based company Nakd. Courtesy
of The Ebeling Group. Executive
Producer: Mick Ebeling; Producer:
Susan Lee.

Jump cuts between camera
angles, distances, and movements
of the figure to create a sense of
drama and urgency.

8.28

In an identity for Domestika, a community that fosters sharing artistic disciplines, jump cuts and frame stutters were choreographed to match the rap-like beat of the soundtrack. Courtesy of Tavo Ponce.

parallel editing

Parallel editing is a common way to explore discontinuous spatial and temporal possibilities. Achieved through the technique of crosscutting, it can be used to create the illusion that different events are interwoven in time or in space. D. W. Griffith's film *Intolerance* (1916), for example, interweaves events from different eras and distant countries based on their logical (versus spatial or temporal) relationships. At one point, he cut from a setting in ancient Babylon to Gethsemane, and from France in 1772 to America in 1916. In *Schindler's List* (1993), director Steven Spielberg used parallel editing to contrast between the hardships of the Jews with the comfortable lifestyle of Schindler and the Nazis.

In motion graphics, music videos have used crosscutting to create impossible worlds in which a character magically appears in different sets or locations "at the same time." In a television commercial promoting Bombay Sapphire's gin, Stardust Studios presented various women, all who represent a heroine, walking through environments, while pieces of the environment attach to them. The use of parallel editing allows the heroine to be transported between different worlds, from a grim, black and white cityscape into an exotic dream, lush with vegetation and wildlife. After diving into a body of water and swimming with a school of translucent jellyfish, she appears to be free and revived and is again transported into a newly transformed sapphire-blue city to make her way home in the evening's clear moonlight (**8.29**).

In a public awareness advertisement for Japan Railways, parallel editing was used to create a dual existence between a young musical performer who passionately plays the violin and a group of kindergarteners. In a second ad, shots of the performer are crosscut with shots of a service manager in a subway station directing commuters to their destinations (**8.30**).

8.29
Frames from "Step into Blue," a television commercial to promote Bombay Sapphire. Courtesy of Stardust Studios.

8.30
Frames from "Service Manager" and "Kindergarten," ads from a public awareness campaign for Japan Railways. Courtesy of The Ebeling Group. Executive Producer: Mick Ebeling; Producer: Susan Lee; Director: Nakd.

event duration and repetition

Controlling the "life" of onscreen events allows you to differentiate actual story time from screen time (or storytelling time). You can take liberties with the duration of events; events can be stretched out to make screen time greater than story time, or they can be consolidated in order to emphasize the principal actions. For example, an event that would normally consume five hours could be reduced down to a few minutes or seconds to deliver the main point. Additionally, events can be repeated, and each repetition can be shown from different camera angles, spatial distances, and heights, as well as at a different speed or frame duration.

In a television segment for Times Now, a cable network based in India, the movement of the graphic flying toward the camera is repeated five times, each time with a slightly different speed and a different angle and positioning in the frame. This break with temporal continuity effectively conveys a sense of urgency that depicts the fastpace of the

8.31
Frames from *6 Minutes*, a segment from *Times Now*, a cable network based in India. Courtesy of Giant Octopus.

broadcast news industry (**8.31**). In a bumper for the Golf Channel cable network, the action of a live-action figure swinging a golf club is repeated in tiny silhouettes that are juxtaposed in the lower portion of the frame. Their similar, repeated motions alter our perception of time to emphasize the swing (**8.32**).

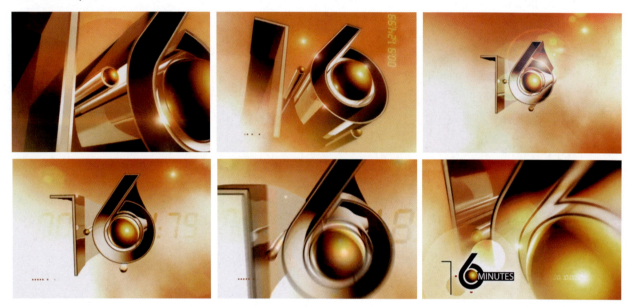

Montage

During the aftermath of Word War I, painters and filmmakers became liberated to explore new ways of presenting ideas through the technique of *montage*. Surrealist and Dada filmmakers began juxtaposing unusual combinations of mundane images of daily life events to explore dreams and the subconscious. Their spontaneous, playful approach to editing, in contrast to Hollywood's traditional continuity style, allowed them to create far-fetched analogies and bizarre personal fetishes. In Salvador Dali's *An Andalusian Dog* (1928), the main character drags two pianos filled with dead donkeys across a room. In a disturbing scene at the beginning of the film, a man slits the eyeball of a woman with a razor-blade, and her reaction is lifeless and apathetic. Hans Richter's *Ghosts Before Breakfast* introduces obscurity and fantasy by incorporating clocks, hats, ladders, and figures into unusual, irrational settings.

8.32
Frames from a bumper for the Golf Channel. Courtesy of Giant Octopus.

conceptual forms

Conceptual montage (also referred to as *idea-associative montage*) involves juxtaposing two different ideas to formulate a third concept or *tertium quid*. This allows you to communicate complex messages to an audience in a short period of time.

One form of conceptual montage is the *comparison montage*, which involves juxtaposing two thematically similar events to reinforce a basic idea. For example, an image of a lighted cigarette on the ground followed by an image of a burning forest conveys the idea of environmental awareness. The *collision montage* involves juxtaposing two thematically unrelated events. The resulting idea is the result of the dualistic conflict between the two original ideas.

Flying Machine's design package for MOJO, a high-definition, male-oriented entertainment network, demonstrates a combination of comparison and collision montage. The goal was to create an edgy, suggestive design that had "attitude." Many of the themes, ranging from beer and cooking to exotic cars, exotic women, music, and travel adventure, allowed creative director Micha Riss to take many liberties in comparing and contrasting images. For example, a shot of twisting and turning kitchen utensils precedes a slow pan of a sensuous female torso in the foreground and the sleek body of a car in the background. The juxtaposition between human and machine, or organic and synthetic, challenges us to make a connection. Another segment featuring extreme close-up shots of a guitar neck and a microphone moving in opposite vertical directions also invites us to construct a tertium quid through comparison and contrast. The composition ends with a medium shot of a female figure erotically extinguishing the barrel of a smoking gun with her lips (**8.34**).

Sergio Eisenstein discovered that if a film was edited to synchronize with the human heartbeat, it could have a tremendous psychological effect on his audiences. In his essay "A Dialectic Approach to Film Form," he compares conflict in history to editing in film. In *Strike!* (1924), he juxtaposes a workers' rebellion being put down with a non-diegetic insert of cattle being slaughtered. Eisenstein's use of parallel editing synthesizes two ideas to produce a third idea symbolizing that the workers are cattle. In the "Odessa Steps" sequence of *Battleship Potempkin* (1925), Eisenstein juxtaposed images of innocence against images of violence. He also mixed contrasting long shots and low-

Clearly, Surrealist painting directly influenced the Surrealist use of cinematic montage. The stark city squares in director Germaine Dulac's The Seashell and the Clergyman (1927) were inspired by the paintings of Giorgio de Chirico. The ants appearing in Salvador Dali's An Andalusian Dog (1928) come directly from his paintings.

8.33
This commercial for BMW employs an animated split screen to tie together various driving conditions governed by weather and terrain. Courtesy of Stardust Studios.

8.34
Frames from a network package for MOJO, a male-oriented, high-definition TV channel featuring a block of original prime-time shows. Courtesy of Flying Machine.

angle shots of the soldiers with close-ups of the citizens to depict their fear and panic. In *October,* Eisenstein forces us to actively interpret the events by confronting us with disoriented sequences of images of the protagonist—the Russian people—the antagonist—the Provisional Government—that continued to support its allies after the Revolution. Shots of soldiers socializing with their German enemies are followed by a shot of a bombardment in which they run to their trenches.

Another scene of the soldiers on the battlefield follows a shot of a cannon being lowered from an assembly line. Shots of a tank are cross-cut with those of hungry women and children standing in breadlines in the snow. As a result, the delineation of narrative is sacrificed in favor of a rhythmically striking composition that invites us to connect with the theme emotionally. Many music videos since the late 1980s have continued to employ Eisenstein's theories of montage.

analytical forms

Analytical forms of montage can be used to indicate a passage of time and condense or expand time within a narrative context. It can also be used to synthesize different time zones of one or more related events into a single event. Although the content is critical and is considered in terms of its thematic attributes, analytical montages often violate continuity in order to focus on the emotional aspects of the subject matter.

The early cinematic technique of *sequential montage* (also referred to as *cause-and-effect montage* or *narrative montage*) has been used to tell stories in shorthand by condensing events down into their primary components and presenting them in their original cause-and-effect

Historical Perspective

In early avant-garde filmmaking, sequential montage often involved deconstructing the content by cutting up the film and editing it back into a condensed series of events. It often relied on devices, such as repetition, close-ups, rapid cuts, and dissolves, to capture and hold the audience's attention. Walter Ruttman's *Berlin: Symphony of a Big City* (1927) is an extraordinary documentary that provides an intimate model of urbanization by juxtaposing sequences of images of horses, trains, bustling crowds, and machines to express the dynamism of Berlin. Associations between the everyday lifestyle of the working class and that of the wealthy elite suggest a ba-

sic similarity, versus a class struggle. The linking of these scenes unifies the content of the film by showing a cross section of a city in motion, the interaction of its parts contributing to the whole.

In Russia, Sergei Eisenstein and Dziga Vertov utilized sequential montage to express ideas about popular culture. Influenced by the Soviet avant-garde, Eisenstein rejected conventional documentaries that involved linking scenes in a smooth, logical manner. His films made complex, visual statements by shocking his audiences with totally unexpected scenes that were composed of numerous different shots.

order. Although the presentation is linear, spatial continuity rules are often broken to emphasize the story's highlights and shift viewers through time to suggest a fleeting passage of events.

In Krafthaus Films' opener for a New Zealand music video competition, sequential montage was employed to showcase "the ultimate sexy rock chick" in "a virtual world where she moves from heavy rock hardware into a more zen-like space after her climax," according to David Stubbs, the producer, writer, and director for the video (**8.35**). In **figure 8.36** an animation based on the Greek legend of Icarus is consolidated into a sequential montage that lasts a little over a minute.

8.35
Frames from the opening titles for a New Zealand music video competition. Produced, written, and directed by David Stubbs and Gareth O'Brien for Radio Active 89FM. Courtesy of Krafthaus Films.

Sequential montages usually do not show the main event; rather, they imply it. This forces viewers to participate in the story by making their own personal connections. A boxing sequence, for example, may begin with a medium shot of one player gearing up to throw a punch. We then cut to a bird's-eye view of both players during the action of the punch. A shot of the crowd immediately follows, and then we cut to a final close-up of the second player down on the ground. The action

8.36
Frames from "Icarus." © 2005
Adam Scwaab.

of the second player receiving the punch is never actually shown. We are also forced to decipher space and time as continuous, even though continuity rules are broken. In a simple motion graphics scenario, a shot of an object moving across the screen is followed by a shot of another object crossing its path. These are the *cause* aspects of the montage. The next shot reveals the object's effect after the impact. The actual event in which they interact is only implied. We are expected to apply closure to realize the full event, rather than being hand-fed all aspects of the story. Although time has been condensed to intensify the emotional feel, the original order of events has been preserved.

In a Sundance Film Festival bumper, Digital Kitchen conceived the idea of using pop-up imagery from children's books. *Their* animated version of Icarus begins with a long shot of the main character poised on a balcony. An abrupt cut reveals a close-up of his legs standing at the edge and then leaving the balcony to propel him on his journey toward the sun. After a quick cut to a circular, radiating image of the sun (a desk lamp), the sequence ends with a scene of feathers floating down behind the main title to the bottom of the frame. Instead of experiencing the entire event, we are treated to its aftermath (**8.37**).

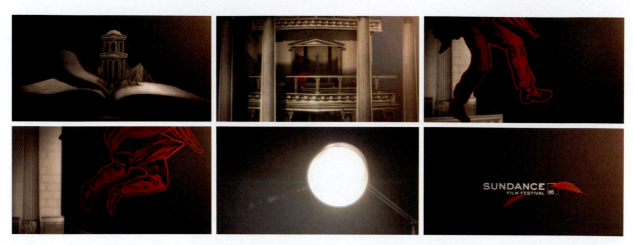

8.37
Frames from an animated bumper for the Sundance Film Festival 2006. Courtesy of Digital Kitchen.

Unlike the sequential montage, the *sectional montage* interrupts the flow of time by bringing the progression of the story's events to a halt in order to focus on an isolated action or event. Events are not presented in their original cause-and-effect sequence, but rather, in a nonlinear fashion, allowing us to construct a unique, new meaning, apart from the larger context they belong to. Herbert Zettl offers a terrific analogy in his book, *Sound, Sight, Motion*: "The sectional montage acts more like a musical chord in which the three notes compose a gestalt that is quite different from playing them one by one."

As an alternative to cutting, events can be juxtaposed pictorially in the form of a split screen display or as a presentation across multiple screens to show them happening concurrently. Sports telecasts and news presentations often rely on the divided screen to reveal specific moments from various points of view. Modern day television dramas, such as *24*, make effective use of split-screen sectional montage to illustrate simultaneous events occurring in different locations.

Summary

Sequential composition considers the manner in which events occur over time. Cinematic language and traditional editing techniques can be used to tell stories in meaningful ways.

Continuity editing practices have been used to create a logical sense of space and time. The use of index and motion vectors can preserve the viewer's logical sense of space between scenes. *Graphic* and *temporal continuity* can be used to create smooth linkages between scenes and

to contribute toward a plot's manipulation of story time. The device of *temporal ellipsis* can condense time in order to omit unnecessary information that might detract an audience's attention from the story.

Discontinuity can be used to enhance anticipation or arouse anxiety. The use of subjectivity through *point-of-view editing* can enhance a story's narrative structure by representing the viewpoint of one or more characters. Breaking spatial continuity can reconstruct an environment that partially relies on the imagination of the viewer. Varying event duration and repetition allows you to break temporal continuity in order to differentiate actual story time from screen time. Events can be stretched out, consolidated, or repeated from various viewpoints.

The technique of montage can be used to help audiences connect or identify with the subject matter. *Conceptual montage* involves juxtaposing two different ideas to formulate a third idea or *tertium quid*. *Sequential montage* tells stories in shorthand by condensing events into their primary components in their original cause-and-effect order. The main event is typically implied, forcing viewers to make their own personal connections. The *sectional montage* interrupts the flow of time by bringing the story's events to a halt in order to focus on an isolated action or event.

Assignments

The following assignments are intended to help you strengthen your sensitivity to the sequential aspects of a composition. Share your work with others and discuss what devices (i.e., motion vectors, frame mobility, event duration and repetition, subjectivity, etc.) were used to create continuity or discontinuity. Consider what aspects of these projects could potentially be applied to "real world" assignments.

spatial continuity: primary motion #1

overview
You will construct and edit three animated sequences of a moving object shown from multiple viewpoints.

objective
To explore how continuity editing can create a logical interpretation of a space shown from multiple perspectives.

A few of these assignments require recording live-action footage. If you do not own or cannot afford a camcorder, use a cellular phone that has video capabilities. (Alternatively, disposable video cameras are inexpensive and can be purchased at most convenience stores.)

Many of these projects involve the technique of nesting, as described in Chapter 12. Be sure that you are familiar with how this technique is used in the application that you are using. For example, Adobe After Effects uses precomps, while Flash uses symbols.

stages

In a program that has 3D capabilities, create a 10-second animation of a two-dimensional shape or letter moving in three-dimensional space.

Nest the animation into three 5-second compositions, and incorporate a camera into each new composition. Adjust the camera's position and settings in each to show a different perspective of the animation.

Nest these three compositions into a fourth 5-second composition, and vary their in and out points to show only a portion of each. Edit them together using straight cuts.

specifications

You are to stay within the 10-second time limit. For this reason, you are to use only straight cuts, since transitions occupy time.

considerations

Attention should be given to how spatial continuity can be preserved from onscreen into offscreen space by maintaining the direction that the element moves between the segments. Consider employing the 180-degree rule. Placing all cameras on one side of an imaginary axis of action will help maintain spatial continuity.

spatial continuity: primary motion #2

overview

You will construct and edit animated sequences of two interacting objects shown from multiple viewpoints.

objective

To explore how continuity editing can create a logical interpretation of an animation in a space that is shown from multiple perspectives.

stages

Create a simple 10-second animation of two shapes or letterforms interacting in three-dimensional space using an application that has 3D capabilities. (You may use an animation from any of the kinetic typography assignments in Chapter 6.)

Nest the animation into four 10-second compositions, and incorporate a camera into each new composition. Adjust the camera's position and settings in each composition to show different perspectives.

Nest these three compositions into a fifth 10-second composition, and vary their in and out points to show only a portion of each. Edit them together using straight cuts.

specifications

You are to stay within the 10-second time limit. For this reason, you are to use only straight cuts, since transitions occupy time.

considerations

To establish spatial continuity in the scenario of two people having a conversation or engaging in a game or physical activity, all cameras are placed on one side of a 180-degree line. The same principle should be applied to this assignment; consider using an imaginary axis of action to determine the correct camera viewpoints. Additionally, consider how spatial continuity can be preserved from onscreen into offscreen space by maintaining the direction that elements move between scenes

spatial continuity: secondary motion #1

overview

You will construct and edit a series of animations that show an object from multiple camera angles, spatial distances, and frame mobility.

objective

To explore how continuity editing can be used to create a logical interpretation of an object in a space shown from various perspectives and mobile framings.

stages

Create a simple shape or letterform in a three-dimensional space using a program that has 3D capabilities.

Create five 10-second compositions, each containing the static shape or letterform. Incorporate a camera into each composition, and adjust its position and settings to reveal a different perspective of the element. Next, animate the camera in each to create a different type of mobile framing. (One composition might show a zoom in from a bird's eye view, while another might employ a tilt upward from a frontal, close-up view.)

Nest these animations into a new 10-second composition, and vary their in and out points to show only a portion of each. Edit them together using straight cuts.

Tips:

1. In most of these assignments, cutting during the element's motion (instead of before or after it) will ensure maximum continuity.

2. Movements should only be presented once in their logical order to preserve continuity.

3. Establishing a spatial context that shows the entire subject at some point during the piece will help maximize spatial continuity.

4. When cutting during a camera move, continue the same move in the following segment through the cut, versus intercepting the cut. For example, if you are panning from a particular camera angle or distance, continue the pan in the same direction in a subsequent sequence that might present the subject from a different angle or distance. Try to match the speed of the consecutive moves to maintain the flow of movement.

specifications

You are to stay within the 10-second time limit. For this reason, you are to use only straight cuts, since transitions occupy time.

considerations

Consider how the effect of frame mobility preserves spatial continuity. Consider employing the 180-degree rule. Placing all cameras on one side of an imaginary axis of action will help maintain spatial continuity.

primary and secondary motion #1

overview

You will construct a live-action sequence of two figures interacting based on a series of shots that show multiple camera angles, spatial distances, and mobile framings.

objective

To explore how continuity editing can create a logical interpretation of an event that is shown from various perspectives and mobile framings.

stages

Choreograph a 10-second performance of two people interacting in a conversation, a game, or physical activity. Since they will be performing the activity several times, have them rehearse the motions so that they are consistent.

Videotape the event five times, each from a different camera angle and distance. Frame mobility can be employed during shooting or on the computer after the footage has been digitized. Each clip should be approximately 10 seconds long.

Digitize and import the clips into a motion graphics application of your choice. Vary the in and out points of each clip to show only a portion of each. Edit them together using straight cuts.

specifications

You are to stay within the 10-second time limit. For this reason, you are to use only straight cuts, since transitions occupy time.

considerations

Consider how frame mobility preserves spatial continuity. Consider employing the 180-degree rule. Placing all cameras on one side of an imaginary axis of action will help maintain spatial continuity.

primary and secondary motion #2

overview
You will record and edit a live-action scene from multiple camera angles, spatial distances, and mobile framings of the event.

objective
To explore how continuity editing can create a logical interpretation of an event that is shown from various perspectives and mobile framings.

stages
With the help of three people, film a short live-action sequence from four different camera angles and spatial distances. Frame mobility can be employed during shooting or created digitally after the footage has been digitized. Each clip should be approximately 10 seconds long.

Digitize and import the clips into a motion graphics application. Vary their in and out points, and edit them together using straight cuts.

specifications
You are to stay within the 10-second time limit. For this reason, you are to use only straight cuts, since transitions occupy time.

considerations
Consider how frame mobility and the 180-degree rule preserves spatial continuity.

breaking spatial continuity

overview
You will reconstruct assignments 1-4 to break spatial continuity.

objective
To investigate how violating continuity can deliberately disorient the viewer in order to arouse mystery or induce emotions.

specifications
You are allowed to duplicate object and camera movements and present them out of their original sequence. Use only straight cuts in order to stay within the 10-second time limit.

considerations
Observe how deviating from the 180-degree rule and cutting before or after object or camera actions makes space discontinuous.

CLIENT: Syncra Systems

PROJECT OBJECTIVE:
to design a tradeshow animated presentation
kmarketing Syncra's supply chain management softw

CONCEPT/VISUALS:
supply chain environments combined
with metaphors of collaboration/teamwork

PART 3

putting motion graphics

1 5 10 15 20 25 30 1 5 10 15 20 25

into practice

conceptualization
developing ideas

Regardless of tools and delivery format, concept development is critical to all forms of graphic communication. Since the beginning of the twentieth century, artists have expressed their ideas through the medium of animation. In more recent years, graphic designers have harnessed the devices of time and motion to convey their ideas in movie titles, network identities, Web sites, multimedia presentations, and environmental graphics. In the past, developing concepts to communicate their ideas was the first challenge. The current challenge is developing *unique* concepts and communicating them by storytelling.

"Creation is the artist's true function. But it would be a mistake to ascribe creative power to an inborn talent. Creation begins with vision. The artist has to look at everything as though seeing it for the first time, like a child."
—Henri Matisse

"The greatest art is achieved by adding a little Science to the creative imagination. The greatest scientific discoveries occur by adding a little creative imagination to the Science."
—James Elliott

00:00:00:09

Assessment

defining the objective

In the industry, clients often think they know what they want but change their mind in the middle of a project. It is wise to review with the client a clear articulation of the project's objective before the creative process commences.

Every design begins with an objective. Without a clear objective, your ideas can become lost in the ocean of right-brained activities. Before plunging back into the creative waters, it is best to clearly define your objective on paper without a lengthy narrative.

Coming to terms with a project's objective may take time. Once it is established, it should be kept in mind from conceptualization through design to the final execution.

targeting the audience

The goal of visual communication is to facilitate a reaction from an audience, and this audience should be clearly defined in order to meet your objective. In the industry, the individuals who are involved in marketing usually have already achieved this, although designers have been known to play a strong role in identifying the audience.

researching the topic

To define your target audience, ask yourself the following questions:

1. What type of demographics (i.e., cultural, social, economic) are relevant to my target audience?

2. What does my audience already know about the subject?

3. What do they need to know?

4. How has this information been communicated before?

5. What single message should people walk away with?

6. What type of response should be expected from my viewers?

Research is key to effective communication. Intriguing concepts and cutting-edge design may not be enough to effectively communicate the information if adequate research is not conducted ahead of time. Diving into the creative waters too soon poses the danger of time and energy being wasted on ideas that may be dynamic but are irrelevant or inappropriate to the project's objectives. Therefore, a thorough analysis of your subject matter should occur before you begin to conceptualize.

Clients can mistakenly assume that the designers are well informed about the topic being considered. This can be dangerous to both parties. Therefore, it is wise to step up to the plate and assume the responsibility of educating yourself about the subject at hand. A wide range of resources are available to aid in your investigation. Many consider the Internet to be the quickest method of digging for information. Others find the library to be the most efficient resource. Setting up a meeting to discuss the material with the client first-hand is, of course, highly recommended, since he or she will be the most valuable source of information. There is nothing wrong with asking too many questions. The more thorough your research, the more effective your design.

9.1

Concept sketches for a trade show video, by Jon Krasner. Courtesy of Syncra Systems, Inc. and Corporate Graphics.

The metaphors used here came as a result of educating myself about supply chain management.

understanding the restrictions

The most successful graphic designers aspire to exceed our own potential. Passion for creativity drives them to become better at what they do. They create art not because they want to, but because they have to in order to feel personally rewarded. However, the industry poses certain restrictions that they need to be aware of.

Budgetary constraints can limit the use of materials, equipment, and reliable technical support and prohibit hiring outside photographers or purchasing as many stock images or video clips as they see fit.

Regardless of how unreasonable deadlines may appear, designers are forced to be realistic about what can and cannot be accomplished within the given window of time that is available. For example, After E! Networks declared the need for a show opening for *Style Court* less than three weeks before airing (after spending many weeks looking through hundreds of static logo designs to choose the show's identity). Designer Susan Detrie was put to the test with a time frame of under forty-eight hours to develop a storyboard. A combination of quick thinking and late evening hours resulted in an engaging board that, like the show's content, presents a variety of images that reflects the show's entertaining nature and wide range of ages. Humorous court icons, such as a bad hairdo, a leopard skin suit, and an evidence bag consisting of 1970s platform shoes, create a feel similar to that of a generic police show, such as *NYPD Blue* (**9.2**).

"With creative freedom, time, money, and reliable technical support, the potential here is limitless. Just imagine the possibilities!"

—*Jon Krasner*

"Better to have the creative reins pulled back than to be kicked in the flanks for more!"

—*Meagan Krasner*

9.2
Storyboard for a show open to
Style Court. Courtesy of E!
Networks and Susan Detrie.

The opinions and biases of clients can also be creatively restricting. Clients are not always open to new ideas (even if they say they are). It is seldom that designers are given complete artistic freedom. Some clients may seem utterly inflexible and closed-minded, while others, unintentionally, attempt to play the role of art director or "creativity gatekeeper." Because the client controls the paycheck, the portfolio, and to an extent, a designer's reputation, pride that is built on years of educational training may have to be swallowed in order to conform and keep your client satisfied. The majority of the time, solutions are usually mutually agreed upon between the client and designer from initial concept to final completion.

These restrictions should not be perceived as limitations to creativity, but rather, as guidelines to help give your ideas direction.

considering image style

There are several types of images to choose from including photographic, typographic, illustrative, abstract, and so forth. These image categories can take on different visual styles from graphic, to textural, whimsical, sketchy, or blended, to name just a few. Techniques, such as cropping, lighting, distortion, color manipulation, deconstruction, layering, masking, and special effects, can enhance the expressive properties of your content before it is integrated into a storyboard.

Addressing the client's needs up front will avoid frustrations down the road. Miscommunication is prone to happen when an intermediary intervenes between you and the client. If the opportunity presents itself, try to establish a one-on-one rapport with the "head honcho." A relationship based on mutual respect and trust provides you the opportunity to unlock the client's mind and convince him or her that your idea will work. With a combination of professionalism, assertiveness, and respect, clients can be convinced on an idea, provided that trust has been built.

The stylistic "flavor" of the visuals—both images and type—depends on your underlying theme or message, whether it is marine, sports, rock 'n' roll, theatre, country, cultural, or eclectic. A figurative interpretation of a concept may require the use of metaphorical imagery, while a different set of images may be more appropriate for a more literal interpretation. The content should also reflect the demographics of the target audience, whether they are artists, yuppies, teenagers, or professionals. These factors should be considered as early as possible.

Consider the following to help you determine the style of your content:

1. percentage of typography, photos, illustrations, and live-action

2. elements needed to be included at the client's request

3. color and size restrictions?

4. overall color scheme?

5. nature of content (i.e., objective, nonobjective, realistic, or abstract?

9.3
Frames from "Planted," a motion identity for Capacity™ motion design studio.

The metaphor of seeds being planted to grow into something beautiful expresses the concept of running a creative business.

Formulation

Once the objective, target audience, and restrictions have been defined and the subject has been thoroughly investigated, the floodgates of creativity can be opened to allow imaginative ideas to pour forth.

brainstorming

Brainstorming is the first step in generating ideas. It works best in an environment that is conducive to creative thought. Annoyances, such as junk e-mail, uncooperative technology, and telephone sales calls, are detrimental to brainstorming. Therefore, scheduling a continuous block of time to think quietly without distractions is recommended. Some people react well to background music while others require complete silence in order to concentrate.

All concepts begin in the imagination. As they enter, they should be recorded immediately. It is wise to have a sketchbook handy to capture

Each new project is a growing experience, and the fruits of your labor do not have to be wasted. Ideas do not have to be completely discarded; they can be written down, drawn on paper, voice recorded, or filed away digitally for future use. (Keep in mind that new ideas are sometimes abandoned and replaced with old ones.)

"An idea is a point of departure only. As soon as you elaborate it, it becomes transformed by thought."
—Pablo Picasso

the spontaneous flow of ideas. Putting pencil to paper is an invaluable process that, like music improvisation, keeps ideas fresh and moving. Pencil sketches (or thumbnails, as they are often referred to in print design) are usually where the design begins to take its form. These should be small and loose, allowing for the quick generation of ideas. Spending too much time polishing a sketch can break creative momentum. Many designers prefer to work out their initial concepts in a more polished, digital format, because the results more closely resemble the final storyboard and the later production.

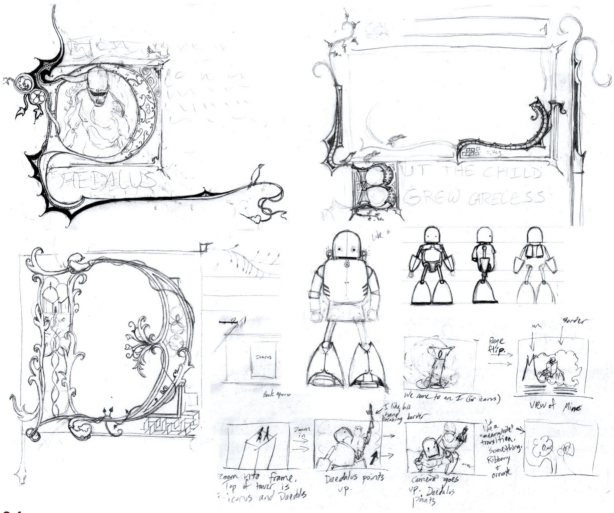

9.4
Concept sketches for "Icarus."
Courtesy of Adam Scwaab.

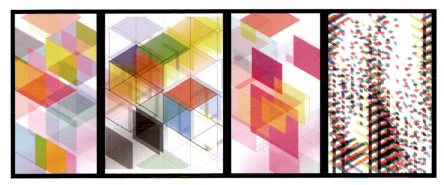

9.5
These early digitally-executed ideas explore how Adobe's multidimensional logo could be potentially animated. Courtesy of twenty2product.

obstacles to creative thinking

Every person experiences moments when they have a mental block that prevents them from creating at their maximum capacity. Although the ability to create cannot be turned on or off at a whim, being aware of obstacles that impede creative thinking is the first step in avoiding them. For example, it's easy to become lured into stylistic trends that have been overused. Biased notions and contrived ideas of what's "hot" can limit the range of creative opportunities and prevent you from being original. Being aware of trends in the industry is healthy, as long as your design does not become reliant on them. The range of digital effects that are available can also intrude on creative thinking, since they require minimal artistic skill or sophistication. Although they can be beneficial when used intentionally, they lack ingenuity, and their ease of use can impede imaginative thinking and obscure aesthetic judgment. The abundance of stock photography, illustration, fonts, and clip art makes it easy for designers to rely on ideas relating to popular culture rather than on their own capacity to conceptualize. Last, the demand for acquiring technical proficiency, due to the rapid pace of software development, can be an impediment to creativity. It is important to not lose sight of your primary goal as a designer.

9.6
These digitally-executed sketches for Fuel TV's signature network ID are based on the fictional character, "Poopa-Ooba," a demi-god who invented Skatism as a culture and religion for skate-boarders. Courtesy of FUEL TV.

See DVD for final animation.

pathways to creative thinking

Creativity can be mistaken for originality, when in fact, very few original ideas exist. Many designers merge previous concepts in their own personal way. *Creative* designers, like laboratory scientists, trust their intuitions and are not afraid to face new challenges. Yet, the creative process can be elusive. Ideas sometimes spring up when we least expect them to. Inspiration, risk taking, and experimentation can foster innovative thinking and allow ideas to develop naturally.

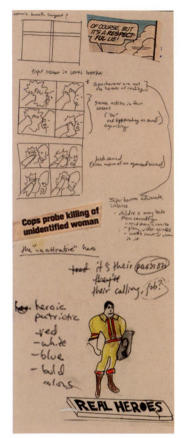

9.7
Sketches for a sting entitled
Hero Stereotype by Megan Mock,
University of San Francisco,
Professor Ravinder Basra.

9.8
Frames from an opening to a
CD-ROM mailer for Accurate
Data. Concept and design by Jon
Krasner. Courtesy of Belden-
Frenz-Lehman, Inc.

inspiration

Inspiration is the motivating force behind innovation. Unlike a job that
ends when the shift is complete, seeking out inspiration is a continuous
process of searching for new angles and directions in an attempt to
smuggle your ideas into each new assignment.

Artists often find inspiration in identifying with their subject. A student
of mine chose to express the theme of domestic violence in a project
based on visual metaphor. Based on her working with people who were
victims of domestic abuse, she was able to relate to the psychological
consequences that they faced; her emotional identification inspired
her to develop genuine ideas. In an animation for a CD-ROM mailer,
the topics of panic and disaster served as inspiration to market backup
data software to protect important information from the possibility of
a hard drive crash.) Panic was expressed from a physiological stand-
point through images pertaining to physical and emotional responses
that occur during times of stress or fear. Disaster was communicated
through images of natural phenomena such as tornadoes and floods.
These themes served to create an entertaining presentation that view-
ers could experience before interacting with the program (**9.8**).

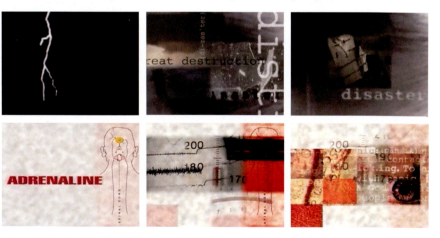

The capacity to identify with your subject, however, does not always
come naturally. In most cases, it occurs after conducting adequate
research. In 2000, twenty2product was asked by RockShox, a leading
company in the global cycling community, to develop concepts for a
Web site and trade show video. After becoming familiar with the
cycling industry, twenty2product developed an appreciation for the
mechanical know-how involved in designing bicycle parts. Technical
machine drawings became a source of inspiration and were used to

inform the look and feel of the graphics. Complex diagrams, abstract graphic patterns, typography, and live-action footage were integrated into a highly compelling series of sketches that conveyed forward thinking, the millennium, and all of the things that it implied (**9.9**).

9.9
Web site sketches for RockShox. Courtesy of twenty2product.

9.10
Frames from a political evening program for the Franco-German culture *arte*. Courtesy of Velvet. (*Also see Chapter 5, figure 5.18.)

The antique Greek drama of Ariadne and Theseus served as an inspiration for the central theme. Two elements from the story, a labyrinth and a ball of yarn, establish the context of political entanglement. The body movements and gestures of the actors symbolize puppets being pulled on a string and the masters who pull the strings.

Be open to ideas from almost any source—magazines, books, films, etc. Involving the client may reveal that you are not an incredible walking idea factory; however, ideas that formulated through collaboration may be more beneficial than those that are generated in isolation. Observing the work of other designers and design movements can also help foster new ideas. This should be exercised with moderation, since relying too greatly on other styles can be dangerous.

risk taking

Throughout history, stylistic movements in art and graphic design were manifested from groundbreaking visionaries and experimenters who deviated from the norm. Fauvist painters were referred to as "wild beasts" by virtue of their garish color combinations and harsh, visible brush strokes. Their work eventually became celebrated and absorbed into impressionist painting. David Carson took risks by ignoring the conventions of print and introduced a broad spectrum of innovative design solutions to *Ray Gun* magazine. Although his style was rejected, it eventually became a milestone in print design and gained popularity among a fast growing audience. The rebellious nature of designers who were hired by MTV challenged the conventions of corporate identity by introducing an entirely new edgy style that eventually spawned new approaches to broadcast animation for channels such as CNN, VH1,

9.11

Html and Flash Web site pages. Concept, design, and animation by Jon Krasner. © AML Moving & Storage.

Pride in workmanship and family traditions served as inspirations for these designs.

and Nickelodeon. These individuals did not gain artistic satisfaction from following the same design recipe; rather, they broke out of their safe, cozy territories to embrace and celebrate the power of imagination by keeping an open mind and considering unexpected ideas.

Taking risks means venturing into new, unfamiliar territory. This may feel uncomfortable because of the potential dismissal of an idea by your client or audience. (Realize that you can always fall back on an alternative, perhaps less radical, approach.) Despite the level of discomfort, applying the same formula time after time can become intellectually dull, and your creative resources can become stale if you remain on a plateau for too long. The consequences of not being accepted by the mainstream are worth your chance of discovery.

experimentation

Like science, artistic concepts are based on an evolution of discovery through experimentation. Experimentation contributes to ideation by opening up your thought processes and eliminating contrived or trendy solutions. It relies on the element of play and embraces the unexpected, allowing accidents to become possibilities. New discoveries

can lead to sophisticated approaches to problem solving. Further, experimentation gives you the opportunity to attain individuality. Since risk taking is involved, experimental play is not intended to produce mediocrity; rather, its goal is to make life less predictable.

A friend of mine once defined art as "studied playtime." In order to maintain that state of mind and keep the pathways to creativity open, take the "scenic route" and allow your mind to wander. Stay alert to the possibility of serendipity. If you find yourself coming back to an idea that lacks ingenuity, revisit it later from a fresh perspective.

My six-year-old son, Harris, is often lost in experimentation when collecting discarded objects for a "garden party" or preparing for his trip to the Arctic Circle. To him, time magically folds in on itself, and the surrounding world comes to a screeching halt. In many cases, his original idea becomes secondary to the exciting possibilities that he discovers along the way. Later in his life, Harris will become exposed to rules and conventions. I will always be there to celebrate and help him embrace his imagination, creative spark, and individuality.

Cultivation

Once ideas have been formulated, they must be cultivated to mature properly, just as a garden must be cultivated by fertilizing, weeding, and watering to produce a successful harvest.

evaluation

Once your concepts are generated through brainstorming, evaluating them objectively helps you decide what to keep and what to discard before plummeting into production. This involves reconsidering the concept's appropriateness with respect to the project's goals. Questions to ask youself at this stage are:

1. Will my concept capture and hold my audience's attention?

2. Is this idea based strictly on technique or trend?

3. Is this concept different enough from what has already been done?

4. Is this concept realistic enough to implement technically?

5. Will the means needed to implement my idea fit within the budget?

"In traditional design you learn from accidents: You spill paint and come up with something better than what you intended. The same thing happens on the Mac: You go into Fat Bits, see a pattern, and say, 'Ah, that looks better than the original!'"
—*April Greiman*

selection

Once evaluation has taken place, the process of selection begins. On a positive note, you get to make the first cut before the client begins his or her jurying process. Although it can be painful to let go of invigorating ideas that may be more appropriate for another project, presenting too many concepts can be counterproductive. Consequently, the client can develop the expectation that you will always provide numerous possibilities for every project. Relinquishing this much creative

control to the client can result in him or her choosing a concept that you do not strongly support. In your absence, bits and pieces of your ideas may be mixed and matched in a way that is not in line with your thinking. Further, the opinions of other coworkers not involved in the project may be taken into consideration; such uninformed input can be detrimental to what you are trying to accomplish. Therefore, it is in your best interest to be discriminating and submit only the concepts that, in your opinion, are the best.

clarification and refinement

Depending on the client's and test audience's response, your concept will most likely require further clarification. Pencil thumbnails may not adequately describe your idea in visual terms. More finished roughs should give a clearer representation of the visuals and typography, compositional treatment, and motion strategies. Techniques such as collage, photomontage, and photocopying allow quick composites to be generated. A wide range of natural media, including brush, marker, and colored pencil, can also be used to introduce color and texture. Digital refinement can offer a degree of polish. Depending upon the scope of your project, it may be necessary to go a step further and develop motion tests to resolve how elements will move and change ahead of time. Additionally, the client is able to experience the kinetic quality of the concept before production, allowing him or her to give approval and provide feedback early on.

In 2004, twenty2product developed a set of motion tests to be used for a looped opening animation sequence to "My Favorite Conference," a large-scale trade show in Singapore (**9.13**). This event was sponsored by IdN, an international publication for the design community in Asia-Pacific and other parts of the world. Similar to Macworld, the event was dedicated to the merging of different graphic design disciplines to give rise to unique creative and contemporary insights. The goal of the opening sequence was to introduce topics to be presented at the conference and acknowledge the individual speakers and corporate sponsors. Terry Green, creative director and co-founder of twenty2product, refers to these segments as "artifacts" of their working process that may or may not appear as a layer in the final composition. Working in this manner helped move ideas forward.

9.12
A series of motion studies for Adobe's Expert Support trade show offered ways that the components of the Adobe logo and titling could be animated in an orthographic space with a flattened perspective. Courtesy of twenty2product. Copyright 2004 Adobe Systems.

9.13
Frames from motion sketches for "My Favorite Conference." Courtesy of twenty2product. Copyright 2004 IdN, all rights reserved.

9.14
This set of motion tests were used in a music video for Susumu Hirasawa, a Japanese electropop-artist, known in Western cultures for his anime soundtracks. They were also used in a promotional spot for Santana Row, a premier retail and entertainment complex in San Jose, California. Courtesy of twenty2product.

Storyboards

Once a concept has been clarified, refined, and has received client approval, the next stage of conceptualization involves storyboarding. In most cases, the storyboard is the final phase of conceptualization.

A storyboard is a cohesive succession of images (or frames) that provide a visual map of how events will unfold over time, identifying the key transitions between them. Sometimes accompanied by supporting text, it establishes the basic narrative structure of your concept. **Figure 9.15** demonstrates a storyboard for *Nefertiti Resurrected*, aired on the Discovery Channel in 2003. According to Director Michael Middeleer of Viewpoint Creative: "We sought to demonstrate the beauty, drama and mystery surrounding Nefertiti and show how the Discovery Channel resurrects one of ancient Egypt's most famous and powerful queens."

Storyboarding requires preparatory mental visualization, since there are many factors that need to be determined, such as the types of visuals (images, typography, live-action footage) that will be used, the stylistic treatment of the visuals, types of motion and change, the spatial or compositional arrangement of the frame, and progressive or sequential aspects, such as transition, pace, birth, life, and death."

9.15
Storyboard frames for *Nefertiti Resurrected* (2003). Courtesy of Viewpoint Creative and Discovery Channel.

visual content and style

Traditional and digital artistic processes and media, including drawing, painting, sand, collage, and montage, can be used alone or in combination to support the image style that you choose. Images that are created in raster-based paint applications can yield a certain hand-executed or photographic look. Postscript graphics that are generated from vector-based programs can achieve a flatter, more stylized quality. If you are appropriating existing images (versus generating original artwork), pixel-based software, such as Adobe Photoshop or Corel Painter, offer a great deal of flexibility and control in image editing and manipulation.

Environmental or atmospheric conditions should also be considered. The background provides the setting or stage where events take place, and at this stage, the background should be developed and treated as an integral part of the piece. Background images can be moved or changed over time, or they can serve as unchanging backdrops against which the animations of foreground elements take place. In the three-dimensional environment, lighting, environmental effects (i.e., fog, water, and smoke), and camera views should be planned during storyboarding, since both play a significant role in establishing the atmosphere and perspective of a scene.

pictorial and sequential continuity

The single most important measure of a storyboard's effectiveness is its continuity. The pictorial continuity must indicate cohesion between the style of images and type, choice of color scheme, and treatment of compositional space. The sequential or progressive continuity between frames must be clear in order to convey a comprehensible and logical flow of events.

Pictorially, the style of the visuals should be coherent across all frames. The storyboard also should illustrate how elements will be organized spatially within the frame. For example, an organized pictorial space may enforce the movements of elements to adhere to an underlying grid. On the other hand, the motion of objects in a loose, free-flowing composition may produce a more random effect. Establishing a clear distinction between background and foreground elements can achieve a strong sense of spatial depth, while breaking traditional figure-ground relationships through heavy layering will flatten the space.

9.16
Storyboard design, by Justin Ruggieri, Kansas City Art Institute, Professor Jeff Miller.

This storyboard illustrates the concept of sociophobia—the fear of people or society. As the viewer looks out, he sees a highly abstracted cityscape with personified symbols walking by. The city's buildings are layered with various words and phrases.

Sequential or transitional continuity is seen in the timing of sounds in musical compositions, in the arrangement and refinement of movements in dance, and in the pacing of images, actions, and camera moves in film. All of these demonstrate how motion and time are planned and constructed before the final production.

The arrangement of all elements, background and foreground, moving and nonmoving, changing and nonchanging, is critical in achieving the desired aesthetic effect with regard to the pictorial composition of the frame. Additionally, it helps determine the visual hierarchy of information on the screen. Careful thought must be given to maintaining a clear distinction between elements of varying importance by virtue of their relative sizes, color, duration, and positioning. Relationships between the image and typographic content and the edges of each frame should also be considered. These types of pictorial considerations are discussed in more detail in Chapter 7.

In addition to pictorial continuity, the storyboard should convey a basic sense of how elements move and change over time and space, as well as the methods in which they enter the frame and leave the frame. It should also clearly express a logical order of the key events, and the transitions between them should be cohesive and clear. This type of "orchestration" is a developmental process that requires strategic planning, unless your project calls for improvisation. (Chapters 5 and 8 discuss a variety of approaches to choreographing motion and time.)

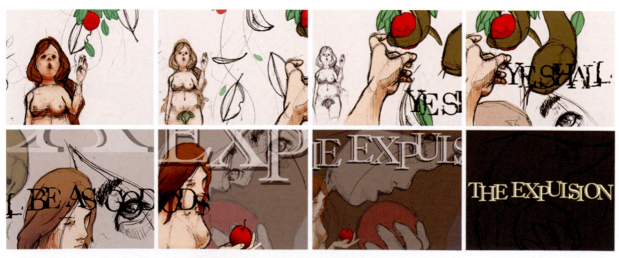

9.17
Storyboard design by Mike Cena, Fitchburg State College, Professor Jon Krasner.

stages of development

early development

The execution of a storyboard can range from a series of quick sketches to a group of highly developed color images. Depending upon your own working process, the client's demands, and other factors, such as budget and time, most storyboards go through several iterations before they are executed digitally to be presented to the client.

After your concept has been refined, it can be translated into an *initial comprehensive*—a series of quick, sequential drawings that have a 4:3 aspect ratio of a typical, rectangular frame. Here, you should divide your story into its major sequences and transitions, being aware of visual continuity. These small sketches will save you time later, since they can be changed easier than the enlarged, polished frames of a final comprehensive. Each scene can be individually worked out on a separate piece of paper and later rearranged or discarded once they have been analyzed. The quality of the drawings is not as critical as the flow of actions between the frames. In fact, dedicating too much time to making each image look realistic can sacrifice the most critical factor—continuity. Considerations such as the flow of actions or events from scene to scene, the clarity of transitions between the scenes, the approximate time it will take to animate the scenes versus the allowed time, and the resources needed to create the desired effects should be given careful attention during this stage of design.

Although there are cases when the initial storyboard sketch may look much like the final comprehensive, the client may never see it. In most cases, it allows you to evaluate the work solely on your own professional expertise. Keep in mind that there is room for further improvement, and several drafts may be necessary before arriving at the final storyboard. Evolution is the key to successful storyboarding. Creative ideas are meant to build upon one another over time.

9.18
Initial comprehensive sketch for SKY Cinema Italia's *Spazio Italia*. Courtesy of Flying Machine. (*See **Chapter 2, figure 2.56** for final animation frames.)

See DVD for final composition.

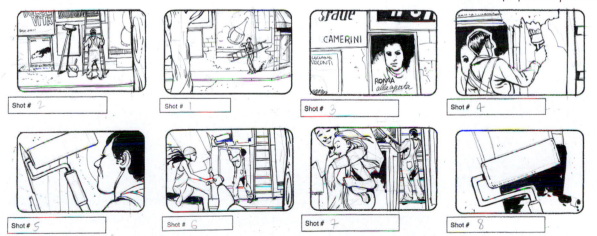

This stage offers tremendous creative potential, allowing you to deviate from your original ideas. Elements may be altered, simplified, exaggerated, added, or deleted. Stay alert to the possibility of serendipity, since

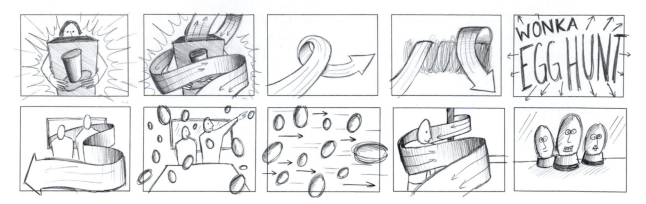

9.19
below: Storyboard sketches for Nestlé's Wonka Egg Hunt. Courtesy of Shadowplay Studios. (*See **Chapter 10, figure 10.13** for final animation frames.)

"happy" accidents can offer many creative opportunities. Do not go too far down a road with a concept before submitting a rough story-board. The business risk may be too great to plunge into the waters too quickly. The client should be kept in the loop along the way in order to avoid too much time being spent on perfecting ideas, only to have them rejected later. Unless your concept has been accepted verbally or in writing (preferred), proceed with caution! Posting frames to the Web can save valuable time in getting approval.

the final comprehensive

Once your sketches have been revised, they should be reworked and edited down into a *final comprehensive*—a more refined series of frames showing major events, transitions, framing, and camera moves. These can be created on nearly any medium. Although hand-drawn artwork is sometimes still used, digital execution is the favored method of storyboard production today, since it is quicker than generating original artwork and may be more appropriate in representing the subject in situations where the visuals will be photographic. If time is a critical factor, stock photographs and illustrations are available on-line or by purchase of CD-ROM content by numerous suppliers. (You should carefully read the terms and conditions to avoid using materials illegally or without permission.)

brevity and clarity

The final comprehensive should be succinct, featuring only major events. Transitions between frames should be easily readable. Six to ten frames are typical for a 30-second spot, while a 1- to 2-minute movie trailer might require up to twenty frames. Station IDs and Web site introductions are usually presented in no more than eight frames.

In the past, "comping" involved drawing out the details by hand on tissue or tracing paper with markers. This type of quick, visual thinking was considered a highly evolved skill. During the late 1980s and early 1990s, "paint systems" such as Quantel's Paintbox were used by storyboard artists for preproduction. Today, common desktop tools such as Photoshop and Illustrator can quickly generate, manipulate, and composite images and type.

professionalism

Professionalism is critical to convincing the client (and yourself) to settle on an idea. Sloppy execution, lack of attention to detail, and ambiguity of presentation can create a negative impression.

Today, digital images, because of their degree of polish, are commonly used to generate final comps. The most impressive-looking boards are assembled from high-quality prints that are pasted up onto poster or bristol board. Supporting text can be added as a supplement; however, it should not be used as a substitute for a lack of clarity in the images. Including action-safe and title-safe borders on each image allows all parties to visualize the variable 10% perimeter of the frame.

Your finished storyboard should serve as a basis from which additional creative opportunities can be pursued. Although major decisions have already been worked out, there is room for experimentation and continued creative development during production (provided that the client has some degree of flexibility).

9.20
Final comprehensive storyboard for *Icarus*. © Adam Schwaab.

9.21
Storyboard for SKY Cinema Classics' show opening. Courtesy of Flying Machine.

The doors of a darkened theatre open, allowing us to walk down the aisle to experience a mélange of typography and cinematic imagery from historical moments, including a World War II fighter plane and a figure in a trench coat occupying the space around us. As the curtains draw open and the flickering projector brings the screen to life, the SKY Cinema Classics logo blazes across it.

9.22

above: Storyboard for Fine Living Network. Courtesy of Another Large Production and Susan Detrie.

9.23

below: Storyboards from "Cowboy Transformation" and "Smoke" IDs, SKY Cinema. Courtesy of Flying Machine.

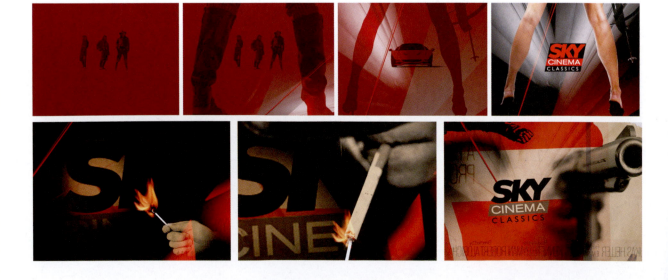

Animatics

Since storyboards describe motion in a static manner, animatics, or animated storyboards, are sometimes needed to pre-visualize and resolve the motion and timing of events. They take the art of storytelling one step further than storyboards by breathing life into the images and synchronizing their movements and transitions to sound. (For this reason, animatics are usually produced after the soundtrack has been created.) In some cases, the storyboard and soundtrack may be modified, and a new animatic may be generated, if necessary, until the storyboard is perfected.

Animatics have proven to be time and cost effective, since editing during this stage can prevent you from dedicating unnecessary time and labor to generating content that may be potentially eliminated. They can bring clients closer to final production more quickly, allowing them to pinpoint potential problems related to lighting, cinematography, and sound production. This means fewer iterations during implementation, since the major changes that need to be made have already been detected.

Animatics can range from crude, animated sketches and improvised video footage to polished motion graphics sequences that combine 2D and 3D animation with hand-drawn and digital illustration. When creating an animatic, it is important to keep in mind that you are not just presenting an animated slideshow of the storyboard imagery; rather, you are presenting the types of movements, changes, and camera angles that may occur in the final production.

In an animatic for an in-store video showcasing Nike's Air Max 2, Terry Green of twenty2product was presented with several live footage assets and asked to develop a scheme that would tie them together and integrate them with text and graphics. He quickly composited stock images and the video footage to provide a clear idea of how the final piece would be animated and sequenced. This allowed both twenty2product and the client to assess potential problems, develop solutions that would remedy those problems, and rethink the entire approach at an early stage prior to production (**9.24**).

Animatics have existed since the early days of film, and the first person to be credited with putting them into action is George Lucas. Empire of Dreams is a documentary that has been aired on Arts and Entertainment Network and contains a segment about Lucas' conversion from storyboard to animatic. Additionally, a story about the animatic from Star Wars Episode I has been posted on the Star Wars Web site (http://starwars.com). Other animatic examples from Lucas, such as the one produced for Raiders of the Lost Ark, can be found on YouTube.

In television, animatics have been used as preliminary versions of commercials before they are made into full spots. They have also been used for marketing purposes, video game animation templates, and actual bumpers and show openers.

9.24

Frames from an animatic for
Nike's Air Max 2 in-store video.
Courtesy of twenty2product.

9.25

These animatics were used in a
pitch for the worldwide in-store
presentations of the German
fashion brands ESCADA and
ESCADA Sport. Courtesy of
Daniel Jenett.

9.26

Frames from the final in-store
presentation for ESCADA.
Courtesy of Daniel Jenett.

Summary

Assessment, the first step in conceptualization, begins with defining an objective before plunging into the creative waters. This objective must consider the demographics of the target audience and their prior knowledge of the subject being communicated. Research is key to being well informed about your topic, and thorough analysis of the subject must be conducted before conceptualization takes place. Motion graphic designers must also understand budgetary constraints, deadlines, and the degree of client flexibility to new ideas. These restrictions should not be perceived as limitations to creativity, but rather, as creative guidelines that can help give ideas direction. Direct communication with the client can avoid frustrations down the road. Clients can be convinced on an idea, provided that a relationship consisting of mutual trust and respect has been established.

Designers should be aware of obstacles that impede creative thinking and obscure artistic judgment, such as overused trends, effects that lack ingenuity, and the over-abundance of stock images and fonts. They should also embrace pathways to creative thinking. Inspiration can be achieved by establishing personal connections with the subject, conducting adequate research, and involving the client. Risk taking and experimentation can also be liberating by preventing reliance on safe, mainstream design solutions.

Once ideas have been formulated, they must be cultivated through evaluation, selection, clarification, and refinement.

A storyboard is a cohesive succession of frames that establishes the basic narrative structure of a concept. It shows how events will unfold over time and identifies key transitions between events. The single most important measure of a storyboard is its continuity. Pictorial continuity indicates a cohesion in the content and style of visuals. Sequential continuity communicates a comprehensible flow of events between frames. A storyboard usually goes through several revisions before it is refined and presented as a final comprehensive.

Animatics, or animated storyboards, help resolve motion issues ahead of time. They can be time and cost effective, as they can allow clients to pinpoint potential problems early. Animatics can range from crude, animated sketches to polished motion graphics sequences that combine 2D and 3D animation with hand-drawn and digital illustration.

10

animation processes
creating motion

The human eye has the capacity to assemble slightly different consecutive images that are presented at a fast enough rate and interpret them as one continuous movement. This phenomenon, called persistence of vision, provides motion graphic designers with the devices of time, motion, and change to convey their messages and move their audiences.

"The ability to deconstruct a movement and reassemble it in a new or convincing way is the animator's territory. Many artists have realized their visions using animation as a means to externalize their inner thoughts and unique points of view. Animation gives the viewer the opportunity to gaze at a frozen moment of thought and to experience another person's rhythms."
—Christine Panushka

00:00:00:10

Frame-by-Frame Animation

10.1
Dutch animator Chris de Deugd used pastels, ecoline, watercolors, and colored pencils on paper and frosted cells in her debut film *Daedalus' Daughter* (2001).

According to Chris, this poetic film depicts a "sad refrain about mortality, sung in burnt sienna and sepia, the colors of the earth."
© il Luster.

The term *frame-by-frame animation* defines itself: animation that is created on a frame-by-frame basis. Flip-books were one of the earliest frame-by-frame animation techniques. Each piece of paper contained an individual, unique drawing, and the illusion of continuous motion was produced when the drawings were displayed one after the other by flipping the pages quickly. The more drawings (or frames) that were displayed each second, the smoother and more believable the motion was when they were played back in sequence, allowing the subjects to spring to life. Over the years, many animation techniques have evolved through experimentation with media and materials.

Frame-by-frame animation includes two types of frames: *key frames* and *in-between frames*. *Key frames* (or *extremes*) are nonadjacent frames that identify the most major changes in a scene. These are used as guides for constructing the intermediate or in-between frames that complete the transitions between the key frames. The number of in-between frames can vary, depending on the degree of motion or change that is needed. Generally, small numbers of frames per second produce quick changes and abrupt transitions, while greater numbers produce smoother transitions. Depending on the subject matter, it is not always necessary for an animation to contain large numbers of frames. In fact, four or five key images may be adequate for a looped sequence that is intended to produce a continuous repetition of events.

Frame-by-frame animations are well suited for situations that involve changing the physical appearance of images. For example, a figure's eyes may bulge out of their sockets, or a creature's feet may grow into a tail or set of flippers, or a letterform may change its surface texture.

Over the last two decades, digital technology has streamlined animation production. The versatility of software can mimic traditional processes without the need for a film camera. The cost of materials has decreased, although there are other expenses such as software, hardware, and a more highly trained and highly paid staff. The reduction of time, labor, and cost justifies the industry's eager embrace of digital production.

Whether your content is generated by conventional or digital means, animating on a frame-by-frame basis can be a time-consuming undertaking. Its great advantage, however, is having ultimate control over every mark, line, and brush stroke to develop your vision. Professional experience or a fine arts degree is not necessary to create meaningful compositions. In fact, the most primitive drawings can be provocative or humorous when played back in sequence. However, some degree of drawing or painting experience is beneficial, along with creativity, patience, and a familiarity with the techniques that are described here.

classical "old school" animation

During the 1930s and 1940s, classical or "old school" animation for film was a labor-intensive undertaking that involved generating artwork on a frame-by-frame basis. Since film runs at a rate of 24 frames per second, a single minute of film required 1,440 individual drawings. These drawings were executed on paper or on semi-transparent sheets of vellum or onionskin to allow previous frames to show through the frame on which the artist drew. This technique was known as *onion skinning*. In later years, it involved placing a light source beneath a drawing on a translucent page. The animator referenced the positioning of elements to draw new elements in slightly different positions.

cell animation

Cell animation, invented by Earl Hurd in 1914, reduced the time and labor of classical animation. Celluloid film sheets were used to layer foreground, middleground, and background elements. Background images were usually executed on opaque media such as paper, and the cells would be superimposed in front of a camera. Only elements that changed needed to be recreated. Still, cell animation was a meticulous task, since 24 individual drawings were needed for each second of film. Since senior-level animators needed to focus their time on establishing the key actions, *cleanup artists* were hired to refine the key images by erasing and smoothing the pencil lines. The responsibility of executing all the in-between drawings was delegated to the "in-betweeners."

Digital production does not require computer-generated imagery; it can embrace any combination of hand-rendered techniques or be as simple as scanning consecutive frames and playing them back on a computer or optimizing them for playback over the Web.

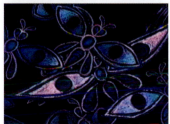

10.2
Frames from *Madan and The Miracle Leaves*, by Frederic Back. © Trees for Life, Inc.

This animation is intended to promote the use of the drumstick tree—a rich source of vitamin A—in villages in India that face vitamin deficiencies.

Before cell animation was invented, many productions created from drawings on paper combined foreground and background images on a single sheet. Every element had to be recreated for every frame.

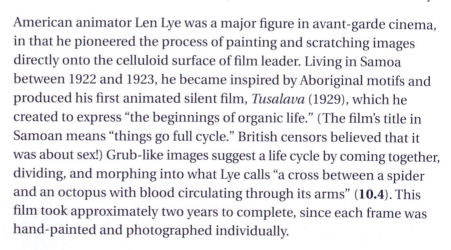

Historical Perspective

Hand inking and xerography were two common techniques for transferring hand-created artwork from paper to animation cells. Both practices are still practiced today. *Hand inking* involved tracing drawings onto clear acetate cells with quill pens and brushes (similar to monks during the Middle Ages, who spent hours hunched over in scriptoriums to produce illuminated bibles.) An example is Disney's *Fantasia.* Hand-inked cells from the 1950s are popular collector's items and can be seen in art galleries. In the mid-1930s, Disney Studios developed a photographic process in which a drawing could be reproduced photographically onto an animation cell. This technique was first utilized in *Snow White and the Seven Dwarfs* and continued throughout the early 1950s. *Xerography,* also created by Disney, involved photocopying pencil drawings onto celluloid. It yielded a truer depiction of the original artwork and enabled greater spontaneity. Additionally, simulating camera zooms was possible by reducing or enlarging images with the Xerox technique.

direct-on-film

The term *direct-on-film* refers to the "cameraless" animation technique of creating images directly on a filmstrip. This method allows an endless variety of effects to be created with traditional media, chemical compounds, or processes such as scratching, burning, and rubbing. The emulsion of black film can easily be altered or removed chemically.

10.3
Len Lye, c. 1957. Courtesy of Cecile Starr.

American animator Len Lye was a major figure in avant-garde cinema, in that he pioneered the process of painting and scratching images directly onto the celluloid surface of film leader. Living in Samoa between 1922 and 1923, he became inspired by Aboriginal motifs and produced his first animated silent film, *Tusalava* (1929), which he created to express "the beginnings of organic life." (The film's title in Samoan means "things go full cycle." British censors believed that it was about sex!) Grub-like images suggest a life cycle by coming together, dividing, and morphing into what Lye calls "a cross between a spider and an octopus with blood circulating through its arms" (**10.4**). This film took approximately two years to complete, since each frame was hand-painted and photographed individually.

Intrigued by the occult, Harry Smith spoke of his art in alchemical and cosmological terms. His process of painting onto 35mm stock was combined with stop-motion and collage. Similar to his life and personality, his art was complex and mysterious and has been interpreted as explorations of unconscious mental processes. In his first animation, he placed adhesive gum dots to the film's surface, wet the film with a

brush, and sprayed it with a dye. After the film dried, it was greased with Vaseline, the dots were pulled off with tweezers, and color was sprayed into the unprotected areas that were occupied by the dots. Another film was created with masking tape and a razor blade.

In American animator Stephanie Maxwell's film entitled *Driving Abstractions* (1997), the experience of driving at night is conveyed in an abstraction of colorful, energetic bursts and patterns of light in a three-dimensional darkness. The imagery was created by drawing, painting, and etching onto the emulsion of clear and black 35mm film stock with markers, paints, and dilutions of nitric acid (**10.6**).

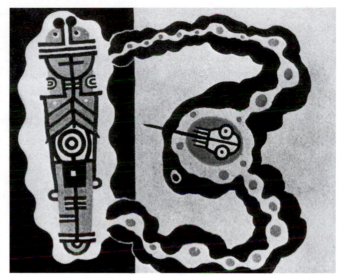

10.4
Frame from *Tusalava* (1929) by Len Lye. Courtesy of Cecile Starr.

10.5
Film strips from *Early Abstractions*. Courtesy of Harry Smith Archives and Anthology Film Archives.

10.6
Frames from *Driving Abstractions* by Stephanie Maxwell (animator) and Allan Schindler (composer).

freehand animation

Today, the process of freehand animation, whether it's produced direct-on-film, on paper, or on the computer, covers a wide gamut of styles and genres, from traditional figurative animation to expressive abstract painting and spontaneous gesture drawing.

Many substrates are available for freehand animation. The advantages of paper are affordability, availability, and its acceptance of a wide range of media. However, its density makes it difficult to view previous frames while creating new frames. Since papers vary in opacity, a minimal amount of transparency may be enough to create an onion skin effect. Nonabsorbent substrates such as glass, Plexiglas, and ceramic tiles allow paint or ink to be wiped away easily and allow spontaneity and improvisation, since images are in a constant state of evolution.

Throughout history, animators have experimented with media and substrates. J. Stuart Blackton produced one of the earliest American animations entitled *Humorous Phases of Funny Faces* on a blackboard with chalk. After each frame was filmed, part of the image was erased and redrawn with a slight alteration (**10.7**).

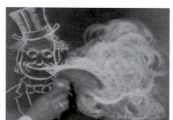

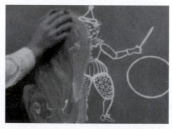

10.7
Frames from *Humorous Phases of Funny Faces* (1906). © Vitagraph.

Contemporary Polish animator Piotr Dumala etched images onto plaster and recorded each subtle alteration onto film (**10.8**). The more obscure stop-motion technique of *sand animation* involved drawning images into sand with brushes, wooden sticks, stencils, strainers, and fingers. After a frame was photographed onto film, portions of the image were wiped away, updated, and photographed again. This

freeform process, which is still used today, keeps the artistic process fresh and spontaneous (**10.9**). *Pinboard animation* was another eccentric process that was invented in the early 1930s by Russian filmmaker Alexander Alexeieff and his American wife Claire Parker. A contraption consisting of closely-spaced pins that could be set to varying heights could cast shadows to produce dramatic expressionistic effects when subjected to light. The resulting forms had a soft, chiaroscuro effect, that resembled charcoal drawings or etchings (**Chapter 6, figure 6.23**).

10.8
Frames from *Crime and Punishment* (2000) by Piotr Dumala. © Acme Filmworks.

10.9
Frames from a sand animation for the letter "A" by Eliot Noyes. Courtesy of Sesame Workshop.

10.10
Claire Parker moving pins with a roller into a perforated screen that is lit to create areas of light and dark. From *Experimental Animation*, courtesy of Cecile Starr.

The depth of the pins affects the degree and distribution of light and shadows.

The development of desktop applications has provided a more affordable range of "natural media" tools that are designed to imitate traditional media such as charcoal, acrylic, oil, and watercolor paint, crayon, chalk, and fountain pens, to name just a few. Freehand drawing can be performed on a frame-by-frame basis. In fact, you can emulate the direct-on-film technique by painting on or altering multiple frames simultaneously, versus working on one frame at a time. Brushes can be customized with regard to their shape, size, and degree of softness.

10.11

Frames from a spot for Infiniti Triant. Courtesy of Nissan North America, Inc. and Humunculus.

Original drawings were created freehand on animation cells.

Graphics tablets can heighten artistic expression by enhancing the process of drawing and painting in the digital environment. Lines can be drawn with increased sensitivity through pressure control to produce more natural results. Depending upon the speed and pressure that is applied, lines can become lighter, darker, thinner, or fatter. For these reasons, in addition to preventing carpal tunnel syndrome, they are wise, long-term investments.

collage and mixed media

The technique of collage, which involves assembling printed and found materials, provided early twentieth-century painters a heightened sense of spontaneous, artistic freedom. In many cases, surface texture and pattern dominated over the clarity of the subject matter. Animator and director Terry Gilliam popularized the technique of stop-motion collage in his work for *Monty Python's Flying Circus*. Independent filmmakers Frank and Caroline Mouris pushed the envelope of mixed media collage in their classic short *Frank Film* (1973). Their innovative process has been featured in commercials, documentaries, music videos, and shows, including *Sesame Street* and *3-2-1 Contact*. Filmmakers have continued developing a broad range of styles ranging from heavily layered nonobjective compositions to conceptual, representational works.

10.12

Frames from *The Adventures of Prince Achmed*. This film took almost three years to complete. The characters were black cardboard marionettes that were cut out with scissors and photographed frame-by-frame. Courtesy of Cecile Starr.

A type of collage animation, known as *cutout animation*, was developed by Lotte Reiniger during the sound-on film era of the 1930s. Her unique, silhouette style is evident in *The Adventures of Prince Achmed*, one of the first animated motion pictures to be produced (**10.12**)

The beauty of collage in motion graphics is that images and type can be integrated in ways that would be difficult to achieve in the physical world. Digital layering can mimic the feel of collage or cutout animation with the added components of transparency and blending.

stop-motion

The technique of stop-motion continues to be practiced in motion graphics. In a television spot for Nestlé, stop-motion animation was applied to still photographs of children to create the effect of implied movement. The resulting playful, refreshing mood communicates the sense of enjoyment and curiosity that a child would find as a participant in a scavenger hunt for chocolate (**10.13**).

10.13
Frames from a TV commercial for Wonka Egg Hunt products. Courtesy of Shadowplay Studio.

10.14
Frames from the Pinto network series of IDs for FUEL TV. Produced by Brand New School. Courtesy of FUEL TV.

Stop-motion frames were shot with a digital camera, which enabled the director to instantly view small sequences. Pinto is a stuffed sports action figure who finds himself in dangerous situations while skating, snowboarding, or riding his motocross bike.

10.15
Frames from a set of network IDs. Courtesy of FUEL TV.

Stop-motion was applied to a fictional demigod who invented Skatism and a clan of panda bears to create a feeling of "intercepted communications from some distant planet whose daily realities defy human comprehension." (*Advertising Age* magazine).

rotoscoping

Live-action imagery can serve as the basis for animation. The practice of *rotoscoping*—drawing or painting over live footage—covers a wide range of animation approaches, including freehand, image alteration, and compositing. Today's digital technology can automate color and tonal adjustments, special effects, and standard operations such as blurring, dodging, burning, and tinting to individual frames or ranges of adjacent frames. The possibilities of "painting on movies" allow you seamlessly combine live-action images with animated content.

Rotoscoping can be a labor-intensive undertaking that requires time and patience. However, if your goal is to achieve realism, the results are extremely rewarding. Plan on creating a comfortable environment for yourself, and schedule adequate time so that you can work efficiently at a steady pace.

10.16
Loose gesture drawing over a live-action figure heightens the artistic expression of the image.

Rotoscoped animation looks only as mechanical as you make it. Simply tracing the outlines of filmed images can make a subject look lifeless and boring. Choreographing its movements and physical attributes beforehand, however, can help determine the right amount of exaggeration to make it appear more lively and animated. Devices such as acceleration and squash-and-stretch can heighten artistic expression and naturalize the subject, keeping it from clashing with other elements in the composition.

Using the right tools can help streamline your activity. A graphics tablet and a pressure-sensitive stylus can expedite the workflow while protecting your carpal tunnels.

Frame rate is also a consideration, and experimentation may be needed to find a compromise between smooth playback and the amount of drawing time needed to generate the content. High rates between 15

Historical Perspective

Rotoscoping was developed in 1917 by Max Fleischer during the silent film era. It involved tracing stages of movement from live human and animal subjects from film one frame at a time. Used as a learning aid for animators to become better acquainted with motion and timing, this practice held up over the years and soon became a cornerstone of Walt Disney's in-house training. According to American catoonist and animator Walter Lantz, "I would take the old Charlie Chaplin films and project them one frame at a time, make a drawing over Chaplin's action, and flip the drawings to see how he moved. That's how most of us learned to animate."

Max Fleischer's use of the rotoscope can be seen in his early *Out of the Inkwell* films such as *Koko the Clown* and the 1940s *Superman* series. There were limitations, such as lengthy production time, cost, and trends, which were set mainly by Disney.

10.17
Adobe Photoshop's unique Filmstrip format allows you to paint on individual frames or across a series of frames to achieve a direct-on-film animation effect. Here, a movie clip was exported from Adobe After Effects in Filmstrip format and rotoscoped in Photoshop. The filmstrip appears as a long, vertical image that encompasses each video frame. The frames are subdivided by borders, each containing a number and time code. Gesture drawing was performed on a transparent layer above the video clip layer, frame-by-frame. The file was then flattened and re-saved as a Filmstrip document to be played back in After Effects.

and 30 fps provide smooth playback but more frames. Lower frame rates will produce fewer frames but choppier moevements. Frame rates between 6 and 12 fps can achieve adequate, believable results. If you are stranded on a desert island or are serving a long prison sentence, rotoscoping at a frame rate of 24 or 30 fps might make you famous if you are rescued or released!

A fond memory from the 1980s is a-ha's music video "Take On Me." Its integration of line drawings and live-action color images is still refreshing to this day.

10.18
Frames from *Siblings* (2005).
© 2007 Jon Krasner.

Generating simple line drawings
from live footage of my children
allowed me to express the idea
of pure childhood experience in
a world that can restrict personal
expression and individuality.

*The fact that film cannot yield
instantaneous playback and is
expensive to process might have
enhanced the abilities of "old-
school" animators by forcing them
to concentrate on getting the
choreography right the first time
around!*

film capture

The rich, soft quality of motion film is attributed to the light-sensitive
emulsion that is capable of capturing high-resolution images photo-
graphically (unlike video, which records images as electronic signals).
Additionally, film cameras have the inherent ability to capture mate-
rial one frame at a time, which is critical for any form of stop-motion
animation. For these reasons, film continues to be a preferred medium
by many independent and commercial animators.

Since most independent designers cannot afford 16mm film, Super
8mm is still considered to be an acceptable format. Companies such as
MovieStuff (http://www.moviestuff.tv) specialize in transferring Super
8 footage to mini-DV tape, which then can be digitized from a DV
camcorder to a computer for storage and postproduction.

digital capture

For processes that do not involve rendering frames by hand, the
advantages of capturing frames on a computer are instantaneous play-
back, preservation, and affordability. Instantaneous playback enables
you to get the feel of the motion as it progresses without having to wait
for a lab for development. Digital storage preserves the quality of the
work, unlike film or videotape that degrades over the years. Finally,
there are no developing costs.

The most efficient methods of digital capture are DV cameras, digital still cameras, scanners, and single-frame capturing software. Unlike film cameras, the majority of consumer camcorders do not have a built-in single-frame capture mechanism. Standard analog and digital video camcorders are made to shoot several frames each time the button is pressed. However, an analog or digital camcorder can be used as an input device to record frames into the computer (versus videotape). Alternatively, you can invest in software that allows for single-frame capture. Today, digital cameras are remarkably inexpensive, and most frame capture programs accept USB or FireWire connections. An alternative method to a camcorder or digital camera is to create your production on a piece of glass placed directly on a scanner. Each manipulation can then be digitized and saved as a frame.

There are a few important considerations that apply to digital capture. First, the input resolution should be determined in advance. Since the quality of raster-based images decreases when they are scaled up, be sure to digitize the artwork at a resolution that will accommodate scaling. Here is a standard formula that you can use: screen resolution x degree of scaling = input resolution. For example, if your images will be enlarged twice their size, scan them at 144 dpi ($72 \times 2 = 144$).

When planning a project, be careful not to underestimate the amount of available disk space that will be needed; prepare for large storage requirements. FireWire devices have the best chance of playing the frames back smoothly, due to their high data transfer rates.

To streamline your process, keep different animation sequences in separate folders. Because frames are usually imported into applications in numerical order, name them with "padded" numbers (**10.19**).

10.19
Sequences of frames from different segments of an animation are saved in separate folders and named with "padded" numbers.

tips

Depending on the length and complexity of your animation, all of the techniques discussed here require substantial time and patience. Here are a few additional tips to help streamline your process:

1. Start by creating thumbnails.
Loose drawings (or quick digital mockups on the computer) can go a long way in helping you resolve the basic motions of elements ahead of time. They can also help determine how your scenes will fit into the visual flow of the composition before you create a storyboard.

2. Work smart.

Since key frames depict the most dominant changes, create them first, and then generate the intermediate frames. Nonchanging elements such as backdrops and static images should be developed only once, since they can be used repeatedly. Objects that change their physical appearance should also be developed independently.

3. Enlist the photocopier.

The photocopy machine can be a wonderful production tool in creating complex animations. The harsh or sketchy appearance of xeroxed images can be a satisfying tradeoff for the time and energy of creating individual frames by hand. Photocopying can also yield certain camera effects, such as zooming, by reducing or enlarging the images.

In collage or cutout-style animations, photocopying actual objects onto transparencies can eliminate the meticulous task of tearing out images from magazines or other sources. (Unless you are using a surgeon's scalpel and a magnifying glass, the results are also much cleaner.) The raw, high contrast look of xeroxed images can add to the conceptual and aesthetic aspects of your design. Be sure to read the photocopier's manual; extraordinary effects can be achieved by experimenting with its brightness and color settings.

4. Plan the duration of motions individually.

Choreographing simultaneous movements can be challenging, and establishing a game plan ahead of time will pay off in the long run. As a general rule, longer actions require more frames than shorter actions. Fifteen or more frames may be necessary for a walk cycle, while only two to three frames may be needed to animate a blinking eye.

5. Layer.

If you envision your animation having various levels of foreground and background elements, create them on overhead transparencies or on official celluloid sheets. Overlaying them allows you the freedom and flexibility of adding depth to the frame. As an alternative, consider photocopying opaque artwork onto transparencies. Your local Kinko's, Office Max, or Staples are affordable options for accomplishing this.

6. Let the camera do the work.

Camera movements, such as pans, tilts, and zooms, can easily be achieved by changing the camera's position in relation to the artwork in small steps, as opposed to having to emulate these effects by

hand-executed means. Alternatively, you can move the imagery. Repetitive motions, such as rolling, vibrating, or lifting the base, can produce the effect of waves at sea, walking, or experiencing an earthquake.

7. Loosen up and push the media!

Be expressive and experimental in your artistic style. (You do not have to be a cartoonist!) There is a wide range of drawing approaches, and content can be executed with any combination of media.

8. Sacrifice detail for pictorial continuity.

Complex textures and details can lead to inconsistencies that become eyesores when your frames are played in sequence. Moving foreground characters in traditional cell animations are usually painted with flat colors, as opposed to background scenery, which is often more detailed and complex.

9. Combine media and techniques.

Frame-by-frame animation does not need to rely on any one technique. Combinations of the traditional and digital media and techniques can contribute toward a richness of content and personalize your style. Investigate what feels natural; there is no "right" or "wrong" formula.

10. Consider lighting.

Lighting is one of the most vital aspects of filming. Bad lighting can cause unwanted shadows or overexposure. Be sure that you have plenty of light to work with. Studio lights are designed to match the color balance of film. If you cannot afford them, desk lamps or halogen lights can suffice with filters or manual white balance on digital cameras.

11. Shoot "on2s," "on3s," etc.

Animations that do not require seamless motion can be shot on every other or every third frame. This works well for collage or cutout animations that are meant to look choppy.

10.20
Alex Wall combined original watercolor illustrations with digitally-generated textures and graphics in this visually stunning composition. Courtesy of Alex Wall, Fitchburg State College. Professor Jon Krasner.

Interpolation: An Overview

Interpolation is the process by which an element's spatial or visual characteristics are animated between two or more instances in time. Theses instances are known as *key frames*. Key frames designate where the most extreme changes occur on a timeline and contain data about an element, such as its position, size, orientation, transparency, or

color. Unlike frame-by-frame animation, intermediate data between key frames are automatically calculated without having to create the in-between frames one at a time. For this reason, interpolation can generate animations much quicker, with less effort and with greater control over how motion and change are choreographed.

Interpolation can be applied to the *primary motion* of elements in a composition or to the *secondary motion* of a camera to achieve mobile framing. In **figure 10.21**, beginning, middle, and end key frame values describe an object's spatial location at three different points in time. The data between these key frames are automatically interpolated to produce animation when the sequence is played back. This frame range marks the beginning and the end of the interpolation. The last key frame of the frame range denotes the beginning key frame of the next, adjacent frame range.

10.21
After Effects and Flash use key frame event markers. A beginning and end key frame value describes an object's spatial location at two different frames or points in time. The last key frame of a frame range denotes the starting key frame of the next frame range.

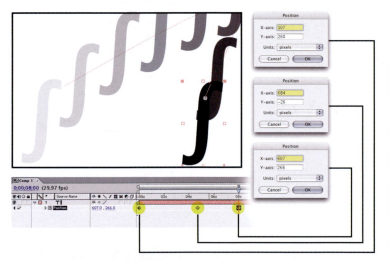

Creating effective animation requires substantial focus and aesthetic sensitivity. Beginning animators often create too many keys, resulting in jerky movements and painstaking editing. Others allow the software to perform too much of the work, resulting in unnatural movements.

Linear interpolation produces mechanical, uniform motion or change. Differences in the velocity values of the intermediate frames occur in steady time increments. The rate of motion progresses at a consistent pace until a new interpolation occurs at a new key frame. *Nonlinear interpolation* (or *Bezier interpolation*) produces less predictable, more lifelike results, and smoother transitions between interpolations. *Spatial interpolation* refers to the direction that objects travel over space. *Visual interpolation* refers to visual properties, such as color, texture, opacity, and shape geometry. *Temporal interpolation* refers to the rate at which objects travel over time, taking into account factors such as acceleration and deceleration.

Spatial Interpolation

Spatial interpolation (also referred to as *path animation*) involves animating an object's position, orientation, or scale. In applications such as Adobe After Effects, spatial interpolation is achieved by establishing key frame values on a timeline (**10.22**). The property of position defines the horizontal and vertical direction that elements travel along a predetermined "route" or motion path. *Linear spatial interpolation* occurs on straight motion paths; *nonlinear spatial interpolation* occurs on curved motion paths. The geometry of a motion path can be modified to change an element's course of travel (**10.23**).

10.22
In Adobe After Effects, spatial interpolation is established by key-framing an object's position, rotation, and scale properties on a timeline.

🔅🔊◯🔒	🔳 #	Source Name	Mode	T	TrkMat	0:00f	05f	10f
🔅	▽ ▢ 1	◼ circle.tif	Normal ▾					
		▷ Masks						
		▷ Effects						
		▽ Transform	Reset					
		⊙ Anchor Point	324.5 , 324.5					
◀ ✓		▷ ⊙ Position	104.0 , 53.0			◆		◇
◀ ▢		▷ ⊙ Scale	41.0 %				◆	◆
		⊙ Rotation	0 × +0.0 °					

Most applications offer *motion tracking*—a process that enables you to monitor an element's movement and generate a motion path from the movement. The resulting path can then be applied to different objects to make it move along the same direction. Through this technique, objects can be choreographed to mimic the movement of other objects in space. In **figure 10.24**, the x and y coordinates of groups of pixels that pertain to live-action elements in a video clip are tracked, and the resulting data is used to generate motion paths. The paths are then applied to other layers containing typography and graphics.

10.23
Motion paths can be represented as straight lines, curves, or a combination of lines and curves and can be modified to change an element's course of travel.

10.24
Motion tracking of a group of pixels is used to generate a motion path. The path's data can then be applied to another image to make it appear to be following the movement of the hand.

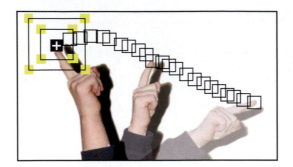

Visual Interpolation

Visual interpolation involves animating an object's visual appearance by changing its geometry, color, transparency, or surface texture.

interpolating form

Animating changes in geometry can be achieved by morphing or by applying distortion effects. *Morphing* produces seamless intermediate changes between two images. *Cross-dissolving* and *warping* are the two most commonly used digital morphing procedures. Cross-dissolving involves interpolating the colors from the pixels of a source image to those in a corresponding destination image. Although this method does not alter shape geometry, it is effective when the initial images have similar structures. Warping, in contrast, shifts the physical locations of pixels between images without transforming their colors. *Point warping* uses control points to govern the method in which pixels shift their positions in space (**10.30**). Combining these techniques can produce effective results.

10.30
Point warping shifts the locations of an image's pixels in space to distort its geometric appearance.

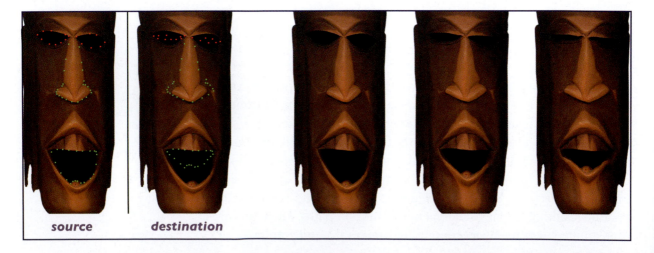

source　　　*destination*

In Flash, the technique of shape tweening interpolates the vertex points of two vector-based shapes. Flash's "shape hints" can be used to achieve increased precision when animating complex shape changes, since they identify points that are matched between starting and ending shapes (**10.25**). For example, in morphing a graphic of one animal into another, shape hints instruct the software to morph the legs, head, and tail regions of the start and finish image independently, giving you more control over each animation.

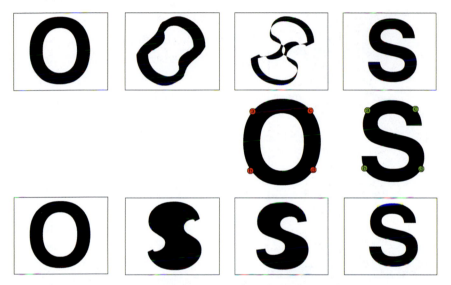

10.25
In Flash, shape hints are added to the start and end key frames and positioned relative to each other at each key frame. This gives you better control of how geometric changes will occur during the interpolation.

To achieve maximum results, it is best to morph images that are similar in size, shape, resolution, and background content. For example, if the starting image is a close-up of a face, a close-up of a different face would be a more appropriate choice than a full body shot of another person. Matching the general size and shape of the face can also improve a morph's transitional quality. If the source and destination images have uniform or matching backgrounds, the effect will be focused on the subject—not on the background.

As an alternative to morphing, distortion filters can produce incremental changes in 2D or 3D form. 3D modeling and animation programs offer mathematical processes such as Free-Form Deformation (FFD), a common process that is used to twist, bend, and stretch 3D models in Computer-Aided Design (CAD). In the 2D environment, warping effects can shift an image's pixels by altering sets of vertex points. This can be used to correct unwanted distortions or to emulate the effect of the image wind or water distortion (**10.26**).

10.26
After Effects' Bezier Warp filter can reshape an image by altering a set of vertex points. Interpolating this operation creates the effect of the image blowing in the wind.

interpolating surface

In addition to form, surface properties, such as value, color, opacity, and effects, can be interpolated through key frames. Standard brightness operations, such as Levels and Curves operations, can be used to animate tonal effects by remapping an image's distribution of dark, mid-tone, and highlights over time. Common color adjustment operations, allow you to alter an image's hue, brightness, or intensity level, or add a color tint to a monochromatic image. Advanced color channel operations, such as After Effects' Channel Mixer, provide specific control over an image's individual red, green, and blue color components (**10.30**).

10.27
After Effects' Shatter filter allows you to "blow things up" by exploding a layer into pieces varying in shape and size and dispersing them over space.

The development of effects filters in the marketplace continues at a rapid pace. The possibilities of animating the appearance of images are endless, especially when they are used in combination. In addition to the multitude of filters that come bundled with software, third-party developers continue to create and distribute compatible "plug-ins," many of which are intricate enough to serve as standalone applications. Some can generate textures, distortions, and sophisticated volumetric simulations to generate organic phenomena, such as fire and smoke. Others can produce photographic effects, such as solarizations, lens flares, camera shakes, and video malfunctions. All of these effects categories can be interpolated on a timeline by setting key frames.

10.27
A grayscale image is tinted, and the tint is interpolated over time.

10.28
Opacity can be animated to create simple dissolves between images.

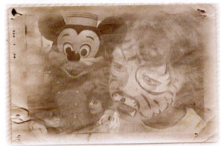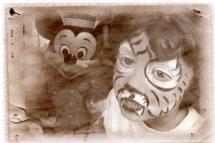

10.29
Hue/Saturation is interpolated to increase an image's saturation levels, and Color Balance is key-framed to shift the image's color cast over time.

10.30
After Effects' Channel Mixer is used to blend the red, green, and blue data of an image. Entering different percentage values can create astonishing effects, such as sepia tones. A "Set Channels" effect can also create a variety of provocative color effects. Here, it is used to replace the luminance values of one image layer with the values from another layer.

10.31
The use of adjustment layers in After Effects allows you to apply multiple tonal and color effects to all layers that appear underneath it in the timeline. Altering an adjustment layer's opacity controls the degree to which the effects apply to its underlying layers. After Effects' "Blend with Original" parameter is interpolated to animate the progression of an adjustment layer's effect.

Temporal Interpolation

Temporal interpolation describes the manner that elements move through time. While controlling the direction of an object on a motion path affects its spatial interpolation, controlling the speed that the object moves affects its temporal interpolation.

Linear temporal interpolation produces mechanical, uniform motions and is represented by a straight line on a speed graph. Differences in velocity values between key frames occur in steady time increments, and the rate of motion or change progresses at a consistent pace. *Non-linear* (or *Bezier*) *temporal interpolation* involves acceleration or deceleration, resulting in less predictable, more natural motions. Smoother transitions between frame ranges produce more realistic results.

controlling duration and velocity

Velocity is a temporal property that can be governed by controlling the distance between key frames. Closing down or opening up the space between key frames on a timeline shortens or lengthens the duration of events (**10.32**). You can also control velocity by modifying the degree of interpolation. For example, After Effects allows you to change the start or end values of the key frames corresponding to an element's position, scale, or rotation numerically or manually (**10.33**).

In most applications, velocity curves can be altered to accelerate or decelerate an incoming and outgoing velocity. For example, an object can slow as it approaches the key frame and then speed up as it leaves the frame (**10.34**). Once an element's velocity between key frames has been calculated, it can be adjusted so that elements play back at their normal rate, speed up, or slow down. The technique of *time stretching* allows you to control and change how fast the content in a layer moves by manipulating the layer's duration. For example, stretching a layer to 200% doubles the frame length so that the animation plays back at half speed; shortening the length to 50% doubles the speed (**10.35**). Time stretching can be applied to an entire animation sequence or to its individual segments to introduce speed changes. For example, you can play a portion of a sequence in slow motion, while the remainder plays back at normal speed.

10.32
Adjusting the distance between key frames on a timeline can alter a motion's velocity by changing its duration. Compressing the distance between the key frames produces greater velocities as the duration of the action is shortened. The space between the dots on the motion path is wider, indicating a greater velocity.

10.33
The amount of interpolation of key frames can control the velocity of an element's motion.

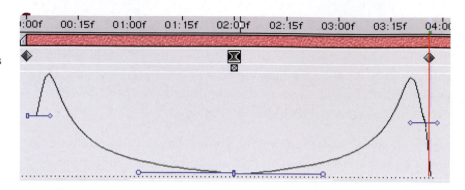

10.34
Using a Velocity graph, you can adjust the rate of motion to control how fast or slow changes occur between key frames. In this case, the velocity curve was manipulated to create the effect of the motion gradually stopping and starting again.

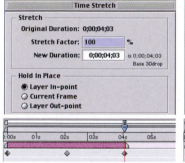

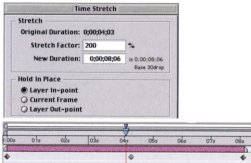

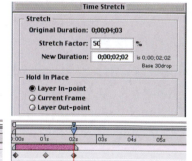

10.35
After Effects' "Time Stretch" function allows you to speed up or slow down playback by entering key frame values on the timeline.

Most applications also offer built-in algorithms that can produce acceleration or deceleration. Flash's "ease in" and "ease out" feature, for example, uses a standard velocity curve. In **figure 10.36**, After Effects' Easy Ease In function is applied to the last position key frame, producing a gradual deceleration of an object as it approaches its final position. Acceleration in the velocity at the beginning of the inter-polation results when Easy Ease Out is applied to the first position key frame. When it is applied to both key frames, the incoming and outgoing velocities are affected. (The spacing between the dots on the motion path is uniform before each effect is applied.) Initially, the graph displays a straight line, indicating a constant speed of motion along the path. After each algorithm is applied, the spacing changes to represent acceleration and deceleration.

10.36
Adobe After Effects' "Easy Ease" operation.

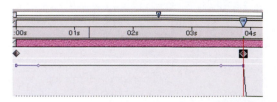

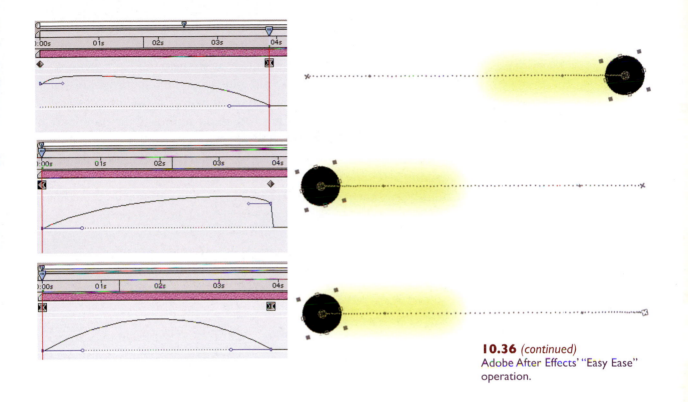

10.36 *(continued)*
Adobe After Effects' "Easy Ease"
operation.

Coordinating Movement

Multiple transformations can be combined on a timeline, allowing an element's absolute and relative positioning, scale, and orientation to be animated simultaneously.

Advanced techniques, such as parenting and nesting, provide more control in coordinating different types of movements between elements. For example, a figure's hands, arms, head, and legs can be animated separately, and these animations can be combined into one. The entire subject consisting of moving parts can then be animated to walk across the screen.

parenting

Parenting in animation is a powerful technique that allows you to create relative (no pun intended) movements between elements by setting up hierarchical relationships. For example, the chimes and hands of the clock can rotate independently while following the position of their parent, the clock, as it moves across the screen.

The concept of parenting is easy to understand if you apply this simple analogy: When parents hold their child's hand to keep him or her from straying away, the child naturally moves with the parent and follows wherever the parent goes. The child maintains the freedom to turn or move freely within his or her own space; however, those motions are not transferred back to the parent. The main actions of the parent are automatically passed on to its children; however, a child's action does not necessarily affect the parent. A parent can have an infinite amount of children. (Having three, I would suggest stopping there!) However, a child can only have one parent. Children can be parents to other children, and there is no limit to the hierarchy that you can build.

10.37
In After Effects, a parental hierarchy is built to coordinate the motions of the main "body" and its smaller parts.

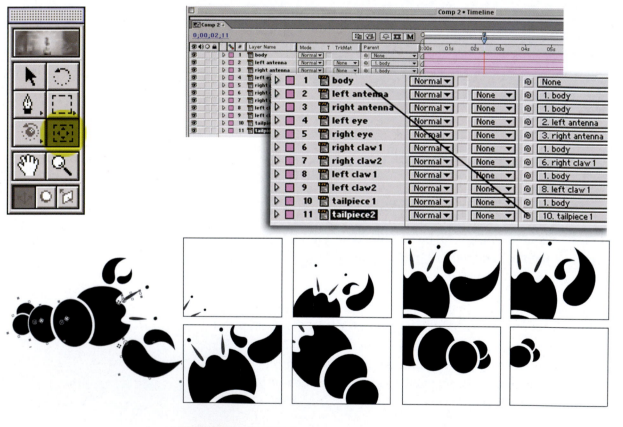

nesting

Complex animations may consist of many different types of movements. The technique of nesting (referred to as precomposing in After Effects) allows you to organize individual movements into separate animations that can later be combined.

In figure 10.38, symbol nesting in Flash is used to combine and coordinate individual movements. In Symbol 1, the rotation of the graphic is interpolated across a series of key frames. Symbol 1 is brought into Symbol 2. Inside Symbol 2, Symbol 1 is looped 4 times, and its opacity is interpolated to fade out at the end of the last sequence. Symbol 2 is then animated in the scene to a motion guide layer. Each individual component of the animation can be refined inside its original symbol.

10.38
Symbol nesting is performed in Flash.

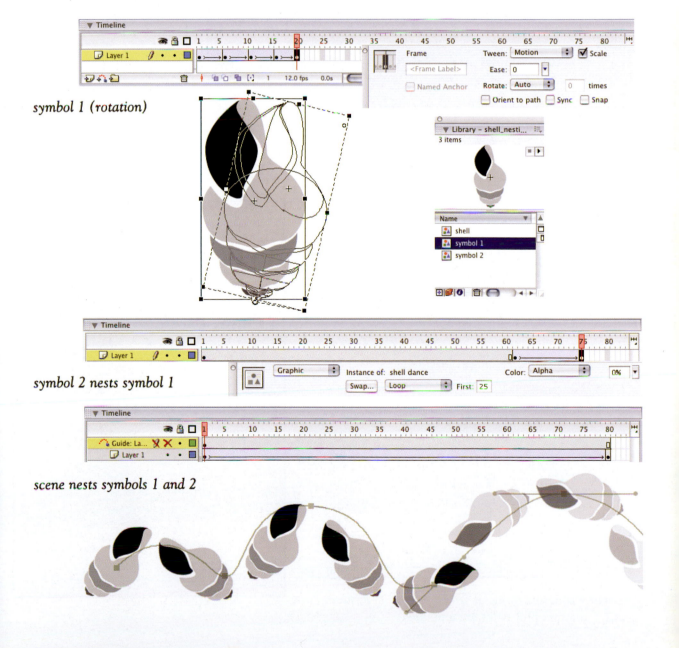

10.39
Composition nesting in After Effects is used to combine and coordinate individual layers that animate at different speeds.

Comp 1				
0;00;09;29 (29.97 fps)				
Source Name	Parent	:00s	01s	02s 03s
▽ ■ 1 1.eps	⊚ None			
▷ 🖸 Rotation	1 x +0.0 °			
Switches / Modes				

Comp 1 Comp 2				
0;00;09;29 (29.97 fps)				
Source Name	Parent	:00s	01s	02s 03s
▽ ■ 1 2.eps	⊚ None			
▷ 🖸 Rotation	2 x +0.0 °			
Switches / Modes				

Comp 2 Comp 3				
0;00;09;29 (29.97 fps)				
Source Name	Parent	:00s	01s	02s 03s
▽ ■ 1 3.eps	⊚ None			
▷ 🖸 Rotation	4 x +0.0 °			
Switches / Modes				

*Each image is animated in its own Comp
with varying speeds of rotation.*

Comp 1 Comp 2 Comp 3 Comp 4			
0;00;01;13 (29.97 fps)			
Source Name	Parent	:00s	01s
▷ ■ 1 Comp 1	⊚ None		
▷ ■ 2 Comp 2	⊚ None		
▷ ■ 3 Comp 3	⊚ None		

*Comps 1, 2, and 3 are nested inside of Comp 4
to group the animated images together.*

Comp 1 Comp 2 Comp 3 Comp 4 Comp 5			
0;00;04;24 (29.97 fps)			
Source Name	Parent	:00s	01:
▽ ■ 1 Comp 5	⊚ None		
▽ Transform	Reset		
· 🖸 Anchor Point	360.0 , 240.0 , 0.0		
▷ 🖸 Position	388.4 , 226.0 , 0.0		
· 🖸 Scale	⊚ 100.0 , 100.0 , 100.0		
· 🖸 Orientation	0.0 ° , 0.0 ° , 0.0 °		
· 🖸 X Rotation	0 x −29.0 °		
▷ 🖸 Y Rotation	0 x +38.0 °		
· 🖸 Z Rotation	0 x +0.0 °		
· 🖸 Opacity	100 %		
▷ Material Options			
Switches / Modes			

*Comp 4 is nested inside of Comp 5, and its Position
and Y rotation properties are animated.*

mobile framing

Today, 2D and 3D motion graphics packages give designers considerable control and flexibility to experiment with mobile framing. Inserting "camera objects" into a composition can portray various perspectives and viewpoints. Adobe After Effects, for example, provides several camera presets, all of which simulate the capabilities of common lenses and 35mm film. These are named according to focal length, which describes the distance between the image display and the viewer's perspective (**10.40**). Editing between different camera views can show an action unfolding from different angles and spatial distances.

Basic camera motions that are used in traditional filmmaking can be emulated through interpolation. Panning and tilting, for example, can be achieved by moving an image that is wider than its visual field across the frame. Zooming can be achieved by changing the camera distance in relation to a subject or by scaling the subject up over time.

10.40
After Effects provides camera presets that simulate the capabilities of common lenses and 35mm film.

10.41
After Effects' multiple-view layout allows you to view different views of a scene from different angles.

10.42
After Effects lets you navigate a
camera in one view while
observing the result in the other.

Comp 5, which contains an animation of the wheel rotating 360°, is nested inside of Comp 6 and assigned as a parent to the camera as seen in the Timeline above.

relative scale of background image to frame

10.43

An object is interpolated to move across a background image that is larger than the dimensions of the frame. Dollying is performed by parenting a camera to the object. As a result, the camera (or our point of view) moves horizontally with the object on the x axis.

relative scale of background image to frame

Comp 5, which contains an animation of
the wheel rotating 360°, is nested inside
of Comp 6 and assigned as a parent to the
camera as seen in the Timeline above.

10.44
The object from **figure 10.43** is interpo-
lated to move across a background that is
larger than the frame's dimensions. A cam-
era that is parented to the object follows its
course of travel or motion path.

Summary

Frame-by-frame animation involves creating individual images and displaying them in quick succession to create *persistence of vision*—the illusion of continuous motion. *Key frames* identify major changes in a scene and are used as guides for constructing the *in-between* or *intermediate frames* that complete the transitions between them.

During the 1930s and 1940s, classical frame-by-frame animation for film was a labor-intensive undertaking that involved executing drawings on paper or on semitransparent sheets of vellum or onionskin. Cell animation reduced the labor of classical animation by layering foreground, middleground, and background elements onto sheets of celluloid film. Experimental film pioneers popularized the direct-on-film or "cameraless" technique, which involved creating images on filmstrips with traditional media, chemical compounds, or processes such as scratching, burning, and rubbing, as well as collage and stop-motion animation. Today, desktop animation programs offer "natural media" tools that offer designers a heightened sense of freedom.

Unlike frame-by-frame animation, *interpolation* software can calculate intermediate data between key frames to produce linear or non-linear uniform motions. *Spatial interpolation* (or *path animation*) involves animating an object's position, orientation, or scale, while *visual interpolation* involves animating its geometry, color, transparency, or surface properties. *Temporal interpolation* describes how elements move through time. Velocity is a temporal property that can be controlled by governing the distance between key frames as well as through the technique of time stretching.

Advanced animation techniques such as parenting and nesting allow you to coordinate and preserve types of motions and modify them independently. Further, most motion graphics applications allow you to work with "cameras" to portray various perspectives and viewpoints of a composition. Basic camera motions that are used in traditional cinematography can be emulated digitally through interpolation.

11

motion graphics compositing
synthesizing the content

Motion graphics compositing techniques have become more advanced, allowing for the seamless integration of 2D and 3D images, typography, and live-action content. The advent of digital technology has both enhanced and complicated the process of compositing, and "thinking in layers" has become a standard trend.

The hybridization of digital and traditional media allows motion graphic designers to create complex compositions that are visually arresting and commercially effective. The unusual creative possibilities that exist in merging diverse imagery are pushing the limits of artistic experimentation and expression.

"There are contexts in which what is happening in the whole cannot be deduced from the characteristics of the separate pieces, but conversely; what happens to a part of the whole is, in clear cut cases, determined by the laws of the inner structure of its whole."
—Max Wertheimer

00:00:00:11

Compositing: An Overview

Compositing involves seamlessly merging a variety of separate visual elements into a uniform, seamless compositional space. It allows you to create unusual relationships that are impossible to achieve in the real, physical world by combining live-action footage, graphics, hand drawn elements, and typography.

Historical Perspective

In the early twentieth century, Dadaist and Futurist artists were among the first to liberate ideas through the techniques of collage and photomontage. The German Dada movement at the end of World War I prompted painters and graphic designers to explore collage, and photographers to experiment with multiple exposures, combination printing, and assembling cutout pieces of photographs. The works of George Grosz, John Heartfield, Herbert Matter, and Kurt Schwitters were among the most influential of this period, demonstrating a heavy reliance on experimentation, playfulness, and spontaneity.

The role of the compositor used to be unique and specialized. When digital editing processes replaced traditional video editing tools, the distinction between compositors, editors, and CGI artists became blurred. The gap between video editing and motion graphics software has also narrowed, since live-action footage has become an integral component of motion graphic design. Further, the processes of animation and compositing are often performed at the same time and with the same software.

In a FUEL TV network ID produced by Brand New School in Los Angeles, images exist in a seamlessly layered magical world, where eagles fly over ancient landscapes, bikes leave trails of rainbow-colored paint, unicorns gallop over fire-engulfed swords, and skaters ride the edge of a rainbow, created to help brand the channel. Inspired by seventies airbrush art on surfboards, as well as the sides of vans and rock album covers, director Jonathan Notaro synthesized live-action footage, three-dimensional images, and digitally airbrushed graphics (**11.1**).

A variety of animated 2D and 3D graphics interact with one another in an instructional video for the music channel Fuse. Buck, a motion graphics design company in Los Angeles, aimed to make the content feel like the humorous nature of Fuse. Ryan Honey, Creative Director/ Co-Owner of Buck, based his concept on how to make things out of brands that are related to music in some way. The Fuse Shoe Box theme, for example, shows how to make a speaker out of a Puma shoe box; the Winterfuse Fronts shows how to make metal teeth fronts of the word 'Fuse' out of a stick of Winterfresh Gum (**11.2**).

11.1
Frames from *Fantasy*, produced by Brand New School (Los Angeles). Courtesy of FUEL TV.

11.2
Frames from *Winterfuse Fronts* and *Fuse Shoe Box 3000*, IDs. Courtesy of Buck.

11.3
In the opening title sequence to
Boogeyman (2005), transparent
moving words that fade in and
out set the film's mood. Courtesy
of Reality Check Studios.

Blend Operations

The most basic compositing techniques involve controlling the
transparency of multilayered images and the manner in which their
colors "mix" visually.

Degrees of transparency between static and moving elements in a
composition can be established by specifying a layer's opacity value.
Similar to interpolating an element's positioning, scale, or rotation
over time, opacity is an attribute that can be animated to emulate
semiopaque materials, such as water or glass, or to create simple
dissolves between key frames (**Chapter 10, figure 10.28**).

Blend operations (also referred to as *composite modes* or *layer modes*)
offer a journey of discovery by allowing you to mix the hues, saturation,
and brightness values of superimposed images. **Figure 11.4** illustrates
standard blend operations. *Multiply* references the color and bright-
ness data in the color channels of both layers and multiplies their pixel
values, resulting in a blend of progressively darker colors. Multiplying
any color with black produces black, while multiplying it with white
leaves the color unchanged. Values between black or white produce
progressively darker colors. *Screen* multiplies the inverse of each layer's
pixel values, producing lighter colors. The effect is similar to projecting
photographic transparencies on top of each other. *Overlay* multiplies
or screens a layer's pixel values depending on the color and brightness
information of the underlying layer. *Darken* overlays pixels from a top
layer that are darker in value than the layer(s) below. *Lighten* produces
the opposite effect of darken, overlaying the top layer's pixels that are
lighter in value than those of the layer below. *Difference* subtracts pixel
values of the top layer from those of the bottom layer or vice versa,
depending on which has the greater value. *Exclusion* produces a
similar effect with lower contrast. *Hue* generates a result based on the
brightness and saturation levels of the bottom layer's pixels and the
hue of the top layer's pixels. *Saturation* considers the luminance and
hue of the top layer's pixels and the saturation of those of the underly-
ing layer. *Luminosity* takes into account hue and saturation values of
the bottom layer and the luminance values of the top layer.

Figure 11.5 illustrates a rich arrangement of three-dimensional and
two-dimensional animated images, colors, patterns, and textures. This
was made possible by varying the opacity levels and blend modes of

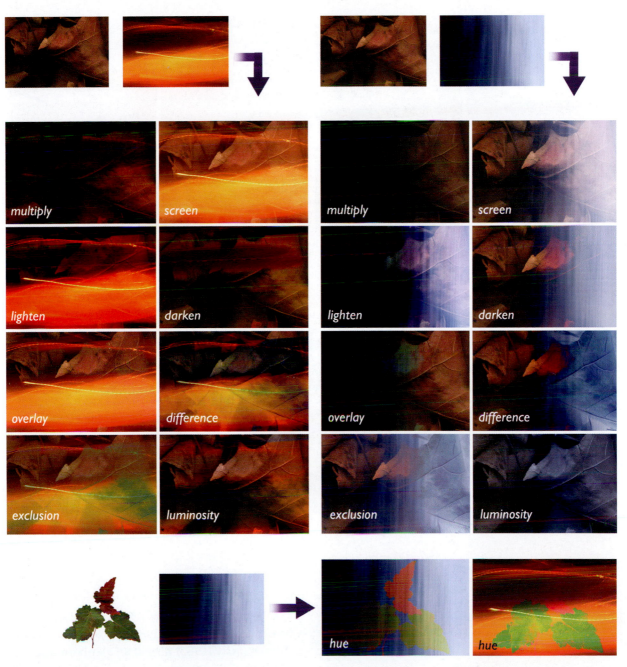

11.4
Standard blend operations used for layer compositing.

the layers. In **figure 11.6**, an organically rich and tactile palette of photographs, simple graphic forms, and brush strokes was achieved by assigning different composite modes to the composition's layers in a multilayered promotional spot for explore.org.

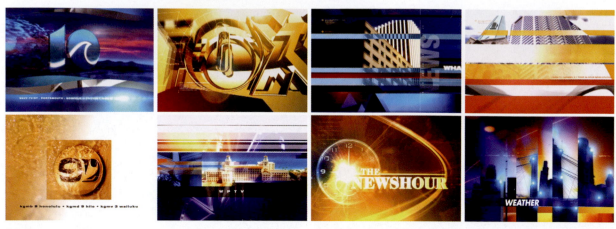

11.5

Frames from Giant Octopus' motion graphics news reel.

11.6

Frames from *Explore*. Courtesy of Belief.

In this composition, After Effects' layer modes were used to achieve a richness of color and texture of images that were photographed from various world locations.

Keying

Keying is a technique that eliminates a selected range of colors to create areas of transparency. It is often used to place actors or scale models shot against a solid green or blue screen into imaginary situations. For example, the classic *Sgt. Pepper Party* (1967) filmed an elephant against a green screen that was replaced with a "background plate" of the Adelphi Hotel. In *Spider-man* (2002), the hero is filmed leaping around a room painted with a flat color that was substituted with footage of a cityscape. *The Matrix* (1999) involved placing multiple cameras in a 360-degree room painted with green or blue. Computer-generated images were "keyed" into the scene to produce a seamless composite.

chroma and luma keys

Chroma keys are single colors that are used to substitute parts of a scene with new data. The most well-known implementations of chroma keying in television occur in the local news. A talent who appears to be speaking in front of an animated weather map is most likely sitting in front of a blue backdrop. The blue hue is keyed out in the production room, and the animated map footage is inserted into the broadcast.

In a title sequence for a music video competition held in New Zealand, live-action subjects were shot against a green screen and composited with illustrations ranging from half fish–half drill, Jandal plants, spanner trees, a skill saw ocean, and animal builders. This blending of images was created to convey the theme of "do it yourself" for a target audience of young artists between the ages of sixteen and thirty (**11.7**).

The term "chroma key" is often used in the video industry, whereas in film, the term "matte" is more common. Both processes are related in that mattes are often generated from keys. When a subject is filmed against a blue screen, the blue hue is removed, and a matte is left behind from the foreground image (similar to a cookie cutter).

11.7
Frames from *Handle The Jandal* (2005). Courtesy of G'Raffe.

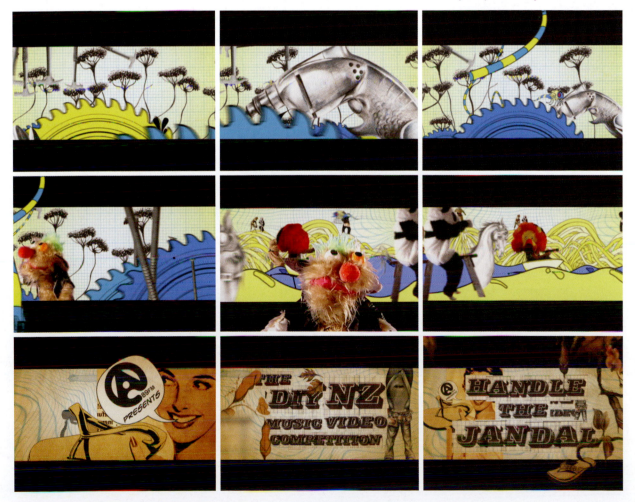

11.8
Frames from *Untitled 003: Embryo*. (2007). Courtesy of Belief.

In this experimental narrative short, Santa Monica-based design studio Belief filmed the main character, a neurotic man stricken with agoraphobia, in front of a blue screen to create the illusion of him flying through the sky

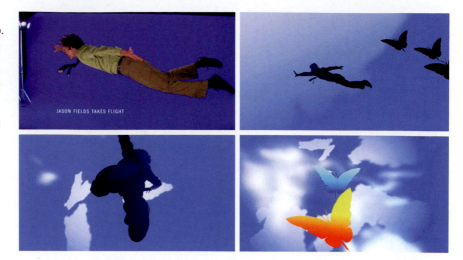

Luma keys are brightness keys that enable a range of tonal values to become transparent. The technique of luma keying works best with high-contrast footage in which the background's tonal ranges are significantly different than those of the foreground elements.

> *Bright blue and green are considered to be the standards for chroma keying in the broadcast television industry.*

keying tools

In the past, keying tools were out of the price league of independent animators and motion designers and could only be found in professional television studios. Today, they are well integrated into most motion graphics compositing applications. Adobe After Effects, for example, contains versatile tools for refining mattes created from luma and color keys. In **figure 11.9**, a threshold value is asigned to a luma key to determine what pixels become transparent according to their level of brightness. After Effects' color key operation can knock out evenly lit backgrounds that have minimal or no variation in color (**11.10**).

11.9
After Effects' luma keying process allows you to specify a threshold value to determine what pixels become transparent according to their brightness.

An edge thin operation can help eliminate edge pixels that contain the luma or key, and an edge feather option can soften the foreground-to-background transition (**11.11**). If a background contains subtle color fluctuations due to uneven lighting, a color tolerance function can knock out unwanted pixels (**11.12**). After Effects' color range operation defines a matte using a color key eyedropper tool that allows you to select a range of colors to key out. The resulting matte can be refined, expanded, and "painted" over to achieve a better key. Additionally, the edges between the transparent and opaque areas of the matte can be feathered to soften the transition (**11.13**).

11.10
After Effects' color key operation.

11.11
After Effects' edge thin option can eliminate residual edge pixels containing the luma key and feather the transition from foreground to background.

11.12
After Effects' color tolerance function can help knock out backgrounds that contain subtle fluctuations of color.

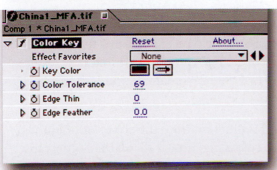

11.13
After Effects' color range option defines a matte that can be refined.

11.14
After Effects' choking options.

Since fine details can be difficult to key out, After Effects provides "choking" methods that can refine a key. For hard edges, a "simple choker" is ideal for cleaning or tightening up a key, while a "matte choker's" detailed settings can blur the area between the subject and the background, providing a softer transition (**11.14**).

keying tips

The process of keying takes time, patience, and the right tools if it is to be accomplished successfully. Here are a few general guidelines:

1. Avoid the key color, and choose the right color.

Be sure the subject that you are shooting or creating does not contain values or colors that are similar to the type of key being used. If it has bright values, luma keying it against a white background may result in "dropout." You may need to reshoot or recreate the subject on a background that is more suitable for keying.

Be sure that the background is different from the colors or brightness levels of your subject. Some colors are more difficult than others to key, such as reds, because of the high constant of red in many color

Historical Perspective

In the 1970s, Petro Viahos invented the *Ultimatte*—an analog video processor that performed soft edge matting. In the mid-1990s, the term "Ultimatte" denoted a closer association with chroma keying. During the 1990s, Ultimatte Corporation's high-end Ultimatte system was used by broadcasting and film studios around the world. When a subject was placed in front of a blue screen, the Ultimatte activated the background image and allowed it to appear in proportion to the amount of blue that it recognized in the camera's blue channel. Areas containing the brightest and most saturated blues were replaced with the background source, while darker blue areas caused less of the background to show through

variations. Even the most subtle movements or changes in lighting can cause a red key to bleed into the image. In **figure 11.15**, red was not a wise choice because of the amount of red found in the subject's skin tones. Green proved to be a more effective key color.

A backdrop can be any color, as long as it is uniform and is not a part of the foreground subject. Green and blue are the most widely used in video, since they are built from red, green, and blue (or in some cases YUV) signals. Skin pigments vary; some work well with a blue screen, while others are better equipped for green. If you are keying live footage, the DV format prioritizes luminance over chroma. Since green has a higher luma content than blue, green usually yields a better result.

2. Research your materials.

Your local hardware or home improvement store can provide you with affordable paint to be mixed at 100% purity at your request. As an alternative to paint, blue or green fabric can be used, as long as it is smooth and free of wrinkles. Muslin, which can be purchased at any art supply store, can be stretched over a wooden frame and painted to make the fabric tight. Bulletin board paper from any local school or office supply store can also be handy and allow you to extend the screen onto the floor. Rolls of green or blue photographers' paper can also be used. Try to prevent wrinkling, crumpling, or tearing, which can cause subtle fluctuations in color value.

4. Light wisely!

Lighting is a critical factor to keying. Color uniformity is critical, and the backdrop should be evenly lit with several bright, diffused light sources. Lighting inconsistencies can be caused by unwanted shadows from backgrounds that are not uniformly lit or from subjects placed in

11.15
If a subject contains color or brightness values that are similar to the key, dropout may result.

Many production houses have cyc walls (or infinity walls) consisting of two walls and a floor that curve into each other. Seamless transitions between wall and floor produce the illusion of infinite background space. This facility can be rented with the inclusion of lighting equipment.

close proximity to the backdrop. Because of subtle fluctuations in tone, the color of shadows may not be uniform enough for your software to produce an accurate key. A handheld meter can confirm that light distribution is consistent. Place your subject as far away from the background as possible to prevent shadows from falling onto the screen.

"If you were to set up a luma key shot of a TV personality in front of a white backdrop, things might go fine, right up until the talent starts perspiring. When his shiny forehead catches the key light and reflects back a 100 percent luma level to the video camera— whoops. Your expert suddenly has a hole in his head. This is a bad thing."

—Bill Davis

Measures can prevent or minimize the effect of *spillover*—a phenomenon that occurs when background light reflects onto the subject. An overhead ambient light with an amber or yellow gel can wash out color that might spill over into hair detail. A backlight with a color gel that is complementary to the key color also can reduce spill by neutralizing the effect. (Try using a magenta gel against a green screen or an orange gel against a blue screen.) Be sure that light falling onto the subject is not falling onto the background. Separate the subject from the background at a substantial distance. Finally, imitating the lighting of the environment that will be keyed in behind the subject adds a sense of realism to the final composite. Cheap floor fans can come in handy if you can't afford a wind machine!

5. Use high-quality footage.
Despite the superior quality of digital video over analog video formats, its compression codec is prone to producing video artifacts, blockiness, and noticeable aliasing along curved and diagonal edges when keying. Therefore, high-end analog video formats, such as Beta-SP, are recommended over DV when capturing footage to be keyed in the studio. S-VHS or Hi-8 produce troublesome edges, and VHS is out of the question. If your only choice is to capture your footage with a digital video camera, there are work-arounds.

6. Experiment.
Spend considerable time experimenting with lighting, camera settings, and the positions of your subject and backdrop. Planning in advance will save time and labor in the long run.

7. Work closely.
Zoom in closely to the composite to make sure that the edges of your foreground elements look clean.

9. Soften the transition.
Effective keys avoid the harsh look of hard-edged foreground elements that appear cut out with a pair of scissors. Softening a key's effect with a slight feather or edge blur can help fuse foreground and background

images together naturally, giving the appearance of the two being indistinguishable. Edge blurring works especially well with moving images, as the eye is more focused on the action than on the image. Adobe After Effects' luma and color key operations allow you to soften transitions between subject and background by adjusting the opacity of edge pixels. In **figure 11.11**, the edge thin operation was used to constrict the matte, and the edge feather setting was used to increase the foreground edge transparency.

10. Be patient.
Shadows and fine details can be difficult to work with, even with the most sophisticated software. Therefore, plan to dedicate considerable time to testing your key and cleaning up your mattes, if necessary.

Alpha Channels

Alpha channels are one of the most powerful compositing techniques of combining static and kinetic images and typographic content. The term "alpha channel" is based on a 32-bit file architecture. Unlike a 24-bit color (or RGB color) image that contains three channels of information, a 32-bit image carries a fourth alpha channel that functions to store transparency information. That data is used to determine image visibility when imported into a time-based animation or video environment. Transparency, like color, is based on 8 bits or 256 levels of data that dictate which areas of the image will become concealed, which areas will remain visible, and which portions will be semi-visible (or partially concealed). Alpha channels can contain any type of visual data, including simple graphic shapes, letterforms, gradient blends, and elaborate continuous-tone images.

The secret behind alpha is often first understood in the context of a static compositing program such as Photoshop. (Alpha channels have been one of Photoshop's most powerful features since its inception in the 1980s.) Transparency data that is stored inside an alpha channel can be applied to an image as a mask (or a selection), or can be imported into a motion graphics environment (**11.16**).

When a 32-bit image is brought into a time-based environment, its visibility honors its alpha channel, meaning that it is only displayed where white or gray levels are present in the alpha channel. Areas that correspond to black are cropped (or "keyed") out (**11.17**).

Alpha channels should not be confused with an image's red, green, and blue color channels. Unlike a 24-bit color (or RGB color) image that contains three channels of information, a 32-bit image carries a fourth alpha channel that stores transparency (or alpha) data. The alpha channel's 8-bit data is reserved to give an image or video clip shape and transparency when composited in a motion graphics environment.

Adobe Illustrator and Photoshop content created on transparent backgrounds retain their background transparency when imported into a motion graphics application. This is because an alpha channel matte is automatically generated.

11.16
Transparency data that is stored inside an alpha channel can be applied to an image as a mask (or a selection), or can be imported into a motion graphics compositing environment.

11.17
When a 32-bit image is brought into a time-based environment, its visibility conforms to the data stored inside the image's alpha channel. Portions of the image corresponding to black areas remain invisible. When composited with a background image, the underlying image appears through the transparent or alpha portion.

Mattes

A *matte* is a static or moving image, which, like a stencil, can be used to govern the visibility of another image. In compositing, mattes provide unlimited creative possibilities.

Generating hand-executed mattes for moving images on a frame-by-frame basis depicts traditional rotoscoping in its true form—laborious hours spent on meticulous detail! The development of keys, alpha channels and masks (or splines) has automated this process by performing automatic matte extraction.

Historical Perspective

Hand-executed mattes in the film industry have been used to create a variety of illusions since the beginning of motion pictures. One of the oldest special-effects techniques involved using a double-exposure matte. A cameraman would film a group of actors cautiously walking across a bridge, and a piece of black paper or tape would cover a portion of the lens corresponding to the sky, leaving that area unexposed. The film was rewound, and black paper or tape was placed on the lens to cover the exposed portion of the film.

A menacing thunderstorm scene was then filmed at a slow film speed, so that when played back normally, the clouds appear to be quickly rolling in across the sky. Both scenes might be shot separately on separate pieces of film, and through optical compositing, projected onto a third piece of film one frame at a time. Alternatively, both sequences might be scanned into a computer, digitally composited, and written back out to a third piece of film with a film printer.

luma mattes

A *luminance matte* (or *RGB matte*) is an external image that is used to make portions of another image transparent, based on its combination of RGB brightness values.

Luminance mattes should not be confused with alpha mattes, which are *internal* mattes that are derived from alpha channels. Alpha mattes are attached to images; the data residing inside of an alpha channel is used to control what parts of the image will be visible. (It also determines *how* visible the parts will be, according to the brightness levels.) Luminance mattes are external to images and are needed when an alpha channel is not present (for example, QuickTime video). Alpha mattes are 8-bit, grayscale images, and luminance mattes can be 8-bit or 24-bit images consisting of three RGB channels. Luminance mattes can be static or moving, while alpha channel mattes can only be static.

In **figure 11.19**, the brightness levels of an external luminance matte govern the visibility of a superimposed image over a background. Black areas function as the mask, and white areas permit the background to pass through at 100% opacity, like paint being pushed through the holes of a stencil. Intermediate gray values represent varying levels of transparency, allowing the image to pass through partially, depending on how light or dark the gray levels are. (The lighter the gray, the more opaque the image will be; the darker the gray, the more transparent it will be. This is not physically possible with traditional stenciling.)

11.18
Traditional silkscreen printing offers an analogy to how mattes are created digitally. Ink is pushed through the unprotected areas of a screen to form a positive image. The areas of the screen that are covered with emulsion act as a matte, preventing the ink from being transferred to the paper.

11.19
A luminance matte is used to govern the visibility of a superimposed image over a background.

11.20
A track matte consisting of black type on white is used to combine a static background with a superimposed QuickTime layer. The video layer referencing the matte is sandwiched between the matte and background layers. Dark areas of the matte clip the footage to the letterforms, allowing the background imagery to show through regions outside the type.

In **figure 11.20**, After Effects' track matte feature involves the use of luminance and alpha mattes. Their difference has to do with where the information determining visibility resides—in an image's RGB channels or in its alpha channel (if it has one).

video layer *background layer*

luminance matte

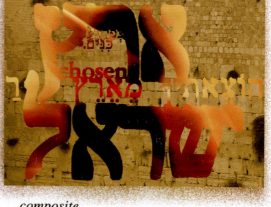

composite

*luminance matte
(inverted)*

composite

11.20 *(continued)*

matte styles

Both alpha channel mattes and luminance mattes can be composed of solid shapes, feathered shapes, gradients, typography, and entire images. Additionally, they can be "painted" digitally from black, white, and gray values and from brushes varying in size and softness.

solid mattes

High-contrast black-and-white mattes mimic conventional stenciling or silkscreening in that they can confine images to shapes. In **figure 11.21**, an image appears through a white shape on a blackground. The image is clipped to the areas of the matte containing the brightest luminosity values, while the background image appears at full opacity through the regions of the matte that are black.

11.21
A solid, high-contrast black-and-white matte confines an overlying image to a specific shape.

continuous tone mattes

Unlike traditional mattes that act like cookie cutters, digital mattes can be composed of feathered edges, paint strokes, gradients, and images that have intermediate levels of gray. Portions of a matte containing pixel values of 128 (halfway between black-and-white or 0 and 255) allow superimposition to occur at 50% opacity. Values between black and white allow superimpositions to occur at varying degrees. This prospect of semi-permeability can lead to many exciting layering possibilities (**11.22-11.24**).

11.22
A matte containing a shape with feathered edges is used to create a vignette effect. As values become lighter over the transition from the edge to background, the image fades out accordingly.

11.23
Mattes consisting of complex brish strokes, shapes, or patterns offer a variety of artistic effects.

11.23 *(continued)*

11.24
A gradient matte containing uniform changes of tone is used to fade an image out at its edges.

traveling mattes

A *traveling matte* is a matte that changes its appearance or position for each frame in cases where the subject moves or changes. In **figure 11.25**, four different elements are composited in After Effects: an image of a magnifying glass, a luma matte based on the shape of the lens, background text, and a fill layer containing larger text. The order of the layers on the timeline from bottom to top begins with background text, the magnifying glass image, the large text, and the matte. The visibility of the fill layer containing the large text is restricted to the circular shape of the luma matte. The matte layer is registered into position with the lens and is parented to the lens layer so that they both can move together as one unit. The lens' position property is key-framed, and the matte pans along, revealing portions of the fill layer. At the same time, scale key frames are created for the fill layer to simulate the effect of zooming.

In the old days, individual mattes that conformed to the shape of a moving subject were created by hand, frame-by-frame—a tedious, time-consuming process. Today, the advantage of keying is that it performs automatic matte extraction.

11.25

A matte conforming to the shape of the magnifying lens is moved into registration. The visibility of the layer containing clear text is set to reference the matte. The lens layer is parented to the matte layer, allowing them to move as a unit. The matte layer's position property is key-framed.

Masks

11.26

A spline's vertices can be moved, added, deleted, or manipulated to change the shape of the mask.

the nature of splines

Masks offer an alternative compositing technique to keys, alpha channels, and luminosity mattes. Unlike mattes, which establish transparency through brightness data, masks are defined by *splines*— paths that consist of interconnected points that form a line segment or curve. **Figure 11.27** compares typography used as an alpha channel matte to type that is used as a Bezier spline. In the matte, a video clip appears through the white areas (or the alpha portion). In the mask, the splines of the letterforms can be manipulated to change their geometric appearance over time.

11.27

top row:
The image appears through the matte's white areas (the letters).

bottom row:
Text outlines are converted into splines, and their geometry is animated through interpolation.

rotoscoping and animated masks

Generating precise hand-executed mattes for moving images on a frame-by-frame basis depicts traditional rotoscoping in its true form. This process constitutes laborious hours spent on meticulous detail. The technique of interpolating the changing geometry of a spline mask can automate this process.

In the film *Titanic* (1997), puffs of human breath were used to depict the chilled environment of the North Atlantic. (A large portion of the film was shot near the warm waters of the Pacific.) Several breath sequences were filmed and combined onto the original footage. Masks were created to protect foreground elements such as heads and shoulders so that a superimposed breath appearing come out of an actor's mouth would disappear behind them. Each mask was animated with extreme precision to follow the motions of those foreground elements. At points where registration was inaccurate, the compositor manually refined the mask's shape and position at certain key frames.

Most motion graphics packages allow mask properties to be key framed to change over time. In **figure 11.29**, a mask is created on a layer containing a live-action video clip of a book's pages being opened by a gust of air generated from a fan. Key frames are established every ten frames for the spline's shape, feathering, and expansion properties. New key frames are then generated at every fifth frame in between, allowing the mask to more closely adhere to the changing image.

11.28
A mask can be expanded, contracted, or feathered to change its size or soften the transition from foreground to background.

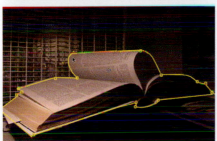

11.29
Rotoscoping is used to perform mask interpolation.

Viewers become immediately drawn to elements that appear to be unnatural in the way that they move or change. Professional "roto artists" dedicate serious attention to maintaining visual consistency, since their goal is to minimize distractions that can be obvious to the most scrutinizing eyes. Even with today's most advanced tools, "roto-masking" can be a tricky and meticulous process. Here are several tips:

1. Analyze the subject.

Rotoscoping requires careful analysis of the subject. This means identifying the frames that represent the most extreme changes. Once these frames have been established, alteration can be performed at those time intervals to conform to the image, and the software's ability to calculate in-between key frames saves a great deal of time and labor.

2. Zoom into your work.

Working close up is critical for achieving precision, especially along complex edges.

3. Minimize the number of vertices.

An undesirable effect of sloppy compositing is *edge chatter*—a phenomenon that occurs when a mask's outline changes irregularly from one frame to the next. This is usually a result of using too many vertex points and moving those points inconsistently between frames. Creating a mask on the frame where an element's shape is intricate allows you to determine the minimum number of vertices needed to adequately mask it over the frames that are being rotoscoped.

4. Break down complex images into multiple masks.

Consider breaking the parts of a complex image down into separate masks and animating those masks individually. This will help establish accuracy and consistency and will help maintain the integrity of the paths. Some masks will only require interpolation of position or scale, while others may need shape alteration by repositioning the vertex points. Mattes that conform to different parts of a subject can be articulated and animated separately.

5. Weigh the options among masking, matting, and keying.

In compositing video images, there are advantages of masking over keying, such as the elimination of spillover caused by poor lighting conditions and the ease of performing in a natural setting versus on a synthetic blue-screen set (in the case of using people as subjects). On the other hand, keying elements that move against a uniform

background can be easier than animating a mask's position and shape frame-by-frame. If only a mask's position changes over time, a luma matte or an alpha channel may be a better solution.

Nesting

One of the most powerful and convenient compositing techniques for constructing complex motion graphics sequences is nesting. The goal of nesting is to implement an organized hierarchy of compositions in order to make the editing process easier and more effective. This process involves two steps: 1) building a layered composition and 2) consolidating that composition into a single layer to be brought inside of another composition.

Most professional nonlinear editing tools leverage the ability to nest in their timelines. The Avid Xpress system, for example, allows you to combine multiple video layers into a single track. In Apple's Final Cut Pro, any number of clips can be nested into a sequence, and audio tracks belonging to the original clips are automatically consolidated into a single track. Motion graphics applications, such as Adobe After Effects and Flash, are also capable of this. After Effects refers to an intermediate (versus a final) composition as a *precomp*. Precomps were used to integrate layers of complex visual information in "First Stop For The News," a television commercial for NY1's twenty-four hour cable news channel (**11.30**). Belief, a motion graphics firm in Los Angeles, created an impressionistic version of NYC based on NY1's campaign to purchase the billboards that were showcased on the city's buses. This concept spawned the idea of a traveling bus that brings the city to life. After taking numerous photographs of iconic intersections around the city, storyboard artists were hired to create traditional hand drawn sketches over the printed photographs on tracing paper. In After Effects, a precomp was built from the original photographs, and various camera movements were incorporated. This composition was duplicated, and in the duplicate precomp, the photographic images were replaced with the pencil sketches. In a third composition, the second precomp containing the pencil sketches was layered on top of the original composition containing the photographs. (Since precomps 1 and 2 shared the same key frames, both sets of images and camera movements were perfectly aligned.) A layer containing images of ink bleeding into paper was sandwiched between precomps 1 and 2 to

allow transitions to occur between photographic and hand-drawn elements. The results were rendered out as QuickTime movies, and the movie files were imported back into After Effects to be layered over a paper-textured background. This process fostered artistic experimentation by reducing the amount of waiting time that it would normally take to render all the precomps and their respective layers.

11.30

Frames from "First Stop For The News," a television commercial for NY1. Concept and motion graphics by Belief.

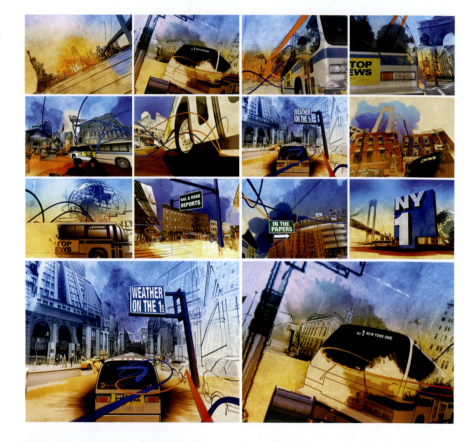

In **figure 11.31**, several QuickTime video clips have been arranged to create the effect of an animated video wall. The precomp is brought into a new composition, and its position, scale, Y-rotation, and X-rotation is interpolated. Additionally, a color tint is applied. This is an example of how nesting allows you to efficiently organize your composites. Rather than having to apply a transformation or an effect to each layer individually, nesting gives you the benefit of applying it only once to affect all layers in the nest. If, at any point, the layers in the original composite are tweaked, those changes are automatically updated in the nested composition.

In the television show opening to *The Hungry Detective* (**Chapter 2, figure 2.18**), After Effects was used to connect multiple precomps. Each precomp consisted of its own internal camera moving in 3D space. Bezier masks, keying, and alpha channels were also used to composite live-action footage, photography, illustration, and 3D graphics. The magnifying glass at the beginning of the sequence communicates a "micro and macro" concept that allows us to "fly" inside the elements almost microscopically.

11.31
Nesting two levels in Adobe After Effects is used to create an animated video wall effect. Comp 1, consisting of multiple live-action video layers, is nested into a second composition, Comp 2. As a single layer in the nested comp, a color effect is applied, and its position, scale, and Y-rotation properties are interpolated as each clip plays separately.

Color Correction

Representing color accurately and consistently is a critical part of compositing. Color correction and enhancement operations can rectify mismatched colors between different sources, enhance color, or alter color to achieve certain types of effects and consistency between visuals. Insufficient lighting conditions due to poor capture, inadequate scanning, or mismatched sources are all variables that may mandate performing color correction.

Since no two people will ever agree on what looks right (including your clients), it is best to trust your own eyes when color correcting your work, especially when attempting to match colors between sources.

improving luminance

Since color varies are highly dependent upon luminosity, improving luminance or brightness information is the first step to establishing color accuracy.

assessing tonal range

Assessing an element's tonal range is achieved by referencing its histogram to identify its range and distribution of brightness values. **Figure 11.32** compares the histograms of a "healthy" and "unhealthy" clip of live-action video. The healthy version utilizes most of the available values between 0 (black) and 255 (white), unlike the unhealthy version, which lacks detail in the shadow areas. Additionally, gaps in the central region of its histogram indicate that the footage is deprived of subtle mid-tone levels.

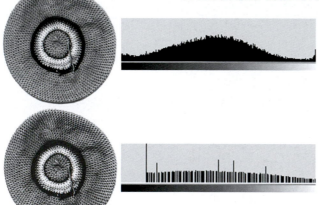

Once tonal range has been assessed, measures can be taken to improve tonal contrast and detail. The most ideal remedy would be to acquire a better original or improve the quality of the original by reshooting or rescanning it. Of course, this is not always possible due to financial and time restrictions. The next and most often the more pragmatic measure would be to improve the element's luminance.

11.32
These histograms demonstrate a "healthy " and "unhealthy" usage of an image's brightness levels.

standard luminance operations

Standard brightness/contrast operations can serve as a quick fix for content that lacks shadow or highlight detail by producing linear shifts in luminosity levels. Darkening shifts shadow details to black, eliminating highlights, while brightening maps highlight details to white, eliminating shadows. Increasing contrast reduces mid-tone levels, causing subtle highlights to be mapped to white and shadows to black. The result, however, can deprive an image of its subtle mid-tone details. The process of *equalization* can produce a more uniform distribution of luminance by mapping the darkest values to black and lightest values to white while redistributing intermediate gray levels more evenly. It can, however, be detrimental to shadow and highlight details. In comparison, the technique of *unsharp masking* produces the most effective results, because shadow and highlight subtleties are accentuated (**11.33**).

original image with a "healthy" histogram

value deprivation caused from standard brightness and contrast adjustments

more extreme value deprivation caused from equalization.

Best improvement of contrast through unsharp masking

Levels and *curves* operations offer more precise methods over how values are dispersed. For example, if shadows are too dark, they can be shifted to higher values without affecting an element's mid-tones and highlights. This process can increase an image's contrast while removing unwanted color casts (described in the next section). Cropping the histogram incorporates values on the extreme lower and upper scale, resulting in accentuated shadow and highlight detail (**11.34**).

11.33
Best improvement of tonal contrast is achieved through the process of unsharp masking.

11.34
Cropping the histogram extends the image's tonal range to include darker shadows and lighter highlight details.

11.35
Redistribution of tonal values on a gamma curve is achieved by shifting the points corresponding to the image's input levels. In this case, only the mid-tone ranges were modified while shadow and highlight details were maintained.

Mid-tone ranges are difficult to target, unlike black and white points. Although mid-tone levels can be set by selecting a neutral region of an image, the results are sometimes unpredictable. A "healthy" scan should contain sufficient mid-tone detail in its histogram. Color correcting poor scans wastes time and further hinders brightness detail.

The most effective approach of improving an image's color luminance is by remapping its original brightness levels to the full 8-bit (256 level) gamut by setting its black and white points. Levels and curves operations allow you to set black and white points by permitting darks or lights above or below a specified threshold level to be remapped to black or white. In the curves operation in **figure 11.36**, the eyedropper corresponding to black is used to selects a pixel with a value of 25. As a result, all pixels between 0 and 25 are remapped to 0 (black). The right eyedropper, corresponding to white, selects a pixel with a value of 220, and all pixels between 220–255 are remapped to 255 (white).

11.36
Improving an image's tonal detail is accomplished by remapping the darkest and lightest pixels to pure black and white, a process referred to as "setting the black and white points."

value alteration

Alteration of luminosity values can be performed to enhance images or to experiment with tonal effects. *Posterization,* for example, reduces the amount of brightness levels that are used, producing a flatter and more graphic looking image. *Inversion* produces a negative image as luminosity values or colors are reversed. Black becomes white, and a light gray with a value of 30 becomes a dark gray of 225. Mid-tone levels are changed the least (128, or 50% gray, remaining unchanged).

removing color casts

Once tonal range has been improved, adjustments can be made to remove *color casts*—unwanted colors that result when an element's red, green, and blue channels are not properly balanced. Color casts can occur universally or can be limited to specific highlight, shadow, or mid-tone details.

Color balance provides a quick method of removing casts by shifting specific color polarities simultaneously. The results are most promising if shadows, mid-tones and highlights are balanced separately. Entire ranges of hues are shifted on the color wheel, producing subtle to dramatic changes. Applying a levels operation to an image's RGB channels can also improve color across its tonal range. Altering individual distributions of red, green, and blue may be more time-consuming, but it provides greater precision in enhancing color and identifying unwanted casts. Cropping the histogram can improve contrast and color depth, because it redistributes the value mapping to the full 256 spectrum. (This approach can also neutralize problematic casts.) Curves, in conjunction with levels, allow precise modifications to be applied to an entire color gamut or to any one or combination of color channels. For example, the red channel of the image in **figure 11.37** has the poorest tonal quality as seen in its histogram. There is also a slight green cast evident in the image's highlights. Extending the value range of the red channel by cropping the histogram, and decreasing the intensity of highlights in the green channel by altering the tonal curve resolves this issue.

color manipulation

Any combination of techniques that have been discussed can be performed experimentally on individual elements or entire animation sequences. Color alteration can also be performed on grayscale images that have been converted to RGB color space prior to compositing. For

Most motion graphics compositing programs feature tool sets that can be used for color correction. Their key-framing capabilities allow you to make fine adjustments to a portion of a scene or to animate a color effect over time. Apple's Final Cut Pro's levels operation, for example, allows you to alter the distribution of any one of a layer's red, green, and blue color channels at a time. Apple's Shake provides a vast array of manipulation tools that can correct, enhance, and match colors from different sources and combine them with masks and other effects. Its color match operation allows you to create a common color palette between composited images to achieve natural looking results. After Effects' color balance operation provides individual controls for the red, green, and blue channels for shadows, mid-tones, and highlights. Its channel mixer can modify all of the available color channels (similar to how you would mix audio channels using a mixer). A monochrome setting represents an image in black and white while allowing you to tweak the channels to achieve unusual effects. After Effects' hue/saturation operation, lets you shift a layer's hues while controlling its saturation and lightness levels. A "colorize" option eliminates the existing colors and adds an overall tint to create effects, such as an old sepia look.

11.37
Color correction is performed through levels and curves operations in the image's red and green color channels.

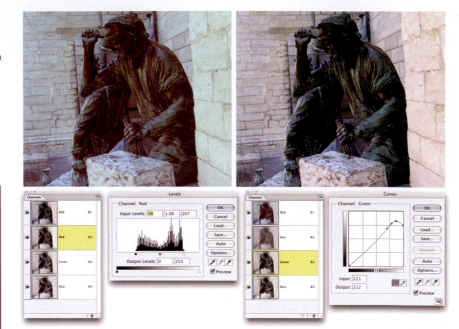

11.38
Photoshop's duotone operation can be used to map a grayscale image's brightness values to specific colors to achieve certain color effects. The image can then be converted back to RGB to be imported into a motion graphics environment.

example, colorization techniques can emulate the effect of a hand-tinted photograph. Grayscale images that have been converted to 8-bit duotones, tritones, and quadtones also lend themselves to achieving dynamic color effects, and these can later be translated back into RGB color space. In **figure 11.38**, Photoshop's duotone, tritone, and quadtone features are used to assign specific hues to the shadow, mid-tone, and highlight regions of the histogram. Once a desired color effect is achieved, the image was converted back to RGB color to be imported into a compositing program.

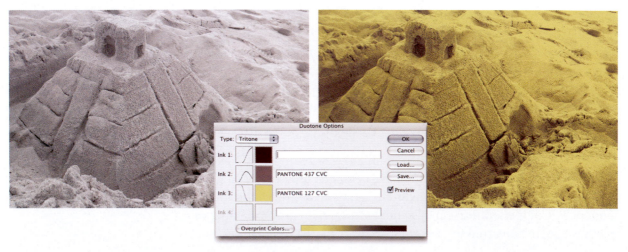

Mixing brightness data between an image's channels is another powerful and intuitive way to enhance color intensities. Brightness percentages from multiple channels can be combined and added to a specified target channel. For example, values within the red channel can be mixed with those from the green or blue components (**11.39**).

11.39
After Effects' "channel mixer" can mix and match brightness values from different color channels to achieve compelling effects.

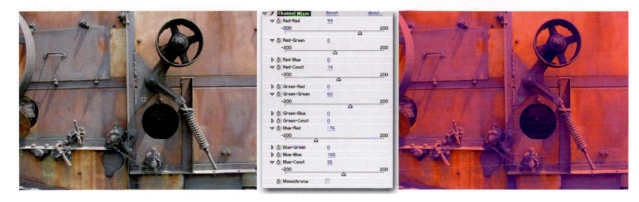

Summary

Motion graphics compositing allows you to seamlessly integrate many types of content into a uniform, multi-layered space to create unusual, visual relationships.

Blend operations allow you to determine how the pixel information of superimposed images blend to create intriguing effects. *Keying* involves eliminating a selected range of colors or brightness levels to produce areas of transparency. *Alpha channels*, which rely on 32-bit color architecture, can also combine different types of content by using transparency data to determine an element's visibility. *Splines* offer an alternative technique of compositing—masking. The practice of *nesting* can be used to construct complex animation sequences by building an organized hierarchy of compositions in order to make the editing process easier and more effective. Most professional nonlinear editing tools leverage the ability to nest animations in their timelines.

Representing color accurately and consistently is critical to achieving effective compositing. Color correction and enhancement operations can rectify mismatched colors from different sources, enhance their color, or alter their colors. Assessing an element's tonal range by identifying its brightness values on a histogram is an important step in establishing color accuracy.

12
motion graphics sequencing
synthesizing the content

The process of sequencing in motion graphics can provide visual rhythm, enhance narrative, create emotions, and enable you to construct and restructure time and space. Time can be dramatically condensed from a period of several weeks into minutes or seconds. Space can be radically altered, jarring viewers between different environments to empower them and give them a sense of omnipresence. Further, sequencing can attribute new meanings to the subject being portrayed, making it more memorable and perhaps even life-changing.

"The essence of cinema is editing. It's the combination of what can be extraordinary images of people during emotional moments, or images in a general sense, put together in a kind of alchemy."
—Francis Ford Coppola

00:00:00:12

Editing: An Overview

The technique of editing has been alive for years, giving much creative potential and power to motion designers. In film and video, it involves the coordination and joining of multiple shots, each shot consisting of a series of frames that occupy screen space and time. In motion graphic design, it is the process of linking two or more motion graphic sequences or two or more views of the same sequence into a cohesive whole.

Traditional *linear editing* involves a linear tape-to-tape process in which specialized equipment, such as videotape recorders (VTRs), switchers, and mixers, are used to sequence footage into a finished production. Today's flexibility of *nonlinear editing* allows you to digitally access and modify frames of footage without altering the original source. (In contrast, the "cut and glue" technique of film editing is destructive, since the actual film negative is cut.) Nonlinear editing is performed on standard desktop computers or on specialized hardware systems (such as the Media 100 and Avid) that can process high-resolution data in real-time. Consumer-level video editing applications, such as Final Cut Pro (Apple Computer, Inc.) and Pinnacle Studio (Pinnacle Systems, Inc.), offers nonlinear editing, compositing, and special effects tools, while motion graphics programs, such as After Effects, offer standard but less sophisticated editing capabilities. Some editing software can be downloaded for free, and others, like Microsoft's Windows Movie Maker or Apple's iMovie, are included in the operating system.

Editing can be broken down into two processes: 1.) selecting and 2.) sequencing. Selecting involves choosing which actions or events will be in the final production. This depends upon your contextual factors, such as the subject being communicated, the intent of the communication, the target audience, and the method or style that will be used to deliver the message. Sequencing involves linking the actions or events together in a way that clarifies and intensifies the information, to create a clear and memorable experience for viewers.

From classical Hollywood films to avant-garde filmmaking and experimental animation, different editing styles throughout history have defined the narrative and nonnarrative form of filmmaking and have inspired trends in motion graphics.

Historical Perspective

Editing itself can dominate a film's style. During the 1920s, film theorists began to realize what film editing could achieve, and it quickly became the most widely discussed film technique to successful cinema. Sergei Eisenstein's early productions, such as Strike, Potempkin, October, and Old and New, demonstrate the attempt by young, experimental Russian filmmakers to make editing their fundamental principle in film during the 1950s.

In the past, video editing was a linear process that required careful planning in advance. Today, simple cuts, inserts, superimpositions, and masks can be performed digitally in any order, offering a greater degree of flexibility and precision in the timing and synchronization of events. Additionally, they allow motion graphic designers to readily alternate between multiple sources of footage in a more spontaneous and creative manner.

Editing is established through the use of cuts and transitions. Both of these techniques necessitate a visual strategy that requires patience, sensitivity, and intuition. It is important to remember that intuitive judgments can lead to conscious decisions.

Cuts

The cut has been the most widely used editing technique since the invention of film. It produces abrupt, instantaneous changes of space or time in a sequence, or between sequences, of images, actions, or events. Unlike transitions, they do not occupy time or space. Cutting between images with different points of view or different types of framings can contribute to the emotional impact of the theme. If poorly used, however, cuts can create undesirable results that look like mistakes rather than intentional, artistic decisions. As discussed later in this chapter, rhythmic cutting can help determine pace and regulate event density. For example, the frequency of cuts in an MTV spot or a short television commercial might establish sensory bombardment of visual information, whereas the more limited number of cuts in a documentary nature film may preserve its modest, academic integrity.

The soundtrack in music videos often aids motion graphic designers in determining where visual cutting should occur.

In **figure 12.1**, simple cuts between segments of digitally-projected images and credits conform to subtle changes in the music to create a quiet sense of drama and suspense. In contrast, the rapid, rhythmic cuts in the typographic sequence in **figure 12.2** give the company's identity a high intensity feel.

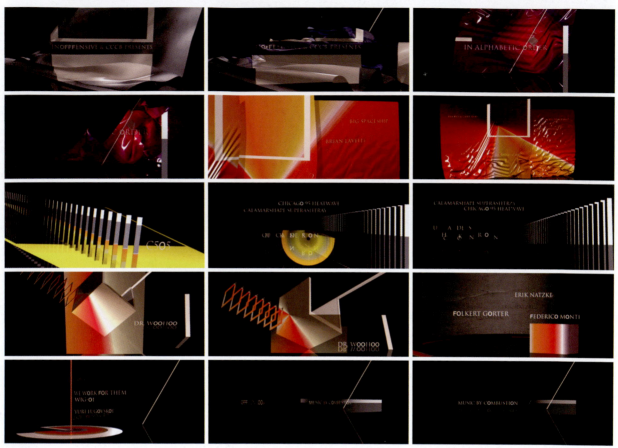

12.1

Frames from the opening titles for OFFF's BCN 06 event. Courtesy of Renascent.

Crosscutting involves cutting between different actions that occur at the same time to keep viewers informed of two or more events. In traditional chase scenes it can build tension by shifting back and forth from the pursuer to the pursued. As a result, both lines of action are tied together, indicating that they are concurrent. This technique can enrich a narrative continuity and alter time by accelerating or slowing down the main action. It also gives viewers a range of knowledge that is greater than that of the subject. Although it creates some spatial discontinuity (discussed later in this chapter), it can link separate events together to produce a sense of cause and effect.

Parallel editing involves crosscutting between independent spaces or events to suggest that they are taking place simultaneously. It also creates a sense of omnipresence, giving viewers unrestricted access to onscreen and offscreen space by alternating between events from one line of action with events from other places. It can also create parallels

Edwin S. Porter's The Great Train Robbery (1903), a landmark of American silent film, is an early example of parallel editing. Many of the shots depend upon our ability to imagine that the crosscut scenes extend into off-screen space where events continue to develop whether we are present to view them or not.

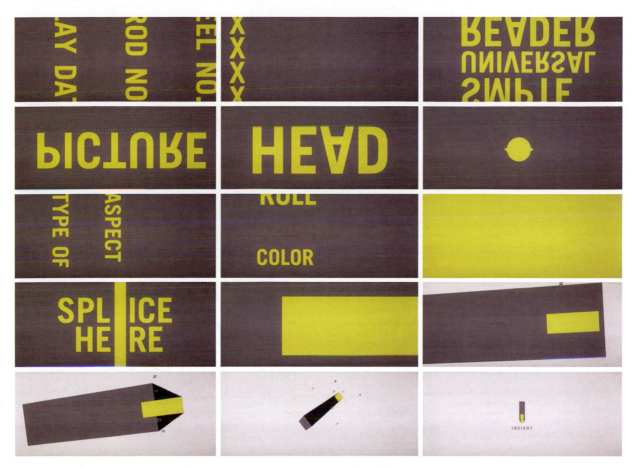

12.2
Frames from a motion ID for Insight, a company specializing in behind-the-scenes film production. Courtesy of Renascent.

by suggesting analogies to draw the viewer into the action. Parallel editing is basic to motion picture editing and has been used to describe relationships between images and their corresponding soundtrack. The technique of *counterpoint* functions in the opposite way—to show relationships between images that are not parallel to the accompanying soundtrack. Both of these techniques have been used for creating suspense and altering the passage of time.

A *cutaway* shows an event or sequence of events that are unrelated to the main event. Its objective is to temporarily draw attention away from the action as it continues to unfold in offscreen space and time. In *Heritage*, a personal film about themes from the Old Testament, a sequence showing a close-up of a Torah reading precedes a shot of an Israeli dancer moving to the sound of his voice. Cutaways are also used to establish symbolism, such as an image of a dancing flame followed by a rabbi reciting a prayer (**12.3**).

12.3

Frames from *Heritage*, Phase III, by Jon Krasner. This sequence uses cutaways between a Torah reading, an Israeli dancer, a flame, and a rabbi reciting a prayer.
© Jon Krasner, 2007.

12.4

The opening titles to *The Movie Hero* (2003) employs cutaway views between the main talent, who believes that his life is a movie watched by an audience that only he can see, and images of movie theatre concessions.
Courtesy of Shadowplay Studio.

Many believe that Russian film-maker Lev Kuleshov, who helped establish the basis for montage during the silent film era, pioneered the technique of parallel editing by linking together different shots of actors who seemed to be looking at each other, although they were filmed on different Moscow streets. Many filmmakers have employed the "Kuleshov effect" by juxtaposing shots of disparate events to create a cohesion between different spaces or time zones.

As an alternative to cutaways, *jump cuts* produce abrupt changes or noticeable jumps in the positions or movements of elements against a constant background. (Alternatively, the ground can change abruptly while an element remains fixed in space.) Because there is a visible change in the content, it becomes obvious that part of the composition has been cut out. The illusion of continuous time is broken.

Jump cuts became popular narrative devices during the 1960s and continue to be used to accentuate rhythm, abbreviate time, signal emotional stress, or cause viewers to be momentarily perplexed. In a series of promos for Comedy Central's hit series, *Chappelle's Show*, a frequent use of jump cuts in the subject's movement, positioning, and camera views works in concert with the background's bold graphic shapes to express the sharp, defiant humor of the series (**12.5**).

A *flash cut* is a rapid interchange between two shots to create a dramatic, psychological effect. Sometimes a single frame is enough to arouse fear or shock. Jump cuts and flash cuts are discussed later in this chapter with regard to establishing temporal discontinuity.

Transitions

Transitions are alternatives to using straight cuts to link sequences of images or actions. Both in their style and in their speed, they allow a smooth flow between changes by providing a link between sequences. Whether transitions are generated by the camera during capture, produced optically in a lab, or digitally on a computer, they play an influential role in the timing of events by providing gradual changes between sequences over a designated time period in a composition. Aesthetically, it is essential that you exercise artistic discretion in using transitions appropriately and in moderation without becoming overly dependent upon their effects.

The most common types of transitions are dissolves, fades, and wipes. Dissolves are frequently used to indicate passages of time. They involve smooth, gradual changes of opacity between two overlapping events so that the ending frames of the first event incrementally blend with the opening frames of the next. This method of transition softens abrupt changes between frames, producing the effect of one sequence melting into the other. (In sound, a dissolve is commonly referred to as a *crossfade*.) As mentioned later in this chapter, using dissolves can aid continuity because they act as thematic or structural time bridges between events.

A dissolve's length can produce various effects. For example, a slow dissolve can indicate a long time lapse, while a quick one can convey a brief passage of time. In a bumper for Showtime Networks, slow dissolves are used to enhance the concept of flowing silk (**12.6**). If a

12.5
Frames from Comedy Central's *Chapelle's Show.* Courtesy of Freestyle Collective.

dissolve is frozen midway, a *superimposition* results, producing ghosted images of two different sources. (Stopping a crossfade would produce a mix of two different audio sources.)

12.6
Frames from a bumper for Showtime Networks. Courtesy of Giant Octopus.

In most motion graphics and digital editing applications, the parameters of built-in transitions can be altered in terms of their duration, size, and orientation, depending on the type of transition.

A *fade* is a dissolve from or to black (or any solid color). It is achieved by gradually increasing the exposure until the image reaches its full brightness capacity. A *fade-out* is obtained by gradually decreasing exposure until the last frame is completely black. Fades are generally used at the beginning or end of major events to signify a major change in content, time, or space. As such, they represent a distinct break in a story's continuity. The length of a fade is usually taken into strong consideration with regard to the timing and mood of the overall piece. In the title sequence to *Mansfield Park*, the use of fades between long durations of events effectively establishes the tone of the film (**Chapter 6, figure 6.21**). The opening titles to the film *Moth* employ fades between the strange transformations of rotating macro close-ups of light bulb filaments and the opening scene, to indicate that a passage of time has passed (**12.7**). In a bumper for a weekly ice hockey series broadcast across NTL's cable network, short fades are emulated through actual players skating in and out of a theatre spotlight in a blacked out ice hockey rink. Small increments of time between the actions reflect the passion and excitement of the game (**12.8**). In a student project involving a fictional product advertisement, Eric Eng's incorporation of fades and dissolves between shots of varying camera angles focus on the subject's organic forms to express its power and beauty (**12.9**).

Wipe transitions were common in the 1930s, involving an image literally pushing the previous image off of the frame through a horizontal, vertical, or diagonal movement. A *flip* (or *flip frame*) is a type of wipe in which the images appear to be cards flipped one after another. Wipes

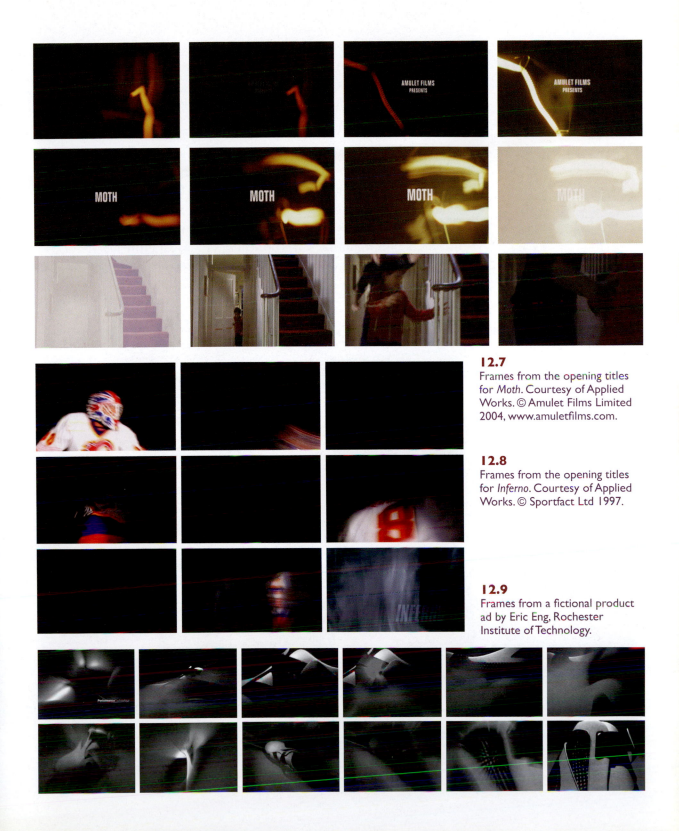

12.7
Frames from the opening titles for *Moth*. Courtesy of Applied Works. © Amulet Films Limited 2004, www.amuletfilms.com.

12.8
Frames from the opening titles for *Inferno*. Courtesy of Applied Works. © Sportfact Ltd 1997.

12.9
Frames from a fictional product ad by Eric Eng, Rochester Institute of Technology.

can move in any direction, open any side, start in the center and move outward toward the frame's edges or vice versa. Additionally, they can begin as one shape and morph into another. (Split-screen effects are often created by wipes that are partially completed.)

In addition to standard dissolves, fades, and wipes, most applications offer a variety of complex graphic transitions that can be customized and animated; they can flip, bounce, and crush their way into the frame. Transitions such as clock wipes, checkerboards, and Venetian blinds typically are included in most consumer packages, while more complicated transitions can be generated from actual black and white images or alpha channels. It is critical to exercise mature aesthetic judgment and use these types of transitions appropriately with respect to the integrity of your concept and design.

12.10
A linear wipe reveals new imagery in a specified direction. For example, at 90 degrees the wipe travels from left to right.

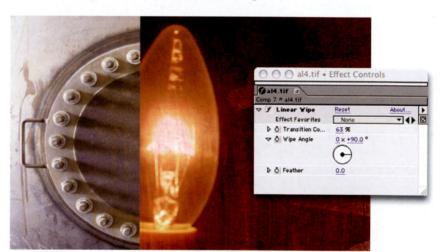

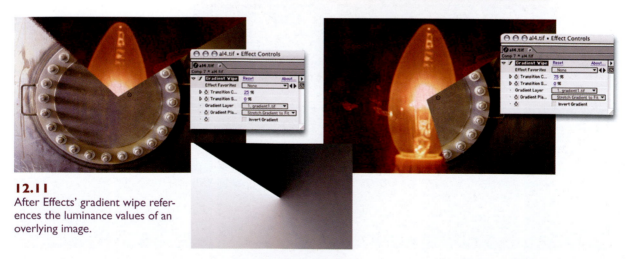

12.11
After Effects' gradient wipe references the luminance values of an overlying image.

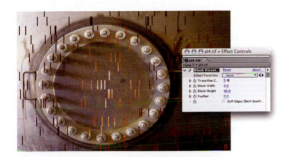

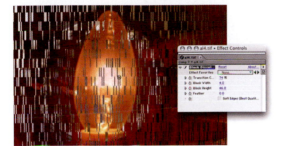

12.12

above:
Adobe After Effects' block wipe creates the effect of an image disappearing in random blocks. This transition allows you to specify the pixel width and height of the blocks.

12.13

below:
Susan Detrie's quiet, elegant, animated transitions for Fine Living Network consist of simple, two-dimensional graphic planes that move fluidly across the screen at various angles. Courtesy of Fine Living Network and Susan Detrie.

Last, transitions can involve using images from one scene to introduce images or events in the next. A great example of this is a design for a trailer and on-air package for the 2006 *Arion Music Awards* (**12.14**). The concept behind the project was to personify various categories of music in a fresh, contemporary way through the use of colorful animated illustrations. There are several image transitions that smoothly link the events. For example, a ring of piano keys enters into the frame to form a mask that encloses the underlying background imagery. The mask becomes smaller and quickly transforms the imagery into the next scene featuring several female dancers wearing a piano-like collar around their necks. An extreme graphic close-up of a woman's profile enters the frame from the right and moves across the screen toward the left, its color shifting us into a new space. Another transition in scenery occurs when a medium shot of a male figure playing guitar zooms into a space that becomes the last scene featuring a television host that turns into the music video award, a golden trophy.

12.14

Frames from the trailer and on-air package design for the *Arion Music Awards*, organized by the Mega Channel, the first corporate channel to launch on the Greek airwaves. Courtesy of Velvet.

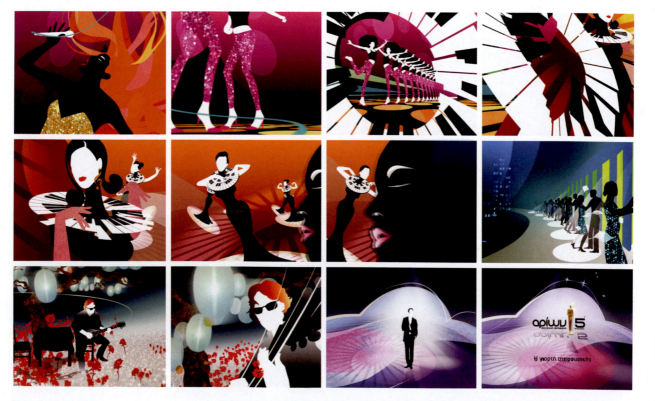

Figure 12.15 illustrates another example in a network rebrand for BET J, a cable television channel intended to showcase jazz music of black musicians. Freestyle Collective aimed to create a design that expressed

the soul and funk of jazz. The device of frame mobility (discussed later in this chapter), emulated with a continuous zoom out, was used to create smooth transitions between three different levels of space: 1) a woman aboard an airplane, 2) the airplane itself, and 3) a scene featuring a road, landscape, building, and the airplane flying off in the distance. Another composition for BET J uses a pair of musical symbols as a natural means of transition into a graphic cityscape. In a header for *50 anos bo es nada*, a documentary series that narrates the history of the Spanish television, Ritxi Ostariz's transitions are created by zooming into a portion of an image that becomes the ground for the next scene which features different elements (**12.16**).

12.15
Frames from a network rebrand for BET J, a spin-off cable television channel of BET (Black Entertainment Television), intended to feature jazz music. Courtesy of Freestyle Collective.

12.16
Frames for *50 anos bo es nada*. Courtesy of Ritxi Ostariz.

Pictorial transitions can also be created by cutting or dissolving between an image at the end of one sequence and a similar image at the beginning of the next, as illustrated in Hillman Curtis' Flash advertisement in **figure 12.17**.

12.17
Frames from "Greenville," an
online Flash advertisement for
Craig Frasier/Squarepig.tv.
Courtesy of hillmancurtis, inc.

Mobile Framing

Mobile framing offers an alternative method of constructing motion
graphics sequences versus standard cuts and transitions that are
associated with editing. The camera techniques described in Chapter
6 can be employed physically or digitally to break up a composition
into various segments. **Figure 12.18**, for example, shows a continuous,
unedited motion graphics sequence of three-dimensional forms that
move uniformly as the "camera" zooms out and rotates our point of
view to establish a final frontal view of the image.

12.18
Frames from a logo animation
for Heidelberg. Courtesy of
Renascent.

Frame mobility can also impact our sense of pace and rhythm, since it
occupies duration in a composition. The velocity or speed in which the
camera moves is an important consideration. A quick pan away from a
subject can arouse curiosity or wonder, while an abrupt movement can
induce the element of surprise or shock. Music videos often organize
the velocity of camera moves to the underlying rhythm of a song.

Establishing Pace

Pace—a vital, yet elusive, aspect of sequencing—represents the speed in which content is presented. It functions to deliver messages in the most engaging and meaningful way, taking into consideration the duration that events exist onscreen and the manner that cuts and transitions are used to link them. Film and video editors are expected to know how to choose an editing pace that establishes the mood of the content. Many of today's feature films and TV shows are often paced fast, allowing you to follow the basic story but enticing you to watch it again. Subtle events that are missed can be enjoyed during a later viewing. On the other hand, documentary films and training videos are usually slower paced, since their objective is to deliver information clearly the first time around without losing the audience's interest.

A composition's pace can change over time to communicate different aspects of a story. In the opening titles to the television miniseries, *The Path to 911* (2006), the pace picks up as the film progresses toward an extreme close-up of the World Trade Center. Each shot is heightened to inform us that an event is about to occur. Mundane scenes of a person's morning journey to work become transformed into images of large groups of people that are juxtaposed with close-ups of feet, hands, and bird's-eye views looking down into the city's streets (**12.19**).

12.19
Frames from the opening titles to *The Path to 911*, a miniseries that aired on ABC on September 10, 2006 and September 11, 2006. Courtesy of Digital Kitchen.

tempo and event density

In music, *tempo* refers to the speed that beats occur in each measure. In film, animation, and motion graphics, tempo refers to the speed that events occur over time.

Most of us have experienced that a slow tempo can support a languid pace, while a fast tempo can establish a brisk one. Moderate tempos can reinforce a sense of positive, forward progress and can be applied to a wide range of styles, from the energy of a corporate presentation to cheerful good feelings in a travel spot. The tempo you choose can determine and regulate the number of cuts and transitions that will be applied to your composition or the *event density*. For example, the large number of cuts in many car commercials create a high-density, edge-of-the-seat impact, while a smaller number of cuts in a nature documentary may generate a tranquil, serene atmosphere. David Carson's experimental film, *End of Print*, illustrates a high-density composition through short, rapid bursts of disassociated, disjointed images and typographic elements. Carson's precise, dynamic editing to the soundtrack creates an information overload that bombards us with information (**12.20**). In contrast, the slow tempo of *The Path to 911* (**12.19**) is characterized by minimal cuts between segments.

12.20
Frames from *End of Print*, based on the book, *End of Print* (1995) by David Carson and Lewis Blackwell. © David Carson.

transition speed

The speed that transitions take place is another factor that can help establish and regulate pace. The duration of dissolves, fades, or any other types of transitions that take place *between* events may affect the composition's overall pace more than the style of transition

you choose. Generally speaking, fast-paced compositions with rapid transitions across small ranges of frames can deliver snappy, energetic effects, while slow fades or dissolves that occur over long time intervals can produce a more deliberate and dignified feel.

Establishing Rhythm

In music, listening to the repetition of beats and accents in a song can identify its rhythm.

Rhythm and pace are directly related. A rhythm with a steady, consistent pace can be effective in that it is predictable enough for viewers to feel subconsciously and tap their feet to. On the other hand, a rhythm with an inconsistent, variable pace can be effective because it breaks predictability, treating viewers to the element of surprise.

From traditional cinema to MTV, *rhythmic editing* (also referred to as *dynamic editing*) has been applied to both narrative and non-narrative forms of film and motion graphics. It has also been applied to both continuous and discontinuous approaches to editing. During the early twentieth century, avant-garde Cubist and Dada filmmakers, as well as filmmakers from the French Impressionist and Soviet montage school subordinated narrative concerns to developing complementary editing approaches to establish rhythmic patterns. (Even classical

Historical Perspective

French Impressionist and Soviet avant-garde filmmakers often subordinated narrative to pure rhythmic editing. In French Impressionist films, rhythmic editing was often used to depict inner turmoil or violence. For example, the impact of the train crash in the film *La Roue* was conveyed through a series of accelerated shots that became shorter and shorter over time.

Rhythm was also a key element in the work of Surrealist filmmakers such as Hans Richter, who combined improvisation and innovative camera usage with a sense of formal Constructivism to produce continuous rhythmic themes throughout his films.

Lev Kuleshov's *The Death Ray* (1926), Sergio Eisenstein's *October* (1927), and many of the films of Alfred Hitchcock also show how rhythm can dominate narrative.

Experimental filmmaker Martin Arnold took rhythmic editing to the extreme. Piece Touchee (1989), an 18-second sequence taken from a 1950s American "B" movie, was reproduced frame-by-frame and manipulated according to its temporal and spatial progression. In Passage a l'acte (1993), a postwar family breakfast scene from the 1950s film, To Kill a Mockingbird, is transformed into a disturbing, compulsive, rhythmic sequence of repetitive movements and sounds. The sound of the opening and closing of the screen door mimics gunfire, and repeated shots of the family members who, like a broken record, yell out parts of words or twitch back and forth seem to pulsate to an underlying continuous, monotonous beat.

In music, rhythm describes how sounds of varying length and accentuation are grouped into patterns called measures. The timing of notes in each measure is independent of the tempo that governs the composition's pace. If you tap your foot faster or slower to the beat of a tune, the rhythm does not change —only its tempo.

Hollywood cinema explored the rhythmic use of dissolves in montages.) When sound films became the standard, rhythmic editing was evident in musical comedies, dance sequences, and dramas. During the 1960s, fast cutting to the beat of a tune was used in television commercials for soft drinks and during the 1980s in music videos, in which a rapid succession of highly stereotyped images were cut to match the rhythm of the soundtrack.

continuous rhythm

In music, dance, or any other form of time-based, artistic expression, most of us seem driven by rhythms that are discernable, steady, and constant. Many filmmakers, animators, and motion graphic artists who have been inspired by avant-garde cinema and Eisenstein's experiments with montage have strived to create uniform, rhythmic structures in their compositions.

timing

In motion graphics, *timing* can be considered in establishing a steady, continuous rhythm. In music, timing differs from tempo, in that it indicates the number of beats in a measure; tempo describes the speed of the beats in each measure. If you are a musician or have a basic knowledge of musical composition, you may already know that a 4/4 timing yields a different tap-of-your-foot-to than a 3/4 time signature, which, if played slowly, can feel like a waltz.

If you are editing to music, the timing of beats and accents can help determine the underlying visual rhythm. Alternatively, you can recite a verse in your mind or listen to the beat of a metronome to create a sense of timing if sound is not available. In **figure 12.21**, the timing of the cuts between photographs of urban hipster scenes and dream-like live-action imagery was precisely edited to match the piece's soundtrack. In a student project entitled *My Hero*, Eric Decker gave careful consideration to the cuts between segments and the timing in which various foods and condiments enter and leave the frame. Both are precisely edited to match the rhythm of the soundtrack (**12.22**).

frame duration

The duration that a composition's segments remain onscreen is one of the most basic temporal considerations of rhythmic editing, allowing you to govern the amount of time that viewers are allowed to see and interpret the content.

12.21
Frames from a network package for MTV K, the first premium channel under the MTV World family geared specifically toward young Korean-Americans. Courtesy of Freestyle Collective.

Combinations of live action video, still photos and vibrant animations are edited to match the timing of the soundtrack to evoke the young, cool lifestyle that has become synonymous with MTV culture.

12.22
Frames from *My Hero*, by Eric Decker. Produced in "Dynamic Typography" at the Rochester Institute of Technology, Professor Jason Arena.

A segment in a composition can be as short as a single frame or as long as thousands of frames, running for many minutes. One of the simplest ways to construct a consistent rhythm is by making all the segments approximately the same duration. Regardless of the content, related or unrelated images, actions, or events that are presented in equally spaced time intervals, will produce a steady rhythm that unifies them into a cohesive whole. This also means that the number of cuts and transitions that are used (or the event density) are distributed throughout the composition in equal intervals. A silent viewing of Man Ray's avant-garde film, *Emak Bakia* (1926), illustrates this concept. The romantic, underlying musical rhythm that prevails throughout the film is largely due to the fact that the durations of thematically related moving objects and figures on the screen are similar.

repetition of image and action

Cutting or transitioning between recurring segments that have matching or similar images or actions can also introduce uniform rhythm. This can help create a sense of structural continuity and maintain a sense of pace and cohesiveness in a composition.

Experimental animations from the 1920s relied heavily on the concept of repetition to achieve rhythm. Fernand Léger's and Dudley Murphy's Cubist film, *Ballet Mécanique* (1924), builds a rhythmic structure from juxtaposed mundane objects that are treated as motifs and are repeated in different combinations in rapid succession. Highly rhythmic sequential movements of spinning bottles, faces, hats, and kitchen utensils, which taken out of their original context, recur in highly organized arrangements. Body gestures and facial expressions seem to be mechanically orchestrated to move in concert with the film's soundtrack. Graphic contrasts, frame mobility, and rapid sequences of close-ups, medium close-ups, and extreme close-ups illustrate a complete abandonment of the continuity system in favor of achieving a dance-like choreography of rhythm (**12.23**). In Viking Eggeling's *Symphonie Diagonale* (1924), each movement was choreographed to a steady, mechanical tempo. Rhythm is articulated by the manner and speed by which geometric elements appear and disappear in the frame, along with the duration for which they remain on the screen. In many instances, figures build over time, line by line, and varying shades of gray create the effect of images fading in and out to the underlying musical score. The arrangement of different themes within the piece can be compared to the orchestration of a symphony (**12.24**).

12.23
Fernand Léger's *Ballet Mécanique* (1924) demonstrates a consistent rhythmic progression of abstract images and actions.

Image and action uniformity was also a key element in Hans Richter's approach of combining spontaneous improvisation with formal organization. Throughout his Surrealist film, *Ghosts Before Breakfast* (1927), a strong underlying rhythm is maintained in the relative speeds that elements move from shot to shot. Equal numbers of characters or objects also remain constant throughout the film to preserve rhythm. For example, three men in the one scene follow three hats in the previous shot. Additionally, shapes that fill the frame are spaced apart at equal intervals. In one particular scene containing five guns that are rotated to form a pinwheel image, the guns are spaced equidistant from each another. The rhythm is also present in the speed at which they turn. Recurring images of flying hats also establish a continuous rhythm throughout the composition.

In musical arrangements, individual notes and durational sonic patterns of notes that repeat at regular intervals can contribute to a composition's rhythmic flow to create unity. In classical music, certain themes may be duplicated to give the piece a unique personality that differs from other arrangements. Without repetition, a musical composition can stray away aimlessly in too many directions, lacking a focus.

In a bilingual on-air opener and program design for "DW Euromax" (**12.25**), objects such as violins, shoes, chandeliers, chairs, and fountain pens are strategically arranged into moving patterns or more complex abstract shapes. The elements move at constant speeds and are spaced apart at equal intervals. The repetition of these elements in consecutive segments ties the film together into a unified composition.

12.24
Filmstrip from Viking Eggeling's *Symphonie Diagonale* (1924). Taking almost four years to complete, this frame-by-frame animation showed a strong correlation between music and painting in the movements of figures that were created from paper cutouts and tin foil. Viking Eggeling died in Berlin approximately two weeks after his film was released.

12.25
Frames from "DW Euromax," a
bilingual on-air program design.
Courtesy of Velvet.

variable rhythm

Rhythm does not have to be uniform; in fact, it can change over time in order to vary the mood of a composition. Unlike dance music, where the rhythm is steady and continuous, the variety of tempo changes throughout a piece of classical music characterizes its different phases.

Variation in rhythm allows new material to be introduced into repetition. It can help break predictability and be used to emphasize a particular point of interest. It can also allow you to simply stay in synch with the soundtrack if your piece is a music video. Even if the "beat" of the soundtrack is steady and constant, introducing changes in the way images and actions are presented, as well as tempo, event density, and frame duration of content can add variety. In Léger's *Ballet Mécanique*, the relative scale of objects in the frame changes through the use of close-up, medium close-up, and extreme close-up shots. Additionally, close framings are used to isolate and emphasize form and texture, while other framings, such as upside-down shots and masks, introduce rhythmic variation.

emphasis

Emphasis marks an interruption in the fundamental pattern of events. It can also break predictability and define a point of focus. In music, emphasis is achieved by providing accents in order to make certain notes or combinations of notes stand out. In character animation, it is used to exaggerate movement. In motion design, it is used to contribute toward the visual hierarchy. For example, an element that flies or tumbles into the frame calls more attention to itself than one that moves slowly and uniformly.

varying event frequency and tempo

Showing the same event repeatedly, but in a different way, can block the viewer's normal expectation about the narrative. In fact, it can invite viewers to focus on the actual process of assembling the story. One way to achieve this is by changing the tempo in which events are presented. This also serves as an easy way to introduce rhythmic possibilities. Slow motion seems to interrupt a composition's flow, because it presents a close-up of time (similar to holding your breath), while fast motion seems to accelerate you forward in time. In a broadcast commercial for a supermarket in Spain, Joost Korngold of Renascent was given the task of creating seamless transitions between groupings of pears, a glass of milk, and several oranges to illustrate the process of

12.26
Frames for "Eroski," a broadcast commercial for a Spanish supermarket. Courtesy of Joost Korngold. © Renascent 2007.

waking up in the morning, driving to work and starting the day. Based on a rough storyboard sketch, his challenge was to make the transitions between the elements as interesting as possible by creating harmonious movements of the objects and the camera. The incorporation of fast motion and accelerated camera movements creates an exciting, unpredictable visual rhythm against the underlying, steady beat of the soundtrack (**12.26**).

In TV12's PSA promoting vehicle safety, a brisk tempo is established through rapid jump cuts that occur during a rotated and zoomed-in view of a Roadsense Team vehicle. The tempo suddenly gives way to a steady but moderate pace that accompanies a layering of complex road signs that move uniformly across the screen (**12.27**).

In the network package for MOJO (**Chapter 8, figure 8.34**), discontinuous rhythm was deliberately used to create an edgy attitude and almost disturbing feel in order to arouse anticipation. In fact, it was intended to invoke precisely the opposite reaction that you would get from watching the Hallmark Channel or Martha Stewart. Rapid cuts between images occur at an unsteady pace, changing according to the soundtrack. Instead of using music, motion graphics company Flying Machine implemented pure sounds to create strong rhythmic contrasts. One particular segment shows a dramatic contrast in which a shot of a group of rapidly twisting and turning kitchen utensils is immediately followed by a slow pan of a sensuous female torso and a car. The repetition of events, such as alcohol being poured into a glass, film projections, and extreme close-ups of female body parts, occurs at an unpredictable rate to reinforce the element of surprise.

varying frame duration

Controlling the rhythmic succession of images, actions, or events by manipulating their onscreen duration provides plenty of opportunities to introduce variety into a composition's rhythmic structure. Regardless of the time that images, actions, or events "live" in the frame, if their onscreen durations are similar, the predictability of the rhythm can grow cumbersome if they are long or become irritating if they are short. (Keep in mind that this is not always true. Similar durations of events can establish a pleasing, underlying musical rhythm, as in Man Ray's *Emak Bakia*.) Combining sequences consisting of different frame lengths can create irregular rhythms. For example, shortening or lengthening each consecutive sequence can produce an accelerated or decelerated rhythm, which can produce the effect of drama and tension, leading viewers to expect a change in narrative action. Mixing and matching short and long sequences can serve to renew the audience's attention and refresh their interest. (This means that the distribution of the cuts and transitions that link a composition's segments can also be variable).

pause

In addition to incorporating inserts and cutaways, pauses can also vary a composition's rhythm and pace. A pause can be a series of black consecutive frames between two segments or a specified time interval where the action remains frozen on the screen. Pauses can also be used to give viewers time to rest between events, emphasize a point, create expectations or tension, or help regulate the viewer's perception of the flow of time.

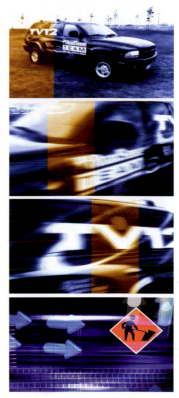

12.27
Frames from TV12's "ICBC Roadsense." Courtesy of Tiz Beretta and Erwin Chiong.

Birth, Life, and Death

In Chapter 5, birth and death describe how elements are introduced into the frame and the manner in which they leave the frame. "Life" describes their duration or how long they live or reside in the frame. In sequencing, all of these factors need to be given considerable attention. The sequential or transitional continuity that is established in many of the storyboard designs in Chapter 9 is largely due to the method in which elements appear on the screen and how they leave the frame. This allows transitions between events to flow smoothly and be easily deciphered without even seeing their actual movement.

Introduction and Conclusion

The significance of a story's beginning and conclusion cannot be overstated. Critical thought must be given to how you plan to capture your audience's attention and keep them engaged throughout the duration of the piece. Your opening and closing sequences must establish both a strong start and a strong finish. They should be given at least twice as much attention as the middle of the composition. Beware of overloading these segments with too many special effects and transitions; sometimes simplicity can be most effective (less is more) in establishing and confirming the concept.

Summary

The technique of *editing* involves coordinating and joining multiple images, actions, or events into a cohesive whole. *Cuts* produce instantaneous changes between scenes. *Parallel editing* involves joining separate events together to produce a sense of cause and effect. *Cutaways* are used to shift the viewer's attention away from the main action as it unfolds in offscreen space and time. *Jump cuts* produce abrupt changes in the positions or movements of elements, breaking the illusion of continuous time. *Transitions* are passages of time that allow gradual changes between events. For example, *fades* are used to signify major changes in content, time, or space, representing distinct breaks in a story's continuity. Mobile framing through camera movement is an alternative to linking sequences through cuts and transitions.

A composition's editing pace is based on the duration that events exist onscreen and the manner in which cuts and transitions are used to link them. Factors that help determine and govern pace are tempo, event density, and transition speed.

Rhythmic editing can be used to create continuity or discontinuity. Presenting events in equally spaced time intervals and establishing graphic and action uniformity between segments produces uniform rhythm. Varying a composition's tempo, changing the duration of onscreen events, and inserting pauses can break predictability in order to maintain the interest of viewers.

Critical thought must be given to the principles of birth, life, and death as well as the story's beginning and conclusion.

index